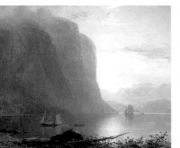

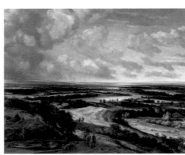

This book is dedicated to Naomi Levine, President of the Winnipeg Art Gallery
Board of Governors, who persuaded me to come to Winnipeg to lead the Gallery into its
centennial year; to my wife, Hazel Mouzon Borys, and son, Roman Mikhail Borys,
for joining me on this wonderful journey; and in memory of Ferdinand Eckhardt who,
sixty years ago, ushered the Gallery into the modern era and into its new home,
one of Canada's finest Modernist buildings.

100 MASTERS

ONLY IN CANADA

STEPHEN BORYS

WINNIPEG ART GALLERY

WITH ANDREW KEAR

100 Masters: Only in Canada

© Winnipeg Art Gallery 2013

Copyright permission has been sought and obtained for all photographic artwork contained herein.

Library and Archives Canada Cataloguing in Publication

Borys, Stephen D. (Stephen Donald)

100 Masters : only in Canada / author: Stephen Borys ; contributing writer : Andrew Kear.

Includes index.
Catalogue of an exhibition held at the Winnipeg Art Gallery from May 11 to August 18, 2013.

ISBN 978-0-88915-011-9

1. Art, Canadian—Exhibitions. 2. Art, American—Exhibitions.
3. Art, European—Exhibitions. I. Kear, Andrew, 1977- II.
Winnipeg Art Gallery III. Title. IV. Title: One hundred masters.

N6540.B67 2013 709.71'07471 C2103-900119-0

Credits

Primary author and editor: Stephen Borys

Contributing writer: Andrew Kear

Designer: Frank Reimer

Copy editor: Joan Padgett

Printed and bound in Canada
by Friesens Corporation, Altona, Manitoba

Distribution: ABC Art Books Canada,
www.ABCartbookscanada.com

Exhibition Presenting Sponsor: BMO Financial Group

Winnipeg Art Gallery, wag.ca

DEDICATION PAGES, FROM LEFT TO RIGHT:

Lucius O'Brien, *Sunrise on the Saguenay, Cape Trinity*; Chelsea Porcelain Manufactory, Potpourri or perfume vase; Robert Motherwell, *Untitled (Ochre and Black Open)*; Pablo Picasso, *La Miséreuse accroupie*; Lawren S. Harris, *Icebergs, Davis Strait*; Paterson Ewen, *Shipwreck*; David Milne, *Blue Church*; Jack Bush, *Spot on Red*; Philips Koninck, *Panoramic River Landscape with Hunters*; Félix Vallotton, *Fleurs*; Jan Lievens, *Portrait of Jacob Junius*; Gustave Caillebotte, *Voiliers au mouillage sur la Seine, à Argenteuil*

OPPOSITE PAGE: Morris Louis, *Beth Vav* (detail)

CONTENTS PAGE: Claude Tousignant, *Gong 80*

PAGE 11: Pierre-Auguste Renoir, *Le concert* (detail)

PAGE 13: A. Y. Jackson, *Lake Superior Country* (detail)

PAGE 14: Rembrandt van Rijn, *A Woman at her Toilet* (detail)

PAGE 16: Giovanni Paolo Panini, *A Capriccio of Roman Ruins with the Pantheon* (detail)

PAGE 20: Paul Kane, *Fort Garry and St. Boniface* (detail)

Contents

Lenders to the Exhibition

Agnes Etherington Art Centre, Queen's University, Kingston, ON
Art Gallery of Alberta, Edmonton, AB
Art Gallery of Greater Victoria, Victoria, BC
Art Gallery of Hamilton, Hamilton, ON
Art Gallery of Nova Scotia, Halifax, NS
Art Gallery of Ontario, Toronto, ON
Art Gallery of Windsor, Windsor, ON
Beaverbrook Art Gallery, Fredericton, NB
Canadian War Museum, Ottawa, ON
Confederation Centre of the Arts, Charlottetown, PE
Glenbow Museum, Calgary, AB
MacKenzie Art Gallery, Regina, SK
McCord Museum, Montreal, QC
McMaster Museum of Art, Hamilton, ON
McMichael Canadian Art Collection, Kleinburg, ON
Mendel Art Gallery, Saskatoon, SK
Minneapolis Institute of Arts, Minneapolis, MN
Montreal Museum of Fine Arts, Montreal, QC
Musée d'art contemporain de Montréal, Montreal, QC
Musée national des beaux-arts du Québec, Quebec City, QC
Museum of Anthropology at The University of British Columbia, Vancouver, BC
Museum London, London, ON
National Gallery of Canada, Ottawa, ON
Royal BC Museum, Victoria, BC
Royal Ontario Museum, Toronto, ON
The Rooms Provincial Art Gallery, St. John's, NL
University of Lethbridge Art Gallery, Lethbridge, AB
University of Toronto Art Centre, Toronto, ON
Vancouver Art Gallery, Vancouver, BC
Walker Art Center, Minneapolis, MN
Winnipeg Art Gallery, Winnipeg, MB

Message from the Presenting Sponsor

BMO FINANCIAL GROUP is very pleased and proud to support the *100 Masters: Only in Canada* exhibition as the Presenting Sponsor.

100 Masters is one of the most ambitious projects undertaken by the Winnipeg Art Gallery, bringing together one hundred works of art of the highest calibre from museums across the country. With paintings and sculptures by American, Canadian, and European masters borrowed from twenty-eight public collections in Canada and two in the United States, the exhibition provides a magnificent window into the past five hundred years of art, history, and society. What a fitting way for the WAG to celebrate its centennial year, and what a source of pleasure and inspiration for the community.

BMO proudly supports charitable initiatives in the communities where we operate through donations and sponsorship programs. We embrace the diversity of people's social needs, ideas, and interests, and therefore we distribute our contributions over a broad range of initiatives including education, health, arts and culture, community development, and sports and athletics.

On behalf of BMO, I offer sincere congratulations to Dr. Stephen Borys, WAG Director and CEO and Curator of *100 Masters*, the Board of Governors, and the entire staff on the occasion of the Gallery's centennial and the presentation of this historic exhibition. I invite visitors to enjoy this once-in-a-lifetime opportunity at Canada's oldest civic art gallery.

John C. MacAulay
Senior Vice-President,
Prairies Central Canada Division

Foreword

Besides being a source of pleasure, inspiration, and pride for the communities that build and support them, public art galleries are also where we go to learn about ourselves and to connect to each other across time and space. We tend not to go to art galleries to learn about everyday things; they are not repositories of typical material culture, but rather of the atypical, the exceptional, the not-ordinary-at-all things—whether new or old—that speak *of* us, and *to* us, emphatically. What art galleries call art are examples of the extraordinary products of human agency that a multigenerational consensus has deemed worth preserving. Besides that, both philosophy and common sense offer disappointing definitions.

For many people, the art gallery is where we saw our first painting or sculpture, where we first encountered exquisite photographs, where we happened upon some of the strangest, craziest things imaginable, things that were deliberately made to defy understanding. They are where we discovered that some chairs are no longer for sitting on and that some vases will not hold flowers again; their new functions are to be wondered at as outstanding examples of ingenuity, sensibility, and intelligence.

Art provides us with beautiful evidence of change and advancement. Art galleries, therefore, are encouraging places that concentrate positive energy. They are where you go to enjoy the gorgeous parade of our ever-mutable values, and to watch our best attempts to transfer those values from parent to child, from community to individual, and then back again, transformed everywhere there are people and for as long as human civilization exists. Art galleries are where we see what links us to the generations that preceded us and to the people we do not resemble. They are where we celebrate humanity.

Though no art was ever made to last forever, we have wanted it to; and so we invented the art gallery, not so long ago, to preserve art artificially. But art is a living thing, it lives and dies with the generations that make it, only to be reborn—sometimes centuries later—in the art gallery where it is repurposed by people for whom it was not made and who invest it with new meaning. So when autochthonous traditions are broken, here as everywhere on earth by the calamities of history, excluded from the rhythm of life and death and rebirth wherein culture imitates life, we are all robbed of our heritage because cultures learn from each other, not from themselves. When cities are bombed, graves robbed, monuments vandalized, the victors cannot be heroes. The art gallery is where we grieve for our benighted species, consoled by what little is left.

A place of celebration, of knowledge, and of power, boastful and proud, the art gallery is as psychically cacophonous as it is usually quiet. It is a place of magic, astonishment, and veneration, a place of mourning for what has been lost and for what is not there. And it is a place of healing, healing through remembering, through acceptance, and through resistance. Although its purpose is quite straightforward, the art gallery is, perhaps, our most complex institution.

There has been a public art gallery in Winnipeg for a hundred years. In our country, that is a long time, but in our land, it is very recent. The excitement in the world these days about the Winnipeg art scene is quite new and mostly involves people in their twenties, thirties, and forties, but also older generations, people who grew up with the Winnipeg Art Gallery as a primary resource. But then Winnipeg has always been in the game; only the number of players has increased. In fact, there has been art-making in this region since before there was a word for it, since people first stopped at The Forks. It has always been a special place.

How this beautiful gallery is celebrating its centennial speaks eloquently of just how special a place Winnipeg is. Stephen Borys, a Winnipegger in the best sense, has organized an exhibition of some of his favourite works of art from public collections across Canada. His taste is fine and his knowledge is broad, but that is not the point of this show. *100 Masters: Only in Canada* is a party for all of us. In a way, we are all in Winnipeg to celebrate not only one city's cultural maturity, but also our own general excellence, our own coming of age. Aside from its many pleasures, surprises, and old fondnesses, this festive exhibition is an elegant gesture, a warm and smiling wave of solidarity from one Canadian art-loving city to all the others.

Marc Mayer
Director and CEO
National Gallery of Canada

Acknowledgements

My first expression of gratitude is to the lenders to *100 Masters: Only in Canada*, the thirty institutions in Canada and the United States who graciously consented to part with their works of art for this historic exhibition at the Winnipeg Art Gallery. These lenders—represented by their respective directors, curators, registrars, and collections staff—all rank as co-organizers by virtue of their tremendous support, and I remain in their debt for their collective efforts and collegial spirit.

The successful realization of this exhibition and book depended heavily on the participation of the entire WAG staff, and I thank them for their dedication, hard work, and enthusiasm. I should also like to acknowledge with profound appreciation the volunteer leadership at the WAG: the Board of Governors, chaired by Naomi Levine; the WAG Foundation, led by Richard Yaffe; the Volunteer Associates, headed by Judy Kaprowy; and the Centennial Committee, overseen by Lila Goodspeed, who all championed the project from the start. This publication would not have been possible without the long-standing support of an anonymous donor who made a generous contribution to underwrite the entire cost of this book. In addition to the unprecedented support received from our centennial sponsors, The Winnipeg Foundation, led by CEO Richard Frost, recognized the national importance of this historic undertaking and made a significant financial gift. BMO Financial Group raised the bar high as the presenting sponsor, and I extend a personal note of gratitude to long-time WAG supporter John MacAulay, Senior Vice-President, Prairies Central Canada Division, whose return to Winnipeg was fortuitous. PACART acted as the official shipping sponsor, and thanks go to Mark Starling and Rick Vincil who crafted a sponsorship package that resulted in the safe and efficient transport of close to one hundred artworks from the twenty-eight Canadian lenders. The exhibition production was supported by many corporate sponsors all of whom are acknowledged in the exhibition and supporting material. Funding from Canadian Heritage, the Province of Manitoba, the City of Winnipeg, and the Winnipeg Arts Council played an important role in the WAG's centennial year initiatives, including this exhibition.

For the last two years, *100 Masters* has demanded the energies and attention of many members of the WAG staff, and among them I would like to acknowledge the following individuals: my senior management team of Helen Delacretaz, Bill Elliott, Pamela Simmons, Judy Slivinski, and Anna Wiebe for their support and expertise, and for taking on many extra duties so that I could direct my efforts to this project whenever necessary. Helen Delacretaz kept the curatorial and museum services teams on schedule and aligned from start to finish; Maxine Bock, my Executive Assistant, regularly went beyond the call of duty with her administrative support and helped keep the directorate running smoothly during my research trips and time away from the office; Ellen Plouffe skillfully orchestrated the loan request and approval correspondence in addition to many other documents; Lisa Quirion arranged for the photographic images for reproduction and study, and handled all copyright issues; and Karen Kisiow masterfully coordinated the enormous shipping portfolio, always mindful of our budget. My thanks are extended to other staff who contributed in different ways to this gallery-wide enterprise: Rachel Baerg, Sophie Begin, Mike Carroll, Catherine Collins, Kenlyn Collins, Deloree McCallum, Debra Fehr, Aline Frechette, Lisa Friesen, Hugh Hansen, Mike Malyk, Heather Mousseau, Radovan Radulovic, Doren Roberts, Sherri Van Went, the WAG volunteer corps, and the dedicated security and custodial teams. The successful realization of this project depended heavily on the participation of all of these individuals, and each one shares in its authorship.

Over the summer and early fall of 2012, Nina Schroeder worked as my research assistant, conducting bibliographic research, corresponding with the lenders, and preparing the curatorial files. Her descriptive entries for the thirty lending institutions have been published on the *100 Masters* website. After her departure for studies at the University of Oxford, Lukas Thiessen, a graduate student at the University of Winnipeg, assisted with the maintenance of the curatorial files as well as assisting with the production of the audio tour. In the crucial months leading up to the printing of the catalogue and the installation, Alex King took on the important task of

exhibition coordinator in addition to compiling the index for the catalogue and writing the gallery didactics. Aside from lessening my research and administrative load at many points during the project, these three individuals contributed greatly to the quality of the publication and the final presentation —and I remain in their debt.

Among the WAG staff, I must single out Andrew Kear, Curator of Historical Canadian Art, who researched and wrote the catalogue entries for the Canadian works. When I realized I would need assistance with the production of the Canadian entries due to my workload, Andrew gladly accepted the challenge and produced a group of compelling and erudite texts for the artworks. He is to be congratulated for his outstanding work on the catalogue, which is the richer for his significant contribution.

Specials thanks go to Donovan Bergman and the staff at Friesens Corporation for their role in producing such a beautiful catalogue, and for their sponsorship toward the publication costs. The intelligent layout of texts and images, with an elegant and accessible design, is due to the enlightened graphic work of designer Frank Reimer. The scrupulous editing and proofreading of the manuscript was carried out by Joan Padgett, who also provided invaluable counsel on content and style in the final review stages. The dramatic installation and didactic presentation is thanks to the vision of guest designer Gordon Filewych (Onebadant), who was supported by the WAG's installations team led by Carey Archibald, and design services headed by Lisa Friesen. My directorial colleagues at the Association of Art Museum Directors and the Canadian Art Museum Directors Organization, many of whom are lenders to this exhibition, have been a tremendous source of encouragement throughout this endeavour, and I extend my warmest thanks to each one involved.

My greatest debt, as always, is to my wife, Hazel Mouzon Borys, who gently encouraged me at each step of this undertaking and shared in my passion to bring some great art to Winnipeg to mark the WAG's centennial. With our son, Roman Mikhail Borys, we have embarked on a continuing tour of Canada, which has added much to our fascination with and love for this land. Looking back on personal and professional encounters in the course of traversing this huge country, *100 Masters: Only in Canada* has evolved as a gift to all Canadians from the nation's oldest civic art gallery.

Finally, I extend my sincere thanks to the following individuals from the lending institutions, whose engagement and support—from the first conversations about loans to the last couriered shipment—are what really made this exhibition possible: Agnes Etherington Art Centre, Queen's University: Janet M. Brooke, Matthew Hills, Jennifer Nicoll, David de Witt; Art Gallery of Alberta: Pamela Clark, Catherine Crowston, Bruce Dunbar, Kimberly Van Nieuvenhuyse; Art Gallery of Greater Victoria: Lori Graves, Stephen Topfer, Jon Tupper; Art Gallery of Hamilton: Christine Braun, Tobi Bruce, Louise Dompierre, Benedict Leca; Art Gallery of Nova Scotia: Ray Cronin, Sarah Fillmore, Shannon Parker, Troy Wagner; Art Gallery of Ontario: Alison Beckett, Felicia Cukier, Lloyd DeWitt, Matthew Teitelbaum, Sean A. Weaver; Art Gallery of Windsor: Catherine Mastin, Nicole McCabe, Srimoyee Mitra; Beaverbrook Art Gallery: Sarah Dick, Terry Graff, Bernard Riordan; Canadian Museum of Civilization: Tanya Anderson, Michelle Godin, Bill Moore, Mark O'Neill, Patrice Rémillard; Canadian War Museum: George Barnhill, Laura Brandon, Avra Gibbs Lamey, Meredith MacLean, Mark O'Neill, Susan Ross, James Whitham; Confederation Centre of the Arts: Sandi Hartling, Kevin Rice; Glenbow Museum: Daryl Betenia, Ray Jense, Donna Livingstone, Travis Lutley, Lia Melemenis; MacKenzie Art Gallery: Bruce Anderson, Leah Brodie, Timothy Long, Jeremy Morgan; McCord Museum: Stéphanie Poisson, Karine Rousseau, Suzanne Sauvage, Christian Vachon; McMaster Museum of Art: Julie Bronson, Ihor Holubizky, Carol Podedworny, Rose Anne Prevec; McMichael Canadian Art Collection: Sharona Adamowicz-Clements, Janine Butler, Victoria Dickenson; Mendel Art Gallery: Angela Larson, Donald Roach; Minneapolis Institute of Arts: Kaywin Feldman, Tanya Morrison, Patrick Noon, Heidi S. Raatz, Nicole Wankel, Matthew Welch; Montreal Museum of Fine Arts: Stéphanie Aquin, Nathalie Bondil, Anne-Marie Chevrier, Jacques Des Rochers, Hilliard Goldfarb, Anne Grace, Simon Labrie, Marie-Claude Saia, Natalie Vanier; Musée d'art contemporain de Montréal: Patricia Da Pozzo, Paulette Gagnon, Danielle

Legentil, Véronique Malouin, Lucie Rivest, Anne-Marie Zeppetelli; Musée national des beaux-arts du Québec: Mario Béland, Claude Bilodeau, Paul Bourassa, Daniel Drouin, Michèle Grandbois, Line Ouellet, Dyan Royer on behalf of Catherine Perron, Phyllis Smith; Museum London: Janette Cousins Ewan, Cassandra Getty, Brian Meehan; National Gallery of Canada: Karen Colby-Steward, Charlie Hill, Paul Lang, Clément Lormand, Josée-Britanie Mallet, Ceridwen Maycock, Marc Mayer, Kristin Rothschild, Marie-Claude Rousseau, Christine Sadler, René Villeneuve; Royal BC Museum: Martha Black, Kathryn Bridge, George Field, Jack Lohman, Jenny McCleery, Shelley Reid, Kelly-Ann Turkington; Royal Ontario Museum: Nur Bahal, Janet Carding, Mariano Galati, Arlene Gehmacher, Robert Little, Brian Musselwhite, Tricia Walker, Nicola Woods; The Rooms Provincial Art Gallery: Chris Batten, Mireille Eagan, Sheila Perry, Caroline Stone; Museum of Anthropology at The University of British Columbia: Susan Buchanan, Karen Duffek, Anthony Shelton, Ann Stevenson, Moya Waters; University of Lethbridge Art Gallery: Jane Edmundson, Juliet Graham, Josephine Mills; University of Toronto Art Centre: Heather Darling Pigat, Niamh O'Laoghaire, Maureen Smith; Vancouver Art Gallery: Kathleen Bartels, Danielle Currie, Kim Svendsen, Ian M. Thom; Walker Art Center: Darsie Alexander, Eric Crosby, Barbara Economon, Adam D. Erickson, Loren Smith, and Olga Viso.

Stephen Borys
Director and CEO
Winnipeg Art Gallery

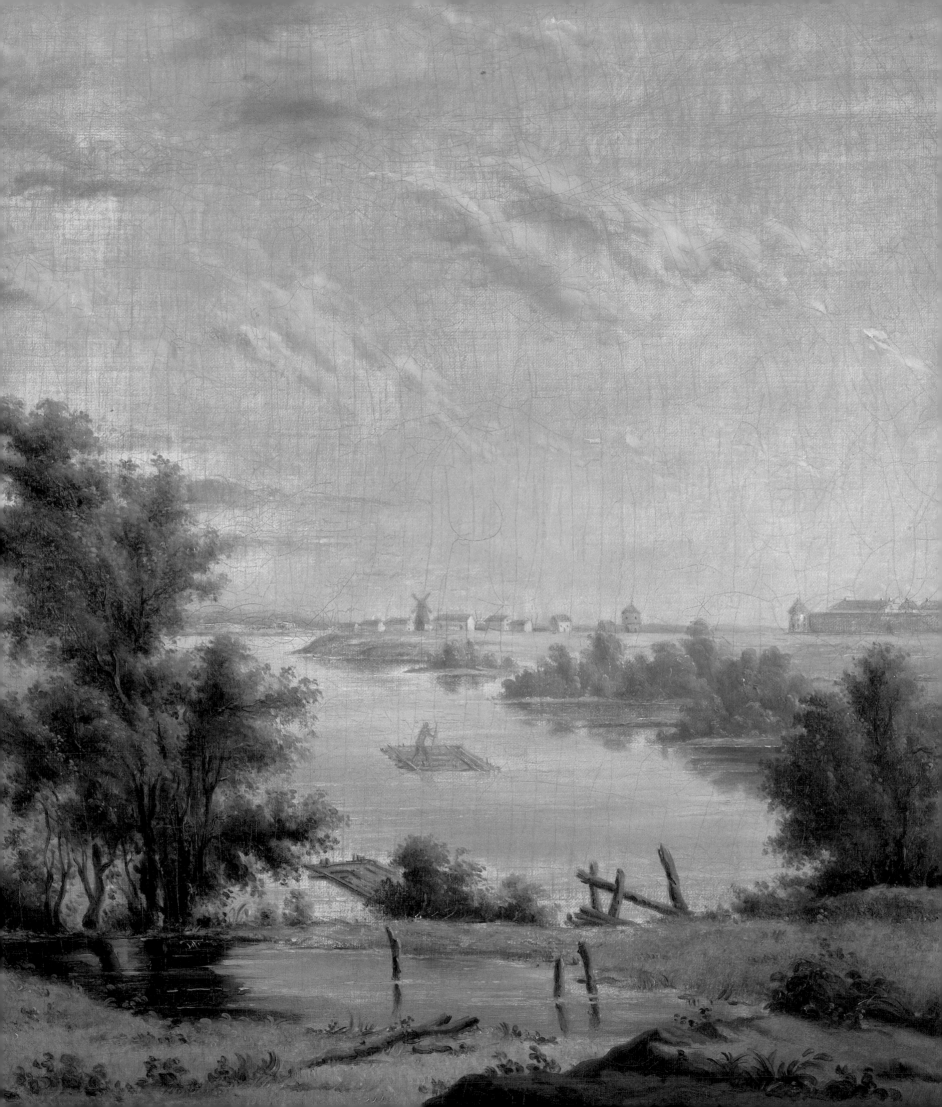

STEPHEN BORYS

From East to West and Back

AN APPRECIATION

FROM ITS ESTABLISHMENT IN 1912 as the first civic art gallery in Canada to its role a century later as one of the leading visual arts institutions in the country, the history of the Winnipeg Art Gallery is inextricably linked to the principle that the cause of art is the cause of the people. Sustained by a distinguished lineage of professional staff, volunteers, members, and supporters, and defined by the outstanding collections, exhibitions, and programs it has built, the WAG is a product of the people and art that fill its spaces, which make possible its broad reach into the community. Among the WAG's founders was businessman James McDiarmid, who said the "ideal Winnipeg" included an art gallery, "the best thing in the way of art to be seen in Western Canada." This legacy of artistic exploration and public engagement remains the foundation of the Gallery's mission a century later. The year 2012 marked our centennial, and with it the charge to organize an exhibition that celebrates not just the WAG's rich art holdings but those from across the nation. The result is *100 Masters: Only in Canada*, a truly historic assemblage of one hundred works of art from twenty-eight museums in Canada and two in the United States. This exhibition pays tribute to our founders and the myriad supporters who have followed, bringing us to this critical place in our history where we embrace a new generation of cultural advocates to help lead us forward.

Early in the research for this book, which accompanies the exhibition, I asked my colleague, Marc Mayer, director and CEO of the National Gallery of Canada, if he would write the foreword. Without hesitation, he agreed, and delivered an introduction that captures, with the eloquence and forthrightness that I have come to associate with Marc, the essence of this exhibition—a celebration for all of Canada on the occasion of the Winnipeg Art Gallery's centennial year. Before sending the final draft, he mentioned that what he liked most about the project was the manner in which the WAG had chosen to mark its centenary—by organizing an exhibition that showed what is great about Canada and its cultural holdings. Call it a missive to our sister institutions on our one hundredth anniversary or a sign of gratitude for their support over the last century; it is an ambitious enterprise that could not have been possible without the participation of the very museums with whom we partner. In his foreword Mayer writes:

Winnipeg Art Gallery John Everett Millais, *Afternoon Tea*; Abraham Anghik Ruben, *Kittigazuit*;
Lionel Lemoine FitzGerald, *Poplar Woods*

"*100 Masters: Only in Canada* is a party for all of us. In a way, we are all in Winnipeg to celebrate not only one city's cultural maturity, but also our own general excellence, our own coming of age. Aside from its many pleasures, surprises, and old fondnesses, this festive exhibition is an elegant gesture, a warm and smiling wave of solidarity from one Canadian art-loving city to all the others." This candid perspective emboldened me to shift the focus of my essay from the art historical to the geographical and the rediscovery of the cultural holdings in museums spread across the country. Beyond mapping the artistic assets held in ten provinces and one state, I have retraced my steps from coast to coast, highlighting the experiences that led to the selection for this exhibition. Part travelogue and part diary, the essay charts the challenging but gratifying task of bringing to Winnipeg a group of artworks soundly linked to the cultural fabric of Canada (and by extension, the United States) through a collection of thirty museums, all of which have special ties to the WAG. Almost every conversation that contributed to the final selection of the one hundred loans either began or ended in front of the object; and it was these experiences in galleries, vaults, and museum offices across the country—looking at the art—that has remained the most enjoyable and transformative part of the journey.

There are actually more than one hundred works in the exhibition. Faced with the quandary of how best to represent the WAG's collection in this historic undertaking, I selected ten of the Gallery's most important artworks, bringing the total pieces in the exhibition and accompanying catalogue to one hundred ten. The addition of six paintings from the Minneapolis Institute of Arts and the Walker Art Center may seem to buck the exclusivity of Canadian loans for *100 Masters*; however, the long-standing relationship between Winnipeg and Minneapolis, including collaborations between the WAG and these two institutions, is one that warrants special status on the occasion of our centennial. In 1970, the year the Gallery prepared to move into its new home on Memorial Boulevard, Canada's Consulate in Minneapolis, Minnesota, was opened, one of six established across the United States that year. Aside from the current twenty billion dollars in trade between Canada and Minnesota, and the six hundred thousand Canadians who travel to the state each year, there is the long record of cultural exchanges between Winnipeg and Minneapolis. When the Vienna-born Ferdinand Eckhardt became the director of the WAG in 1953, he launched the Gallery into the modern era and eventually into its first permanent home. With his directorship came a renewed focus on building the permanent collection and expanding the exhibitions program. While he often turned to other Canadian museums for loans and partnerships, he also looked to opportunities in Minneapolis, the closest metropolis to Winnipeg with an international art collection. Recalling his first days as director, Eckhardt wrote: "My tendency was to show art of the highest possible quality, and when I looked around in the west of Canada, there was no art museum of any standard. Everything else was in the east, in Toronto, more than a thousand miles away." He wanted to make the WAG a centre for Canadian and international art, and he did this by bringing world-class art to Winnipeg through acquisitions, loans, and touring exhibitions. *100 Masters* honours Eckhardt's legacy by presenting artwork of the "highest possible quality" from twenty-eight museums across Canada and two American institutions.

The Rooms Provincial Art Gallery Christopher Pratt, *Young Girl with Seashells* • **Confederation Centre of the Arts**
Jack Shadbolt, *Flag Mural*

The subtitle for the WAG exhibition, *Only in Canada*, calls for some elucidation. As the former curator of Western art at the Allen Memorial Art Museum at Oberlin College, Ohio, where I also taught in the art history department, I recall the day in 2006 when one of the great paintings in the collection—*St. Sebastian Tended by Irene and a Companion* by the seventeenth-century Dutch artist Hendrick Ter Brugghen—appeared on the cover of Pierre Rosenberg's book, *Only in America: One Hundred Paintings in American Museums Unmatched in European Collections* (Milan, Italy: Skira Editore, 2006). As it turns out, the Ter Brugghen was the painting most often named in the author's correspondence with museum directors and curators as one of the works to be included in his book. Rosenberg, a former president-director of the Musée du Louvre, recounts his travels across the United States as a graduate student, museum professional, and, in this instance, a curator in search of paintings from American museums that were "unmatched" in European collections. He intentionally stayed away from the word masterwork in his search because the term, in his view, could not be defined; and if it could, the definition would continue to change with time. Instead, he sought out the piece that was unique, one that succeeded in augmenting our understanding of the artist, or as Rosenberg stated, "the idea we have of that artist." (Rosenberg, *Only in America*, 13) Resigned to the fact that museum professionals in both the United States and Europe would challenge him on his choices, Rosenberg fortified his justifications with scholarly and anecdotal information, all the while conceding that it was always his personal aesthetic that led to the selection. The checklist for *Only in America*, he wrote: "reflects moods, maybe even

whims. In some cases I wished to underscore what is already consecrated and universally famous, in others I sought to focus attention on an outstanding work by an artist who was not so. I insist: it mirrors my personal choice, subjective, impassioned, and I grant, arbitrary" (Rosenberg, *Only in America*, 21).

In adopting the format of a travel journal to present the story behind the planning of this exhibition, I returned to the template for *Only in America*, which was, admittedly, a book and not an exhibition. I used somewhat similar criteria for my selection, and accommodation was made for institutional (from the lenders), art historical (from academic colleagues), and personal viewpoints in the process. Granted, I was not necessarily looking for the unmatched or unique work, nor did I restrict myself to what Rosenberg called the "already consecrated and universally famous." However, this didn't make the selection process any easier. Approaching the potential lending institutions with a preliminary loans list, I was usually presented with a completely different list from the lender. In other instances, when I solicited museum colleagues for their suggestions, having had difficulties assembling a list, I was often overwhelmed by their generosity. Rarely did we ever agree on all of the same works, but on no occasion did I leave without thinking that the works being offered for loan were of the highest quality and an excellent match for the exhibition.

The question of the masterwork came up during almost every one of the museum visits, the discussion often starting beforehand with initial correspondences. Aside from a few extended debates, the subject usually brought us to the place where a conversation on what was outstanding, unique, or important about a work had expanded to

Beaverbrook Art Gallery Thomas Gainsborough, *An Extensive Wooded River Landscape, with Cattle and a Drover and Sailing Boats in the Distance*; Graham Vivian Sutherland, *Men Walking*; Laurence Stephen Lowry, *Beach Scene, Lancashire*

include new information and perspectives. Shifting from masterwork to master, there was much less debate with colleagues over the list of artists chosen for the exhibition, and the justification for their inclusion. The concept of master proved to be a much easier term to agree upon than masterwork, and in each case the selected work highlights a key moment within the artist's oeuvre as well as in the larger context of his or her school.

There were also other elements to consider, including period, school, medium, and genre, all of which impacted the formation and character of the final list. From the start it was my intention to split the selection evenly between Canadian and non-Canadian works; among the loans there are fifty Canadian works and a combination of fifty European and American works. While the list includes paintings, sculptures, decorative arts, and some photography-based works, paintings lead the presentation. No artist is represented by more than one work (excluding pendants or multiples) with the exception of Alex Colville, who has two paintings. The one hundred loaned artworks by the Canadian, European, and American artists span six centuries, from 1500 to 2010. Within this five-hundred year time frame, there is also a larger concentration of eighteenth- to twentieth-century works as we planned to include primarily historical and modern works—or pre-contemporary works. The weighting of the exhibition in the earlier periods reflects the exceptional opportunity for the WAG to borrow important paintings that are rarely lent or that would not otherwise be available for loan.

The curatorial decision to focus on pre-contemporary works was also based on the WAG's centennial exhibition program, which launched with

two major contemporary shows, *Winnipeg Now* and *Creation and Transformation: Defining Moments in Inuit Art*, and concluded with *100 Masters: Only in Canada*. Organizing a major loan exhibition ranging from the Old Masters to works of the twenty-first century presents many challenges, not the least of which is what a survey show can really accomplish in its coverage. Clearly it was not possible to address, let alone highlight, the important developments in contemporary art as represented by Canadian institutions. For that reason, only a small group of Canadian contemporary pieces are included, often providing critical links within the overall presentation. Not surprisingly, this exhibition contains some of my favourite works, but many of these also turned up on the short lists of the directors and curators who assisted in the final selection. Ultimately, I had the luxury of making the final call, which, as Pierre Rosenberg conceded in his selection for *Only in America*, "mirrors my personal choice, subjective, impassioned, and I grant, arbitrary" (Rosenberg, *Only in America*, 21).

One last criterion that had to be addressed was geography, and more specifically the alignment of certain artists with the regions in which they have lived and worked, and consequently, where their work has been collected. As I travelled across the country, colleagues often recommended works by the artists from that particular region such as Christopher Pratt and Mary Pratt in St. John's; Joseph Légaré and Jean Paul Lemieux in Quebec City; Paul Peel and Greg Curnoe in London; Henry Glyde in Calgary; William Kurelek in Edmonton; Emily Carr and Lawrence Paul Yuxweluptun in Vancouver; and E. J. Hughes in Victoria. In many instances, the sense of place and belonging with these artists and their work superseded

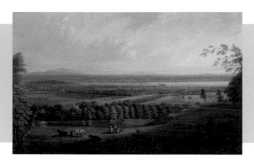

Art Gallery of Nova Scotia Alex Colville, *Ocean Limited* • **McCord Museum** James Duncan, *Montreal from the Mountain*

the first inclination to downplay geography. Some lenders felt strongly that their selections should correspond with the artists connected to their region and collections while others focused on a different set of criteria. The geographical factor, particularly in a country as large as Canada, is difficult to avoid when one is gathering artworks from across the nation. In the vaults of the Musée d'art contemporain de Montréal, looking at dozens of paintings by Paul-Émile Borduas and Charles Gagnon; at the McMichael Canadian Art Collection, considering the Group of Seven and their circle; studying Lionel LeMoine Fitzgerald and Wanda Koop at the Winnipeg Art Gallery; or surveying the work of Jeff Wall and Emily Carr at the Vancouver Art Gallery, it is difficult not to be swayed by place. There are, of course, a few exceptions to this pattern—the Jack Shadbolt from Charlottetown and a Claude Tousignant from Edmonton—which only served to enrich the dynamic mosaic that was evolving as my checklist took shape.

The visits to museums and galleries across Canada and in Minneapolis afforded me the luxury of exceptional access to the various holdings, often in the company of directors, curators, and collections staff. Representing Canada's oldest civic art gallery and curating an exhibition that celebrated our centennial year certainly aided our pursuit of the very best loans. Looking at the works in person was essential for the research and selection, but to this was added a series of passionate discussions with numerous colleagues about the art and the artists. Initial conversations with directors and curators expanded to include collection and exhibition managers, registrars, and conservators. At each stage of these communications, the appreciation for the scope of this national undertaking gained momentum

along with the realization that together we were bringing one hundred art treasures to Winnipeg.

In preparing to write this essay, I went back to my calendar from the fall of 2011, when I began the cross-country tour to visit the museums lending to *100 Masters: Only in Canada*. The tour was spread out over a year; and at its conclusion in November 2012, I had visited thirty institutions in twenty cities, and looked at hundreds of artworks. While the journey didn't follow a directional course from coast to coast, it seems fitting that I recount the trips from east to west as the tour began in St. John's, Newfoundland, at The Rooms Provincial Art Gallery in November 2011. Sheila Perry, director of The Rooms, had invited me to give a lecture at the museum on one of my research areas—the depiction of architectural ruins in French landscape painting—affording me the opportunity to combine two projects into one trip. There was a somewhat ominous start to the trip: en route to St. John's from Halifax, the right engine on our regional jet blew, resulting in thirty minutes of panic and an emergency landing in Charlottetown, Prince Edward Island, which brought me unexpectedly to another lender to the exhibition. I arrived safely in St. John's just in time for the evening lecture, but a few hours later a major snowstorm hit the coast, immediately altering my research itinerary. The next day was spent in the hotel room as the entire city was shut down after the record snowfall. The drawback of being snowbound for a day on what was to be a program-packed trip was offset by the remarkable views of the city and harbour from the hotel window. The next day, Sheila Perry managed to traverse the snow-packed streets to give me a quick tour of the city including a stop at Signal Hill, one of the closest points to Europe in North America and the site of the first transatlantic

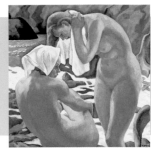

Montreal Museum of Fine Arts Lyonel Feininger, *Yellow Street II*; Gerhard Richter, *Landscape near Koblenz*; Edwin Holgate, *The Bathers*

wireless signal by Marconi in 1901. The spectacular views of the Atlantic and St. John's harbour brought to mind the many artists from the region and away who had captured the breathtaking scenes on their canvases. At The Rooms, the search for works by Newfoundland artists Christopher Pratt and Mary Pratt was successful, and it seemed appropriate that Christopher Pratt's *Young Girl with Seashells*, featuring a figure set against sections of a room, the land, and the sea, was the first work to be confirmed for the exhibition. After seeing The Rooms' recently acquired *Home from Bragg's Island*, one of David Blackwood's most ambitious paintings, Sheila and I were convinced it should be included as well.

My discussions with Kevin Rice, director of the art gallery at the Confederation Centre of the Arts in Charlottetown, actually began at a Canadian Art Museum Directors Organization (CAMDO) meeting at the National Arts Centre in Ottawa, Canada's other national arts centre. I had initially hoped to borrow Jean Paul Lemieux's *Charlottetown Revisited*, painted in 1964 as part of the Confederation Mural Collection; however, its recent restoration and fragile state (not to mention size) prevented it from travelling. Instead, I chose Jack Shadbolt's *Flag Mural* painting, also commissioned for the newly constructed Centre in 1964. Recalling my first meeting with Shadbolt when I was a graduate student at the University of Toronto and working at a commercial gallery that represented him, I relished the thought of bringing west, to Winnipeg, a politically charged mural from the East Coast. I welcomed Kevin Rice's suggestion of *The Local Stars* (1888) by the Charlottetown artist Robert Harris, who also painted the iconic group portrait *The Fathers of Confederation* (destroyed in the fire on Parliament Hill in 1916). The Confederation Centre was founded as Canada's National Memorial to the Fathers of Confederation, who had gathered at Province House in Charlottetown in 1864. A few months later at a Canadian Arts Summit meeting in Banff, Alberta, I had the opportunity to dine with Jessie Inman, CEO of the Confederation Centre, and Wayne Hambly, chair of the board, and was pleased when, upon hearing of the selections for the WAG exhibition, they confirmed I had made the right choices.

I returned to the East Coast again in June 2012 to visit museums in Fredericton and Halifax. A series of delayed flights from the west found me arriving at the Beaverbrook Art Gallery in Fredericton five minutes before closing. It was my good fortune that colleagues Bernard Riordan, director of the Beaverbrook, and Terry Graff, chief curator, offered to stay late so we could tour the galleries and vaults, and strategize on loans. Any expectations to borrow some major paintings were tempered by the fact that their own international touring exhibition of masterworks would be on the road at the same time as *100 Masters*, and thus key works would not be available for loan. I took some consolation in knowing the WAG would be one of the hosting venues for the tour in September 2014. However, given the strength of the British collections at the Beaverbrook, we had little difficulty finding three gems including landscapes by Thomas Gainsborough and Graham Sutherland, and a beach scene by Laurence Stephen Lowry, an artist whose work is a rarity in Canadian collections.

Flying directly from Fredericton to Halifax takes you over the Bay of Fundy, which, on a clear summer evening, is particularly enchanting with the view of low tide and the stunning red clay banks. Images of the sea, particularly the waters of the Atlantic, would figure prominently in the selections from the

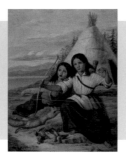

Musée d'art contemporain de Montréal Paul-Émile Borduas, *Épanouissement* • **Musée national des beaux-arts du Québec**
Théophile Hamel, *Jeunes Indiennes à Lorette*

Art Gallery of Nova Scotia in Halifax. Arriving at the AGNS, I was intent on borrowing two works in particular by Alex Colville and Tom Forrestal, both acquisitions made possible thanks to the support of Christopher Ondaatje, and as such, on long-term display in the Ondaatje Gallery. Colville's *Ocean Limited*, named for the CN passenger train that ran between Montreal and Halifax, connects us to the Maritimes and to the artist's world of Magic Realism. *Island in the Ice* by Tom Forrestal, a student of Colville's, features a massive ice floe that had developed in Halifax harbour when Forrestal lived in the city. An unexpected surprise was the suite of view paintings of Halifax by the eighteenth-century French artist Dominic Serres, which were on Ray Cronin's (the AGNS director) short list. After the gallery visit, I toured the citadel and harbour, which reconfirmed the decision to borrow the paintings by Serres, the views being integral to the history of the founding of Halifax.

In the spring of 2012, I made the first of three research trips to Montreal and Quebec City. Having completed my doctoral work at McGill University, I was well acquainted with the various collections in Montreal and looked forward to having the museums represented in the exhibition. The McCord Museum, for many years administered by McGill, and still responsible for the care and management of the university's Canadian history collections, remains Montreal's foremost history museum. David Ross McCord, the museum's founder, spared no expense in assembling his national collection. James Duncan's panoramic painting *Montreal from the Mountain*, executed almost fifty years before Ross established his museum, matches the calibre of the collector's superb taste. Christian Vachon, curator of paintings, prints, and drawings, presented a number of works

for consideration including paintings by Cornelius Krieghoff, William Berczy, and other Quebec painters; however, the splendid view of Montreal by Duncan remained one of his first choices, and mine as well.

The quest to borrow a group of important Old Master paintings from the Montreal Museum of Fine Arts was challenged by competing loan requests and exhibition conflicts, not to mention the museum's impressive reinstallation of the European galleries. Nathalie Bondil, director and chief curator of the MMFA, along with her curatorial team still managed to help me select five outstanding works for *100 Masters* including the finest Gerhard Richter landscape painting in Canada, *Landscape near Koblenz* from 1987, an Alexander Calder mobile, and one of Edwin Holgate's most celebrated figure paintings, *The Bathers* from 1937. Returning to see the Lyonel Feininger retrospective exhibition at the MMFA, it was useful to view the artist's *Yellow Street II* in the context of his other Berlin paintings, confirming the best qualities of the work. The request to borrow the painting was seconded by Anne Grace, the MMFA's curator of modern art, who had worked on the exhibition. The addition of the Henry Raeburn portrait came on another trip to Montreal, and the painting would stand as a strong representative of the MMFA's impressive British painting collection.

At the Musée d'art contemporain de Montréal, director Paulette Gagnon offered to show me her favourite paintings from the collection including works by Alfred Pellan, Paul-Émile Borduas, and Charles Gagnon. From their extensive holdings of Borduas, Paulette's choice of a 1956 canvas, entitled *Épanouissement*, was particularly inspiring, as was the Gagnon *Splitscreen/of April/d'avril* from 1974, and both were added to the final list. For the Pellan,

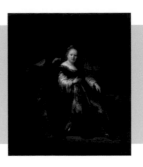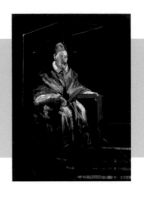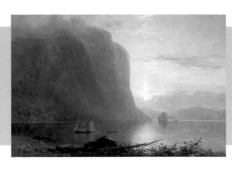

National Gallery of Canada Rembrandt van Rijn, *A Woman at her Toilet*; Francis Bacon, *Study for Portrait No. 1*;
Lucius O'Brien, *Sunrise on the Saguenay, Cape Trinity*

we chose the artist's imposing *Quatre Femmes* from 1944, which I thought would serve as a variation of Pablo Picasso's *Les demoiselles d'Avignon* for the exhibition. From the very start of the research of the MACM's collection, I was drawn to the monumental works by Carl Andre and Richard Long; however, given their size and fragility, particularly with Long's grey sandstones, I was guarded in my optimism for the loans. The approval of the three paintings as well as the Andre and Long sculptures, along with Paulette's strong endorsement of the selections, came as wonderful news and a high point in the national tour. A few weeks after the visit, I was shocked by the news of the severe flooding in the MACM's vaults due to a record rainfall in Montreal (over forty-five millimetres falling in a two-hour period). Fortunately, the quick action of the museum staff saved countless artworks from loss or harm, although several works sustained significant damage.

Travelling by train from Montreal to Quebec City in April of 2012, I arrived as a freezing rain and windstorm was descending on the city, leaving most of the Musée national des beaux-arts du Québec without power. Paul Bourassa, director of collections and research, alerted me to the power outage while I was en route, extending his offer to accompany me to the vaults by flashlight if necessary. Fortunately, some auxiliary lighting was working so we managed to view most of the paintings with adequate illumination, although for parts of the tour in the galleries, Paul led with his flashlight. The trip was a great success with the loans of historic works by five of the heavyweights of Quebec painting: a pair of portraits by Antoine Plamondon, Joseph Légaré's *Paysage au monument à Wolfe*, Théophile Hamel's *Jeunes Indiennes à Lorette*, James Wilson Morrice's *La communiante*, and a triple

self-portrait by Jean Paul Lemieux, acquired directly from the artist's estate. I ended the visit with a brief meeting with Line Ouellet, the newly appointed director of the MNBAQ, who seconded the selections and expedited the final approval of the loans from Quebec's national museum.

After attending the Canadian Arts Summit in Banff, Alberta, in March of 2012, I shared a ride back to Calgary with Marc Mayer. In our discussion about the WAG's centennial exhibition, he asked what I had hoped to borrow from the National Gallery of Canada, and before I could answer he offered some suggestions. He began with the Francis Bacon *Study for Portrait No. 1*, without question the most important painting by Bacon in Canada, followed by Lucius O'Brien's *Sunrise on the Saguenay, Cape Trinity*. He then inquired if I would be interested in borrowing Barnett Newman's *Voice of Fire*, and that's where the discussion took a fascinating turn. I was certain that the work had not been lent since its acquisition, and I actually wasn't even sure if Marc was serious about his question. In any case, the ceiling height in the WAG's tallest gallery is 5.2 metres (17 feet) and *Voice of Fire* is 5.43 metres high so we were out of luck with one of Canada's most celebrated paintings. Marc, with the support of his curatorial team, still managed to deliver with six extraordinary loans, highlighted by six of the most celebrated artists in the national collection: Rembrandt van Rijn, Paul Kane, Vincent van Gogh, Lucius O'Brien, Henri Matisse, and Francis Bacon. Two of these works were also on my original list: Rembrandt's *A Woman at her Toilet*, one of the twelve works acquired by the NGC from the Princes of Liechtenstein in the 1950s—and without equal in Canada—and the van Gogh still life from the Paris period. During my curatorial tenure at the NGC, I had

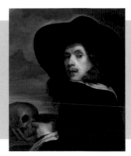

Canadian War Museum John Byam Liston Shaw, *The Flag* • **Agnes Etherington Art Centre** Michiel Sweerts, *Self-Portrait with Skull*

written several entries for the publication *Treasures of the National Gallery of Canada* (2003) including those for Rembrandt and van Gogh. I recall when Pierre Théberge, the director at the time, chose the Lucius O'Brien painting for the cover, the first Royal Canadian Academy painting to enter the national collection in 1880, the year of the NGC's founding. In the loan negotiations, the input of the resident experts—including Paul Lang, deputy director and chief curator, Charlie Hill, curator of Canadian art, and René Villeneuve, associate curator of Canadian art— proved most helpful. After five loans were confirmed, I mentioned to Christine Sadler, chief of exhibitions management at the NGC, that we were still looking for a Paul Kane, having been unsuccessful thus far with requests to other museums. A few days later I received a call from René Villeneuve who, in discussion with Charlie Hill, agreed that Kane's *Fort Garry and St. Boniface* from 1851 would be a fitting addition to the list. The spirit of generosity from colleagues old and new at our national gallery came as a strong endorsement for the WAG's centennial project.

The task of selecting a few key works from the Canadian War Museum and the Canadian Museum of Civilization, the two institutions managed by one executive body, was more complicated given their vast holdings across many cultures, periods, and genres. Mark O'Neill, president and CEO, oversees both museums, and he arranged for a meeting with senior curators and collections managers. In advance of my visit, the staff had begun assembling a short list from the two national collections including paintings, sculptures, and artifacts. Most of our time together was spent looking at works from the Canadian War Memorials Collection, which was established during World War I with the support of Max Aitken, later

Lord Beaverbrook, as well as Prime Minister Robert Borden. From the War Memorials Collection I selected paintings by Canadian artists Alex Colville and Lawren P. Harris, and paintings by British artists John Byam Liston Shaw and William Nicholson, which happen to be two of the largest canvases in the collection, and as such they are rarely lent by the museum. Colville's *Infantry, near Nijmengen, Holland* was the artist's second work in *100 Masters* (the other coming from the AGNS); however, I was convinced it was the right choice given the painting's link to Winnipeg—the artist has depicted the Royal Winnipeg Rifles Infantry Regiment from sketches he made as a war artist in February 1945 in Holland.

The trip to the Agnes Etherington Art Centre at Queen's University in Kingston in June 2012 was focused on the renowned Bader Collection, a corpus of over one hundred primarily Dutch and Flemish paintings, assembled by Alfred and Isabel Bader of Milwaukee, Wisconsin. Over the years, much of their collection was gifted or is on long-term loan to the AEAC. David de Witt, the Bader curator of European art, whom I had met years before when I was a curator at the Allen Memorial Art Museum at Oberlin College, Ohio, gave me a tour of the permanent collection galleries to see some recent acquisitions from the Baders. It was in the galleries that we viewed two portraits by Jan Lievens and Michiel Sweerts (a rare self-portrait), both gifts of the Baders, and both on the WAG's short list. Having secured the magnificent Rembrandt portrait from the National Gallery of Canada, I was able to concentrate on the other Dutch masters at Queen's. In the vaults, David was excited to show me a large landscape from the 1660s by the Dutch painter Philips Koninck, which had just arrived from the

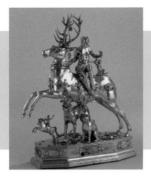

Royal Ontario Museum Matthias Walbaum, *Diana and the Stag* • **University of Toronto Art Centre** Lucas Cranach the Elder, *Adam and Eve*; Sir Edward Burne-Jones, *Portrait of Caroline Fitzgerald*

Bader Collection and had not yet been put on display. As I was hoping to borrow the two portraits by Lievens and Sweerts, I did not expect to be able to have the Koninck as well, but was very pleased when David said it was a possibility. After the vault tour, I headed off to Toronto, deeply grateful for the time spent in Kingston and which has become home to one of Canada's pre-eminent university art museums supported by respected art history and art conservation programs. It was only after my return to Winnipeg, still in pursuit of a painting by Jack Bush for the show, that I came across his *Spot on Red* from 1960 in the AEAC's collection, a gift of Sam and Ayala Zacks. One of Clement Greenberg's favourite Canadian artists, who was included in his seminal exhibition *Post-painterly Abstraction* in 1964, I was coveting the Kingston picture for the show. When I called Janet Brooke, who was director of the AEAC at the time, to ask about the work she understood immediately why it might be on the list and promised to expedite the review process, which led to the approval.

The visits to the Toronto-area museums and galleries took place over several separate trips. Months before the visit to the Royal Ontario Museum in June 2012, I had discussed the exhibition project with Janet Carding, the ROM's director and CEO, at an Association of Art Museum Directors meeting in San Francisco. Her first question was what was I really looking for from a museum with six million objects. After our conversation, she promised to have her curatorial team assemble their own lists; however, before the lists came a lively debate on the definition of a masterwork and how best to represent the ROM's vast collections. Struggling to come up with a list of works, I was grateful for the curators'

input and thrilled when I saw what they were willing to part with for the exhibition. It was also at this point that we agreed the ROM loans would be from the decorative art collections, with one exception: a painting by Cornelius Krieghoff. This suited me fine as their recommendations were simply too good to turn down. Contributing to the ROM list were curators in the World Cultures department including Arlene Gehmacher, Robert Little, Brian Musselwhite, and Corey Keeble. Meeting with Robert Little, the Mona Campbell curator of European decorative arts, we toured the galleries and storage areas where I was able to see everything on the curators' list. Examining several key English silver-gilt pieces, which Robert had assembled in a vault anteroom, I would have been content stopping there, but the tour of the decorative art galleries and period rooms yielded more treasures for consideration. The lone painting on the ROM list, Cornelius Krieghoff's *An Officer's Room in Montreal* from the Sigmund Samuel Collection, was a personal favourite ever since my graduate days at the University of Toronto. Later, recalling Janet Carding's first question about what I wanted for the show, I realized it had been capably answered by her own curators.

The University of Toronto Art Centre had not yet opened in University College when I was a student at the university, and the art collections were spread out across the campus including in the Justina M. Barnicke Gallery at Hart House. Today the UTAC is home to three of the university's permanent collections including the renowned Lillian Malcove Collection. UTAC director Niamh O'Laighaire, who was president of CAMDO when I joined the Board in 2009, offered to assemble a list of paintings and sculptures that would feature works from all three collections. We began with several medieval works,

Art Gallery of Ontario Pierre-Auguste Renoir, *Le concert*; Pablo Picasso, *La Miséreuse accroupie*; Claude Lorrain, *Coast View with the Embarkation of Carlo and Ubaldo*

first viewing the beautiful panel painting of *Adam and Eve* by Lucas Cranach the Elder from the Malcove Collection. The painting was on display in an elegantly furnished gallery devoted to the medieval collection of paintings and sculptures made up largely from the Malcove gift. The Cranach painting, one of the finest in Canada, was on both of our lists. I also welcomed Niamh's suggestion of *Portrait of Three Friends*, by William Pars, which features a young John Graves Simcoe, later General and Lieutenant Governor of Upper Canada, who was responsible for the founding of York (Toronto). During my student days, the painting was installed in Simcoe Hall in the Office of the President. Looking at two paintings by the British artist Edward Burne-Jones, I chose the *Portrait of Caroline Fitzgerald*, which has a Toronto connection, the sitter's father having studied at Upper Canada College and later practiced law in the city.

When I sent my initial loans list in late 2011 to Matthew Teitelbaum, director and CEO of the Art Gallery of Ontario, he responded with the news that most of the works could not be lent due to the reinstallation of the permanent collection galleries and impending loans. However, he did assure me that Lloyd DeWitt, curator of European art, would come up with an equally compelling list for consideration. I was pleasantly surprised when some of my favourite French pictures appeared on Lloyd's list including the Claude Lorrain landscape and a delightful pastoral work by François Boucher, by far the best in Canada. I had borrowed Claude's *Coast View with the Embarkation of Carlo and Ubaldo* a few years before for an exhibition on architectural ruins that I had organized for the Allen Memorial Art Museum at Oberlin College, Ohio, and the Museum of Fine Arts, Houston. With Lloyd's recommendation, I

added the pair of Roman view paintings by Giovanni Paolo Panini and the sumptuous *Le concert* by Pierre-Auguste Renoir, a gem among the AGO's Impressionist pictures. At this stage, I had yet to secure a painting by Pablo Picasso for the exhibition, so when Lloyd suggested *La Miséreuse accroupie*, a 1902 work from the artist's Blue Period, I was elated. In a subsequent meeting with Matthew Teitelbaum, he asked if I had been able to obtain what I wanted for the exhibition, and I confirmed that with the loan of the six European works, both he and Lloyd had certainly delivered.

Driving on the expressway from Toronto to Kleinburg to visit the McMichael Canadian Art Collection, I tried to remember how long it had been since the multi-lane highway had replaced the road I used to take as a student, which passed by farmers' fields and groves of trees. It was our goal to borrow five Canadian paintings from the McMichael, and the recently appointed director, Victoria Dickinson (who had spent two years in Winnipeg at the Canadian Museum for Human Rights as chief knowledge officer), was swift to suggest some of the stars of the collection. We discussed the highly successful international touring exhibition *Painting Canada: Tom Thomson and the Group of Seven*, which had opened to record crowds at the Dulwich Picture Gallery in London in late 2011. Featuring many of the Group's signature works, it would be presented at the McMichael in January 2013. Given the demands of the exhibition tour and extended loans, I was aware of what might not be available for *100 Masters*. However, I was pleased when Victoria's list included a few of the McMichael treasures on the international tour. After selecting two dazzling landscapes by A. Y. Jackson and Franklin Carmichael, I had the challenging but

McMichael Canadian Art Collection Tom Thomson, *In Algonquin Park* • **Art Gallery of Hamilton** Henri Fantin-Latour, *Le jeune Fitz-James*

pleasurable task of picking works by Lawren S. Harris and Tom Thomson. I went back and forth between Thomson's *Byng Inlet, Georgian Bay* and *In Algonquin Park*, both painted in 1914, a seminal year for the artist and the Group—and the Canadian art scene. Thinking of the works of his contemporaries that were in the show, and the seasons and locales depicted, I ended up choosing the image of Algonquin Park. The picture sums up what is at once plain and majestic about the winter landscape and Thomson's ability to capture the Canada of our imagination through his art. I had been considering two works by Lawren S. Harris from the MacKenzie Art Gallery and the Mendel Art Gallery, but after viewing his *Icebergs, Davis Strait* in the McMichael collection, painted in 1930, I made the decision to take the McMichael work. Looking back, I still lose sleep over which Harris was the right one for the show, but I'll leave that assessment to the audience. Content with the Group of Seven works on the list, I looked at several paintings by David Milne, and selected his *Blue Church* from 1920.

The trips to Hamilton were split between the Art Gallery of Hamilton and the McMaster Museum of Art, two institutions I was counting on to augment the European and American works in the exhibition. The rich European holdings at the AGH, particularly nineteenth-century painting and sculpture, are well known, and this was reflected in the initial list that director Louise Dompierre had prepared for me. Touring the galleries and vaults with Tobi Bruce, senior curator of the AGH, we focused on the European and American pictures, singling out easel paintings by Henri Fantin-Latour, Albert Marquet, Félix Vallotton, and Rockwell Kent. While it was not the plan to borrow Canadian works from the AGH,

I did inquire about two well-known paintings from the collection, William Blair Bruce's *The Phantom Hunter* and Alex Colville's *Horse and Train*; however, neither was available due to prior loan commitments and conservation issues. At the end of the tour, Tobi showed me Charles Comfort's *The Dreamer*, painted in 1929 and depicting an architect friend in a rather unconventional composition. I was drawn to Comfort's connection to Winnipeg (he settled in the city with his family in 1912 and lived there until 1925, studying at the Winnipeg School of Art) and his later post as director of the National Gallery of Canada, but it was the bold Modernism of the large canvas that convinced me it should be in the exhibition. I also looked at several works by Prudence Heward including *Girl under a Tree*, which features a female nude in a lush landscape, but I was set on borrowing the artist's *Sisters of Rural Quebec* from the Art Gallery of Windsor. I didn't manage to get to Windsor on this trip east, but was grateful for director Catharine Mastin's affirmation that I had selected the right Heward. Measuring over a metre and a half in height, it is a monumental work and one of the artist's most notable portraits.

When I wrote Carol Podedworny, director of the McMaster Museum of Art, about the exhibition, she asked senior curator Ihor Holubizky to assist in assembling a list of possible loans. Ihor had contributed essays to a number of WAG catalogues, and I met with him at McMaster in the early summer of 2012 to discuss possible loans for our centennial exhibition. Recalling the quick succession of notable European and Canadian acquisitions by the McMaster Museum after the Herman Levy Bequest in the 1980s, I was pleased to see several of these pictures on Ihor's list. I had hoped to borrow the Otto Dix portrait, but

Art Gallery of Windsor Prudence Heward, *Sisters of Rural Quebec* • **McMaster Museum of Art** Claude Monet, *Waterloo Bridge, effet de soleil*

it had been promised to a retrospective exhibition. I also considered the early still life by Vincent van Gogh, but given its fragile state and the fact that I had just secured the van Gogh canvas from the National Gallery of Canada, I turned to other artists represented in McMaster's small but impressive collection of European paintings. At the top of the list was Claude Monet's *Waterloo Bridge, effet de soleil*, by far the most beautiful of the Thames series in Canada, and Gustave Caillebotte's *Voiliers au mouillage sur la Seine*, the only work by the Impressionist painter in a public Canadian collection. On both our lists were the two panel paintings depicting *The Man of Sorrows* and *The Mater Dolorosa* by Aelbrecht Bouts, which are in outstanding condition and unmatched in Canadian collections. They were acquired in the early 1990s shortly after the National Gallery of Canada purchased two panels of the same subject attributed to the workshop of Dieric Bouts. The last piece I chose from McMaster was George Romney's double portrait of a father and son examining an écorché figure, which I thought was an appropriate work for a university with a good medical school. The generosity of the McMaster Museum of Art, an outstanding university art museum with a reach far beyond the academic community, made a significant contribution to the European contingent in *100 Masters*.

Driving on the 401 Highway to London to see director Brian Meehan and his staff at the Museum London, I thought about the well-known paintings by Jack Chambers of the 401, knowing that I would be seeing an unrivalled representation of his work in London. But instead of choosing one of the highway images (one of the best of which is actually in the Art Gallery of Ontario), I chose a work that Brian had recommended, entitled *Mums*. The still life was

painted in 1968, the same year Chambers painted the *401 Towards London*. As a child, I recall a large picture of yellow chrysanthemums painted by my mother, and seeing the Chambers still life took me right back to that time. Turning to the nineteenth-century collection, I wanted to include one of Paul Peel's academic paintings, and with Brian's assistance I chose the iconic *The Modest Model*, although *Covent Garden Market, London* was a close second. Visiting London, the two other local artists whose work demanded attention were Paterson Ewen and Greg Curnoe. After looking at several paintings by the artists, I chose Paterson Ewen's *Shipwreck*, painted a century after the Peel work, and Greg Curnoe's *The True North Strong and Free*, which completed the quartet of London artists to be represented in the WAG exhibition. Heading off to Toronto, it was particularly gratifying to know that from the Museum London I would be borrowing four outstanding works, all by artists who had lived and worked in that city.

As I prepared for the trip to the MacKenzie Art Gallery in Regina in July 2012, the one work I knew I wanted to borrow was Auguste Rodin's *The Kiss*, which was acquired by Norman MacKenzie in Paris shortly before the artist's death. MacKenzie, who also purchased the Rodin bronze *Eternal Spring*, bequeathed his entire collection to the University of Saskatchewan in 1936, the gift forming the core collection of the gallery named in his honour. As the executive director, Jeremy Morgan, was away during my visit, Bruce Anderson, the collections manager, took the time to assist with the viewing. Head curator, Timothy Long, had also proposed a number of works including the Edward Poitras, *Traces: A Car, A Camera, A Tool, A Container*, which was included in the artist's installation at the 46th Venice Biennale

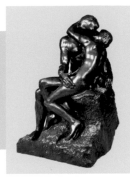

Museum London Paul Peel, *The Modest Model* • **MacKenzie Art Gallery** Auguste Rodin, *The Kiss*

in 1995. The search for a Michael Snow painting happily concluded in Regina when I saw his *Olympia* from 1963. The large canvas, over three metres wide and in pristine condition, is an important early example of the artist's *Walking Woman* series, and was a frontrunner on the MacKenzie's list for the WAG exhibition.

Driving north to Saskatoon to visit the Mendel Art Gallery (the future Remai Art Gallery of Saskatchewan), I was looking forward to seeing Lawren S. Harris's *Mountains Near Jasper* from 1930, and a Bertram Brooker painting related to the 1928 work *Sounds Assembling* in the WAG's collection. During the course of my research and travel, I had become accustomed to having the luxury of more than one option with many of the Canadian masters, and this was the dilemma I faced at the Mendel. In the end, I chose the Harris *Icebergs, Davis Strait* from the McMichael and the Brooker from the WAG. But it was impossible to resist Arthur Lismer's *Autumn, Bon Echo* painted in 1926. The picture, from the collection of Fred S. Mendel, was exhibited in the Mendel Art Gallery's inaugural exhibition in 1964 and donated by the Mendel family the following year. It was also on the gallery's short list assembled by registrar Donald Roach and the curatorial team, concluding the representation of the Group of Seven in the exhibition.

Months before a visit to the Glenbow Museum in Calgary, I had chatted with Kirsten Evenden, who was director and CEO at the time, about what might be appropriate to borrow from the Glenbow's collection. With over one million objects in the various museum and art sections, the task was made a little easier by limiting the selection to the painting collection. In consultation with her staff, Kirsten had made

a few recommendations including historical and modern Canadian works. We toured the galleries, which at the time of the visit featured a survey of Canadian works from the collection. I had decided beforehand that I wanted to borrow the enigmatic work by Henry Glyde, *She Sat Upon a Hill Above the City*, and I was not disappointed when I saw the work in person. I looked at a number of paintings by Norval Morrisseau, whose work is well represented in the collection, and after much deliberation I chose *Bearman* from the early 1970s. I later learned that the picture was one of the most popular works in the museum. Outside of their Canadian art holdings, I was thrilled to find a major painting by the American artist Morris Louis. With the New York art critic Clement Greenberg's connection to the Emma Lake Artists' Workshop in Saskatchewan, a number of modern American paintings ended up in Western Canadian museum collections. There was no record of the huge canvas ever being lent so I was pleased when it was approved for Winnipeg, despite requiring the largest crate in the show.

I drove from Calgary to Edmonton to visit the Art Gallery of Alberta, and began with a tour of the galleries with the acting director and chief curator, Catherine Crowston, who was appointed executive director a few months after my visit. The visit continued at the gallery's off-site storage facility, located a few blocks away, where the AGA registrar, Bruce Dunbar, had arranged to give me a vault tour. Bruce's knowledge of the collection was matched only by his ability to remember the location of what seemed like every important painting in the AGA collection. While I had come first to see the Canadian works, like the visits to Regina and Saskatoon, I had become used to finding works by

Mendel Art Gallery Arthur Lismer, *Autumn, Bon Echo* • **Glenbow Museum** Norval Morriseau, *Bearman*

American Modernists. The physical proximity to the Emma Lake Artists' Workshop, which began in 1955 and was visited by Clement Greenberg in 1962, certainly helped bolster the American presence in the collection. However, it was mainly the initiative of Terry Fenton, director of the Edmonton Art Gallery from 1972 to 1988, that led to a significant group of American paintings from the 1950s to the 1970s entering the collection. From the group, I chose Kenneth Noland's *Must*, one of his diamond-shaped canvases from 1966, the same year as Claude Tousignant's *Gong 80*, which was also on the list. Other Canadian paintings included a Jane Ash Poitras and William Kurelek's *Glimmering Tapers 'round the Day's Dead Sanctities*, one of the stars of the artist's retrospective exhibition organized by the Winnipeg Art Gallery, the Art Gallery of Hamilton, and the Art Gallery of Greater Victoria in 2011. A major exhibition of Alex Janvier, installed at the time of my Edmonton visit, helped with the selection of one of his works from the AGA's collection. I chose *Lubicon*, which was painted in 1988 as a direct response to the plight facing the Lubicon Cree and their land claims.

A few years ago, I delivered a lecture on William De Morgan and the Arts and Crafts movement at the University of Lethbridge Art Gallery, which gave me the opportunity to spend some time in the vaults of the ULAG. Aside from the size of the permanent collection, which numbers over thirteen thousand objects, I was impressed with the quality of their holdings in modern and contemporary Canadian and international art. Serving on the CAMDO board of governors with ULAG's director, Josephine Mills, I had many opportunities to discuss the exhibition project with her. After considering the request, she offered a range of works and media, and I was pleased

that one of my first picks was on her list as well: Andy Warhol's painting of Mao from 1973, which is part of the artist's series based on the image of the Communist Party leader found in the *Quotations from Chairman Mao Tse-tung*, published in 1964.

The spring 2012 CAMDO meeting was held in Vancouver, providing the occasion to plan out several visits to the West Coast museums I hoped would be lending to the WAG exhibition. I had first corresponded with Kathleen Bartels, director at the Vancouver Art Gallery, about the exhibition in the summer of 2011, and she offered me a list of her personal favourites, all by modern and contemporary West Coast artists. On the list were seminal works by Emily Carr, Jeff Wall, and Robert Davidson, with whose inclusion in the show I strongly agreed. Ian Thom, senior curator at the VAG, picked up the conversation from Kathleen, and we began exchanging names and works mainly by British Columbia artists, with the exception of a spectacular Jack Bush that Ian had suggested I consider. For the visit to the VAG, Ian had arranged for the works on our lists to be viewed in the vaults and galleries beginning with a selection of paintings by Emily Carr. Choosing the Carr proved to be one of the most difficult choices given the VAG's pre-eminent collection of the artist's work. First considering an early landscape, we eventually went with Kathleen's choice, which was also seconded by Ian, and Carr's *Big Raven* from 1941 emerged as one of the great icons of *100 Masters*. There was little debate about which Jeff Wall to pick as everyone agreed that *Outburst* was the one to borrow. The two other works from Vancouver, a painting by Lawrence Paul Yuxweluptun entitled *The Impending Nisga'a Deal. Last Stand. Chump Change.* and a monumental wall sculpture by Robert Davidson, *Killer Whale*

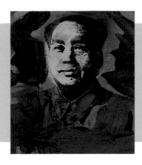

Art Gallery of Alberta Alex Janvier, *Lubicon* • **University of Lethbridge Art Gallery** Andy Warhol, *Mao*

Transforming into a Thunderbird, represented two important Indigenous artists from the West Coast whose work has been championed by the VAG and several prominent collectors in the region.

Anthony Shelton, director of the Museum of Anthropology at The University of British Columbia, worked with his curators in assembling a list of works for consideration. Arriving at the MOA in May 2012 during a torrential rainfall, and departing after cloud cover had dissipated, leaving a clear sky, I had the pleasure of seeing Arthur Erickson's building from several interior and exterior elevations. The curators presented a group of works, almost all sculptures, by the First Nations peoples of the Pacific Northwest Coast. The MOA houses close to forty thousand ethnographic objects as well as over five hundred thousand archaeological objects, so I appreciated the guidance of the curatorial team with the review of possible loans. Erickson's great hall, looking out to the Pacific Ocean, features several intact totem poles as well as fragments from Haida and other First Nations villages along the British Columbia coast. It was there that I discovered Bill Reid's *Wasgo* (*Sea Wolf*), carved from a single block of cedar wood as part of a commission for the museum in 1962. At that point, I decided that if I could bring one major sculpture from the MOA to Winnipeg it would be this masterwork by Reid, whose art has helped to connect the traditional mythology of the Haida people to the contemporary world in which they live.

Flying from Vancouver to Victoria at sunset is in itself worth the trip west, and my museum visits the next day were as rewarding. With the assistance of Jon Tupper, the director of the Art Gallery of Greater Victoria, and registrar Lori Graves, I had assembled a short list before my visit to the AGGV. An Emily Carr exhibition was up at the time, but we agreed that the artist's *Big Raven* from the Vancouver Art Gallery was the best choice. In Vancouver, I had also looked at paintings by E. J. Hughes, an artist whose unique vision of Canada's West Coast has left an extraordinary body of work interpreting the natural and man-made character of the region. But when I saw the AGGV canvas I was considering, *Steamer at the Old Wharf, Nanaimo* from 1958, I was certain this was the right choice. In the galleries, Jon pointed out F. H. Varley's *Mirror of Thought*, which would represent one of three artist self-portraits in the WAG exhibition. While not every member of the Group of Seven is represented in the exhibition, I felt compelled to include this self-portrait by the artist most associated with the important portraits and figure paintings done by the Group. Varley executed the work in Vancouver during the summer of 1937, after he had returned briefly to the city from Ottawa where he had moved the year before. The painting signalled both the end of an affair and the artist's West Coast sojourn.

The last stop in Victoria was at the Royal BC Museum where the outgoing executive director, Pauline Rafferty, had arranged for me to meet with the curatorial staff to discuss and view possible loans. The combined collections, divided between human and natural history, are vast, numbering over seven hundred thousand objects, which made the assistance of the resident curators extremely helpful in the selection. On the visit, I met with Martha Black, ethnology curator, and Lorne Hammon, history curator, who represented the human history section comprising artifacts relating to the Aboriginal and non-Aboriginal human history of British Columbia.

 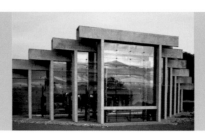 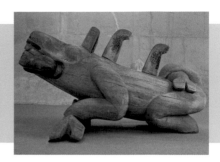

Vancouver Art Gallery Emily Carr, *Big Raven* • **Museum of Anthropology at The University of British Columbia**
Bill Reid, *Wasgo (Sea Wolf)*

On Martha Black's list were two masks, and after viewing them I was convinced they should be on the final list. The painted wood Tlaolacha [dhuẃláx̌a] mask from Bella Bella on Campbell Island in the central coast region of British Columbia dates from the late nineteenth century and was donated to the RBCM in 1893 by Bernard Fillip Jacobsen. The donor was the younger brother of the Norwegian naval captain Johan Adrian Jacobsen, who had travelled to the British Columbia coast in the 1880s to acquire works for the Berlin Ethnological Museum. It is the oldest Aboriginal piece in the exhibition. The Kwakwa̱ka'wakw Cannibal Birds mask was made by Chief Na̱ka̱p̓a̱nka̱m, Mungo Martin, one of the twentieth century's most celebrated Kwakwa̱ka'wakw carvers representing the Northwest Coast style. Known for his ceremonial masks, Martin made the work in the RBCM in 1953 to coincide with the opening in Thunderbird Park in Victoria of a replica of his traditional big house in Tsa̱x̱is (Fort Rupert).

Having completed my travels to the Canadian museums lending to *100 Masters*, I reserved the final research trip for Minneapolis where I hoped to borrow a group of European and American paintings from the Minneapolis Institute of Arts and the Walker Art Center. From the subtitle of the exhibition, *Only in Canada*, one might assume all loans are from Canadian collections; however, an exception was made to honour the long-standing relationship the WAG has had with these two American institutions. Minneapolis remains for many Winnipeggers and Manitobans a popular destination, within driving distance or an easy flight; and the collective holdings of the MIA and the Walker are among the premiere attractions for visitors. I approached Kaywin Feldman, director of the MIA, and she responded

enthusiastically to our request to borrow some key works. A few years earlier, the WAG had sent down an exhibition of Inuit sculptures, and so we agreed that the MIA's loan of four European and American masterworks would be an excellent reciprocal exchange. Beginning in 2011, I made two trips to the MIA to meet with deputy director and chief curator Matthew Welch, and then with Patrick Noon, curator of European art, to discuss possible loans. Patrick and his curatorial team had come up with a list of twelve paintings from which I selected four: two early twentieth-century paintings by the American artists Maxfield Parrish and George Bellows, and two works by Jean-Honoré Fragonard and Ernst Ludwig Kirchner. Parrish's *Dream Castle in the Sky*, whose size alone (measuring over three metres in width) demands the viewer's full attention, is one of the finest paintings by the artist in an American public collection. The George Bellows portrait of *Mrs. T. in Cream Silk, No. 2*, painted in 1920, was a favourite of the MIA curators, and upon viewing the imposing work in the galleries, I understood why. Patrick did not have to convince me of his suggestion of *The Grand Staircase of the Villa d'Este at Tivoli* by the eighteenth-century French painter Fragonard, as I had written my doctoral dissertation on the artist's garden paintings. Executed during Fragonard's stay in Rome, the painting now in the MIA was purchased by Charles-Joseph Natoire, director of the French Academy in Rome, directly from Fragonard before the artist returned to Paris in 1761.

The loan negotiations with the Walker Art Center actually began in the summer of 2011 in Los Angeles when I was in the Getty's Museum Leadership Institute, where Darsie Alexander, the chief curator at the Walker, was also participating. We continued

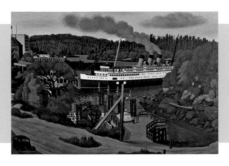

Art Gallery of Greater Victoria E. J. Hughes, *Steamer at the Old Wharf, Nanaimo* • **Royal BC Museum** Chief Nak̲aṗankam̲, Mungo Martin, *Cannibal Birds mask*

our discussion about possible loans for the exhibition after the Getty program, and I followed up with Olga Viso, director of the Walker, about borrowing two key works. It was tempting to consider pieces from the Walker's contemporary collection; however, as the exhibition was focused mainly on pre-contemporary works, I chose canvases by the American Modernists Frank Stella and Robert Motherwell. Stella has been called the leading figure of Post-painterly Abstraction, and his *Sketch Les Indes Galantes* comes from a series begun in 1962, which features the most complex compositions the artist had produced at that point in his career. Motherwell's painting, *Untitled (Ochre and Black Open)*, is part of the *Open* series the artist began in 1967 and continued to work on until his death. In researching the work, I came across an interview with Motherwell and Jack D. Flam, which includes a statement by the artist that captures much of what the year-long series of museum visits for *100 Masters* was all about: looking again at the object. In the interview, Motherwell talks about standing in front of one of his paintings in an art gallery, when the visitor next to him, unaware he was talking to the artist, asked him what the work meant. Looking directly at his own painting, Motherwell tried to recall the very actions that had resulted in the finished painting, all the while recognizing that to offer the meaning of the work is "essentially unanswerable, except as the accumulation of hundreds of decisions with the brush" (Dore Ashton and Jack D. Flam, *Robert Motherwell*, exhibition cat., New York: Abbeville Press, 1983, 12).

As curators, we often look for the meaning in the work of art, trying to find ways to link it to a style or school, or situate it within a particular movement. But there is also a point when we turn to the object and venture no further in our reflection. Despite all

the layers of art history and connoisseurship that may support or challenge this direct encounter, there always remains a way to access the physical work. There is no substitute for that experience of standing in front of the painting or sculpture in the gallery. I remember the day in September 1994 when I received a call from Catherine Johnston, senior curator of European art at the National Gallery of Canada, inviting me to interview for a curatorial post at the NGC. At the time, I was preparing for my doctoral defense at McGill University and was focused on Fragonard and the garden landscape. The interview took place on a Saturday afternoon, and the questions posed by Dr. Johnston were centred on the works displayed in the galleries. Recalling the interview and the position I subsequently accepted, I realized that the perspective acquired as a graduate student had shifted as I embarked on a new art historical engagement. Walking through the galleries, being quizzed on matters of style and attribution, the dialogue had settled squarely on the art. It is in this same way that I hope the *100 Masters* exhibition has enabled us to focus on each piece, obliging us to look again and enjoy. With this presentation of paintings and sculptures, spanning centuries and schools, the inclination to compare or contrast is easily displaced by the opportunity to engage with the artwork and its intrinsic values.

In an exhibition that covers five hundred years, there are the evident links from century to century— elements of style, method, and representation—and *100 Masters* reveals a multitude of art historical connections. Reading the catalogue or visiting the exhibition, certain developments are expected while others may surprise or delight. At the same time, one may discover gaps in the chronology that perhaps beg

Minneapolis Institute of Arts Ernst Ludwig Kirchner, *View of Dresden: Schlossplatz* • **Walker Art Center** Frank Stella, *Sketch Les Indes Galantes*

the question, what is missing? But the gaps are just large enough to push us toward the individual parts of this vast collection, which is one of the most gratifying outcomes. While we take pleasure in surveying the flow of images and gestures, and the advance of ideas and themes evolving by decade or century, there is the prospect of examining again and again one artist and one creation. It is with ease that we move from a portrait by Rembrandt van Rijn to a landscape by Claude Lorrain, from François Boucher to Joseph Légaré, or from the figure by Henri Matisse to one by Michael Snow. We can envisage the brush and palette of Claude Monet with Paul-Émile Borduas and Robert Motherwell, relate the imagery of Francis Bacon to Andy Warhol, and find the pastoral in Thomas Gainsborough as well as in Gerhard Richter or Wanda Koop. We understand the shift of the human condition from Michiel Sweerts to Edward Burne-Jones to Pablo Picasso, while the interiors of Jack Chambers and Christopher Pratt appear fixed, and the compositions of Kenneth Noland and Claude Tousignant advance. The associations abound in *100 Masters*, and they encourage this act of bonding. But these links have the tendency to become less important when we experience a discrete work drawn from a group of one hundred ten, as each one of them has the power to command our attention. Here a succession of distinct encounters becomes the most rewarding part of the visit.

Moving into my curatorial office at the National Gallery of Canada in the fall of 1994, I found a catalogue for a loan exhibition held in 1960, the year after the NGC moved into its new (temporary) home on Elgin Street in Ottawa. To mark the building's opening, which coincided with the eightieth anniversary of the gallery, a group of European and American museums had lent thirty-six paintings to an exhibition entitled *Masterpieces of European Paintings, 1490–1840*. The wonderful tradition of museums lending their best to celebrate the opening or anniversary of a sister institution is longstanding. In 1962, on the Winnipeg Art Gallery's fiftieth anniversary, a number of special exhibitions were organized. For one of the catalogues, WAG director Ferdinand Eckhardt wrote: "The art gallery is not just a place for a few peculiar people to spend their time idly. An art gallery is a necessity and fulfills a most useful function in any civilization. The arts stimulate and inspire. They are most influential in our emotional life." Fifty years after Dr. Eckhardt's remarks, we can confirm that the role of the art gallery—of art—in our lives and communities has continued to stimulate and inspire as well as enlighten and reward. Approaching the second century of its mandate, the Winnipeg Art Gallery is poised to carry on this pursuit with art. As the Gallery turns one hundred years, thirty museums from east to west have lent some of their finest works to mark this historic event—and we are invited back to the place where the object leads our exploration.

Lucas Cranach the Elder German, 1472–1553

Adam and Eve, 1538

Oil on panel 40.5 x 59 cm

University of Toronto Art Centre, Toronto
Malcove Collection, Gift of Dr. Lillian Malcove; M82.147

LUCAS CRANACH PRODUCED over thirty depictions of the story of Adam and Eve between 1510 and 1546, with the composition modelled largely after Albrecht Dürer's famous engraving of the two Old Testament figures, first printed in 1508. The panel from the University of Toronto Art Centre's Malcove Collection is the only example of the subject by Cranach in Canada. It is dated and signed by the artist with his familiar monogram of the winged dragon that is from his personal coat of arms, visible on the base of the tree at the centre of the composition.

There is little information about Lucas Cranach the Elder's early years before his arrival in Vienna around 1500. He came from a family of painters and took his name from his birthplace in Kronach, in the state of Bavaria in Germany. It is likely he first studied with his father, although there are no extant works from this part of his career. Arriving in Vienna at the mature age of thirty, he quickly found patrons and important private and public commissions, and by 1504 he was invited to be a court artist under the patronage of Frederick the Wise, Elector of Saxony in the electoral capital of Wittenburg. Duke Frederick was also the protector of Martin Luther, whose subsequent friendship with Cranach helped secure his place as the leading artist of the Protestant Reformation. Aside from producing several portraits of Luther as well as the illustrations for Luther's translations of the Bible, Cranach became the godfather to the reformer's first son. While the artist's own two sons, Hans and Lucas, worked in his large studio, they failed to achieve the stature and fame of their father, which

was due in part to the elder's desire to maintain a singular artistic identity within his studio.

For this painting, Cranach adopts Dürer's composition in which Adam and Eve are presented as the ideal form of the first man and woman. They are shown in symmetrical natural poses that recall both antique sculpture and medieval iconography. Dürer's Adam may reference the Hellenistic Apollo Belvedere, which was excavated in Italy in the late 1400s. Cranach shows Eve offering Adam the bitten apple while still holding onto a branch of the forbidden tree of knowledge of good and evil. Adam is seen turning to Eve as he is about to take the apple while caressing her shoulder with his left hand. Coiled around the tree between the two is the serpent that first convinced Eve to taste the apple. The crouching stag behind Eve symbolizes Adam's human weakness and his surrendering to the temptations of the flesh. As recorded in the Book of Genesis, by partaking in the fruit from the forbidden tree when instructed not to by God, came the original sin and the fall of mortal man.

Executed at the height of his career, the University of Toronto Art Centre panel shows Cranach's mastery of the human figure and his own predilection for the more sensual side of his subjects. The female model used for Eve could be easily modified for other biblical subjects, Venus, and the Three Graces. While he acknowledged the antique origins of the figures as perfected by Dürer, Cranach also embraced the aesthetic of the Gothic form, which was more decorative and corporeal in its proportions.

Unknown artists
Bowl and figure probably made in Rome, Italy c. 1560–1570; associated stand probably made in Spain c. 1530–1570
"The Aldobrandini Tazza" with a figure of the Roman Emperor Otho
(Marcus Silvius Otho, AD 32–69; reigned January 15, AD 69–April 16, AD 69)

Silver: cast, chased, repoussé, and gilded 39.8 x 38 cm

Royal Ontario Museum, Toronto
From the Collection of Viscount and Viscountess Lee of Fareham, given in trust by the Massey Foundation to the Royal Ontario Museum; 997.158.151

THE ROYAL ONTARIO MUSEUM'S tazza (cup) is one of twelve similar tazze, each representing one of the twelve Caesars of the Roman Empire. Several of the tazze bear the coat of arms of the Aldobrandini family in whose collection the works belonged from the late sixteenth century to the beginning of the eighteenth century. While the set was commissioned by an Italian family, the exquisite workmanship points to a south German source, likely Nuremberg or Augsburg. In the mid-1500s, from when the tazze are dated, both cities were represented in Rome by a number of distinguished goldsmiths. It is possible that an Italian master was responsible for the figure and the tazza stem, collaborating with German artists, which was a standard practice in sixteenth-century workshops. John Hayward, one of the foremost authorities on Renaissance and Mannerist silver, described the Aldobrandini Tazza set as "the most impressive single monument of Italian and perhaps European goldsmith's work of the sixteenth century" (John Hayward, *Virtuoso Goldsmiths and the Triumph of Modernism, 1540–1620*, New York: Rizzoli International, 1976, 164).

The source for the history of the Roman Caesars was *De vita Caesarum* (*About the Life of the Caesars*), commonly known as *The Twelve Caesars*, written around AD 121 by the Roman historian Gaius Suetonius Tranquillus, known as Suetonius (AD c. 69–122). Suetonius's account was well received in his day and remains a critical source on Roman history from the reign of Julius Caesar to Domitian.

Marcus Otho Caesar Augustus, originally named Marcus Silvius Otho (AD 32–69) was Roman Emperor from January to April AD 69. He governed Lusitania from AD 58–68 before supporting the rebellion against Emperor Nero, led by Galba, governor of Tarraconensis. Nero's suicide led to Galba becoming emperor; however, Otho was passed over to succeed Galba as governor. He then conspired against the emperor and arranged for his murder by the Praetorian Guard in the Roman Forum. Otho's reign was brief (three months), and after his army was defeated at Bedriacum near Cremona, Italy, he committed suicide.

The Royal Ontario Museum tazza is crowned by the standing figure of Emperor Otho, shown in formal military dress with cape and sword. The figure is cast and chased, and probably made in one section. The bowl is raised in one piece of silver with elaborate repoussé and chased decoration, and supported by a cast riser and the base. Repoussé involves the hammering of the metal from the reverse (or inside) to create a low-relief design, while chasing (or embossing) is the opposite technique, but used in conjunction with repoussé to achieve the overall ornamental effect. The ROM silver tazza is gilded entirely in gold. In the quadrants of the bowl, the goldsmith has depicted four major events in Otho's life as documented in Suetonius's account: "Otho Attempts to kill Galba"; "Otho's Offensive against Galba"; "Otho's Offensive against Vitellius"; and "The Suicide of Otho."

It is thought by some scholars that the twelve tazze were initially commissioned by Cardinal Alessandro Farnese (1520–1589), who then gave them to a member of the Aldobrandini family. The Aldobrandini representative was likely Ippolito the Elder (1535–1605), who became Cardinal in 1581, and then Pope Clement VIII in 1592.

Aelbrecht Bouts Netherlandish, c.1451–1549

The Man of Sorrows and *The Mater Dolorosa*, c.1503

Oil on panel 45.7 x 30.5 cm (each)

McMaster Museum of Art, Hamilton
Levy Bequest Purchase, 1994; 1994.002.0001LB

AELBRECHT BOUTS CAME FROM a family of painters whose workshop was located in Louvain, near Brussels. Together with his older brother, Dieric the Younger, and their father, Dieric the Elder, (who was a founder of the Haarlem school of painting with Albert van Ouwater), they represented an important painting tradition in fifteenth-century Flanders (present-day Belgium) that focused on the devotional image. While Dieric inherited his father's workshop in Louvain, Aelbrecht set up his own practice in the same city. Today, many paintings (including some originally assigned to his father) are attributed to Aelbrecht, while none are attributed to his brother Dieric the Younger.

The McMaster Museum of Art panels are the finest examples of devotional works attributed to Aelbrecht Bouts in Canada, and represent the artist's studio at the height of its reputation. Based on the Byzantine epitaphios image dating back to the eighth century, the Man of Sorrows and the Mater Dolorosa (Mother of Sorrows) were the most common diptych of the Andachtsbilder-type imagery by the fourteenth century. At this time in northern Europe, there was a propagation of exercises of personal piety by the laity, separate from the formal liturgy in the church; as a result, devotional paintings augmented by prayers and readings became an important part of domestic religious activity. The biblical reference to this depiction of Christ is found in the Old Testament book of Isaiah (chapter 53): "He is despised and rejected of men, a Man of Sorrows, and acquainted with grief . . . He was wounded for our transgressions; He was bruised for our iniquities." Christ is usually shown naked above the waist or in a red robe with the crown of thorns on his head, as recorded in the New Testament Gospel of St. Matthew: "And they stripped him and put on him a scarlet robe. And when they had platted a crown of thorns they put it upon his head." *The Mater Dolorosa* shows the Virgin Mother with her hands raised in prayer in the format of a donor portrait, acting as a true witness to the events. This particular depiction, with tears running down the Virgin's face as she personifies the earthly loss, is one of three representations of the Virgin taken from the iconography of Our Lady of Seven Sorrows. Her white veil or wimple is surrounded by a dark blue mantle trimmed with gold thread.

In the McMaster panels, Christ turns slightly toward the Virgin, suggesting a dialogue between the two. He raises his hands to show the wounds of his Crucifixion, indicating we are seeing Christ before his entombment and resurrection. Instead of a gold leaf or more elaborate background, the figures are set against solid complementary colours, which reference each other's costume. As was common with devotional painting, Bouts has attempted to address key aspects of the sitters' physical, emotional, and spiritual states. Nothing is spared in his depiction of Christ's pathetic condition: the long thorns from the crown piercing the transparent skin of his forehead, the drips of blood from his wounds, the sweat and tears covering his face, the swollen, red-rimmed eyes, and the deathly pallor of his skin. The Virgin, enveloped in a scarlet backdrop matching Christ's robe, is shown in a profound state of prayer or meditation.

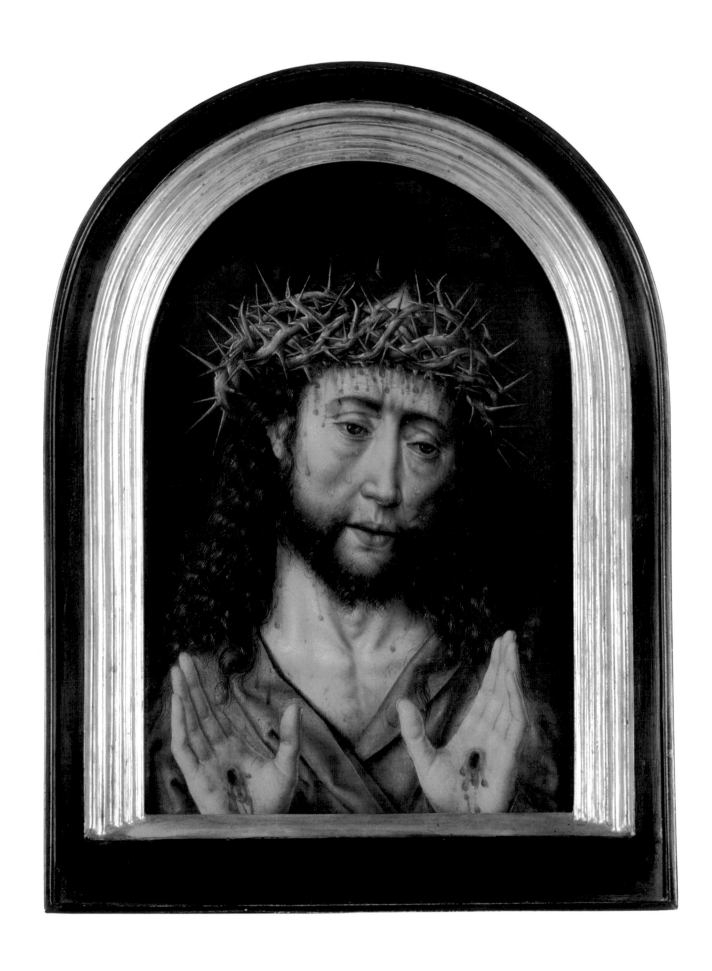

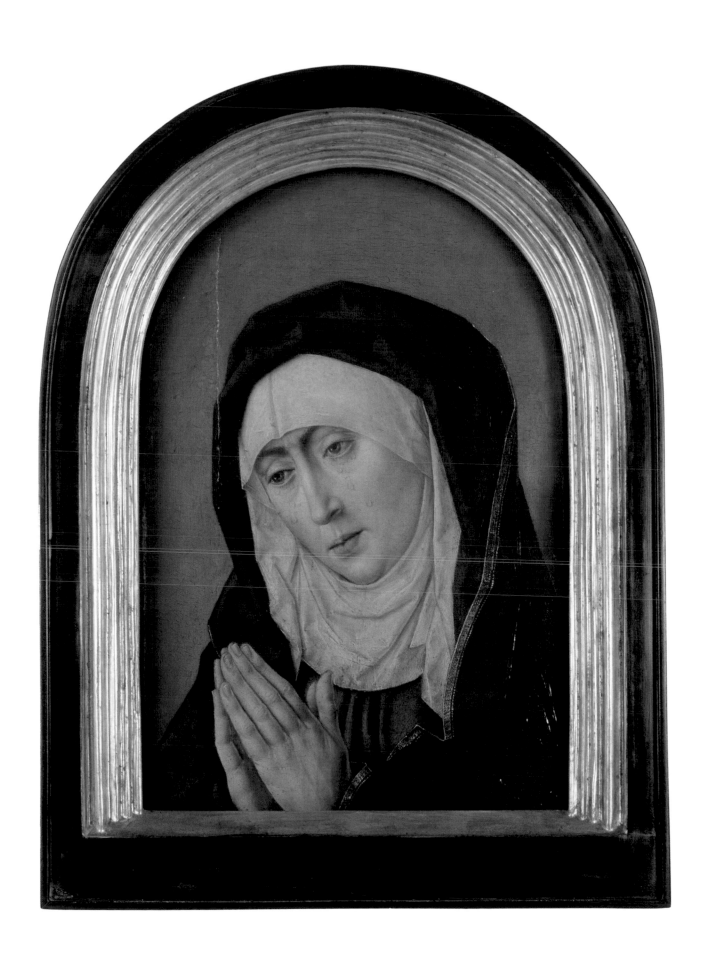

Bartholomaeus Bruyn the Younger German, c.1530–c.1607–10

Portrait of a Man, c.1560

Oil on panel 67.8 x 51.5 cm

Winnipeg Art Gallery, Winnipeg
Gift of Lord and Lady Gort; G-73-54

BARTHOLOMAEUS BRUYN the Younger was part of a family of artists considered the most respected portrait painters in Cologne, Germany, in the sixteenth century. Along with his brother, Arnt, he trained in the studio of his father, Barthel Bruyn the Elder, and together they produced early in his career a series of fifty-seven New Testament scenes for the cloisters of the Karmeliterkloster in Cologne. The Elder Bruyn had established an important school of painting that remained active in Cologne until the late 1500s continuing under the direction of his sons following his death. Unlike many of his contemporaries, Bruyn the Younger (as well as his father and brother) did not enjoy the patronage of the royal court; consequently, his portraits were almost entirely of wealthy members of the patrician or upper bourgeois class in Cologne. As such, Bruyn was at liberty to paint his subjects as they were, focusing on their true physical likenesses and avoiding any requisite iconography or idealized representation. Like his father, he was active in civic affairs and elected to the city council. There is only one signed painting by Bruyn the Younger and no signed works by his father, their respective oeuvres reconstructed around a handful of key commissions that are widely accepted as by their hands. The Elder died of the plague in 1555, and his namesake inherited the workshop where he continued to work for another forty years.

In the Winnipeg Art Gallery work, the half-length, three-quarter view portrait of a man typifies Bruyn's conservative style and formalized approach to portraiture. The compositional restraint is extended to the palette, made up of a muted balance of browns, greys, and black with the lighter tones reserved for the flesh. The identity of the sitter is not known; however, based on his lavish attire, he was likely a person of significant social standing. Set against a dark background, the middle-aged gentleman is dressed in a sable-trimmed black coat, velvet and satin doublet or tunic, and an elegant cloth *schlapphut* or cap. He wears a gold signet ring and holds a red leather prayer book, which may speak to his religious vocation or formal education. The panel is probably one of a pair of portraits of a husband and wife, with the painting of the man to be viewed on the left, occupying the place of honour.

Lord and Lady Gort donated their collection of Northern Renaissance paintings and tapestries to the Winnipeg Art Gallery in 1973. The group of twenty-eight Northern Renaissance works, including paintings by Jörg Stocker, Lucas Cranach the Elder, Barthel Bruyn the Younger, Nicolas Neufchatel, and the Bisham Abbey tapestries from the studio of Bernard van Orley, was assembled in England by Standish Robert Gage Prendergast Vereker, the 7th Viscount Gort. An Irish peer and art collector, whose seat was at Hamsterley Hall, County Durham, Gort first came to Canada in 1911 where he had invested in coal mines in Alberta. He purchased a large tract of land in Winnipeg along with several residential buildings, and was given Canadian citizenship in 1963. An avid art collector, Gort had shipped his collection to Canada for safekeeping during World War II and lent several works to the WAG in the 1950s, which led to the subsequent gift, the largest of its kind among Canadian art museums.

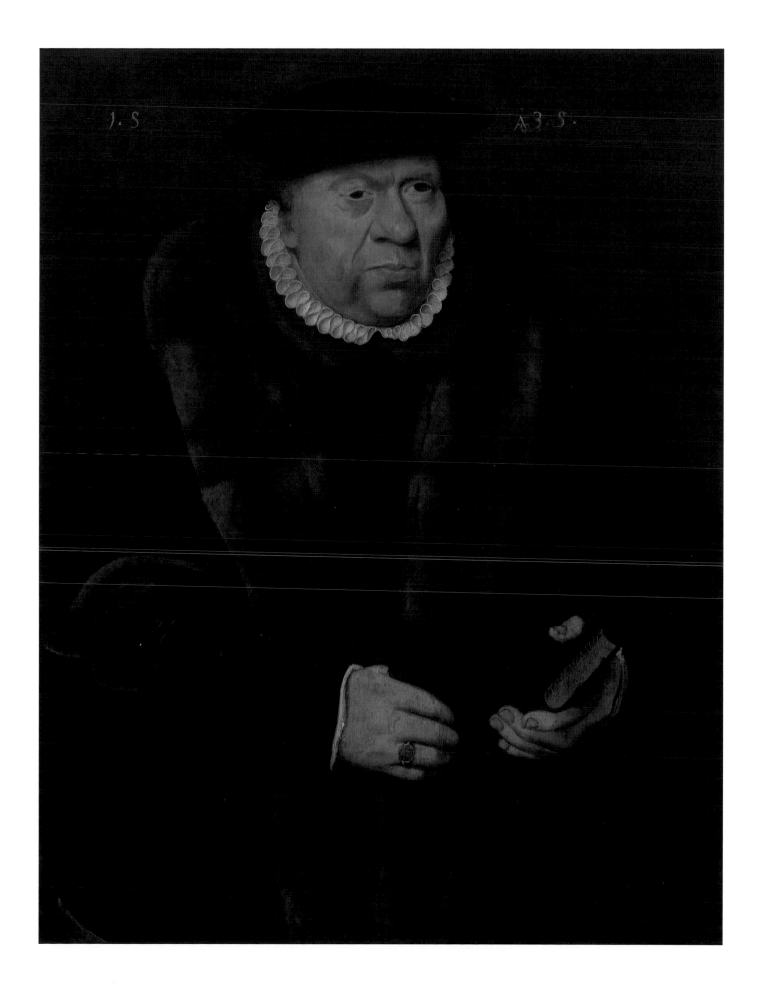

Matthias Walbaum German, 1554–1632

Diana and the Stag, 1600–1605

Silver: raised, cast, chased, repoussé, partially gilded and jewelled,
with internal metal mechanism 34 x 26.4 x 10.6 cm

Royal Ontario Museum, Toronto
From the Collection of Viscount and Viscountess Lee of Fareham, given in trust
by the Massey Foundation to the Royal Ontario Museum; 997.158.152.1-2

BEGINNING IN 1569, Matthias Walbaum studied for six years in Lübeck, Germany, under the goldsmith Hans von Tegelen I. Following his apprenticeship, he worked as a journeyman for several goldsmiths in Augsburg before becoming a master goldsmith in 1590. Walbaum secured the patronage of various royal personages including William V, Duke of Bavaria and members of the Habsburg family. The largest part of his artistic production was ecclesiastical and devotional pieces for his Catholic patrons, which included altars, shrines, monstrances, and vessels used for the mass. Walbaum also produced a number of luxury items such as jewellery caskets and furniture pieces as well as some sculptures. He is credited with the design of the celebrated piece in the Royal Ontario Museum, which features the figure of Diana mounted on a stag, the work functioning as a mechanized drinking vessel and table decoration. Two of his colleagues in Augsburg, Jacob Miller and Joachim Fries, also produced similar versions of the Diana sculpture. The ROM work combines the finest in silver and gold craftsmanship with clockwork technology to serve the most discerning connoisseur or dinner guest.

The ancient myth of Diana and Actaeon is taken from book three of Ovid's *Metamorphoses*, a Latin narrative poem in fifteen volumes completed in AD 8. The third book became one of the most popular classical works during the Middle Ages. According to the myth, Diana, goddess of the hunt, was bathing in a spring when the young mortal, Actaeon, who was out hunting, discovered the naked Diana with her nymphs. While her nymphs tried to cover the goddess, the embarrassed Diana, known for her beauty and chastity, splashed water on Actaeon, who was immediately turned into a handsome stag with a full set of antlers. Transformed and unable to speak, Actaeon runs off and is killed by his fellow hunters (who did not recognize him) after being tracked down by his own hounds. In the ROM sculpture, the figure of Diana and the stag are cast in silver, gilded, and set with jewels. The stag is mounted on an engraved octagonal base, which accommodates several other figures including two large hounds, two salamanders, a toad, a beetle, a hare, two smaller hounds, and a man on a horse, which may reference the tale of St. Hubert or a miniature version of Actaeon. Elaborate silver gilding, repoussé, and chasing, as well as jewelled settings, decorate the metal surfaces.

The mechanized table piece (or automaton) has a clockwork mechanism built into the base that, once wound and released, moves across the table covering approximately sixty centimetres before it takes a right-hand turn, controlled by a swivelling steering wheel. The piece is designed to make four right-angled turns to complete a square path thereby servicing four guests at the table. Once stopped in front of a table setting, the guest would be able to lift the stag from its base, remove its head, and then proceed to drink from the body of the stag. The procedure was easy when the stag was filled with a beverage; however, as the piece made its rounds at the table, the last guests would have a more difficult (and embarrassing) time drinking from the near-empty vessel without spilling some liquid.

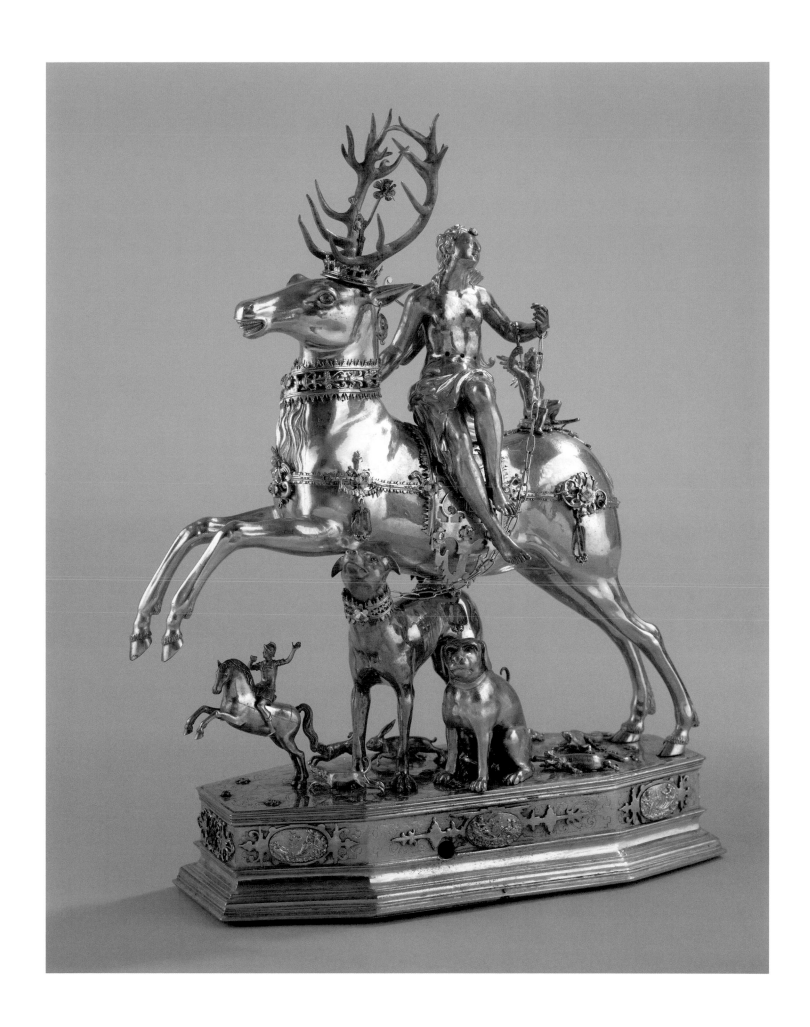

Rembrandt van Rijn Dutch, 1606–1669

A Woman at her Toilet (Heroine from the Old Testament), 1632–1633

Oil on canvas 109.2 x 94.4 cm

National Gallery of Canada, Ottawa
Purchased 1953; 6089

UP UNTIL THE EARLY twentieth century, scholars referred to the subject of this painting as "The Jewish Bride" with the sitter linked more to the Old Testament than to a contemporary Dutch subject. The two biblical candidates considered were Esther and Bathsheba, although Rembrandt van Rijn's wife, Saskia, as well as his sister, Lisbeth, were also suggested as possible subjects. The artist married Saskia van Uylenburch (the niece of his friend and dealer) in 1634, but he lived in her father's house from 1631, hence the suggestion of his wife as the sitter. The National Gallery of Canada work was executed around 1632 when Rembrandt was living in Amsterdam, where he had moved from Leiden the year before, following the death of his father. For the next ten years in what has been called his Baroque period, he produced a number of monumental works including a series on the Life of Christ for the Prince of Orange. He also painted at least five portraits of Saskia and used her as a subject in several other compositions before her death at the age of thirty in 1642.

Of the Old Testament women considered as the subject for Rembrandt's painting, the Jewish heroine Esther is the most likely given the overall characterization of the sitter and composition including her elegant attire, the array of jewellery, and the book on the table behind her. Another compelling argument for Esther is the parallel between Esther's appeal to King Ahasuerus of Persia to help save her people who are threatened with annihilation by the king's first minister, Haman (Esther 5:1), and the plight of Calvinist Holland and its own emancipation from Catholic Spain. In the United Provinces, the Book of Esther was among the most popular of the Old Testament narratives.

The young woman with her waxen, ivory complexion and golden-brown hair is seated at the very centre of the composition, resplendent in her jewels, gold-trimmed velvet mantle or tunic, diaphanous dress, and undergarments. Rembrandt's mastery of light and the subtle way it plays with the surfaces of flesh and various textures is felt throughout the interior scene. The sitter's jewellery includes a gold chain and necklace with precious and semi-precious stones, bracelets, earrings, rings, and hair ornament. The richness of her garments and accessories would make us think she is a royal personage or at least of significant social standing. Comfortable in the privacy of her *toilette*, the woman looks out to the viewer with a gaze that betrays someone observed in personal contemplation. The modestly attired elderly attendant, who stands behind the seated woman, is shown completely in shadow with the exception of her right hand, which holds the comb she uses for the activity of the *toilette*.

The painting was one of twelve pictures acquired by the National Gallery of Canada from the Princes of Liechtenstein in 1953, and it remains the most celebrated work by the Dutch master in a Canadian collection.

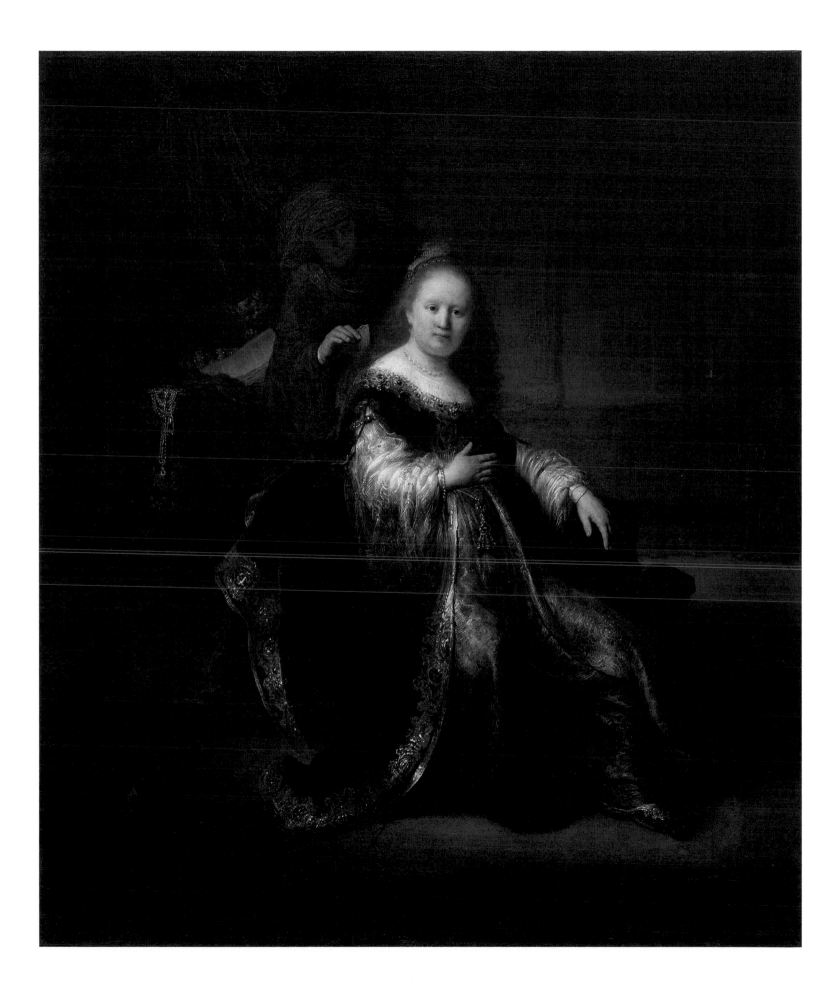

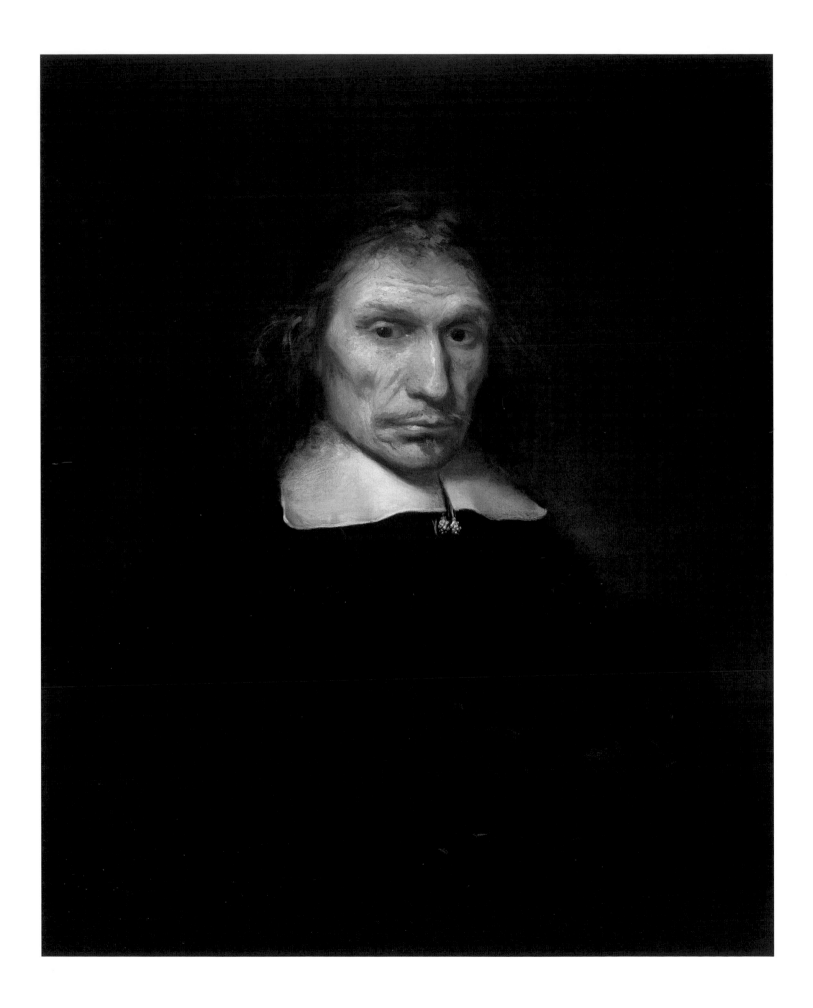

Jan Lievens Dutch, 1607–1674

Portrait of Jacob Junius, c.1658

Oil on canvas 79 x 53 cm

Agnes Etherington Art Centre, Queen's University, Kingston
Gift of Alfred and Isabel Bader, 2009; 52-009

THE SITTER OF JAN LIEVENS'S portrait is Jacob Junius (1608–1671), the son of the Dutch Reformed minister Isaac Junius and his wife, Maria Duyckers. The younger Junius entered the University of Leiden in 1626 where he studied law, after which he secured a position with the Dutch East India Company. He made his fortune travelling through the east with the Company and returned to the Netherlands, then known as the Dutch Republic, around 1655. Shortly after his return, he married the fifteen-year-old Maria Lenaerts, who was from Delft. Junius would have been fifty-one at the time of the wedding, which is likely when the portrait now in the Agnes Etherington Art Centre was commissioned.

Records show that Lievens was only eight years old when he entered the studio of the minor Leiden painter Joris van Schooten for a two-year apprenticeship. Following that, he travelled to Amsterdam, about forty kilometres from Leiden, to study with the history painter Pieter Lastman for another two years. Lievens returned to Leiden around 1619 to set up his studio and began working as an independent artist at the young age of thirteen. In 1625 he met Rembrandt van Rijn, who was also from Leiden, and the two became good friends (and at times rivals). For a period of about five years, they shared a studio, the same models, and sometimes even worked together on the same paintings. Their close proximity and collaborative working arrangement during the Leiden period has made it difficult for scholars to differentiate between some of their respective work. The poet and composer (and secretary to two Princes of Orange) Constantijn

Huygens, who knew both of the artists and sat for his portrait by Lievens, wrote in his autobiography about the two artists' collective and individual skills, singling out Lievens for his invention and boldness.

Outside of the influence of his teacher Pieter Lastman and his friend Rembrandt, Lievens was drawn to the work of the Utrecht artist Gerrit van Honthorst who was one of the finest representatives of the northern Caravaggisti. We see this latter influence mainly in Lievens's work from the Leiden period, which lasted until 1631 when he relocated to England for three years. Lievens moved to Antwerp in 1635 where he lived and worked for the next decade. His final move was to Amsterdam in 1644 where he remained for the rest of his life.

Portrait of Jacob Junius was made when Lievens was producing some of his finest portrait work in Amsterdam. At this stage, he had adopted a more classical approach, often using a monochromatic palette as we see in this picture. Dressed in a black doublet with a plain white collar and tasselled ties and a black cloak resting on his right arm, Jacob Junius is presented without any pretense or embellishment. Lievens has managed to capture the essence of the man's personality by concentrating on his face and penetrating gaze. He is generous with the application of paint, which is carefully built up around the sitter's face, to emphasize the rugged quality of his skin and hair.

Michiel Sweerts Flemish, 1618–1664

Self-Portrait with Skull, c. 1661

Oil on canvas 78.7 x 60.9 cm

Agnes Etherington Art Centre, Queen's University, Kingston
Gift of Alfred and Isabel Bader, 2004; 47-001

LITTLE IS KNOWN ABOUT Michiel Sweerts's early years, but he probably had some formal art training in Brussels where he was born. Like many northern European painters in the seventeenth century, he travelled to Italy to continue his art studies and to visit the sites and monuments of Classical and Baroque Rome, which would become part of the Grand Tour later in the century. By 1646 a register in Rome listed Sweerts as living on Via Margutta in the Santa Maria del Popolo parish, an area that was populated by Dutch and Flemish artists. Sweerts joined the Accademia di San Luca in 1647 as an associate and continued to fraternize with his northern colleagues. Some of these artists were associated with the Bamboccianti, a group of painters led by Pieter van Laer and Jan Miel, known for their unglamorous, naturalistic paintings of everyday life, often featuring dramatized scenes in urban and rural landscapes. Sweerts's paintings, however, were more idealized and classical in their figural composition and colouring. In fact, his style lies somewhere between the Dutch and Flemish traditions in Rome, not fitting well into either circle. He did have the good fortune of securing the patronage of Prince Camillo Pamphili, the nephew of Pope Innocent X, which resulted in painting commissions, employment in a private academy, and the honorary title of Cavaliere bestowed on him by the Pope himself.

Sweerts left Rome for the last time in 1652 and travelled north, eventually settling in Brussels where he established a school of drawing. However, by 1660 he had a change of heart and career, and went to Amsterdam to join the Société des missions étrangères under the charge of the French bishop Monsignor François Pallu. In early 1662, Sweerts accompanied the brotherhood on a mission destined for China via Marseilles. After several months of travel with the group, Sweerts was asked to return home due to his unstable and incompatible behaviour. Upon his dismissal in Isfahan (present-day Iran), he travelled south to a Portuguese Jesuit colony in Goa on the west coast of India, where he remained until his death in 1664.

The self-portrait from the Agnes Etherington Art Centre was painted while Sweerts was associated with the French mission, but likely before he embarked on the trip to the east. In an expression of piety, the artist depicts himself dressed in black cape and broad-brimmed hat, pointing to a skull (actually reaching into the naval cavity of the skull), which is a *vanitas* symbol referencing the brevity of life. There is a dramatic edge to the self-portrait in the use of light and shadow, and the play of colour with the black of the costume set against the artist's pale and slightly flushed skin. Sweerts looks directly out to the viewer, somewhat startled and yet deeply focused on the reminder of his own mortality as he cradles the skull. It is a remarkably straightforward and moving portrait of the artist at a critical moment in his personal life as he contemplates a new vocation.

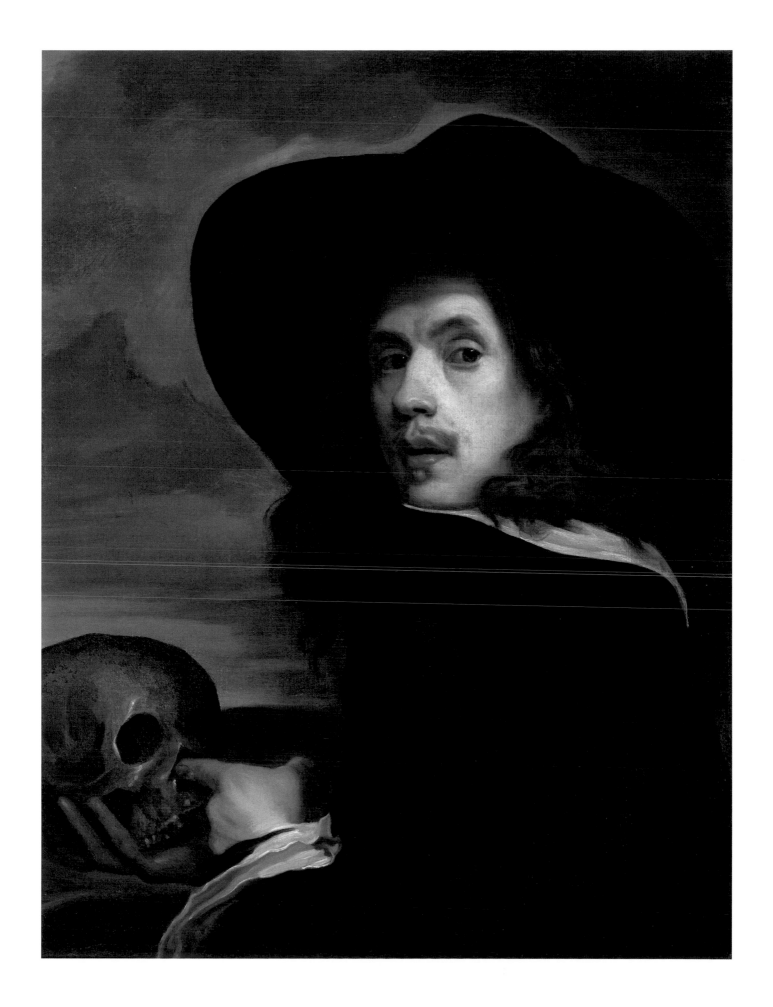

Philips Koninck Dutch, 1619–1688

Panoramic River Landscape with Hunters, c. 1664

Oil on canvas 105 x 135 cm

Agnes Etherington Art Centre, Queen's University, Kingston
Gift of Alfred and Isabel Bader, 2012; 55-005

PHILIPS KONINCK HAS BEEN considered by some scholars as one of Rembrandt van Rijn's most gifted pupils, although there remains little evidence confirming that he actually studied with Rembrandt. That said, it is clear that Koninck was influenced by Rembrandt, and this is reflected particularly in his landscape paintings as seen in this work from the Agnes Etherington Art Centre. The impact of the Dutch master is also evident in Koninck's rich palette and approach to light.

Koninck came from a large family of painters, and he first studied in the studio of his older brother, Jacob Koninck, in Rotterdam. With his second wife, Margaretha van Rijn, the artist ran several successful businesses including an inn, a shipping company (with routes between Amsterdam and Rotterdam), and a ferry service. The sizeable income from the businesses afforded him the luxury of selecting his commissions and the subjects he wished to paint. At the height of his career in the 1660s, Koninck was most in demand for his portraiture and history paintings, although he produced landscapes as well. Today, is it these panoramic landscapes that has set Koninck apart as one of the great Dutch painters of the seventeenth century.

Part of the Agnes Etherington Art Centre's Bader Collection, this painting is typical of Koninck's large-scale landscapes, which features a sweeping composition split evenly between land and sky. The breathtaking view, which appears almost limitless, is achieved by an elevated viewpoint where we see much more than would be humanly possible. The horizon line is void of any trees and man-made structures, which further emphasizes the expanse of this broad vista and keeps the landscape evenly split. In the centre foreground, a falconer in a red coat is shown on his mount, accompanied by two dogs and his servant, who carries a shotgun. From their position, the landscape takes on a pattern of diagonal lines leading up to the horizon. At each stage of the landscape, Koninck introduces a variety of vegetation, land formations, waterways, buildings, animals, and figures to animate the scene as well as chart the course before us. The massive clouds reaching across the sky create impressive shadows on the land, which further enlivens the scene. The overall character of the landscape references the topography of Gelderland, which is the largest province in the Netherlands and located in the central eastern part of the country.

This picture was first attributed to Jacob Koninck, but as a result of research and conservation work, which saw the removal of a repainting of the clouds and areas of foliage by an earlier restorer, scholars have placed the work firmly in the oeuvre of Philips Koninck. Perhaps most noticeable in the restoration of the painting is the artist's ability to give a translucent quality to the landscape, which he accomplishes with his brushwork and colour selection. Koninck's skill as a draughtsman is also evident in the ambitious composition. There are less than eighty landscape paintings attributed to Koninck, and this work remains the most significant landscape by the artist in Canada.

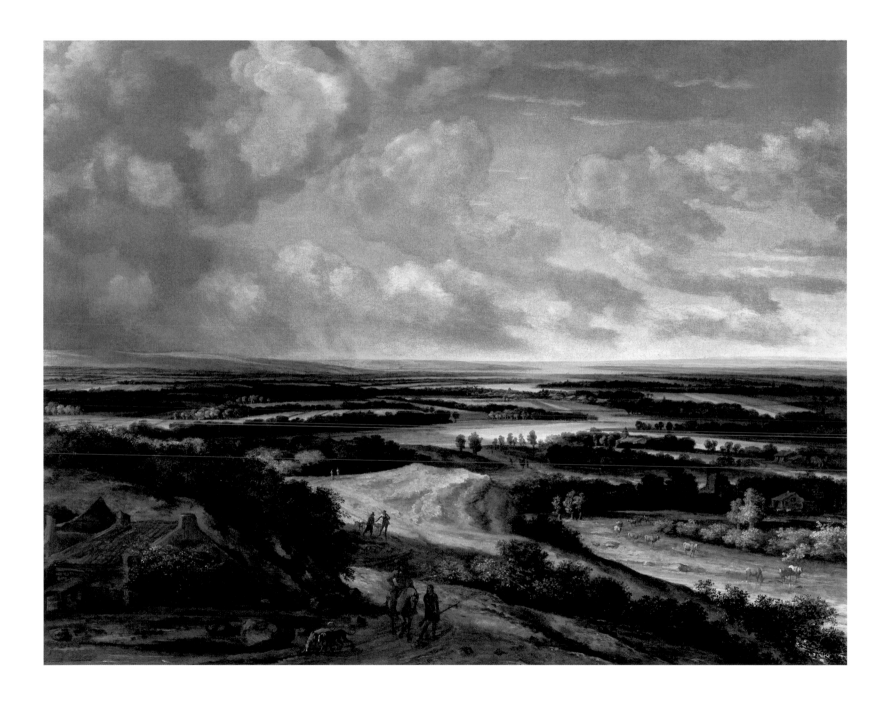

Claude Gellée, called Claude Lorrain French, 1604/5–1682

Coast View with the Embarkation of Carlo and Ubaldo, 1667

Oil on canvas 92.7 x 138.4 cm

Art Gallery of Ontario, Toronto
Gift of Group Captain H. L. Cooper, AFC, Salisbury, England, in appreciation of
the contribution of Canadians in the Armed Forces in the two World Wars, 1962; 62/12

THE ART GALLERY OF ONTARIO work is one of four landscapes painted for the Italian nobleman Prince Paolo Francesco Falconieri (1616–1686) for the Villa Falconieri, and was one of Claude's last major commissions. The subject is taken from Torquato Tasso's epic poem *La Gerusalemme liberata* (*Jerusalem Delivered*), one of the masterworks of sixteenth-century literature. The poem is based on the first Crusade of the eleventh century, which led to the sack of Jerusalem in 1099 by Christian knights and warriors supported by Pope Urban II. The scene depicted in the Toronto painting takes place in Canto 15, after Godfrey has selected the Christian knights Carlo and Ubaldo to search for Rinaldo. Armida, who has fallen in love with Rinaldo, transports him by chariot to the Fortunate Islands (thought to be the Canary Islands). The Magician of Ascalon then arranges for the two knights to meet Fortune, who will guide them across the ocean in a skiff to rescue Rinaldo.

This painting depicts the moment in the story when Carlo and Ubaldo stand in full armour on the shore of a small inlet, while Fortune waits in the skiff in the water. At the far right, Ascalon is seen leaving. It is a remarkably beautiful scene; the morning light, aided by a fine mist that moves across the water and dissipates near the shore, unites every element of the landscape. Captured here is the serene, ideal world of Claude's late paintings in which a harsher morning or evening illumination has given way to a more subtle light, marked by complex layers of colour and tone. Added to the exquisite quality of the light and atmosphere are the elegance of the figures and the depiction of the landscape setting. In the quietness of the morning light, Claude is still able to convey the rhythm of the waves hitting the shore and the soft wind moving through the trees.

Although Claude has chosen the more familiar Italian coastline for his painting—perhaps the area around Naples—the passage from Tasso takes place near Ascalon, a coastal city in present-day Israel. The harbour of Ascalon can be seen in the distance, marked by buildings lining the shore and the approaching ships. Closer to the viewer are two classical temples positioned on a rocky crag, which take their inspiration from the Temple of Vesta and the Temple of Fortuna Virilis in the Piazza Bocca della Verità, the ancient Forum Boarium in Rome.

Claude's contribution to the landscape genre was nothing short of perfection. His portrayal of the ideal landscape has rarely been surpassed, and he is recognized as the greatest landscape painter of his day. He was certainly the most influential figure in French landscape painting, and the Claudian manner is celebrated as an important tradition in the history of European painting. Inspired by the classical ideal as conveyed in the pastoral poetry of Ovid and Virgil, Claude depicted scenes of rustic, natural beauty populated by figures in contented repose and embellished with architectural ruins. This painting remains the most significant work by the artist in a Canadian gallery.

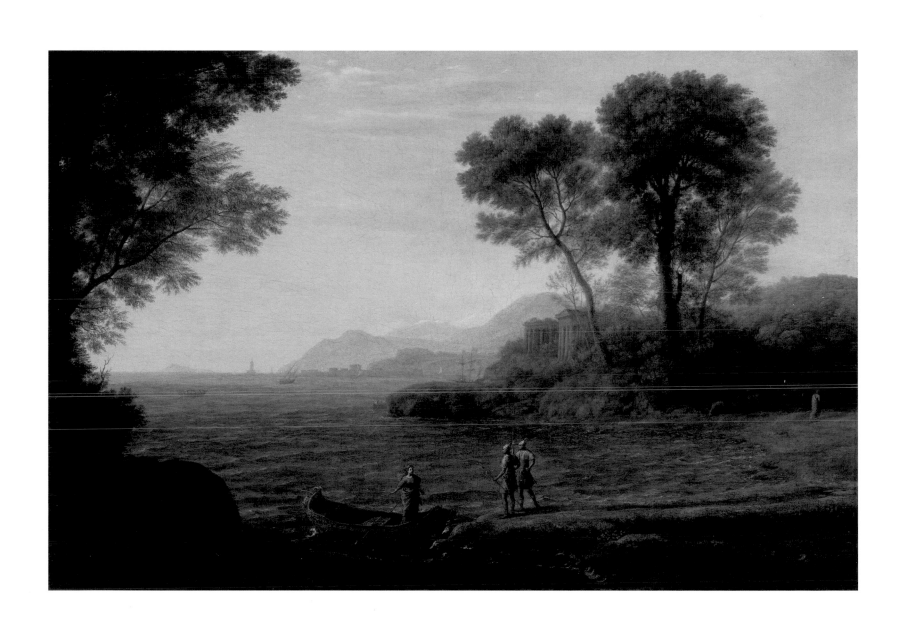

Giovanni Paolo Panini Italian, 1691–1765

A Capriccio of Roman Ruins with the Arch of Constantine, c. 1755

Oil on canvas 99.1 x 135.3 cm

A Capriccio of Roman Ruins with the Pantheon, c. 1755

Oil on canvas 99.1 x 135.3 cm

Art Gallery of Ontario, Toronto
Purchase, Frank P. Wood Endowment, 1963; 62/32; 62/33

GIOVANNI PAOLO PANINI was the leading view painter in Rome in the eighteenth century specializing in *vedute*, or real topographical views. He was best known for his masterfully choreographed scenes of ancient and contemporary Roman buildings and spaces. The architecture of the Roman Forum was a primary source for many of these view paintings, and in the two Art Gallery of Ontario pictures several of the structures in the Forum and other locations in Rome can be identified. Panini responded to both the demands of the French Academy in Rome, where he taught optics and perspective, and to the demands of the art market including the patrons on the Grand Tour who sought out his pictures to take back as mementos of their tours through Italy, Greece, Syria, and other countries in the Middle East. Catering to the latter audience, Panini often created a composite of structures, and, as with many of these arrangements, the role of *capriccio* (a mixture of real and imaginary features) cannot be overlooked. For artists and patrons alike, these impressive structures, like those presented here, evoked the mystery of ancient worlds, the glories of mythology and biblical narratives, and archaeological discoveries. As such, they became the most familiar images of the Grand Tour and the ones frequently documented by artists. Among Canadian collections, the two Art Gallery of Ontario works are the best examples of view paintings by this Roman artist.

Over the centuries, the Roman Forum sustained several building, demolition, and rebuilding phases. Aside from the earliest changes to the Forum under various Roman rulers, most of the more radical modifications to the buildings took place during the Renaissance, which witnessed a widespread conversion of pagan temples into Christian churches. Damage and losses also occurred as a result of new construction, which involved the appropriation of building materials and the use of the Roman Forum as an active quarry. By the eighteenth century, during Panini's lifetime, an enlightened period of archaeological discovery and excavations had begun, which arrested the mania of dismantling and appropriation, and initiated a restoration campaign.

In the *Capriccio* with the Arch of Constantine, Panini has positioned the famous arch in the centre of the composition where it appears dwarfed by the classically designed aqueduct that extends across the entire painting. To the left of the Arch of Constantine are two of the oldest extant buildings in Rome from the second century BCE: the circular Temple of Vesta and the Temple of Fortuna Virilis, which sit next to each other in the Piazza Bocca della Verità, the ancient Forum Boarium by the Tiber River.

In the *Capriccio* with the Pantheon, Panini offers us another perspective of the Roman Forum framed by a massive structure reminiscent of the Baths of Diocletian. Built in the fourth century AD, they were the largest of the imperial baths in Rome and were converted to a church in the sixteenth century. Through the arched opening marked by the Corinthian columns, we see Panini's penchant for ancient buildings and sculptures in Rome including (from left to right) the Pantheon, the Arch of Titus, Trajan's Column, and the Colosseum. In both compositions, groups of elegantly robed men and women gather among the ruins and statuary (including the Farnese Hercules) in various states of conversation and repose.

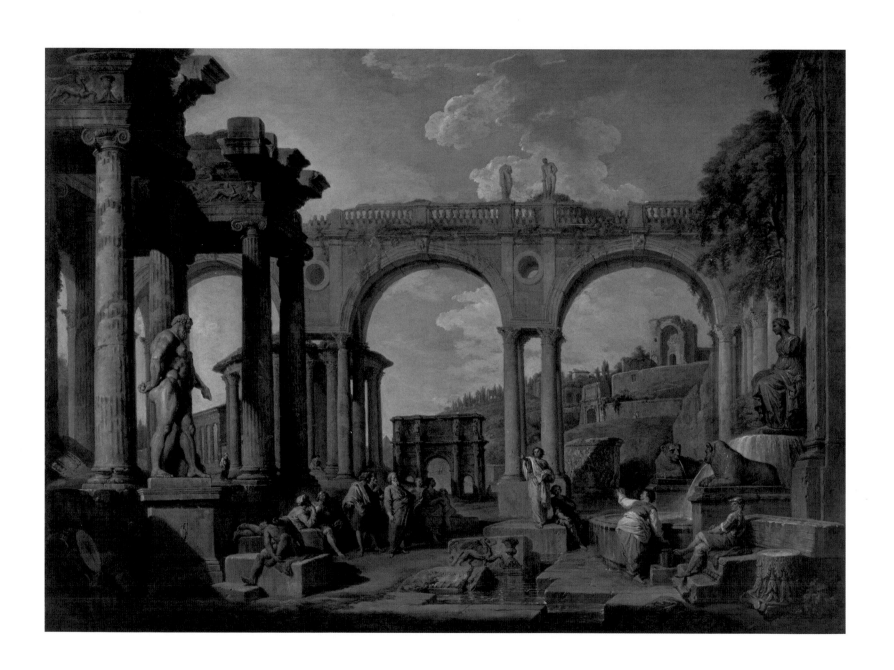

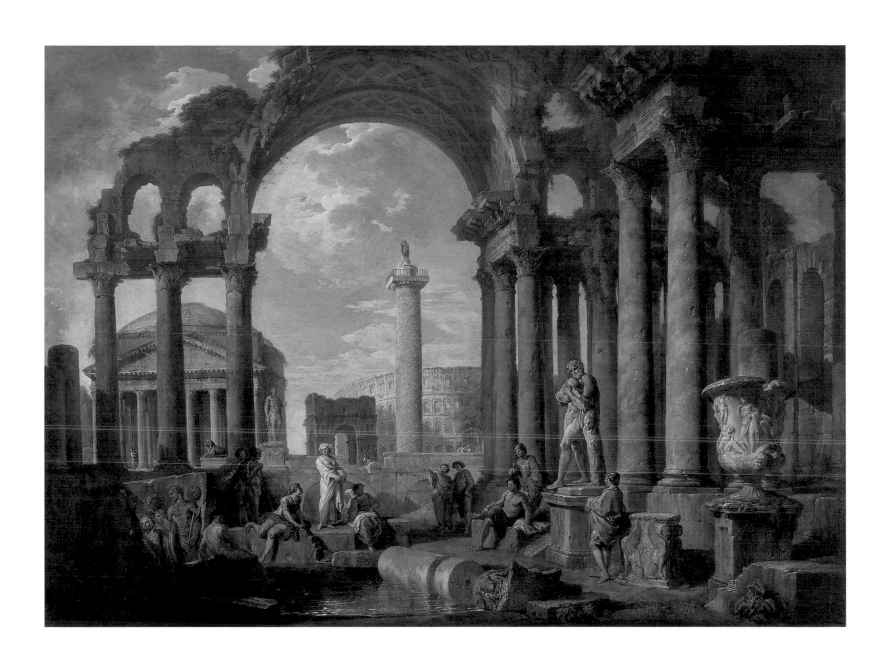

Thomas Gainsborough British, 1727–1788

*An Extensive Wooded River Landscape, with Cattle
and a Drover and Sailing Boats in the Distance,* c.1757–1759

Oil on canvas 75.2 x 111.5 cm

Beaverbrook Art Gallery, Fredericton
Purchased with a Minister of Communications Cultural Property Grant and
funds from the Estate of Mrs. Mae Atkinson Benoit, 1988.03

UNLIKE THE TWO celebrated British landscape painters that succeeded him at the end of the eighteenth century, John Constable and J. M. W. Turner, Gainsborough had little interest in documenting a specific naturalism or topography of the landscape. His interest in the land focused primarily on capturing the essence of the environment and taking the necessary steps and liberties to document this pictorial quality. On his regard for nature, Gainsborough once responded in writing to the request of a distinguished patron, Philip Yorke, 2nd Earl of Hardwicke, who had asked the artist to paint a specific view within his estate. Convinced that the English countryside did not have the elements or appeal to be documented by great landscape painters like Nicolas Poussin or Claude Lorrain, Gainsborough wrote to Yorke: "With respect to real views from Nature in this country he has never seen any place that affords a subject equal to the poorest imitations of Gaspar or Claude . . . If his Lordship wishes to have anything tolerable of the name of Gainsborough, the subject altogether, as well as figures, etc., must be of his own brain" (Mary Woodall, *The Letters of Thomas Gainsborough*, London: Lion and Unicorn Press, 1961, 87, 91).

The Beaverbrook Art Gallery landscape was painted shortly before Gainsborough moved from Ipswich in Suffolk to Bath, in a period known as his High Suffolk period. The area around Ipswich, located on the estuary of the river Orwell, is mostly flat with some rolling hills, wetlands, and large tracts of arable land. It was the ideal setting for the artist to experiment with his desire to produce landscapes that evoke the essence of the place, in colour and mood. As the title describes, the artist has succeeded in combining a range of topographical components with a group of figures, animals, and boats to create a harmonious, idealized image of his own world. In the foreground, a drover on his donkey leads the herd of cattle. In the middle distance, a small inlet, which leads to a larger river, contains a few boats and additional figures. Gainsborough uses rich browns, greys, and greens that recall the Suffolk landscape including its deep reddish-brown soil. The scene is reminiscent of the seventeenth-century Dutch landscape tradition mastered by Jan Both and Jacob van Ruisdael. Gainsborough's style also references the landscapes of the French school, particularly Claude Lorrain in the seventeenth century, and Antoine Watteau and Francois Boucher in the following century. While he trained under the French engraver Hubert Gravelot in London, and studied briefly at the St. Martin's Lane Academy under William Hogarth, Gainsborough was largely self-taught when it came to his landscape painting. He gained much of his experience by copying the landscapes of the Dutch painters. The impact of his earlier studies with Gravelot is evident in Gainsborough's drawings, executed in chalk and graphite, which often served as preparatory explorations for his paintings.

Gainsborough left Ipswich in 1759 and moved to Bath where he remained until 1773. He relocated to London in 1774 and lived there until his death in 1788. His chief competitor for most of his career was Joshua Reynolds; however, this rivalry was limited to portraiture, and Gainsborough remained the leading landscape painter of his day.

Jean-Honoré Fragonard French, 1732–1806

The Grand Staircase of the Villa d'Este at Tivoli, c. 1760

Oil on canvas 81.9 x 104.8 cm

Minneapolis Institute of Arts, Minneapolis
Gift of Daniel T. and Helen E. Lindsay; 2001.235

ONE OF THE GREATEST French landscape painters of the eighteenth century, Jean-Honoré Fragonard was first introduced to the garden landscape in the studio of his teacher François Boucher, painter to Louis XV and professor at and later director of the Académie française in Paris. While Madame de Pompadour would become Boucher's most important patron, Fragonard would enjoy the patronage of her successor, Madame du Barry, who became Louis XV's *maîtresse en titre* in 1769 (and later met her death at the guillotine in 1793). The artist's most famous commission for du Barry, the *Progress of Love* series for her *pavillon de musique* at the Château de Louveciennes, was abruptly cancelled; this suite of paintings is now in The Frick Collection in New York.

Fragonard won the Prix de Rome in 1752, but he remained in Paris for another three years to study with Charles-André van Loo. He travelled to Italy in 1756 as a *pensionnaire* at the Académie de France à Rome where he was enrolled until 1761. In the summer of 1760, he was invited by his patron, Jean-Claude Richard, abbé de Saint-Non, to spend six weeks at the Villa d'Este at Tivoli, located about thirty kilometres from Rome, after Saint-Non had leased it from its current owner, the Duc de Modena, Francesco III d'Este.

As is evidenced in this canvas with its painterly quality and colouring, the precision of Fragonard's visual record of the Villa d'Este and gardens was guided more by his imagination than by any preoccupation with architectural accuracy. However, despite his creative manner, it is possible to locate almost every site that he sketched in the garden including the grand staircase depicted here. A red chalk drawing now in the collection of the Musée des beaux-arts et d'archéologie de Besançon served as the model for the Minneapolis Institute of Arts painting. In Fragonard's painting, this once magnificent Renaissance garden, now unkept and overgrown, still retains its beauty and grandeur. With his vigorous brushwork, Fragonard captures the lush tones of the foliage and the striking light and shadows that animate the space. A few figures at the bottom left are dwarfed by the towering cypresses, hedges, and the crown of the fountain spray. Charles-Joseph Natoire, director of the Académie de France à Rome purchased this painting directly from the artist before he returned to Paris in 1761.

The Villa d'Este was built largely in the late sixteenth century (using an existing villa) by Cardinal Ippolito II d'Este, Governor of Tivoli (and grandson of Pope Alexander VI), with iconographic plans by Pirro Ligorio. The villa became one of the most celebrated Italian Renaissance villas and gardens with over five hundred water jets in fountains, pools, and troughs. By the eighteenth century, the villa and gardens were in a state of disrepair with most of the water hydraulics no longer functioning. After passing from the d'Este family to the Habsburgs (after Ercole III d'Este bequeathed it to his daugher Maria Beatrice who married the Grand Duke Ferdinand of Habsburg), the villa had been offered for sale. Still, it remained a popular destination for tourists and artists including many studying at the Académie de France à Rome.

Dominic Serres French, 1722–1793

Governor's House and St. Mather's Meeting House on Hollis Street,
also Looking up George Street, c. 1762

Oil on canvas 38.1 x 55.9 cm

Part of the Town and Harbour, Looking down Prince Street to the Opposite Shore, c. 1762

Oil on canvas 38.1 x 55.9 cm

Town and Harbour of Halifax as they appear from George Island,
Looking up to the King's Yard and Basin, c. 1762

Oil on canvas 38.1 x 55.9 cm

Town and Harbour of Halifax as they appear from the Opposite Shore called Dartmouth, c. 1762

Oil on canvas 38.1 x 55.9 cm

Art Gallery of Nova Scotia, Halifax
Purchased with funds provided by the Gallery's Art Trust Fund (Mrs. Stewart L. Gibson Bequest);
the Cultural Foundation for Nova Scotia; and private and corporate donations, 1982; 1982.41; 1982.42; 1982.43; 1982.44

DOMINIC SERRES WAS BORN in Auch, the historical capital of Gascony in the Midi-Pyrénées region of southwestern France, close to the Spanish border. He studied at the Benedictine academy at Douai and was expected by his family to take a religious vocation. Before entering the priesthood, Serres fled to Spain where he eventually took command of a Spanish merchantman, likely a cargo ship, sailing to South America and Cuba. In 1752, a ship under his command was captured by the British, and Serres was imprisoned briefly in Northamptonshire, England. Upon his release from prison, he remained in England and married, and was reportedly promoted to the rank of commander in the British Navy as a result of his experience as a seaman. Serres began painting seascapes and naval scenes, securing his first commissions as a country house painter. He moved to London in 1758, studying briefly with Charles Brooking before assuming full-time work as a marine painter. With his son, John Thomas Serres, he published *Liber Nauticus*, which became one of the most important illustrated books on marine painting, first intended to assist students at the Chelsea Naval School. Serres became a member of the Royal Society of Artists in 1765, and was admitted as a foundation member to the Royal Academy upon its establishment in 1768. He was appointed Marine Painter to King George II in 1780, and at his death was succeeded by his son who also served under William IV, known as the "Sailor King."

In 1763 at the Royal Society of Artists, Serres exhibited a series of views of Halifax that he had painted after drawings by Richard Short, a purser with the Royal Navy as well as a trained engraver and naval draughtsman. Stationed on the HMS *Prince of Orange*, Short's tour of duty included Halifax from 1758 to 1759, which is when he produced the drawings, likely with the aid of a camera obscura. Established in 1749 by the British as a fortification against Louisbourg, Halifax was the administrative centre for a large region along the Atlantic coast and west to the St. Lawrence River (where the French had colonies at Montreal and Quebec City), providing safe haven for the Royal Navy and the British garrison troops. Short published engravings after the paintings in 1764, and they were reissued in 1777 by John Boydell, leading to their popularity in artistic and marine circles in Halifax. Serres's inclusion of the Halifax views in the London exhibition came at a time when the British House of Commons was debating the maintenance costs for Halifax, and it appears the impressive views aided the campaign to maintain the settlement. The exhibition of the works also secured Serres the patronage of George Montagu-Dunk, 2nd Earl of Halifax (1716–1771), the British statesman for whom the city was named after his help in establishing Nova Scotia.

Chelsea Porcelain Manufactory
Lawrence Street factory, London, England British, c.1745 –1784
Potpourri or perfume vase, c.1765–1769

Soft-paste porcelain, overglaze polychrome enamel-painted decoration, and gilding 54 x 36.3 x 23.2 cm

Royal Ontario Museum, Toronto
Purchased in memory of Mrs. Mona Campbell with the generous support of the Louise Hawley Stone
Charitable Trust, and funds provided by the T. Eaton Co. Ltd.; Mr. Albert L. Koppel; Mr. Gerald R. Larkin;
and Dr. Morton Shulman, by exchange; Certified Canadian Cultural Property; 2008.32.1.1-2

THE CHELSEA PORCELAIN Manufactory was established around 1744 in the London village of Chelsea by the silversmith Nicholas Sprimont, possibly in partnership with Charles Gouyn, a French jeweller. The factory was the first major porcelain manufactory in England and remained active for forty years. In addition to the collaboration with Gouyn, Sprimont is thought to have engaged a German chemist to help with the technical side of the business. Sprimont sold the business to James Cox in 1769, who in turn sold it the following year to William Duesbury. Duesbury ran the Chelsea operations with his own Derby porcelain manufactory in a production period that was known as the Chelsea-Derby period. He closed the Chelsea branch in 1784 and transferred all remaining moulds and patterns (and many of the workers) to the Derby manufactory.

Chelsea porcelains can be divided into four major production periods: Triangle, Raised Anchor, Red Anchor, and Gold Anchor, with this Royal Ontario Museum piece belonging to the latter period. In the two earlier Anchor periods, the influence of the Meissen and Chantilly manufactories is significant, along with the Kakiemon pottery tradition of Japan. The Chelsea birds and animals, as well as male and female figures, are directly linked to their Meissen counterparts. By the Gold Anchor period, the impact of the Sèvres manufactory in France brought daring stylistic advances to the design and production at the British firm. The Rococo taste was manifested not just with the introduction of new shapes for the Chelsea vessels and figures, but also in the use of opulent coloured grounds and extensive gilding. Similar to the French examples, the fashion for Orientalism

and chinoiserie in both decorative elements and allegorical themes was equally popular in the British manufactory.

The potpourri or perfume vase in the Royal Ontario Museum collection represents the highest quality of eighteenth-century porcelain production in England, a tradition led by the Chelsea manufactory. With its impressive size, complex shape, and elaborate painted and gilded decoration, it is a masterpiece. The vase is soft-paste porcelain with overglaze polychrome, enamel-painted decoration, and gilding over a claret-coloured ground. All of the enamel work is painted over the glazed and fired body at a lower temperature, and the gilding is then applied, fired, tooled, and burnished. The oval-bodied vase sits on a trumpet-shaped base with a scrolled ring and cushion-shaped moulding. Above the body of the vase is a conically shaped neck that flares out to meet a similarly shaped cover with an openwork diamond-shaped handle.

Beyond concessions to the current fashion for Orientalism, the allegorical composition of this vase—in this instance, the senses—also reflects the taste of the day. On one side, a female figure with a small child selects fruit being offered by a male attendant, while an older man offers her shade with an opened parasol. On the other side, a woman plays a tambourine while a man at her side plays a lute or theorbo. In addition to these allusions to taste, hearing, sight, and touch, the actual function of the vessel as a potpourri or perfume vase is a subtle reference to the sense of smell.

François Boucher French, 1703–1770

Les sabots (*The Wooden Shoes*), 1768

Oil on canvas 62.2 x 52.1 cm

Art Gallery of Ontario, Toronto
Purchased through the Frank P. Wood Endowment, 1978; 78/6

FRANÇOIS BOUCHER'S ABILITY to master history, landscape, and portrait painting was impressive, and matched only by his remarkable aptitude in a variety of media including painting, printmaking, tapestry and porcelain designs, and designs for the stage. In 1745 the Marquise de Pompadour was installed as Louis XV's *maîtresse en titre*, and for the next nineteen years she would become Boucher's most important patron. The year after her death, in 1765, Boucher was appointed *premier peintre du Roi* and elected director of the Académie française following the death of Carle Van Loo.

Boucher's painting *Les sabots* in the Art Gallery of Ontario is based on a scene from the one-act comic opera of the same name, which premiered in Paris in 1768. The opera was written by the Italian-born Egidio Duni, with a libretto by Michel-Jean Sedaine, the father of the *opéra comique*. Guy de Maupassant also wrote a novel by the same name in 1883. In the scene depicted in Boucher's painting, the lovers escape to the woods and relax under a large clump of trees, with the young man's wooden shoes positioned prominently in the foreground. The woman, swathed in silks of silvery grey, white, and rose tones, offers her lover berries from a basket, which rests on his knee.

Les sabots fits well into Boucher's rustic country scenes and draws from a rich visual repertoire acquired in part through his tapestry designs and his work for the opera and the *opéra comique*. The subject of the lovers and its picturesque treatment exemplify Boucher's talent with the brush and his adventurous palette. Although he trained briefly with François Lemoyne, it was his early work as an engraver for Jean-François Cars that prepared Boucher for the traditions of the *fête champêtre* and his own pastoral forays through his productions of etchings after Antoine Watteau. The Art Gallery of Ontario landscape shows Boucher at his most luxurious in his treatment of the country landscape. A brilliant blue fills half of the upper portion of the oval composition, and a large clump of trees with heavy foliage dominates the other half. The rich organic cover carpets the foreground where the couple reclines, and a trailing rose bush forms an elegant garland around their secluded garden stage. The natural palette of greens and browns is mixed with the blue and grey of the sky, offering a bucolic environment for the amorous scene from the Duni opera. Of the handful of works by Boucher in Canadian galleries, this painting best represents the rustic splendour of the Rococo landscape that was mastered by the artist, but which was quickly abandoned after his death in 1770.

Charming, rustic scenes like *Les sabots* epitomize the height of the Rococo aesthetic in Boucher's work. With their lighthearted and often sensual stories, the work appealed to audiences and patrons, as well as to his colleagues who designed for the stage. These compositions worked well for designs for the *opéra comique*, particularly as Boucher and the opera director Charles-Simon Favart had developed the genre of the pastoral as a theme.

William Pars British, 1742–1782

Portrait of Three Friends, c. 1770–1775

Oil on canvas 131 x 143 cm

University of Toronto Art Centre, Toronto
University of Toronto Collection, Gift of Sir Robert Leicester Harmsworth, c. 1924; 1999-003

WILLIAM PARS STUDIED AT Shipley's Drawing School (where his brother Henry became the principal) and at the St. Martin's Lane Academy in London. After exhibiting at the Royal Society of Arts and winning the exhibition prize in 1764, he was invited by the Dilettanti Society to join the archaeological expedition to Asia Minor and Greece led by Richard Chandler and Nicholas Revett. Pars worked as the draughtsman on the tour. Upon his return to London, he submitted work to the Royal Academy, including a suite of watercolours of the sculptures from the Parthenon in Greece, and was appointed an associate of the Academy in 1770. The watercolours were included in James Stuart's *Antiquities of Athens*, published in 1777, and their commercial success brought Pars considerable fame and enough support to return to Italy, which he had visited with Lord Palmerston after the expedition to Greece. He settled in Rome and died of pleurisy in 1782 after spending hours in the water at Tivoli where he was painting the famous waterfalls. Upon learning of Pars's sudden death, his friend and fellow painter, Thomas Jones, wrote in November 1782 that the artist's love for the landscape was such that it was "with the greatest difficulty his friends could detach him from his favourite study, and persuade him to apply to portrait painting" (*Thomas Jones, Pencerrig*, The National Library of Wales, 2003).

The three men depicted in Pars's painting can be identified (left to right) as Archdeacon Andrew, John Burridge Cholwich, and General John Graves Simcoe, all of whom were acquaintances of the artist. Sitting between the archdeacon and the captain of the local militia, Cholwich, the son of the member of the British parliament for Exeter, appears comfortable in his position as a member of the landed gentry. Shortly before this portrait was painted, he ran for parliament himself in 1776, but lost by one hundred votes to John Baring. General John Graves Simcoe was the first Lieutenant Governor of Upper Canada from 1791 to 1796 and was responsible for the founding of York, now Toronto. In addition to establishing the modern court system and freehold land tenure in Upper Canada, Simcoe oversaw the abolition of slavery in the region. Archdeacon Andrew is shown leaning against the base of the sarcophagus, supposedly containing the remains of a mutual friend but more likely referencing Nicolas Poussin's celebrated painting *Et in Arcadia ego*. That painting depicts four Arcadian shepherds in a classical landscape contemplating the Latin inscription on a large tomb, which can be translated as "I too was in Arcadia."

In the tradition of the Neo-Classical conversation piece, Pars has created a rustic garden as the setting, complete with architectural ruins, ancient sarcophagus, overgrown foliage, and impressive vistas. The landscape on the left, seen through the opening of trees above the tomb, references the gardens at the Villa d'Este in Tivoli, Italy, and features the towering cypress trees that line the grand *allée* leading to the villa. Separated by an enormous clump of birch or willow, the expansive landscape on the right, behind Simcoe, recalls the rolling hills of the Roman Campagna in the romantic style of Richard Wilson and John Cozens.

For years *Portrait of Three Friends* was installed in the Office of the President in Simcoe Hall at the University of Toronto before it was returned to the Art Centre. A copy of this painting can be found in the RiverBrink Art Museum in Niagara-on-the-Lake, Ontario, and is attributed to Johann Zoffany.

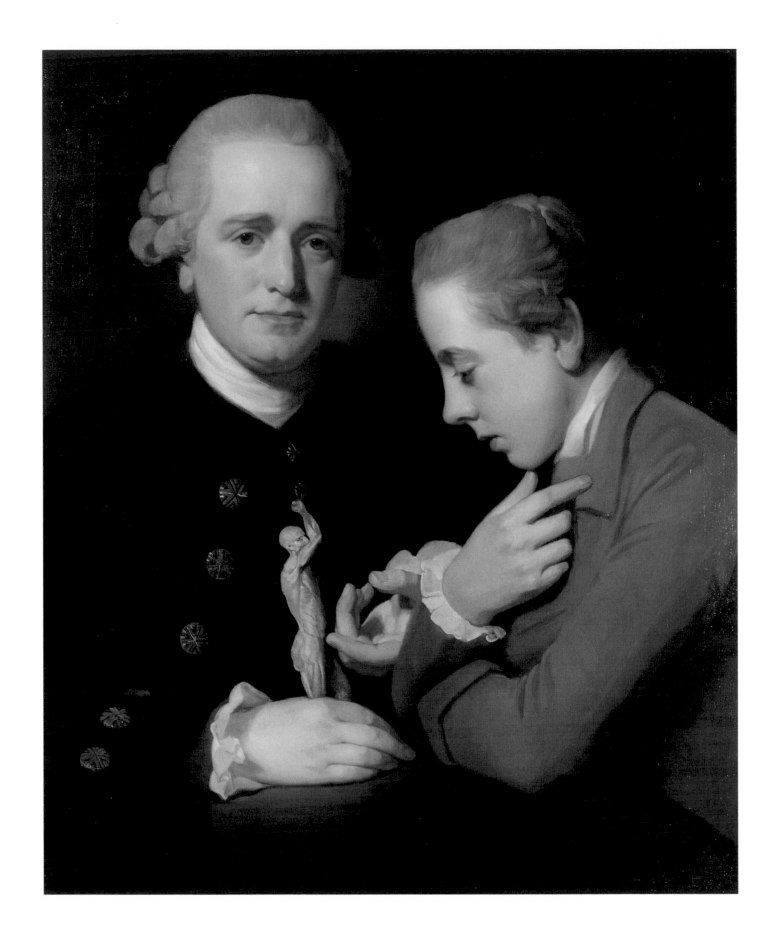

George Romney British, 1734–1802

Robert, 9th Baron Petre, Demonstrating the Use of an Écorché Figure to His Son, Robert Edward, c. 1775–1776

Oil on canvas 76 x 63.2 cm

McMaster Museum of Art, Hamilton
Levy Bequest Purchase, 1994; 1994.004.0001LB

THIS INTIMATE PORTRAIT of a father and son was executed at the height of George Romney's painting career. Both a double portrait and a conversation piece, the picture underlines the artist's skill at capturing the emotional and psychological state of his sitters, particularly when they were children or youths. With his portraits of children, Romney revealed their innocence and vulnerability while at the same time acknowledging their complex natures. In the McMaster Museum of Art work, the two sitters remain connected to each other as father and son, and yet remote in their individual contemplation. In fact, it's likely that the two posed separately and were then brought together by the artist to complete the composition. Holding the écorché figure and gesturing with his other hand, the father, Robert Baron Petre, engages confidently with the viewer while his son, Robert Edward, concentrates on the figure itself. The small cast figure, likely made of ivory or plaster, is a model of the human body with the skin removed and muscles exposed. Dating back to sixteenth-century Italy, these models were used by both scientists and artists in the study of anatomy.

A few years after this painting was commissioned, Baron Petre was elected as a Fellow of the Royal Society and the Royal Society of Arts. In the portrait, we are drawn first to the expressions of the sitters and the positioning of their hands, mainly due to Romney's masterful approach to the palette. The restrained colours and textures of their clothing, even the elegant gold buttons and shirt ruffles, merge with the interior space, allowing their respective gazes and gestures to dominate the scene. The sensitive handling of the skin and hair of the two figures further draws our attention to the face and hands.

In the hierarchy of eighteenth-century British portraiture, George Romney stands next to Joshua Reynolds and Thomas Gainsborough as the genre's most successful and popular practitioner of the day. His rise to fame, however, was noticeably less traditional than that of his two closest rivals. The son of a cabinetmaker, he had limited formal training as an artist. He was not a member nor did he ever exhibit at the Royal Academy, and he never succeeded in holding a royal post as did his two closest rivals. He exhibited only through the Free Society of Artists, but he stopped showing his work publicly after 1772. This less conventional route, however, did not hinder him from recording nearly nine thousand sittings with more than one thousand five hundred sitters in a twenty-year period between 1775 and 1795. He also managed to travel to Paris and several cities in Italy where he studied the Antique and the Old Masters. At the height of his career, Romney was the most competitive and economical portraitist in the business, offering his clients the best value in portraiture in what became known as "the Romney portrait." His standard fee of twenty guineas for a three-quarter-length portrait was less than half what Reynolds charged his sitters.

Sir Henry Raeburn Scottish, 1756–1823

Portrait of William MacDowall of Garthland and Castle Semple,
M.P. and Lord Lieutenant of Renfrewshire (1793–1810), c. 1790

Oil on canvas 116.1 x 89.2 cm

Montreal Museum of Fine Arts, Montreal
Miss Olive Hosmer Bequest; 1963.1404

WILLIAM MacDOWALL (1749–1810) of Castle Semple, Renfrew, and Garthland was the eldest child of William MacDowall and Elizabeth Graham, and heir to a large commercial empire in the sugar and rum trade associated with the firm Alexander Houston & Co. of Glasgow, Scotland. He also had estates in the West Indies and extensive properties in Scotland. The barony of Castle Semple in Renfrewshire was acquired by MacDowall's grandfather, and Castle Semple House became his chief residence. MacDowall studied law at the University of Glasgow but did not pursue a legal career, choosing instead politics and the management of the family estates. He was appointed Lord Lieutenant of the county of Renfrew by King George III in 1793, and represented the county in five different parliaments between 1783 and 1807, serving under Prime Minister William Pitt the Younger. William Adam, a fellow Scottish parliamentarian, wrote of him in 1790: "Mr. MacDowall is a man universally well liked, and has great industry and good sense. Mr. Pitt's ministry is surely under obligations to him . . . He has a good estate in this county, another in Wigtown, and a very large one in the West Indies" (William Adam, *Survey of Scottish Constituencies*, 1790). MacDowall also served as rector of the University of Glasgow and was Commander of the Greenock Sharpshooters.

The portrait of MacDowall with his favourite English Springer Spaniel shows him in the dress uniform of a major general. It was painted at the time when Henry Raeburn was moving into his most successful years as a painter in Edinburgh, and highlights his bravura brushwork and bold palette that set him apart. With limited formal training, Raeburn developed an unconventional approach to his compositions and technique, experimenting with bust-sized and full-length portraits, incorporating large areas of solid colours applied in broad brush strokes, and using dramatic lighting.

At the suggestion of Sir Joshua Reynolds, whom Raeburn had met on a trip to London in 1784, Raeburn undertook the Grand Tour, studying in Italy from 1785 to 1787. Upon his return to Edinburgh, he established a studio on George Street, and it is likely at this time that he was commissioned to paint William MacDowall's portrait. MacDowall himself had taken the Grand Tour between 1771 and 1773, and would eventually commission several portraits including one by Raeburn's English colleague, George Romney, who also painted him in military dress.

Raeburn was Scotland's first major portraitist since the Treaty of the Unions (1706–1707) to remain in his native country, and he is acknowledged as one of the founders of the Scottish school along with Sir David Wilkie. Before pursuing a painting career, Raeburn had apprenticed to the goldsmith James Gilliland in Edinburgh in 1772, and also excelled at watercolour portrait miniatures. Encouraged by the city's leading portraitist, David Martin, Raeburn turned to oil painting. He was elected president of the Society of Artists in Edinburgh in 1812, and became a full member of the Royal Scottish Academy in 1815. King George IV awarded him a knighthood in 1822 during a royal visit to Scotland, and appointed him Royal Painter and Limner the following year. In his lifetime, Raeburn painted over seven hundred portraits, including four of Sir Walter Scott.

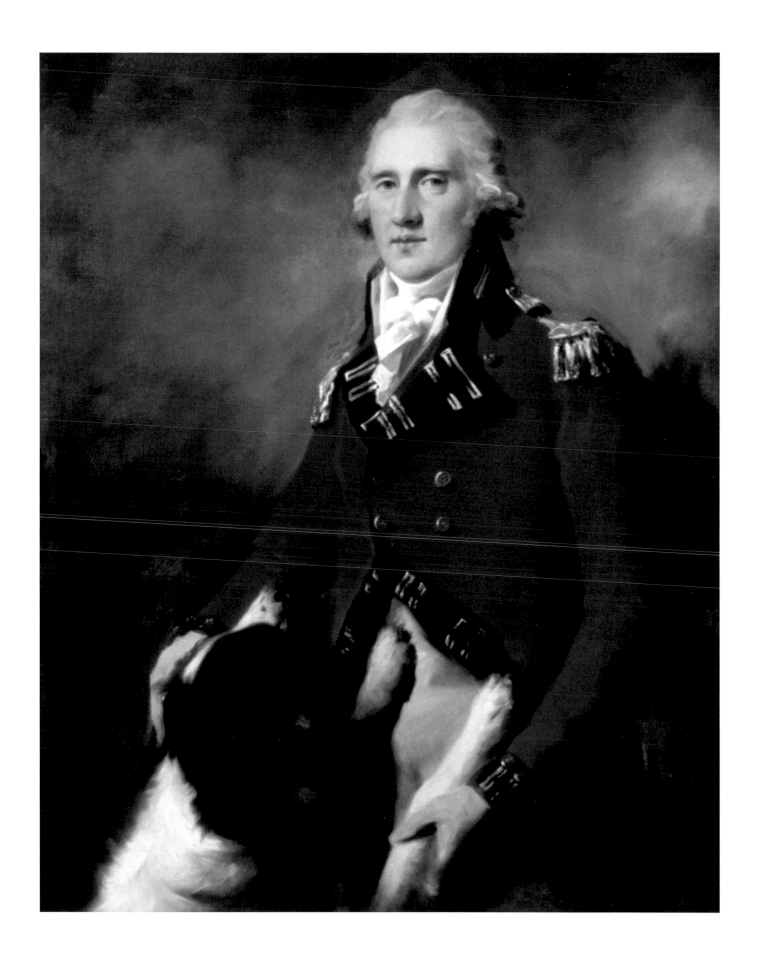

Paul Storr British, 1771–1844

Monumental candelabrum, 1816–1817

Silver: raised, cast, chased, engraved, and gilded 84 x 52.35 x 47 cm

Royal Ontario Museum, Toronto
Donated by the Ontario Heritage Foundation
Gift of Mr. R. G. Meech; 989.93.2.1-16

PAUL STORR WAS ONE of the most important independent master silversmiths in London, working at the end of the eighteenth century and through the first half of the nineteenth century. For a period in the early 1800s (1807–1819), he worked with Rundell, Bridge and Rundell of Ludgate Hill, the leading goldsmiths firm in London. Among his most celebrated early works were a gold christening font made in 1797 for the eldest son of William Cavendish-Bentinck, 4th Duke of Portland, and the presentation cup made for the British Admiral Lord Nelson to commemorate his victory at the Battle of the Nile in 1798.

Storr was first introduced to the metalwork profession by his father, Thomas Storr, who was a chaser responsible for creating the patterns on silverware. The younger Storr apprenticed with the Swedish-born silversmith Andrew Fogelberg in London from 1785 to 1792, after which he entered into a partnership with William Frisbee and registered a joint mark. Storr registered his own mark with the Assay Office in 1793. His association with the distinguished firm of Rundell, Bridge and Rundell began in 1807 when he oversaw a subsidiary on Dean Street in Soho, known as Storr and Co., and then in 1811 he became a partner with John Bridge, the principal maker. Rundell received its royal warrant in 1797, which led to commissions of extensive dinner services, related table ware, and presentation silver including monumental pieces like the candelabrum in the Royal Ontario Museum's collection. After leaving Rundell in 1819, Storr partnered with John Mortimer and established the firm Storr and Mortimer before retiring officially in 1839.

This magnificent silver-gilt candelabrum and centrepiece was made for Charles Brudenell-Bruce, the 2nd Earl of Ailesbury, who was later created the Marquess of Ailesbury by King George IV at his coronation in 1821. The monumental piece, measuring eighty-four centimetres in height, was executed at the pinnacle of Storr's career when he was managing one of the Rundell workshops. In this singular sculptural work we see the merging of the grandiose Neo-Classical style with the decorative flourishes of the Rococo Revival that came to define the splendour of metalwork production during the Regency period, and which is the hallmark of Storr's work. Added to the remarkable design of this piece is the confirmation of Storr's profound knowledge of the nature of metals and his skill at translating a design into a sculpture that matches the beauty and strengths of silver and gold.

The Royal Ontario Museum candelabrum has an interchangeable centrepiece, which allows for the six-branch candelabrum to be replaced by a large bowl. The base section, which supports the candelabrum or centrepiece bowl, is cast silver with elaborate chasing, engraving, and gilding. Sitting on the round base, positioned around a tree trunk draped in a lion skin, are four figures: a putto playing a tambourine, a faun playing a double flute, a putto with a pan pipe, and a bacchante playing cymbals above her head. The iconographic references to Greek mythology are appropriate given the function of the piece. Two plaquettes attached to the base bear the coat of arms of Charles Brudenell-Bruce and his wife, which appears under the earl's coronet and over the Brudenell-Bruce family motto FUIMUS, which translates as "We have endured."

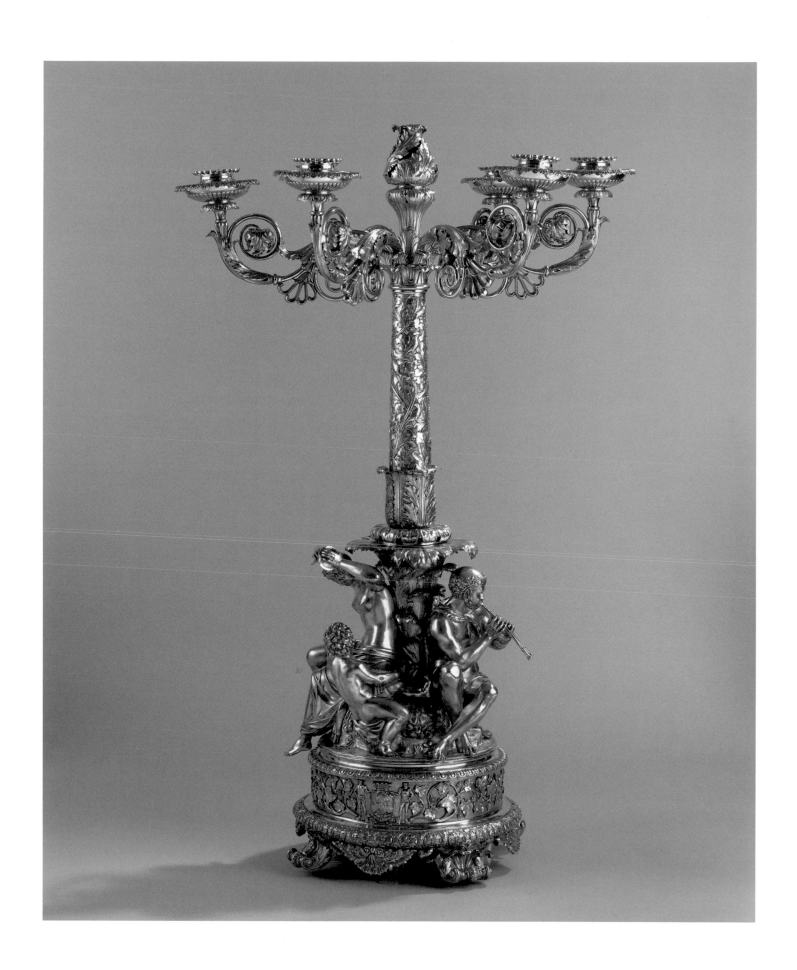

James Duncan Canadian (born in Ireland), 1806–1881

Montreal from the Mountain, c. 1830–1831

Oil on canvas 150.5 x 241.9 cm

McCord Museum, Montreal
Gift of Mr. William D. Lighthall; M966.61

JAMES DUNCAN, AN ARTIST from the north of Ireland, had been in Montreal less than a year when he painted *Montreal from the Mountain*. It is an accurate and absorbing illustration of colonial Montreal, and a work that no doubt helped Duncan establish a teaching career as a drawing master and secure commissions for contemporary and historical views of the city as well as some portraits. His watercolour views would be replicated and published as engravings and lithographs—Duncan was himself a respected printmaker—for picturesque guidebooks and popular weeklies like the *Illustrated London News* and the *Canadian Illustrated News*. Duncan played an active role in Montreal's burgeoning arts scene. He helped form the short-lived but important Montreal Society of Artists in 1847, along with peers such as Cornelius Krieghoff; he exhibited regularly in provincial exhibitions after Confederation. He died a year after the formation of the Royal Canadian Academy, with the rank of associate.

Probably begun in the early fall of 1830, *Montreal from the Mountain* presents a panoramic view of the old city around the time of its incorporation. Duncan paints from a vantage point on Mount Royal's eastern slope, then considered a pastoral edge separate from Montreal. The central skyline is marked by two defining examples of Gothic Revival architecture, structures that remain to this day important landmarks of Montreal's religious and cultural heritage. On the left, the steeple of the Anglican Christ Church Cathedral, constructed in 1814, points skyward; on the right, the broad façade of the Roman Catholic Notre-Dame Basilica, built in 1829, is recognizable even while lacking the

imposing towers that would be added in the 1840s. To the Basilica's immediate right stands the Baroque bell tower of the first Notre-Dame church, which had been constructed in the late seventeenth century.

The McCord Museum picture was likely displayed at the city's Law Courts in March 1831, and *La Minerve*, a francophone newspaper, described the painting as "a polished work which gives a very favourable impression of the artist." This canvas is likely the first, but certainly not the only painting of Montreal that Duncan would paint from Mount Royal during his career. As well as providing an impressive topographical sketch of the surrounding landscape —the distant mountain announces the Monteregian Hills that lead into the Appalachian Mountains in the southeast—the painting illustrates the clear distinction between the old city and the pastureland northwest of Sherbrooke Street. Later in the century, these fields and orchards would become the Square Mile suburb, home to the city's wealthy anglophone elite and institutions like McGill University. The rooftop in the left middle ground is Piedmont, the estate of the New England merchant John Frothingham.

Antoine Plamondon Canadian, 1804–1895

Joseph Guillet dit Tourangeau, fils, 1842

Oil on canvas 91 x 76.2 cm

Madame Joseph Guillet dit Tourangeau, née Caroline Paradis, 1842

Oil on canvas 91.3 x 76.6 cm

Musée national des beaux-arts du Québec, Quebec
Purchase, conservation treatment by the Centre de conservation du Québec; 1956.467; 1956.468

ANTOINE PLAMONDON IS BEST known for his lavish Neo-Classical portrayals of Quebec high society in the 1830s and 1840s: its political, professional, and clerical elite as well as the then provincial colony's emerging French mercantile class. His success ensured his own rise in social stature beyond his family's agrarian roots. Through the assistance of his parish priest, Plamondon apprenticed with another influential Quebec City artist, Joseph Légaré. Plamondon primarily assisted his master with religious commissions and restorations. He established his own studio in 1825, but left Quebec for Paris one year later, along with his cousin Ignace, to further his artistic studies under Jean-Baptiste Guérin, dit Paulin-Guérin, a painter who enjoyed the patronage of the Bourbon monarchy. Plamondon returned to Quebec at the outset of the July Revolution in 1830. His proximity to French royalty aided his self-confidence and reputation. Having published notice of his return in the *Quebec Gazette,* Plamondon settled into a new studio and promptly began receiving ecclesiastical, government, and private commissions. He also worked as an art critic, writing newspaper articles—sometimes under a pseudonym—that aimed at furthering his own reputation and lambasting those of his competitors. In 1834 a young Théophile Hamel became an apprentice to Plamondon, whose career the former would eventually eclipse.

The decade between 1835 and 1845, when Plamondon would paint these companion portraits, was politically and economically unsettled. In 1837 a rebellion broke out in Lower Canada, spearheaded largely by members of the francophone middle class over their lack of political representation and economic power. One legacy of the unsuccessful rebellion was an endeavour by the British to accelerate French cultural assimilation through the unification of the hitherto separate colonies of Upper and Lower Canada. While Plamondon's ultraconservative and monarchist sympathies had precipitated his return from France in 1830, as an established francophone businessman in the comparatively provincial Quebec City, he was amenable to receiving patronage from a wide range of establishment types. These included members of the anglophone business community, such as the Redpath family, to francophone professionals like the politician and rebellion leader Louis-Joseph Papineau.

The Tourangeau companion portraits are, in fact, part of a much larger family commission that Plamondon carried out between 1841 and 1842. The subjects—the recently married Joseph and Caroline Guillet dit Tourangeau, ages twenty-three and eighteen respectively—were members of established bourgeois households living in Quebec City's Saint-Roch neighbourhood. The Tourangeaus were a banking family; Caroline's father, Francois-Xavier Paradis, was a businessman. Plamondon painted companion portraits of both sets of parents as well as two Tourangeau daughters, Flora and Marie-Mathilde, who had recently entered the Augustinian Order. In 1854 Plamondon would complete three more portraits of Tourangeau kin. These works display a set of formal elements that Plamondon perfected in the 1830s and that recur throughout his commissioned secular portraits of the 1840s: the three-quarter pose; soft lighting for the figures as well as a luminous glow behind them that serves to define their heads, necks, and shoulders; and restrained sartorial embellishments that do not compete with the face as the focal point.

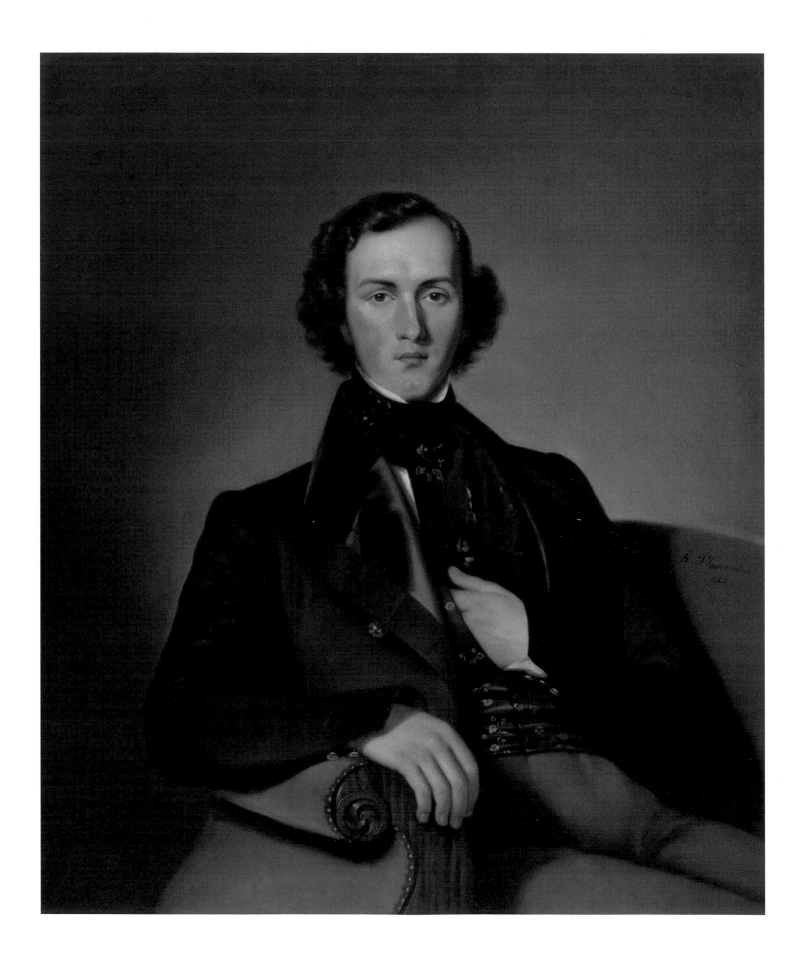

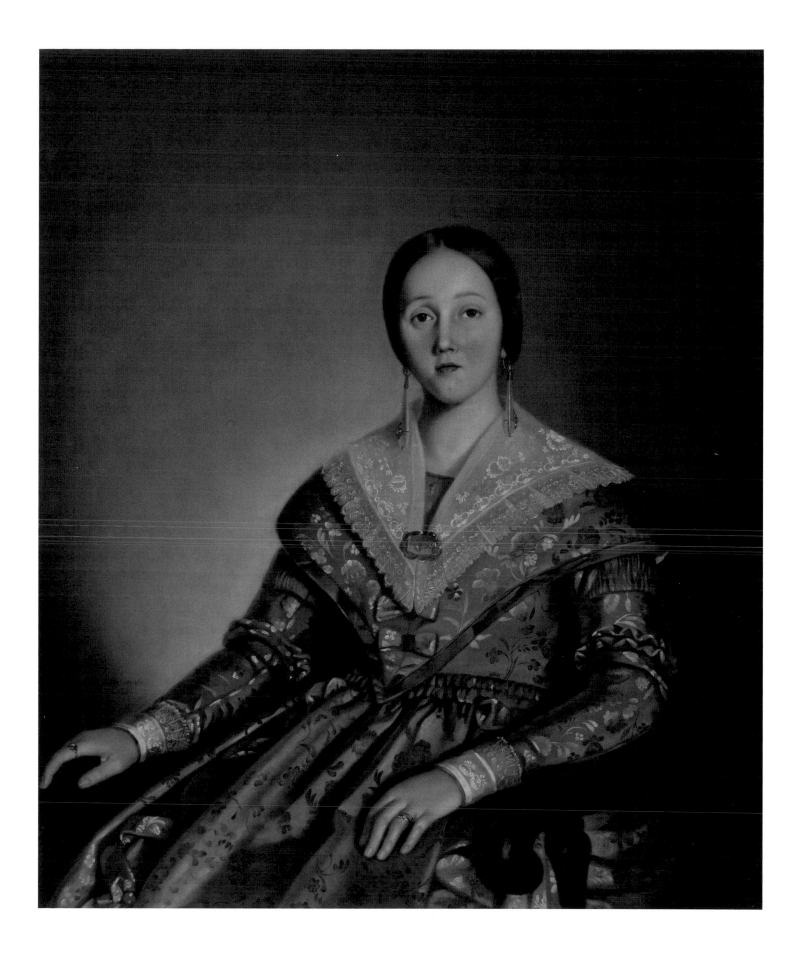

Joseph Légaré Canadian, 1795–1855

Paysage au monument à Wolfe
(*Landscape with Wolfe Monument*), c. 1845

Oil on canvas 131.3 x 174.6 cm

Musée national des beaux-arts du Québec, Quebec
Purchase; 1955.109

JOSEPH LÉGARÉ, ONE OF pre-Confederation Canada's most influential artists, studied at Quebec City's Séminaire de Québec and apprenticed under Moses Pierce, gaining marketable skills as a sign, carriage, and interior painter. He also worked as a restoration painter and copyist, replicating religious paintings for ecclesiastical institutions. One of Légaré's most important early commissions occurred in 1817 with the arrival of one hundred eighty religious paintings for auction, sent from France by Father Philippe-Jean-Louis Desjardins. Légaré helped restore the Desjardins collection, whose works had been pillaged from Parisian churches during the French Revolution before being auctioned to private buyers and Roman Catholic churches throughout Quebec. In 1819 Antoine Plamondon, who would become one of Quebec's most successful portraitists, was hired as Légaré's assistant. A passionate art collector, during the 1830s Légaré ran the Galerie de Peinture de Québec, an institution that faced several setbacks but stands, in retrospect, as one of the earliest art galleries in Canada.

As an artist, Légaré developed a reputation as a chronicler of contemporary events, documenting epidemics, natural disasters, and urban fires. His imagery provided valuable historical records in an era before photography as well as veiled criticism of British colonial policy. Politically, Légaré supported Louis-Joseph Papineau's Patriote movement and its efforts to eliminate the colony's oligarchic tendencies through rebellion in the late 1830s. *Paysage au monument à Wolfe* is one of Légaré's most accomplished works, and perhaps his most defining political statement. It also incorporates elements from European paintings, versions of which Légaré likely had access to through prints. It presents a statue of Major General James Wolfe, whose pose replicates Wolfe's appearance in a circa 1765 painting attributed to the British artist J. S. C. Schaak (now at the National Gallery of Canada). The monument is set in the clearing of a lush forest that, far from being North American, carries in elements found in a landscape by the Italian Baroque artist Salvator Rosa. Wolfe had led the British to victory at the 1759 Battle of the Plains of Abraham, a watershed event that ensured British cultural and political dominance in Canada. To the left of the monument, a reclining First Nations youth mimics Wolfe's gesture. Like the landscape, this figure was taken from another source, this time François Boucher's 1756 painting *Vulcan Presenting Venus with Weapons for Aeneas.*

Boucher's painting relays the classical myth of the calculated seduction by Venus of her husband, Vulcan, to obtain arms for her son, Aeneas. In the Musée national picture, Légaré appears, by analogy, to suggest that the British have deceived First Nations people. The analogy, however, goes deeper; it also serves to remind French audiences of what their culture faces under the British. For the French, the colony's first inhabitants were seen as allegorical representatives of young Canada—that is, of the French people themselves. The painting's political import is strengthened in light of Lord Durham's 1839 report that followed the Patriote rebellions, which recommended that the British pursue assimilation in Lower Canada. It is with some irony that *Paysage au monument à Wolfe* was displayed in the Quebec Pavilion more than a century later in the exhibition *Man and His World*, which opened in Montreal to conclude the nationalistic and unifying celebrations of Expo 67.

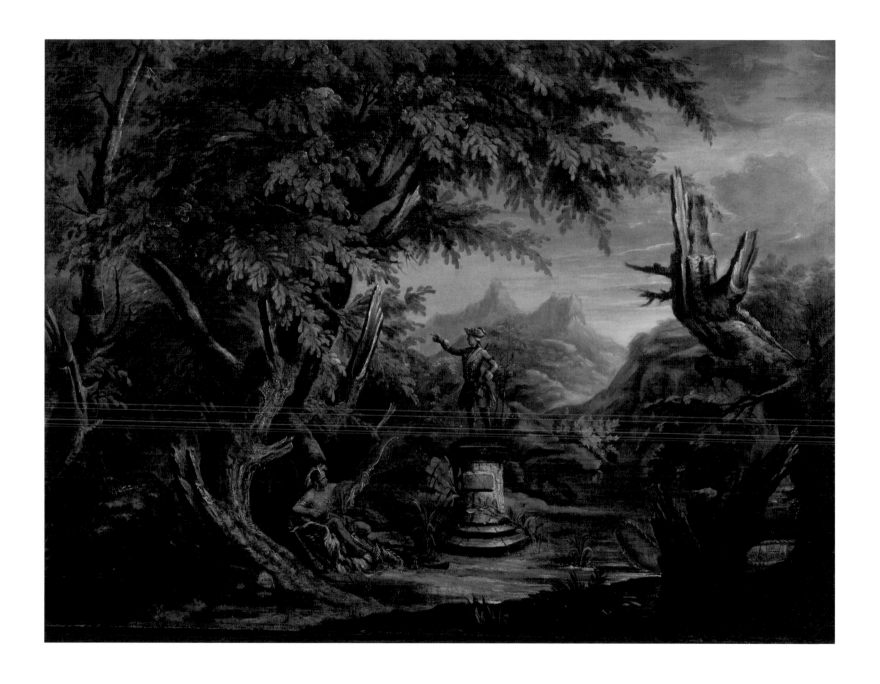

Cornelius Krieghoff Canadian (born in the Netherlands), 1815–1872

An Officer's Room in Montreal, 1846

Oil on canvas 44.5 x 63.5 cm

Royal Ontario Museum, Toronto
Gift of the Sigmund Samuel Endowment Fund, 1954; 954.188.2

CORNELIUS KRIEGHOFF was born in Amsterdam, but spent his early life in Schweinfurt (in the Bavarian region of present-day southern Germany) and Düsseldorf. There is little documentation to support speculation that Krieghoff received any formal artistic training before immigrating to North America in the late 1830s. Arriving in New York in the summer of 1837, Krieghoff immediately volunteered for service in the United States Army and was deployed to Florida at the height of the Seminole Wars. In addition to working as a clerk and in artillery repair, Krieghoff likely found time to sketch, although there is no evidence to suggest that his artistic labours reflected any official capacity. He married a French-Canadian woman, whom he likely met in Vermont where he was discharged from the army, and in 1840 the couple settled in Boucherville in the newly established provincial colony of Canada East (present-day Quebec). After attempting to establish a studio in Rochester, New York, Krieghoff travelled to Paris. He received his first formal training with the Neo-Classical history painter and portraitist Michel-Martin Drolling before returning to Canada in 1845 and settling in Longueuil, Canada East.

The late 1840s saw Krieghoff's career become more anchored in the Canadas. He exhibited extensively in Montreal and Toronto alongside artists like Paul Kane, James Duncan, and William Sawyer. He was instrumental in helping found the Montreal Society of Artists, the predecessor of today's Montreal Museum of Fine Arts. The MSA's 1847 exhibition featured forty-eight submissions by Krieghoff including *An Officer's Room in Montreal*. The painting depicts Andrew Anthony Staunton, a British army surgeon, art collector, and honorary member of the MSA. The focus of this colonial conversation piece quickly turns from the figure of Staunton, lost in his reading, to the dense display of objects and effects that surround him. Over twenty-five paintings appear in this scene: Krieghoff's original compositions, copies of canvases by European artists that he had made in Paris, and painted versions of drawings by Staunton. The pleasure of the work is found in uncovering its minute details. For example, *An Officer's Room in Montreal*, itself, appears in the upper-right corner of the canvas, hung between a set of antlers. Besides the paintings, the interior's walls are adorned with various outfitting articles, artifacts, a bust of Shakespeare, and taxidermy objects. The room is warmly lit, framed as if it were a stage set, which renders the space inviting and open to close inspection. The scene depicts a man of curiosity and taste who held an abundance of interests ranging from the natural sciences to material culture.

Quebec City became the artist's home in 1853, a business decision that resulted in increasing demand for his work among a clientele that included anglophone merchants, military personnel, and tourists. Krieghoff directed his artistic (and entrepreneurial) talents to painting scenes that pleased his patrons and brought him success such as romanticized genre scenes of the francophone peasantry engaged in a recurring set of activities and pastimes, and often incorrectly identified First Nations encampments. Krieghoff used the funds secured by the sale of his work as well as collectibles—birds, coins, and curios—to travel to Europe once again and exhibit his works alongside those of fellow colonial Théophile Hamel at the Paris Exhibition in 1867. He returned to North America that same year, but this time to Chicago, where he died.

Paul Kane Canadian (born in Ireland), 1810–1871

Fort Garry and St. Boniface, c. 1851–1856

Oil on canvas 45.9 x 73.6 cm

National Gallery of Canada, Ottawa
Transfer from the Parliament of Canada, 1888; 102

PAUL KANE ARRIVED AT the Red River Settlement in mid-June, 1846. In his words, the Toronto-based artist was making his way westward to "devote whatever talents and proficiency I [possess] to the painting of a series illustrative of the North American Indians and scenery" (Paul Kane, "Wanderings of An Artist," in J. Russell Harper, *Paul Kane's Frontier*, Toronto: University of Toronto, 1971, 51). *Fort Garry and St. Boniface* is a rarity for an artist who generally confined his time in Manitoba to observing and painting wilderness landscapes, First Nations encampments, and buffalo hunts.

Although he went to great lengths to claim Canadian roots, Paul Kane was, in fact, born in Ireland. His family relocated to North America around 1819. In the words of art historian J. Russell Harper, Kane's life in York (present-day Toronto) "must be pieced together from fact, tradition, and speculation" (Harper, *Paul Kane's Frontier*, 9). He received his first-known private painting lessons in 1830 from Thomas Drury, an instructor at Upper Canada College, and plied his artistic skills as a sign and furniture painter. Between 1836 and 1841 Kane worked as a portraitist in the United States before embarking on a self-directed study of art and architecture in Italy. By the fall of 1842 he had arrived in England (via France) where he likely saw the work of George Catlin, a figure who would have a great influence on Kane's subsequent painting career. Catlin, a young American artist, was then on an English exhibition and lecture tour that centred on the ethnographic paintings of First Nations people he produced during his travels in the 1830s through the North American Midwest. Kane, who returned to North America

in 1843, initiated a similar artistic journey in 1845 through the western regions of future Canada. His primary subjects became First Nations life and the North American landscape. Over the next three years Kane traversed the continent twice, accompanied by seasoned frontiersmen provided by the Hudson's Bay Company, and returned to Toronto with more than six hundred pencil, watercolour, and oil sketches. In November 1848 he exhibited a selection of these works in the city to positive reviews that endorsed Kane's observational accuracy. For the artist, however, these sketches were not the final product, but were records to consult for the production of larger, formally composed canvases.

The National Gallery of Canada picture is an anomaly in Kane's oeuvre as its primary focus is a settlement landscape that is, except for the distant raft driver, devoid of human presence. The painting was based on graphite and oil sketches Kane made on-site in June 1846. Facing south, the Hudson's Bay Company's Upper Fort Garry appears on the right, near the intersection of the Red and Assiniboine Rivers in what is today the city of Winnipeg. The fort's counterpoint is the first St. Boniface Cathedral on the French-speaking eastern shore. A windmill, one of many in the region, testifies to the early presence of milling at the Red River Settlement. With the exception of the bovine flank that emerges from the small stable in the left foreground, Kane's finished canvas is quite faithful to his earlier oil sketch.

Unidentified artist Heiltsuk (Bella Bella)/Canadian

Tlaolacha [dhuẃláxˇa] mask, 19TH CENTURY

Paint, pigment, sinew on wood 29 x 28.2 x 17.1 cm

Royal BC Museum, Victoria
RBCM 72

THIS NINETEENTH-CENTURY MASK is the earliest example of First Nations art in the exhibition. It was acquired at Bella Bella by Bernard Fillip Jacobsen and came to the Royal BC Museum as part of Jacobsen's large collection from the Central Coast of British Columbia in 1893. Jacobsen collected the mask just one decade after the federal government had outlawed the practice of the potlatch. This mask is steeped in historical, aesthetic, ethnographic, and spiritual significance.

Jacobsen was a Norwegian whose older brother, Captain Johan Adrian Jacobsen, travelled to the Northwest Coast in the early 1880s to collect artifacts for the Ethnological Museum in Berlin. In 1885 Carl Hagenback, the owner of the Tierpark Hagenbeck in Hamburg, sought help in recruiting Northwest Coast First Nations people to perform in a touring *Völkerschau* (exhibition of exotic peoples) throughout Europe. Captain Jacobsen was unable to accept the commission, so Bernard undertook the task. In addition to collecting artifacts and recruiting nine members of the Nuxalk First Nation to travel to Germany, Jacobsen met the important First Nations ethnologist George Hunt in Fort Rupert. After touring with the *Völkerschau* for two years, Jacobsen returned to Canada with the Nuxalk and settled permanently in Bella Coola, British Columbia. Despite his ambitions as a collector of ethnographic material and his connections with the Berlin Ethnological Museum, George Hunt, and the German anthropologist Franz Boas, the information Jacobsen presented with his 1893 donation was surprisingly meagre.

Jacobsen identified this mask as belonging to the Tlaolacha ceremonies of the Bella Bella.

Spelled variously as *dloowaloakha*, *glualaxa*, and *dhuẃláxˇa*—meaning literally "once more come shimmering down from the sky"—in this series of dances, ancestral beings are transported from this world into the heavens and then return to earth in recognizable form. The *dhuẃláxˇa* initiate disappears midway through the performance, supposedly taken up to the heavens by a supernatural spirit. When he reappears he performs the dance acquired during his sojourn in the spiritual world.

Many *dhuẃláxˇa* masks have human features, open mouths, and feather-like painted designs. This particular example once had thin pieces of copper attached to the face with small nails, and the distinctive blue-green colour of the mask is the result of the copper's oxidization. A notch in the top-centre of the mask and a piece of twisted sinew indicate that there was once something attached there, perhaps feathers. Traces of red pigment on the inside of the mask are from the dancer's face paint. This mask has characteristics often cited as typical of Heiltsuk carving, particularly the leaf-shaped orb of the eye area, the position of the eye itself, and the arched upper lip.

Théophile Hamel Canadian, 1817–1870

Jeunes Indiennes à Lorette (*Young Indian Girls in Lorette*), 1865

Oil on canvas 63.8 x 47.2 cm

Musée national des beaux-arts du Québec, Quebec
Purchase, conservation treatment by the
Centre de conservation du Québec; 1977.28

THÉOPHILE HAMEL WAS BORN into a farming family on the outskirts of Quebec City. Between 1834 and 1840 he apprenticed under Antoine Plamondon, who was at that time Lower Canada's most esteemed portraitist. Hamel furthered his studies in Europe between 1843 and 1846, becoming the first Quebec-born artist to travel to Italy. It is not known with certainty with whom Hamel studied in Italy, although we know he studied in Rome (where he may have attended the Accademia di San Luca) and Venice, and travelled to Naples and Florence before visiting Antwerp, Belgium. Several self-portraits Hamel produced following his tour of Europe reveal an individual who understands that he enjoys a special status within society. Hamel was one of the first Canadian painters to fully embrace and self-enact the post-Enlightenment image of the artist as visionary. He often set himself within a dramatically lit studio, surrounded by his work, displaying an air of self-assured composure and outfitted in the clothes and with the tools of his creative vocation. Hamel's reputation rose quickly after he exhibited work he had completed in Europe in his studio in Quebec City. He later had his art displayed in Montreal, which was the capital of the Province of Canada from 1844 to 1849 and the artist's base from 1847 to 1851. Demand for his skill as a portraitist, in particular, increased steadily, with his first major government commission—official portraits of assembly and legislative speakers—arriving in 1853 after he had returned to Quebec City. While he painted some landscapes, historical events and personages, as well as religious subjects, Hamel's livelihood and reputation as an artist remained most demonstrably aligned with his portraits, which he continued to produce with great financial return for two decades. He also provided instruction to a younger generation of important Quebec painters, most significantly Napoléon Bourassa.

The Musée national picture is a rare example within Hamel's oeuvre, which is more given to depicting particular individuals of notable civic stature within an elegant and inviting interior than to First Nations youths within a landscape. This is not to say that the way Hamel has represented the two girls is atypical. While Hamel's formal studies had been limited to Rome and Venice, he is known to have seen and, in some cases, made copies of masterworks by a number of European artists including Titian and Rubens. Moreover, his mature style reflects the combined influence of contemporary Neo-Classicism and Romanticism. Quebec artists in the pre-Confederation period, such as Joseph Légaré and Antoine Plamondon, routinely viewed First Nations through an idealizing lens, where figures assume the roles of allegorical types rather than particular individuals. Hamel's painting of unnamed youths hunting amidst the rugged landscape around Quebec City is not a double portrait, but a genre scene. *Jeunes Indiennes à Lorette* emphasizes a common essential proximity and bond between the First Nations figures and the natural world, and draws implicit contrast with European settlement culture.

Henri Fantin-Latour French, 1836–1904

Le jeune Fitz-James, 1869

Oil on canvas 49.6 x 40.6 cm

Art Gallery of Hamilton, Hamilton
Gift of H. S. Southam, Esq., C.M.G., LL.D., 1948; 66.77.3

HENRI DE FITZ-JAMES (1857–1924) was the youngest son of Duke Édouard de Fitz-James, the president of the elite Jockey Club in Paris and a member of one of the great French families of the nineteenth century. The senior Fitz-James had commissioned Henri Fantin-Latour to paint his wife and four children. This led to his mother, the Dowager Duchess de Fitz-James, requesting a group portrait with all fifteen of her grandchildren (aged two to twenty years) at the family seat, the Château de la Loire, near Segré, France, to mark her sixtieth birthday. Fantin-Latour spent four days at the château in 1867, and wrote about the commission: "I am totally immersed in my work . . . They [Fitz-James family] represent moreover the grandest names of the nobility . . . You can imagine how extraordinary it is for me to be launched into such company" (Douglas Druick and Michel Hoog, *Fantin-Latour*, Ottawa: National Gallery of Canada, 1983, 106). Executing the group portrait with the dowager duchess proved extremely challenging for the artist, and the painting was not developed beyond the preparatory drawings; however, the portraits of Duke Édouard's wife and children remain.

This portrait of the young Henri, ten years old at the time of the sitting, is a study in realism as conveyed through the artist's discrete palette and measured brushwork. Almost all the colour in the composition is reserved for the boy's face, with the soft whites and pinks used for the skin, reddish browns for his hair, and deep blue for his eyes. The broad white starched collar and black sweater or coat act almost like a pedestal for the intimate portrait, allowing for the transition from the bust of the boy to the evenly painted background. In his portraiture, Fantin-Latour's desire to capture the character and mood of his sitter takes precedence over the play of light and colour and momentary impressions. This is the only portrait of a child by Fantin-Latour in a Canadian gallery, and the artist has succeeded in offering the viewer a sense of immediacy and solitude in his carefully orchestrated study.

Training first with his father, Jean-Théodore, and then at the Petite école de dessin in Paris, Fantin-Latour's early education was based largely on the academic tradition of copying the Old Masters. While he enrolled briefly at the École des beaux-arts in 1854, he spent considerable time in the Musée du Louvre, studying the masters whom he considered his true teachers. He began submitting work to the French Salon in the 1850s, and although he was first rejected in 1859, he exhibited regularly from 1861 to 1899. Fantin-Latour's output can be divided between his individual and group portraiture (including the celebrated pictures featuring Parisian artists) and his flower paintings, which brought him fame across Europe and North America.

Working at the same time as the Impressionists in Paris, Fantin-Latour remained largely detached from the popular movement. While he was close to Édouard Manet, and good friends with Claude Monet and Pierre-Auguste Renoir, even exhibiting in the Salon des Refusés in 1863, he declined to participate in the first Impressionist show in 1874. He chose instead to remain loyal to the official Salon, keeping on good terms with the critics who supported his work.

Lucius O'Brien Canadian, 1832–1899

Sunrise on the Saguenay, Cape Trinity, 1880

Oil on canvas 90 x 127 cm

National Gallery of Canada, Ottawa
Royal Canadian Academy of Arts diploma work,
deposited by the artist, Toronto, 1880; 113

"THEY HAVE STIRR'D ME more profoundly than anything of the kind I have yet seen." This description by poet Walt Whitman of his experience of Quebec's Cape Trinity appeared in *The London Advertiser* in 1880. That same year, Lucius O'Brien completed his masterpiece of the famous Saguenay cliffs, and the Royal Canadian Academy was established by Governor General John Douglas Sutherland Campbell, the Marquess of Lorne. Painted when O'Brien was over fifty years old, *Sunrise on the Saguenay, Cape Trinity* served as the artist's diploma piece, the donated submission that confirmed his membership. The diploma works of Academy artists constituted the first holdings of what would become the National Gallery of Canada.

O'Brien was born into pioneer conditions, albeit to a prominent military family, in the Simcoe region of southern Ontario, near present-day Barrie. He studied at Upper Canada College before finding work in the office of a Toronto architect where he learned surveying and drafting. Later, he pursued a career as a civil engineer. Having discovered a love for drawing while at school, in the 1850s O'Brien began offering private drawing lessons, entered his work in provincial expositions, and was listed as an artist in the local directory by mid-decade. However, his life changed abruptly in 1857 when he moved to Orillia to manage his family's quarry business and later a general store, got married, and became involved in local politics. He returned to his art practice in the 1860s, his interest rekindled in part by a voyage he took to France and Great Britain. When he returned to Canada in 1869, he settled again in Toronto and ably reinserted himself into the city's art scene. He helped found the Ontario Society of Artists in 1873 and also played an instrumental role in the fledgling Ontario School of Art (predecessor of the current Ontario College of Art and Design) as its vice-president.

The National Gallery picture is a defining testament to a developing sense of Canadian nationalism and the articulation of that sentiment through landscape. In the same year that he completed the painting, O'Brien became a contributor to and artistic editor of *Picturesque Canada*, a popular serial published between 1882 and 1885 that, during the completion of the country's first transcontinental railway, promoted tourism and travel across Canada. O'Brien was adept at creating light-filled landscapes in oil, and particularly in watercolour. His mature work demonstrates knowledge of the English picturesque in the attention it pays to contrasting surfaces and textures. O'Brien's painting of a Quebec region known for its logging and tourism industries is typical in this regard, with the foreground's rough stumps and debris working in consort with the dark weathered cliffs of Cape Trinity to offset the diaphanous pastel sky and shimmering, limpid Eternity Bay. Nature and industry—note the smoke trailing from a distant steamboat—are held in mutual harmony. O'Brien's aesthetic sensibility shares much with the topographical painting tradition that flourished in the immediate post-Conquest era, and indeed his background in civil engineering provided him with the same skills as the artists of the Royal Military Academy in Woolwich, England. However, the NGC work also demonstrates the artist's interest in English Romantic landscape painters, like J. M. W. Turner, and the German-American Luminist Albert Bierstadt.

Gustave Caillebotte French, 1848–1894

Voiliers au mouillage sur la Seine, à Argenteuil (Sailboats at Anchor on the Seine at Argenteuil), 1883

Oil on canvas 60.2 x 73.3 cm

McMaster Museum of Art, Hamilton
Gift of Herman H. Levy Esq., OBE, 1984; 1984.007.0015

AFTER COMPLETING A SERIES of street scenes in 1877, Gustave Caillebotte moved from the urban setting to the rural landscape, shifting his attention to the river Yerres, adjacent his family's country property. There he began work on a group of paintings that focused on rowing and the sporting life along the river. Executed in 1883, the McMaster Museum of Art painting provides a snapshot of the country life the artist loved. Born into a wealthy bourgeois family in Paris, Caillebotte was both a contributor to and champion of the Impressionist movement, exhibiting in several of the group shows and leaving his collection of contemporary French painting to the state, which forms the foundation of the Impressionist collection at the Musée d'Orsay in Paris.

A significant family inheritance enabled Caillebotte to support the Impressionist group, which he did by partially funding their official exhibitions and assisting fellow artists by purchasing their work. Trained as a lawyer and later drafted into the Garde mobile de la Seine during the Franco-Prussian War, Caillebotte had little formal training in art. He produced the majority of his paintings in a span of ten years, between 1875 and 1885. He painted little in the last decade of his life (he died from apoplexy at the age of 45), retiring to his estate at Petit-Gennevilliers near Argenteuil. There he took up gardening, sailboat racing, and design, which led to his election as vice-president of the Cercle de la voile de Paris, the famous yacht club.

The McMaster painting, also titled La Seine à Gennevilliers, shows boats of different designs for rowing and sailing moored at a dock, with a long white boathouse visible across the river. The boat in the centre foreground may be a périssoire, a simple flat-bottomed skiff propelled by the canotiers (oarsmen) with a two-bladed kayak paddle. It was on the river Yerres where Caillebotte mastered his own boating skills. The growing interest in rowing in France was due largely to its popularity among the English who rowed along the Channel. It was the perfect subject for the Impressionist painters, as many of them spent part of their careers living and working in villages along the river.

In his choice of urban subjects, particularly the pedestrians and workers in the streets and spaces of Paris, Caillebotte remained indebted to the work of Édouard Manet and Edgar Dégas. However, when he turned to the country and the Seine River system, he was aligned more with Claude Monet and Pierre-Auguste Renoir. As well, his muted palette and uniform brushwork favour the work of these two Impressionist leaders. Renoir remained one of his closest friends and was the executor of his estate. In the McMaster picture, a range of browns, oranges, and blues applied in long, even strokes and highlighted with heavier whites gives a lateral orientation to the river scene. The unexpected angles and perspectives associated with Caillebotte's city scenes continue in this riverscape. The boats, varying in size and function, are shown at different angles, animating the picture plane. Voiliers au mouillage is the finest example of Caillebotte's work in Canada, and it stands as a wonderful counterpart to the McMaster Museum's painting of Waterloo Bridge by Claude Monet.

Sir Edward Burne-Jones British, 1833–1898

Portrait of Caroline Fitzgerald, 1884

Oil on canvas 82.9 x 52.1 cm

University of Toronto Art Centre, Toronto
Gift of Mrs. Augustine Fitzgerald, 1932;
University of Toronto Collection; 1999-005

CAROLINE FITZGERALD (1865–1911) was the eldest child and only daughter of William John Fitzgerald and Mary A. White. Her father was of Irish descent and came to Toronto as a young man, studying at Upper Canada College between 1830 and 1835. After taking a law degree at Trinity College, Dublin, he returned to Toronto to open a law practice before moving to New York in the 1860s. There he met and later married Mary A. White, the daughter of a wealthy merchant, and they had one daughter and two sons: Caroline, Augustine, and Edward.

While her family maintained a residence at 19 Rutland Gate in London, England, Caroline spent considerable time in the United States, where she later studied at Yale College and was a member of the American Oriental Society. She was known in New York literary circles through her poetry, classical scholarship, and translations. In 1889 she published a book of her poetry, *Venetia Victrix and Other Poems*, dedicating it to her friend Robert Browning, who died a few months after its publication.

Caroline was nineteen years old when she sat for this portrait, and Edward Burne-Jones recorded in 1887 that he completed a portrait of "an American girl," which is likely the University of Toronto picture. She is presented in a Renaissance-styled format that the artist employed in many of his portraits. Shown in a modest black dress with white lace collar, her hands clasping a small book of poetry or prose, Caroline maintains a withdrawn, melancholic gaze, as if she has been interrupted or is simply lost in thought. The laurel leaves, visible in the background, may be a reference to her poetry, while the pink rosebud affixed to the front of her collar is a familiar symbol of youth. A palette of brown, green, and rose adds to the elegant tone of the portrait, alluding to the artist's penchant for the palette of the sixteenth-century Italian painters.

On July 10, 1889, Caroline became engaged to the aristocrat Lord Edmond Fitzmaurice, the younger brother of the 5th Marquess of Lansdowne, the Governor General of Canada from 1883 to 1888. The couple was married in November of the same year in London. Their marriage, however, was short-lived, and in August 1894, Lady Edmond Fitzmaurice filed a petition for wife's nullity on the grounds of non-consummation, and the Decree Absolute was issued the following year. Six years later, in 1901, Caroline married Filippo de Filippi, a well-known Italian explorer, and the couple lived in Rome where Caroline died in 1911. It was the widow of Caroline's younger brother, Augustine, who donated this painting to the University of Toronto in 1932 along with a collection of books and paintings in memory of the Fitzgerald family.

Burne-Jones studied art at the Birmingham School of Art and theology at Exeter College at Oxford, and worked in a variety of media including painting, drawing, stained glass, and book design. He was part of the Pre-Raphaelite Brotherhood in the movement's latter days, and a close friend of William Morris, the leader of the Arts and Crafts movement in England. Morris, Burne-Jones, Dante Gabriel Rossetti, and a few others founded a decorative arts firm in 1861, later known as Morris & Company.

Vincent van Gogh Dutch, 1853–1890

Vase with Zinnias and Geraniums, 1886

Oil on canvas 61 x 45.9 cm

National Gallery of Canada, Ottawa
Purchased 1950; 5045

VINCENT VAN GOGH'S *Vase with Zinnias and Geraniums* was painted in Paris in the summer of 1886, a few months after his arrival from Antwerp where he had been studying at the Antwerp Academy. This would be one of the first of over fifty canvases on floral themes that he produced over the following two years, documenting his initial response to the modern painting scene in Paris. In July 1886, his brother Theo, with whom Vincent was staying, wrote to their mother about his brother's first months in the city and the new focus in his work: "He is mainly painting flowers – with the object to put a more lively colour into his next pictures . . . He also has acquaintances who give him a collection of flowers every week which may serve him as models" (Jan Hulsker, *The Complete Van Gogh: Paintings, Drawings, Skethces*, New York: Harry N. Abrams, 1980, 234). Despite the physical and personal challenges during these first months (a stomach infection led to poor eating habits by van Gogh, which resulted in him having to have most of his teeth surgically removed, and he still hadn't succeeded in selling a painting for money), van Gogh surrendered to his painting and managed to produce a major body of work.

Van Gogh arrived in Paris in time to see the eighth and last exhibition of the Impressionist group, which included a gallery featuring the work of the Neo-Impressionists, among them the rising stars Paul Signac and Georges Seurat including the latter's *A Sunday on La Grande Jatte*. Although van Gogh had spent time in Paris ten years earlier when he worked at the Paris branch of the art dealer Goupil & Company, it was only on this latter stay that he was fully exposed to the Impressionist painters and

their art. He responded immediately to the work of these avant-garde artists and chose the still-life genre to begin his own experiments with this innovative approach to colour and light.

The National Gallery of Canada still life is alive with a brilliant palette and animated brushwork. The individual flowers—zinnias, geraniums, carnations, and bachelor buttons in a variety of colours—assume a three-dimensional quality. The rich impasto reserved for the floral elements adds to the vibrancy of the composition, which is contrasted against the dark-brown background, referencing his earlier work in the Netherlands and Belgium. Now having regular contact with other artists and their revolutionary techniques, van Gogh took the advice of Camille Pissarro and began painting directly onto the canvas without preliminary drawing or sketches. These still lifes from Paris anticipate what is to come two years later in the south of France, when van Gogh lived in Arles and Saint-Rémy-de-Provence and allowed his canvases to erupt in even brighter colours sustained by bold brush strokes.

This painting is one of three flower paintings in the National Gallery of Canada, which holds the only floral works by van Gogh in a Canadian collection. In addition to another flower piece from the Paris period, the National Gallery owns one of the celebrated *Iris* paintings dating to the artist's Saint-Remy period from 1889.

Robert Harris Canadian (born in Wales), 1849–1919

The Local Stars, 1888

Oil on canvas 80 x 105.4 cm

Confederation Centre of the Arts, Charlottetown
Gift of the Robert Harris Trust, 1965; CAG H-13

IN THE 1880S, WHEN *The Local Stars* was painted, Robert Harris was arguably English Canada's most important and sought-after portraitist. His images remain vital touchstones in Canadian political and social history, as well as the country's art history. Born in Wales, Harris immigrated to Prince Edward Island in 1856. His poor eyesight notwithstanding, Harris developed an early devotion to the idea of becoming an artist. During the 1870s through the 1890s, aspiring artists, especially those in North America, regarded French academic painting as representing the height of aesthetic perfection. Harris was no exception, and through the 1870s—between periods when he worked as a surveyor and cartographer to fund his educational exploits—he studied in Boston, London, and Paris. Harris developed his skills with the London-based French realist painter and printmaker Alphonse Legros, and later with Léon Bonnat, an academic painter receptive to Impressionist innovation. He returned to Canada for a brief period, teaching and taking portrait commissions in Toronto between 1879 and 1881. During this time Harris was one of the first Canadian artists to introduce his students, such as George Reid, to French academic methods and standards. Later, he also taught at the Art Association of Montreal. In 1880 Harris became a founding member of the Royal Canadian Academy, and a decade later would serve as its president. Between 1881 and 1883 he undertook his second course of studies overseas at the Académie Julian in Paris with Jean-Paul Laurens and Alexandre Cabanel.

Having successfully exhibited a work at the 1882 Paris Salon, Harris quickly re-established his reputation after returning to Canada in early 1883.

Later that year he was formally commissioned by the federal government to paint a massive group portrait of thirty-three delegates who had attended the 1864 British North America confederation planning conference in Quebec City. Even though the canvas was destroyed in a fire at Parliament Hill in 1916, its image remains well known through reproduction in prints, stamps, and history textbooks. *The Local Stars*, in contrast, is a conversation piece combining subjects the artist returned to frequently: everyday rural life, education, and music. *The Local Stars* (sometimes subtitled *Pine Creek School District*) depicts a community choir practicing its repertoire. An earlier version was first exhibited under the title *Taking His Top Note – The Tenor of Spruce Creek School District* at the Royal Canadian Academy exhibition in 1888. In this first iteration, the main male figure, sporting a full beard, stares intently at his songbook, raising his shoulders and elbows in clear effort to reach a challenging pitch. His straining gesture, combined with the blank stares of his troupe, creates a comical effect that approaches slapstick. Harris painted over this first attempt to create the present image, a more subtle version in which the protagonist's efforts appear measured and cautious. The final painting was displayed at the 1889 Royal Canadian Academy exhibition.

Sir John Everett Millais British, 1829–1896

Afternoon Tea (The Gossips), 1889

Oil on canvas 104.5 x 133.3 cm

Winnipeg Art Gallery, Winnipeg
Gift of the Everett Family from the Everett Collection,
in memory of Patricia Everett; 2009-334

THE BRITISH PAINTER John Everett Millais was one of the founders of the Pre-Raphaelite Brotherhood. This group was formed by Millais, William Holman Hunt, and Dante Gabriel Rossetti in September 1848 in Millais's home in London. The three had met at the Royal Academy of Arts where Millais had been admitted years before at the unprecedented age of eleven. By 1853 he had been elected an associate member of the Royal Academy and was later made a full member. He was created a baronet in 1885, and succeeded Frederic Lord Leighton as president of the Royal Academy in 1896 after Leighton's death. Millais only served a few months, as he died of throat cancer that same year.

Millais's paintings of children were extremely admired, in part due to the artist's skill at capturing elements of the innocence and sometimes pathos of childhood, which appealed to Victorian taste. *Afternoon Tea* in the Winnipeg Art Gallery's collection is one of the best examples of the artist's representation of this popular late nineteenth-century genre. The manner of children being depicted in adult situations is also linked to Millais's oeuvre and his association with the Pre-Raphaelite Brotherhood. Millais himself gave the picture the subtitle *The Gossips*, referencing the fact that these "little women" are not just playing at being adults but have already begun to assume some of the earnestness of grown-ups. The painting is part of a significant group of works produced by Millais in the 1880s that focus on children.

The Winnipeg picture represents the artist at his most ambitious in terms of the grand tableau and the portrait, which was sustained by a more fluid and sensuous handling of paint. The sophistication of his painting technique at this point betrays a shift away from the rigours of Pre-Raphaelitism and a renewed interest in European Old Masters and British historical schools. He was drawn to the work of Titian, Diego Velázquez, and Anthony Van Dyck, particularly for their mastery of colour and tonality. He also found a new admiration for Thomas Gainsborough and Joshua Reynolds in their handling of large-scale portraiture. In these late works, including this canvas, there is a sumptuous quality to the paint surface, which adds to the splendour of the scene, even if it is simply three little girls having a tea party as they pretend to be grown women.

The British critic Marion Henry Spielmann, who was well acquainted with John Everett Millais, included *Afternoon Tea* in his 1898 monographic study of the artist's work. Spielmann described the work as: "a family group of little girls playing at tea in a garden. The nearest child has her back turned to the spectator, and it was for the sake of that sweet little back, said Sir John, that he painted the group" (Marion Henry Spielmann, *Millais and His Works*, Edinburgh and London: William Blackwood & Sons, 1898, 144). Rather than exhibiting the work at the Royal Academy, Millais chose instead to sell it directly to Thomas McLean of London. The picture was exhibited at McLean's gallery at 7 Haymarket, after which the dealer published a limited edition engraving, as he had done for a number of the artist's paintings that he thought would have a wider appeal.

Paul Peel Canadian, 1860–1892

The Modest Model, 1889

Oil on canvas 146.7 x 114.3 cm

Museum London, London
Gift of the Estate of Allan J. Wells with the assistance of the Canadian
Cultural Property Export Review Board, 1990, and conserved by the Canadian
Conservation Institute of the Department of Canadian Heritage; 90.A.42

OF THE MANY CANADIAN painters who studied in France in the late nineteenth century, Paul Peel most successfully mastered the highly finished academic style that dominated the Paris Salons. He achieved this despite his career being cut short by premature death at the age of thirty-two. Peel created images that wove allegory and genre, painting sentimental stories that present an enduring view of everyday life.

Growing up in London, Ontario, Peel began making and exhibiting his art at an early age. He received his first drawing instructions from his father, and his talents were later nurtured by William Lees Judson, an English-born painter who had fought in the American Civil War. Between 1877 and 1880, Peel studied at the Pennsylvania Academy of the Fine Arts with Thomas Eakins, under whom he achieved a deep knowledge of modelling and anatomy. He spent the majority of his remaining life in Europe. He joined an American artists' colony at Pont-Aven in Brittany, France, where he met the painter and his future wife, Danish-born Isaure Fanchette Verdier. In 1882 Peel continued his training in France under the renowned academic painter Jean-Léon Gérôme at the École des beaux-arts de Paris. The artist exhibited widely in Canada (for example, at the Ontario Society of Artists and the Royal Canadian Academy) as well as in France, Great Britain, and Denmark. In 1883, at the age of twenty-two, Peel's submission to the Paris Salon was accepted; beginning in 1887, Peel's work would appear at the annual Salon until his death. Also in 1887, Peel began devoting himself to further studies alongside his newly arrived colleague George Reid, this time with Benjamin Constant at the Académie Julian. Constant instilled in Peel an interest in painting nudes. The technical and compositional sophistication of Peel's work had reached its peak by 1889, the year he painted *The Modest Model* (alternatively titled *Que la vie est amère)*. This work was completed the same year as *The Venetian Bather*, which was the first nude to be publicly exhibited in Toronto in 1890. *The Modest Model* received an honourable mention at the 1889 Salon, an important step toward Peel's realization of an international reputation, which he secured in 1890 when *After the Bath* was awarded a third-class medal and, one year later, purchased by the Hungarian government.

The Museum London picture perfectly encapsulates Peel's effort to construct scenes that are elevated by allegorical reference and remain rooted in the everyday. Adding a sentimental twist to the established nineteenth-century trope of the artist's studio, Peel presents a nude boy, face buried into the back of a stretcher, with the grandfatherly painter peering around to inquire after his model's condition. The scene shows sustained, if sentimental, naturalism. Yet, as one English writer of the time noted, "there is a comic pathos" that removes the painting from the quotidian (Victoria Baker, *Paul Peel: A Retrospective, 1860-1892*, London, ON: London Regional Art Gallery, 1986, 49). The quiver of arrows at the bottom right reveals that the model has been enacting the role of the Greco-Roman deity Eros for the bearded artist. Peel cleverly pictures a scene of ostensibly everyday life, through which the idea of art itself, that which both draws from and reconfigures nature, emerges as an allegorical subject.

George Agnew Reid Canadian, 1860–1947

The Story, 1890

Oil on canvas 123 x 164.3 cm

Winnipeg Art Gallery, Winnipeg
Gift from the Hugh F. Osler Estate; G-47-164

GEORGE A. REID WAS PART of the second wave of Canadian artists pursuing artistic training in Paris in the late nineteenth century. He returned to Canada with a firm grasp of academic principles. Although he would develop a brighter palette and more Impressionistic approach over time, the sympathetic realism that characterizes Reid's genre scenes from the late 1880s to the 1890s remains a singular contribution to Canadian art. *The Story* is one of the finest example of Reid's work from this defining period that is held in a Canadian collection.

The artist from Wingham, Ontario, decided to pursue painting in 1876 after visiting the studio of William Cresswell, a landscape painter and future charter member of the Royal Canadian Academy. Reid began his studies in Toronto with Robert Harris, one of the first Canadian artists to obtain academic training in Paris. He continued his education at the Pennsylvania Academy of the Fine Arts where Thomas Eakins, who taught Reid, had earlier introduced a curriculum that emphasized systematic mastery in representing the human form. Eakins's touchstone was the French academic tradition exemplified by artists such as Jean-Léon Gérôme and William-Adolphe Bouguereau. Following their marriage in 1885, Reid and fellow Pennsylvania Academy alumna Mary Heister settled briefly in Toronto before both continued their studies in Paris at the Julian and Colarossi ateliers. Reid displayed his work at the Paris Salon for the first time in 1889. One year later, having returned to Toronto and opened a studio, he submitted the painting to that venerable annual spring exhibition. Before being shipped overseas for display in 1890, *The Story* was purchased by the wealthy

Toronto financier and politician Sir Edmund Boyd Osler. Reid succeeded in having his works included in four more Salons, the last one in 1896. In addition to his formidable technical reputation as an artist, Reid was also an influential instructor—he was appointed the first principal of the Ontario College of Art in 1912—and an important advocate for the production of mural paintings in Canadian public buildings. Mural projects increasingly defined his painting career after 1900, and with that his propensity for genre scenes was overshadowed by an interest in decorative effects, allegorical subjects, and historical events.

Reid likely began painting the Winnipeg Art Gallery work in the late fall of 1889. After his return from France, he occupied a new studio in Toronto's Yonge Street Arcade. This workspace was amenable to the construction of the complex settings—from parlours to haylofts—that appear in many works from this period. The young models are likely neighbourhood boys whom Reid paid to pose. *The Story* contains the telltale exacting finish and drama of the academic style, although the painting's agrarian quaintness and regional specificity attest to Reid's desire to apply European academic principles to the Canadian scene. Signs of the artist's brushstrokes are minimal, restricted to his rendering of the golden straw. The painting left Toronto and arrived in Winnipeg sometime after 1903 when Sir Edmund Boyd's son, Hugh Farquharson Osler, relocated there. Osler later served as president of the board of the Winnipeg Art Gallery, donating *The Story* to the Gallery in 1947.

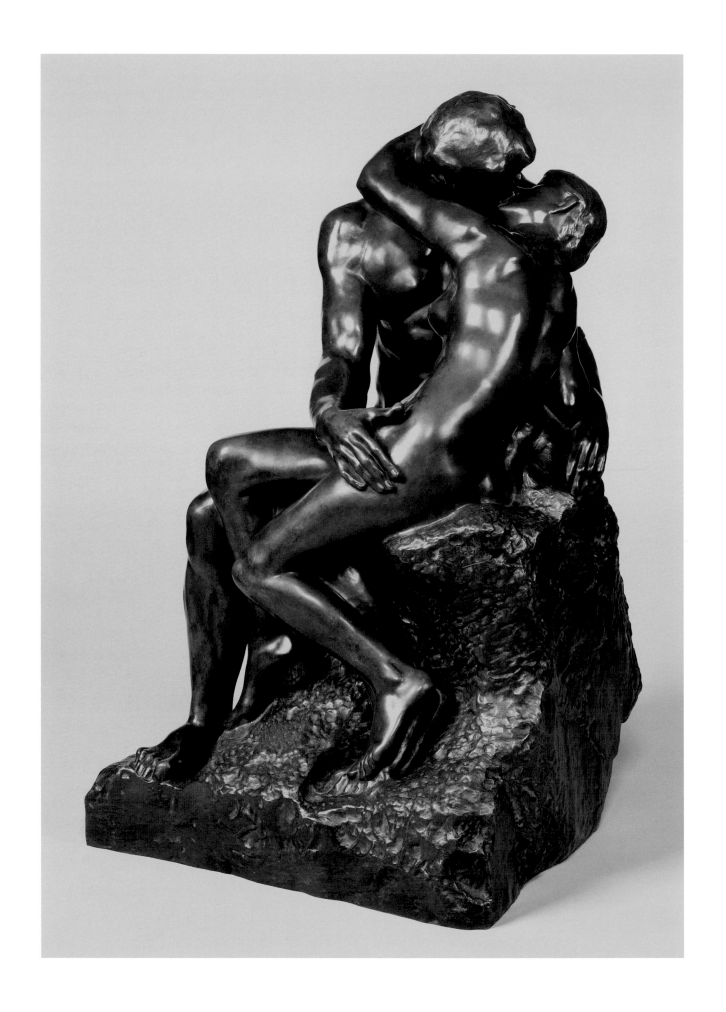

Auguste Rodin French, 1840–1917

The Kiss, c. 1898

Bronze 69.9 x 38.7 x 43.2 cm

MacKenzie Art Gallery, Regina
University of Regina Collection, Gift of Mr. Norman MacKenzie; 1916-005

THE TWO LOVERS depicted in *The Kiss*, considered to be Auguste Rodin's most important classical work, are taken from Dante's celebrated fourteenth-century epic poem *The Divine Comedy*. Francesca da Rimini or Francesca da Polenta (1255–1285), the daughter of Guido da Polenta, lord of Ravenna, was one of the historical figures portrayed in Dante's poem. To reinforce the peace between the Polenta and Malatesta families, Guido married his daughter to Giovanni Malatesta, the deformed son of Malatesta da Verucchio, lord of Rimini. The marriage was performed by proxy by Paolo, Giovanni's handsome brother. Francesca fell in love with Paolo, which led to their deaths at the hands of Giovanni. Rodin used Dante's *Inferno*, the first part of *The Divine Comedy*, as the theme for one of his greatest commissions, *The Gates of Hell*, which originally included *The Kiss* in its composition.

The story of Paolo and Francesca takes place in the second circle of Hell in the *Inferno*, which is reserved for those who have succumbed to lust. Francesca recounts how she committed adultery and was murdered in the name of love at the hands of her husband Giovanni. Paolo and Francesca were reading the story of Lancelot and Guinevere when they were seduced, as Francesca tells Dante in Canto V: "One day for pastime, we read of Lancelot, how love constrained him; we were alone, without all suspicion. Several times that reading urged our eyes to meet, and changed the colour of our faces; but one moment alone it was that overcame us. When we read how the fond smile was kissed by such a lover, he, who shall never be divided from me, kissed my mouth all trembling."

Edmond Turquet, undersecretary in the Ministry of Arts commissioned Rodin in 1880 to design the monumental doors for a new museum of decorative arts, for which the sculptor chose the theme of Dante's *Inferno*. The doors became known as *The Gates of Hell*, alluding to Lorenzo Ghiberti's *Gates of Paradise* for the Cathedral Baptistery in Florence. The plans for the museum were cancelled five years later, but Rodin continued to work on the project. In 1900, to coincide with the Exposition Universelle, the plaster sections of *The Gates*, measuring over six metres in height, were put on display at the Place de l'Alma in Paris. The first bronze of the enormous gates was not cast until 1925, eight years after Rodin's death.

Shortly into *The Gates* commission, Rodin decided to eliminate *The Kiss* from the maquette, though he continued working on the piece. In 1887 he exhibited the half-life-size plaster of *The Kiss*, as it became known, and was eventually commissioned to do a life-size marble for the French state. The piece was well received by critics and the public despite the nudity. Rodin actually treats the embrace with remarkable discretion—the lovers' lips do not touch and Paolo's right hand is restrained in its placement on Francesca's thigh, while he holds the book in his other hand.

As a youth, Rodin tried three times without success to gain entrance to the École des beaux-arts in Paris and ended up working in the studio of sculptor Albert-Ernest Carrier-Belleuse. Today, Rodin is considered the only sculptor of the modern age to be compared with Michelangelo, whom he admired greatly, and he travelled to Italy in the hope of discovering the master's secrets.

James Wilson Morrice Canadian, 1865–1924

La communiante (*The Communicant*), 1899

Oil on canvas 83 x 118 cm

Musée national des beaux-arts du Québec, Quebec
Purchase; 1978.98

JAMES WILSON MORRICE was born into a wealthy family in Montreal. His father, David Morrice, was a very successful textile manufacturer originally from Scotland. The artist likely received drawing lessons and discovered his love of art as a teenager attending the Montreal Proprietary School. His earliest known works date from the late 1870s, watercolour seascapes completed during a family vacation in Maine. Morrice pursued a legal career, studying at the University of Toronto in the 1880s. Despite this detour and his lack of formal training, he succeeded in displaying his work at exhibitions held by the Royal Canadian Academy and the Ontario Society of Artists. Soon after completing his bar exams in 1889, he left for Europe to study painting. Morrice was living in Paris by 1892 and, while he would continue to exhibit work in Canada, he remained an itinerant expatriate and never returned to a law practice. Decades later, in 1913, Morrice confessed to the Canadian painter Edmund Morris, "What prevents me from going back to the Ontario Bar is the love I have of paint" (Charles C. Hill, *Morrice: A Gift to the Nation; the G. Blair Laing Collection*, Ottawa: National Gallery of Canada, 1992, 18).

In Paris, Morrice pursued studies at the Académie Julian, and may have studied with Henri Harpignies. He befriended artists Charles Conder and Maurice Prendergast, and developed a keen taste for contemporary French artists such as Jean-Baptiste-Camille Corot, Pierre Puvis de Chavannes, Claude Monet, and Édouard Manet. He was also deeply inspired by the Anglo-American painter James McNeill Whistler who resettled in Paris from London the same year that Morrice arrived. Later in life, Morrice would meet and work with an impressive list of artists that included Robert Henri, Henri Matisse, and George Rouault. Soon, he was painting scenes of urban and suburban leisure that had come to typify modern life among his colleagues and mentors. Above all, the young artist strove to communicate sensual, aesthetic pleasure through formal arrangement. Morrice did not generally produce preparatory drawings for his larger canvases, although he made copious notes and pencil sketches. He also produced *pochades*, small-format paintings on irregularly cut pieces of canvas or wooden panels on which he captured a general sense of atmosphere. Friends claimed he could spend days painting a support measuring twelve by fifteen centimetres, taking exquisite care and time to mix his paints and observe his subject before committing a dab to the panel. *La communiante*, a large canvas for Morrice, was more than likely painted in his studio and based on sketches and *pochades*. Despite the format, the work illustrates Morrice's great skill at retaining a sense of immediacy and spontaneity. It depicts a young girl being escorted by her black-robed guardian and a young red-headed woman to her first communion. It was completed at a time of transition for the artist, when Morrice moved his studio from Paris's Montmartre quarter to the Quai des Grands-Augustins, where his studio overlooked the Île de la Cité on the Seine River. The painting appeared in the 1899 Salon of the Société nationale des beaux-arts where Morrice was celebrated by French critics as North America's most talented painter since Whistler. The following year, it was exhibited in Philadelphia, at the annual exhibition of the Pennsylvania Academy of the Fine Arts.

Pablo Picasso Spanish, 1881–1973

La Miséreuse accroupie (The Crouching Beggar), 1902

Oil on canvas 101.3 x 66 cm

Art Gallery of Ontario, Toronto
Anonymous gift, 1963; 63/1

LA MISÉREUSE ACCROUPIE, painted in 1902, is part of Pablo Picasso's Blue Period, which lasted for approximately three years and coincided with the artist's first visits to Paris. Of Picasso's early works held by Canadian galleries, the Art Gallery of Ontario picture is the pre-eminent example from his Blue Period. Born in the Spanish coastal town of Málaga, Picasso's first training in art came from his father, José Ruiz y Blasco, who was a painter and art teacher at a state school and a curator at the local museum. Later, the young Picasso enrolled in art academies in Barcelona and Madrid where he received a formal art education, which included working from live models and casts of classical sculpture. By 1897 he had passed his entrance exams for the Real Academia de Bellas Artes de San Fernando in Madrid. He was also making regular visits to the Museo Nacional del Prado where he studied the Spanish masters including Diego Velázquez, Bartolomé Esteban Murillo, El Greco, and Francisco Goya. Nevertheless, while he admired these artists, he spent little time copying their work.

Shortly before abandoning the academy a few months later, Picasso confided to a friend that the Spanish masters were poorly educated, and that "if I had a son who wanted to be a painter, I would not let him live in Spain" (William Rubin, ed., *Pablo Picasso: A Retrospective*, New York: The Museum of Modern Art, 1980, 18). Two years later, it was his first trip to Paris, in October 1900 at the age of nineteen, that changed the course of his career. He travelled with his friends Carlos Casagemas and Manuel Pallarés, and lived in the Montmartre district, exploring the nightlife around the Moulin de la Galette. There, he was exposed to a colourful part of Parisian society and became acquainted with members of the art and literary communities. He returned to Barcelona two months later, but would go back to Paris in June 1901, shortly after the suicide of his good friend Casagemas. Casagemas had shot himself in the company of friends in a Paris café, and Picasso later memorialized the death of his friend in at least three paintings. On his second stay in Paris in 1901, Picasso met Paul Cézanne's dealer, Ambroise Vollard, which resulted in an exhibition of his Paris canvases. By 1904 he had decided to settle in the French capital, taking a studio in Montmartre.

In this work, painted in 1902, a destitute woman is shown kneeling on the ground, her head bowed and eyes closed, with her head wrapped in a white scarf and her body covered in a green shawl. The stylistic influence of El Greco is evident in *La Miséreuse accroupie* in the employment of the monochromatic palette, the elongated forms, and in the heavy use of line to create solid areas of colour and shadow. The woman's clothing, drapery, and the interior all carry the same heaviness of paint, evenly applied, making the canvas a composition of distinct forms. The tragic loss of his friend Casagemas the year before, as well as Picasso's own personal struggles, are reflected in the sombre palette. The powerful blue and grey tones also connect us with the subjects who populated his compositions during this period: the people who lived on and off the street, including prostitutes and beggars, and those who frequented the nighttime establishments in Picasso's neighbourhood.

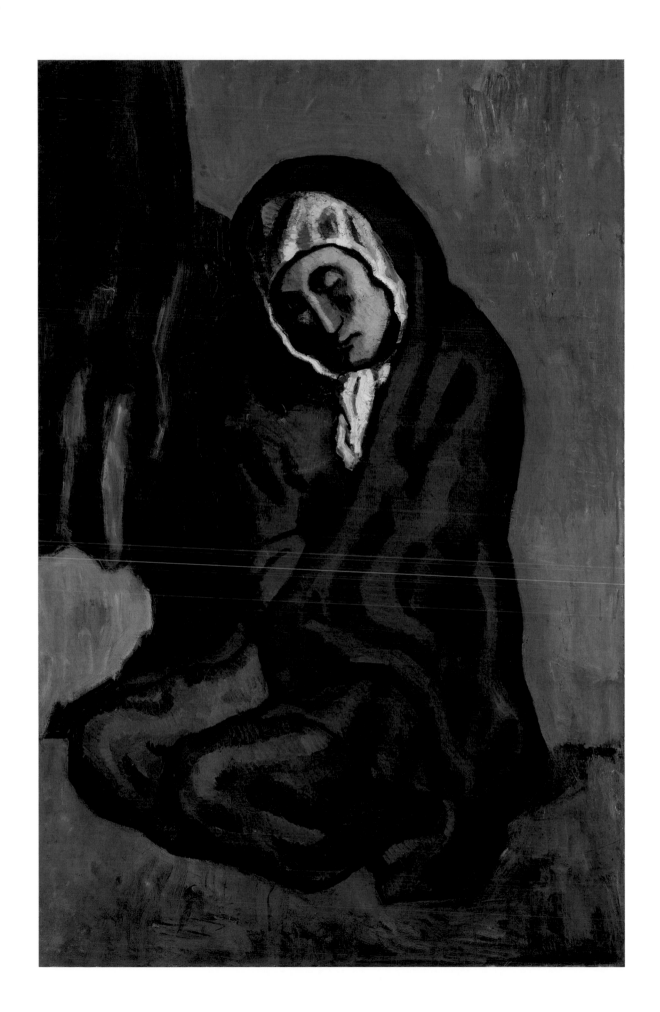

Claude Monet French, 1840–1926

Waterloo Bridge, effet de soleil, 1903

Oil on canvas 65.1 x 100 cm

McMaster Museum of Art, Hamilton
Gift of Herman H. Levy, Esq., OBE, 1984; 1984.007.0043

CLAUDE MONET FIRST SAW London in 1870 when he took refuge in the city during the Franco-Prussian War. He returned again on a few occasions in the 1880s and 1890s, usually in the fall and winter months, making his last trip to London in 1901. As he had done on previous trips, Monet stayed at the fashionable Savoy Hotel, located on the Victoria Embankment on the north bank of the river Thames. There, from his fifth-floor balcony, he had an excellent view of Waterloo Bridge on the left and Charing Cross Bridge on the right.

In total, his time in London yielded over one hundred canvases of the famous river, resulting in one of his most well-known series of paintings, *Views of the Thames,* which featured the two main bridges and the Houses of Parliament. Staying at the Savoy for weeks at a time, often with members of his family, Monet would set up several canvases on easels at the same time so that he could move from one painting to the next as the weather and light conditions changed. His Paris dealer, Paul Durand-Ruel, organized an exhibition in May 1904 that featured thirty-seven of the Thames series including the McMaster Museum of Art picture, which was personally selected by the artist.

Of the handful of *Views of the Thames* paintings in Canadian collections, this stunning picture is the undisputed archetype. On his final trip to London in 1901, Monet focused almost exclusively on views of the Waterloo Bridge. The bridge, erected in 1811, was the primary link for vehicles and pedestrians between the West End of London and the South Bank. Recalling his time in London, Monet later wrote: "I so love London! I love it only in the winter.

It's nice in summer with its parks, but nothing like it is in winter with the fog, for without the fog London would not be a beautiful city. It's the fog that gives it its magnificent breadth. Those massive, regular blocks become grandiose within that mysterious cloak" (René Gimpel, *Journal d'un collectionneur*, Paris: Calmann-Lévy, 1963, 156).

In this view of the bridge in fog, painted in 1903 after Monet had returned to his home in Giverny, France, he allows the atmospheric elements of the day and season to envelop the entire scene. In the winter months in London, the combination of sunlight, cool fog, and the heavy smoke from industrial coal furnaces (their towering stacks visible in the distance) created a dazzling palette of muted pinks, purples, and greys mixed with flashes of red and blue. The brushwork is even, applied quickly in short strokes, while deposits of impasto emphasize the activity and character of the bridge's roadway and massive vault supports. True to his reputation as the leader of the Impressionist group, Monet's first concern in this work was to document an impression at a particular hour of the day when light, air, and colour are massed together into one "mysterious cloak."

The very essence of the Impressionist technique —light, atmosphere, colour, and reflection—is brought to life in this celebrated depiction of Waterloo Bridge. At the same time, Monet's enchantment with the colour and surroundings of London betrays the work of two other artists linked to romantic narratives of the historic city: J. M. W. Turner and Monet's contemporary, James McNeill Whistler, whom he considered a close friend.

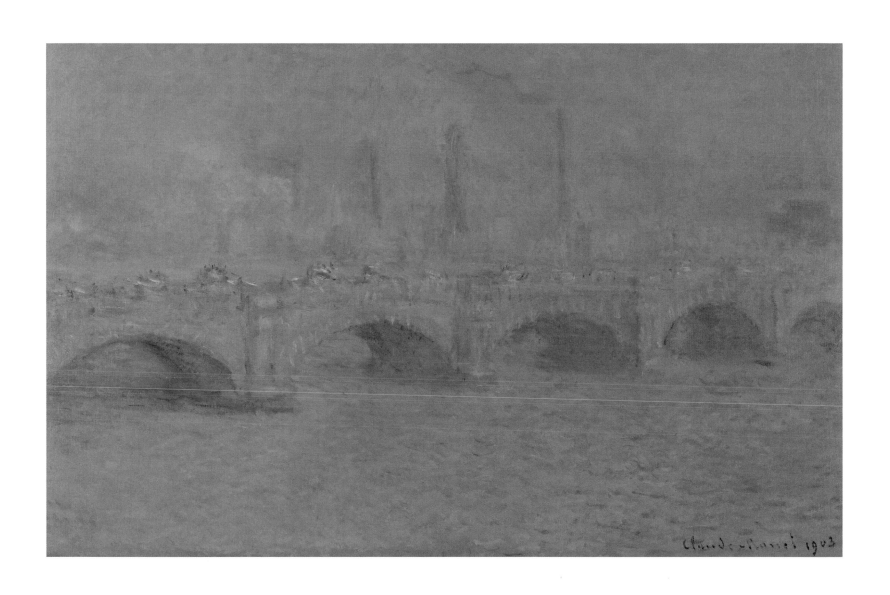

Albert Marquet French, 1875–1947

Le pont Marie vu du quai Bourbon, 1906–1907

Oil on canvas 65 x 81 cm

Art Gallery of Hamilton, Hamilton
Bequest of Marion E. Mattice, 1958; 58.86.T

THIS VIEW OF THE Pont Marie in Paris by the Fauve artist Albert Marquet is one of only two canvases painted from this particular vantage point in the artist's apartment on the Quai Bourbon overlooking the river Seine. When in Paris, Marquet lived mainly on the quais, which resulted in a large body of work depicting the Seine and the views and activities along the river. He would regularly set up his easel in front of a window, and from that spot in his apartment he was afforded a bird's-eye view of the river scene below. The Art Gallery of Hamilton picture shows Marquet at his finest as he presents a sweeping view of the Seine and its banks set in the warm, golden hues of yellow, rose, and brown that he often used for his river scenes. The dark grey forms of the *bateaux-lavoirs* at the bottom of the painting are set against the blue-green waters leading up to the arches of the massive Pont Marie. An assortment of thick, black vertical strokes define the pedestrians that traverse the bridge and the Quai des Céléstins on the right bank.

In 1890, at the age of fifteen, Marquet was sent to Paris by his family to study at the École nationale supérieure des arts décoratifs. It was here that he met Henri Matisse, who became a lifelong friend and colleague. The two went on to study at the École nationale supérieure des beaux-arts under the tutelage of Gustave Moreau. Their circle of close friends included André Derain and Maurice de Vlaminck, and most of them were represented by the French dealer Berthe Weill as well as the Galerie Druet. Inspired in part by Moreau, the group became known as the Fauves (wild beasts), an expression that alluded to their use of bold, arbitrary colours and abstracted compositions. Fauvism triumphed at the Salon d'Automne of 1905, and the Art Gallery of Hamilton picture was painted the following year at the height of the Fauvist period. This also became a critical turning point in Marquet's career as he would eventually move away from the more aggressive palette employed by his friends, choosing instead a more restrained range of colours, which is anticipated in the Hamilton work.

In place of the strident colours and forceful brushwork that had come to define the Fauves, Marquet adopted a modified palette of muted yellow, greys, and greens. With the new palette came a more controlled brushwork that complemented the directional lines and movement of the landscape. He had also studied Japanese brush painting using India ink, and he applied some of these same techniques with his oil paints. The simplified colour scheme also gave him more control in how he drew the viewer into the picture, reserving the option to introduce bolder colours at key points in the composition or with the sightline. In his later years, Marquet remained connected to the latest painting developments in Paris, and he continued to explore new work with his fellow Fauves as well as the Expressionists, at times even returning to the colours of the Impressionists.

Maxfield Parrish American, 1870–1966

Dream Castle in the Sky, 1908

Oil on canvas 179.1 x 328 cm

Minneapolis Institute of Arts, Minneapolis
The Putnam Dana McMillan Fund; 71.25

MAXFIELD PARRISH WAS commissioned by James Jackson Storrow II in 1908 to create this painting for the main hall of his home in Lincoln, Massachusetts. Storrow was a Boston investment banker who was behind the formation of General Motors, and who became the company's third president. Parrish's other notable patrons included Irenée du Pont of Delaware, John Jacob Astor and Gertrude Vanderbilt Whitney of New York, and Edward Bok, editor of *Ladies' Home Journal.*

Parrish received his early art training from his father, Stephen Parrish, who was a landscape painter and printmaker in Philadelphia. The younger Parrish went on to study architecture at Haverford College, and then painting at the Pennsylvania Academy of the Fine Arts and graphic art at the Drexel Institute of Art, all in Philadelphia. In the 1890s, at the beginning of the "golden age of illustration" in the United States, Parrish began working for a number of popular American magazines, including *Collier's, Harper's Weekly*, and *Scribner's Magazine*, where he did cover designs and illustrations. He produced his first cover for *Harper's Weekly* in 1895. The stipple and line drawing of a cook holding a plum pudding with an idyllic landscape visible through the window in the kitchen brought national attention to Parrish's graphic work. Two years later, he was asked to do the illustrations for Frank Baum's *Mother Goose in Prose*, which led to many other commissions for children's book illustrations including *The Arabian Nights* and Eugene Field's *Poems of Childhood*. At the height of his career, millions of prints of his paintings were produced, and it is has been reported that one in four American homes had a Maxfield Parrish work in some format.

The Minneapolis Institute of Arts painting features many of the elements that have come to define Parrish's world—the romantic landscape, medieval architecture, stylized foliage, rocks and water, a classically inspired nude (holding the ancient instrument, the pan pipe) —coloured and lighted by his signature translucent palette. His architectural training combined with a decorative sensibility is understood in this dramatic composition, which introduces a fantastical scene finished with a hyperrealist veneer that Parrish had perfected in his mural work.

Parrish's success as an illustrator was sustained by his remarkable skill as a draughtsman, which has been called almost photographic in its quality and attention to detail. Parrish's father was inspired by the engravings of Albrecht Dürer, and one suspects that Maxfield was drawn to the same tradition in his approach to line. When he turned to easel painting and to murals, which became a lucrative part of his business, he perfected a glazing technique that involved applying consecutive transparent coloured glazes until he achieved the requisite hue and concentration. The effect was similar to the surface of Surrealist paintings, which often had large, glazed areas of one colour. His intense ultramarine blue has been named Parrish Blue after the artist. In his own assessment of the role of colour in his painting, Parrish wrote: "Probably that which has a stronger hold on me than any other quality is – color. I feel it is a language but little understood; much less so than what it used to be" ("Maxfield Parrish," *Bradley His Book*, vol. 2, no. 1 (Nov. 1986), 15).

Tom Thomson Canadian, 1877–1917

In Algonquin Park, 1914

Oil on canvas 63.2 x 81.1 cm

McMichael Canadian Art Collection, Kleinburg
Gift of the Founders, Robert and Signe McMichael,
In Memory of Norman and Evelyn McMichael
1966.16.76

TOM THOMSON WAS born near Claremont, northeast of Toronto, and grew up in Leith, which is located at the southern tip of Georgian Bay. He developed a love of the natural world early in life from his father, an amateur naturalist, and from an older cousin, Dr. William Brodie, who was the first curator of natural history at what is today the Royal Ontario Museum. Thomson meandered through his early career. When poor health prevented him from serving in the Boer War, he apprenticed at a local machinist foundry and attended business school for a brief period. He relocated to Seattle in 1901 to attend a business college run by his brother George to develop the skills to work as a commercial artist. In 1909, back in Toronto, Thomson joined the staff of an established photo-engraving firm, Grip Limited, where he met J. E. H. MacDonald, Arthur Lismer, Frederick Varley, Franklin Carmichael, and Frank Johnston. After Thomson's death, these individuals along with Lawren S. Harris and A. Y. Jackson would form the influential Group of Seven. MacDonald, Grip's head designer, was of particular importance to Thomson. The former instilled in the younger artist an appreciation of the decorative design elements of the Arts and Crafts movement. Learning about the allure the regions north of Toronto had had on older landscape painters like C. W. Jefferies and J. W. Beatty, Thomson began making his own wilderness forays to Algoma, Georgian Bay, and Algonquin Park. Beginning in 1913, Thomson participated in exhibitions and made a number of significant sales to the Ontario government and the National Gallery of Canada, which earned the painter a solid reputation.

By 1914 Algonquin Park had become Thomson's preferred location to gather his artistic source material. Over ensuing years, until his untimely death there in 1917, Thomson would generally paint in the park from early spring to late fall—often earning money as a guide—before returning to Toronto to work up larger canvases during the winter months. Thomson was in Algonquin Park in April 1914 and was joined one month later by Lismer, the first future Group member to encounter the park with Thomson. Jackson, who shared a Toronto studio with Thomson and provided him with informal but vital painting advice, visited the artist in Algonquin along with Lismer and Varley later that fall. Even against the looming uncertainty cast by the outset of World War I, the trip proved immensely productive. Lismer, Jackson, and Thomson executed studies that would serve as the basis for signature works. Thomson, for his part, painted the study for *In Algonquin Park*. The finished painting, completed that fall in Toronto and sold at a Royal Canadian Academy exhibition to raise funds for the war effort, shows the continued influence of the Arts and Crafts movement on Thomson. Its composition, in fact, pays homage to J. E. H. MacDonald's painting *The Edge of the Town, Winter Sunset* (National Gallery of Canada), completed around the same time. The McMichael picture is also significant for demonstrating substantial advancement in Thomson's painting technique. It is in this canvas, as compared to those he completed the previous fall, that one discerns the confident handling and formal clarification that would define his mature output.

Lyonel Feininger American, 1871–1956

Yellow Street II, 1918

Oil on canvas 95 x 86.1 cm

Montreal Museum of Fine Arts, Montreal
Purchase; The Maxwell Cummings Family Foundation; The Ladies' Committee of the Museum;
John G. McConnell, CBE; Mr. and Mrs. A. Murray Vaughan; Harold Lawson Bequest;
Horsley and Annie Townsend Bequest; 1971.35

IN LATE SUMMER OF 1917, Lyonel Feininger returned to his studio in Berlin after spending an extended vacation with his wife, Julia, in the Harz Mountains of Thuringia in Germany. As he prepared for his first solo exhibition to be held later that year at the Galerie Der Sturm, he embarked on an extremely productive phase in his painting career, perhaps in an effort to make up for lost time. The Montreal Museum of Fine Arts painting, which dates from this period, embodies the stylistic forces at play here: his Expressionist roots as well as his exploration of Cubism, which emerged when he was invited to participate in a Cubist exhibition in 1911. In a letter to his wife in 1917, Feininger describes a day that seems to sum up the colour and mood captured in *Yellow Street II*: "A real Sunday morning full of luminosity, with a pale golden light over the trees and roofs, not hard and glassy as in summer, a delicate haze mediating between the sky and the world" (John David Farmer, *A major painting from a critical period in Lyonel Feininger's career*, Montreal: Montreal Museum of Fine Arts, 1972, 5). The composition of brilliant colours and shapes is brought together with an order and logic that he called "prism-ism" instead of Cubism. While the five figures help animate the street with their exotic costumes and poses, it is the rhythm of their forms set against the band of houses that gives the scene its energy. Interestingly, the tricolour Belgian flag is somewhat ill-placed as the architecture is clearly from the Thuringian region of Germany; with his American passport, Feininger would not have been permitted to enter Belgium.

Feininger was born in New York to German parents, both musicians, who expected their son to follow in their footstops. In 1887, at the age of sixteen, he was sent to Hamburg, Germany, to continue his formal music education, but a year later he moved to Berlin to study art at the Königliche Akademie where his first teacher was Ernst Hancke. He eventually moved to Paris where he enrolled in an academy run by the sculptor Filippo Colarossi. To supplement his income, Feininger worked as a cartoonist and caricaturist for different magazines including the German publications *Berliner Tageblatt*, *Das Narrenschiff*, and *Ulk*, and the American publications *Harper's Round Table* and the *Chicago Sunday Tribune* that ran his comic strips *The Kin-der-Kids* and *Wee Willie Winkie's World*.

Feininger returned to Berlin in 1908 and joined a number of German Expressionist groups including Die Brücke and Der Blaue Reiter. After his first solo exhibition at the Galerie Der Sturm in 1917, he met the architect Walter Gropius who offered him, in 1919, a faculty position in printmaking at his newly established Bauhaus School in Weimar. That same year, Feininger designed the cover—a woodcut entitled *Cathedral of Socialism*—for the Bauhaus manifesto, and he remained at the school until its closing in 1933. With the Nazi Party's rise to power over the Weimar Republic, Feininger's art was deemed "un-German" and over four hundred of his paintings were removed from German museums. Seeking refuge, Feininger and his family moved to New York, and in 1944 he was given a retrospective exhibition at the Museum of Modern Art.

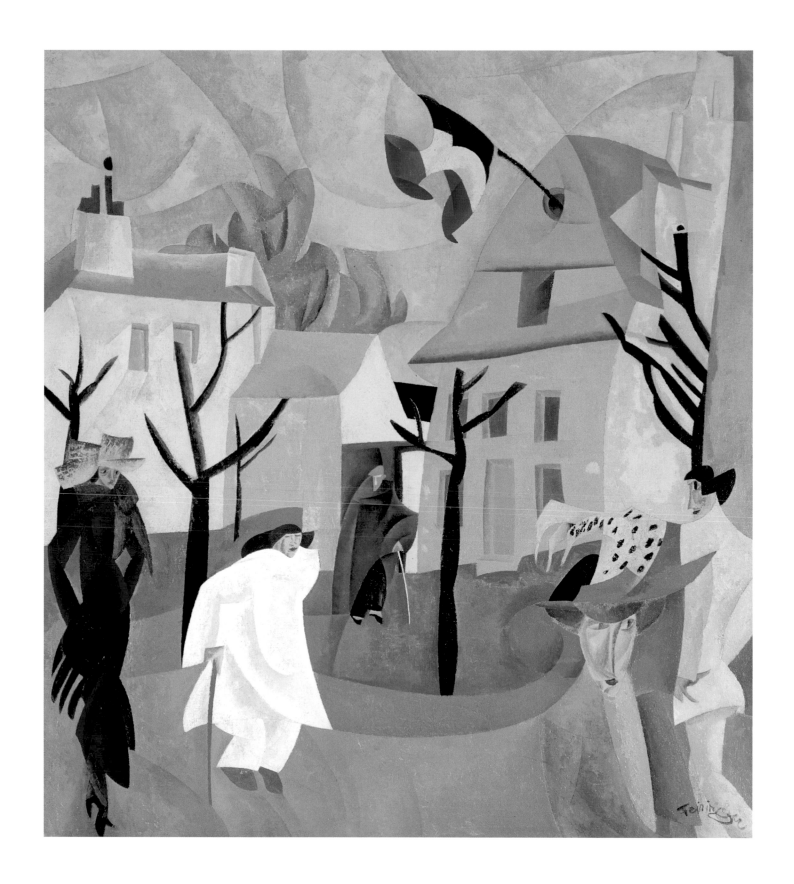

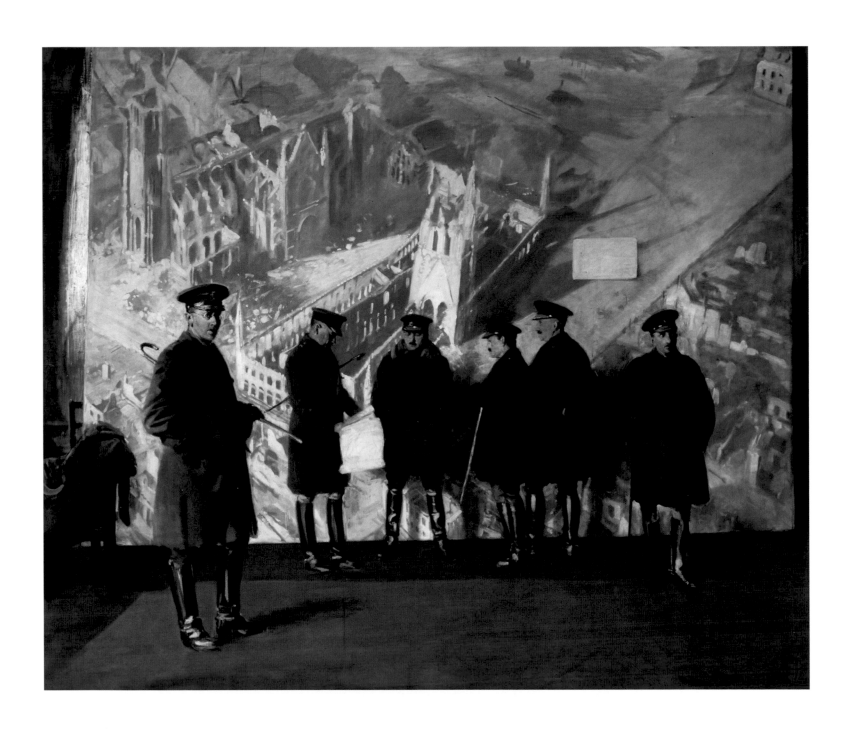

Sir William Nicholson British, 1872–1949

Canadian Headquarters Staff, 1918

Oil on canvas 243.1 x 289.2 cm

Canadian War Museum, Ottawa
Beaverbrook Collection of War Art; CWM 19710261-0537

WILLIAM NICHOLSON'S enormous portrait of the Canadian Headquarters Staff in London, England, was commissioned in 1918 by the Canadian industrialist Max Aitken, 1st Baron of Beaverbrook, as a means to document the Canadian effort during World War I. Three years earlier, the German gas attacks on the Canadian troops during the Second Battle of Ypres in Belgium in May 1915 had resulted in the establishment of the Canadian War Records Office. The initiative was championed by Aitken, who had emigrated to England in 1910 and was awarded the title of Lord Beaverbrook in 1917. After learning of the horrific events at Ypres (where over seventy thousand British, Canadian, and French troops were killed, wounded, or missing between 1914 and 1917), and based on the fact that there was no visual record of the battle, Aitken used his own funds to work with the Canadian and British governments to establish the Canadian War Records Office in 1916. The Office was responsible for the collection of photographs, maps, records, and diaries documenting the Canadian war effort. Aitken also lobbied for an artistic component to the Office, and with the support of Prime Minister Borden, the Canadian War Memorials Fund was created in the same year. The fund, supported by the government and managed by a private corporation, gave Canadian and British artists a military rank and salary to document the war effort at home and abroad. In 1916, only months after the attack at Ypres, the British artist Richard Jack was commissioned by the Canadian War Memorials Fund to produce a painting of the battle. By the end of World War I, the fund had supported the production of close to one thousand works by over one hundred ten artists, more than a third of them Canadian, all of which remain in the collection of the Canadian War Museum.

Nicholson's portrait features the Generals Richard Turner, Alexander McRae, Harold McDonald, Gilbert Foster, and Percival Thacker, as well as Major Furry Montague. The Canadian officers are seen standing in front of a mural of Ypres Cathedral and the Cloth Hall (one of the largest commercial buildings erected in the fourteenth century), both of which sustained major damage during the German bombings of Ypres. Rather than producing a formal portrait of the group, Nicholson chose instead to document a more casual moment as the officers stood unposed as they waited to sit for their official portrait. It has been suggested that for the composition he was influenced by the portraits of Malcolm Arbuthnot, who had photographed Nicholson's children dressed in uniform and in poses very similar to those of the Canadian generals. Nicholson's own son, Anthony, had died of wounds sustained in battle in France only months before he began this painting. Although the painting remained in storage for much of the last century, its recent conservation and installation in the new Canadian War Museum, and inclusion in the artist's retrospective exhibition in 2004 at the Royal Academy of Arts, London, has led to critics calling it one of his greatest works.

Nicholson was an accomplished portrait, still-life, and landscape painter, who established his studio in London by 1917, supported by his active portrait practice. Earlier, he had studied with Hubert von Herkomer in Bushey, Hertfordshire, and then briefly at the Académie Julian in Paris. Aside from his easel paintings, Nicholson had great commercial success with poster design and book illustrations, which began through a collaboration with his brother-in-law, James Pryde.

John Byam Liston Shaw British, 1872–1919

The Flag, 1918

Oil on canvas 198 x 365 cm

Canadian War Museum, Ottawa
Beaverbrook Collection of War Art; CWM 19710261-0656

JOHN BYAM LISTON SHAW was born in Madras, India, where his father, John Shaw, was registrar of the Madras High Court. Shaw's family returned to England in 1878 and settled in Kensington. John Everett Millais saw the work of the 15-year-old Shaw and recommended he enroll at the St. John's Wood Art School. Shaw continued his studies at the Royal Academy Schools in 1890, where he won the Armitage Prize. During World War I, Shaw enlisted in the Artists Rifles, a volunteer regiment of the British Army, and he was later transferred to the Special Constabulary. During the war he produced a number of illustrations for newspapers and magazines, and also completed a number of larger paintings including *The Flag*.

Commissioned by the Canadian War Memorials Fund, *The Flag* was shown at the Canadian National Exhibition in Toronto in 1919, where it was one of the most popular works in the exhibition and subsequently included in an international tour. *The Montreal Star* reported in 1919 that the artist had "captured the sacrificial spirit in which the sons of the Empire laid down the greatest gift they had to give that freedom might triumph" (Jonathan F. Vance, *Death So Noble: Memory, Meaning, and The First World War*, Vancouver: UBC Press, 1997, 108). Shortly after the first exhibition, the Imperial Order of the Daughters of the Empire selected the work to be used in the IODE Print Series that was issued to all Canadian schools after World War I.

In his dramatic staging of the war memorial, Shaw has given each figure a role in this commemoration of the war effort and its remembrance at home. Filling much of the composition is an enormous bronze sculpture of a lion mounted on a tomb-like stone plinth, likely inspired by Edwin Landseer's four lions at the base of Nelson's Column in Trafalgar Square in London. Resting at the foot of the lion, which represents Great Britain and the Empire, is a fallen Canadian soldier who holds the Canadian Red Ensign in his arms. It is the 1907 version of the flag, with Alberta and Saskatchewan added along with the coats of arms of British Columbia, Prince Edward Island, and Manitoba shown in their modern forms. The dead soldier is surrounded by those for whom the sacrifice had been made including the very young and the old. A young woman dressed in black, perhaps the dead soldier's sister or young bride, lies prostrate on the stone ledge in an expression of extreme grief with her hand covering her face. Behind her a bearded man stands at attention, his gaze downward and away from the soldier. Opposite him is a grey-haired woman, draped in a fur coat, who looks across to the man with a face of resignation. Behind the bearded man is a boy who stares up at the large red ensign, perhaps contemplating his own future in service to his country. Other figures are shown in different stages of grief or understanding, some comforting each other and some in solitary contemplation. Absent from the scene are the men in their twenties and thirties who are serving overseas in the war. Shaw used two of his own sons as models for the painting (likely for the dead soldier and the boy), and tragically both were killed in action in World War II.

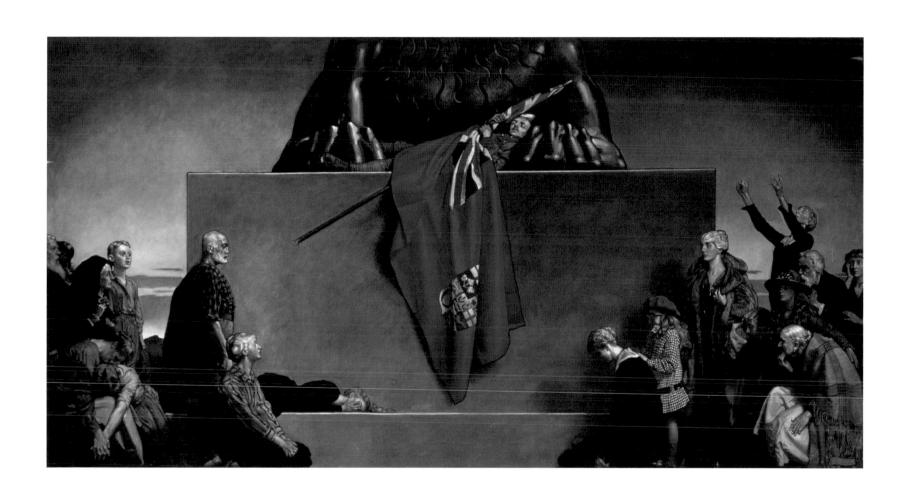

Pierre-Auguste Renoir French, 1841–1919

Le concert, 1918–1919

Oil on canvas 75.6 x 92.7 cm

Art Gallery of Ontario, Toronto
Gift of the Reuben Wells Leonard Estate, 1954; 53/27

AMONG THE IMPRESSIONIST artists, Pierre-Auguste Renoir had perhaps the most distinctive painting style, resulting mainly from his "rainbow palette," which consisted of intense, pure tones almost to the exclusion of black. This celebrated period of "pure" Impressionism was, however, relatively short-lived, and his adherence to the group's aesthetic began to waver in the 1880s as he became more interested in sculptural form. While he continued to explore the relationship of light and colour, and how the two elements worked together on the canvas through the use of a patterned brushstroke, he adopted a more linear style with a highly charged and, at times, decorative palette, as is evident in the Art Gallery of Ontario picture. The stylistic shift did not stop Renoir from participating in four of the eight Impressionist group exhibitions. He shared the spotlight with Claude Monet as one of the leading exponents of the movement, and was always regarded as the most typical figure painter of the group.

One of Renoir's greatest skills was his ability to create immediately engaging scenes; and this was due in no small part to his choice of subjects, which were often women and children in domestic settings. After finding the best models, he would sometimes have them attired in fanciful costumes, and then would paint them in equally colourful interiors filled with textures and decorative elements, as evidenced in *Le concert*. The same palette that animates the two figures—defined by pinks, yellows, greens, and whites—is repeated in the background. The two women and the space they occupy are united by Renoir's brush, marked by its careful rhythm and tone. Instead of competing for the ground, the lively backdrop of drapery, flower, and furniture accentuates the scale and presence of the figures.

The Art Gallery of Ontario painting is one of Renoir's final works, completed a few months before his death in 1919. In the last two decades of his life, the artist's health had deteriorated considerably. The effects of his rheumatoid arthritis forced him to spend more time in the south of France, where he moved permanently in 1907, settling in Cagnes-sur-Mer. Renoir's painting technique was also affected by his physical decline. Eventually the crippling effects of the arthritis and the paralysis caused by a stroke in 1912 made it necessary for him to have his paint brushes strapped to his wrist. In *Le concert* the results of this method can be seen in the loose brushwork and the fluidity of the pigment. Certain areas of the canvas are worked up with light impasto, while other surfaces remain smooth and even sparse as he shifts from paint to glaze. In this elegant composition orchestrated by colour and form, the application of paint appears almost effortless, although at this stage it took Renoir enormous effort even to hold a brush in order to paint. Still, nothing is spared in the artist's desire to bring life to his sitters and their beauty. These same tendencies in his painting technique became even more exaggerated in the *Bathers* series, which Renoir was still working on up to the time of his death in 1919.

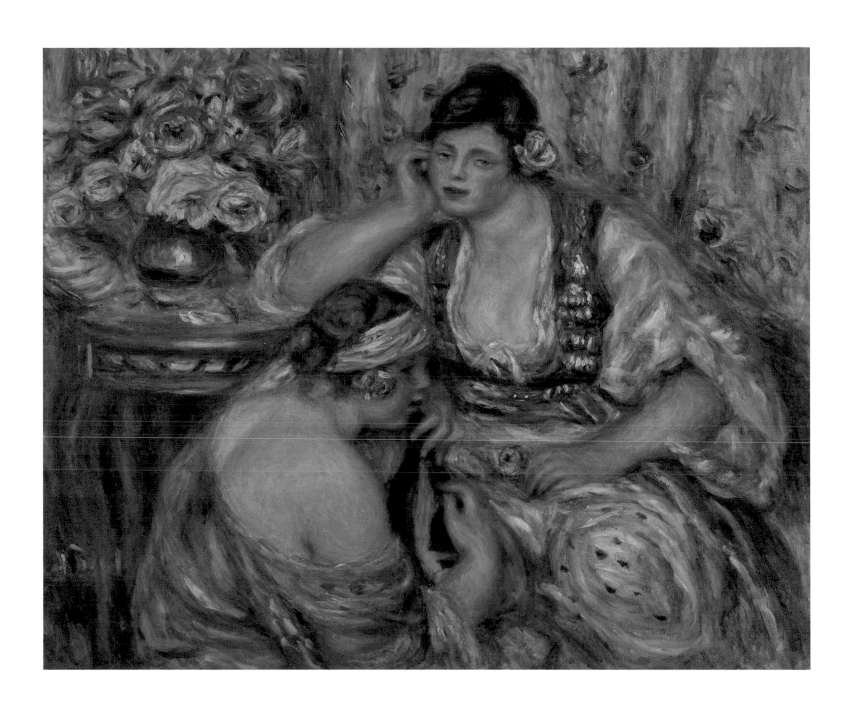

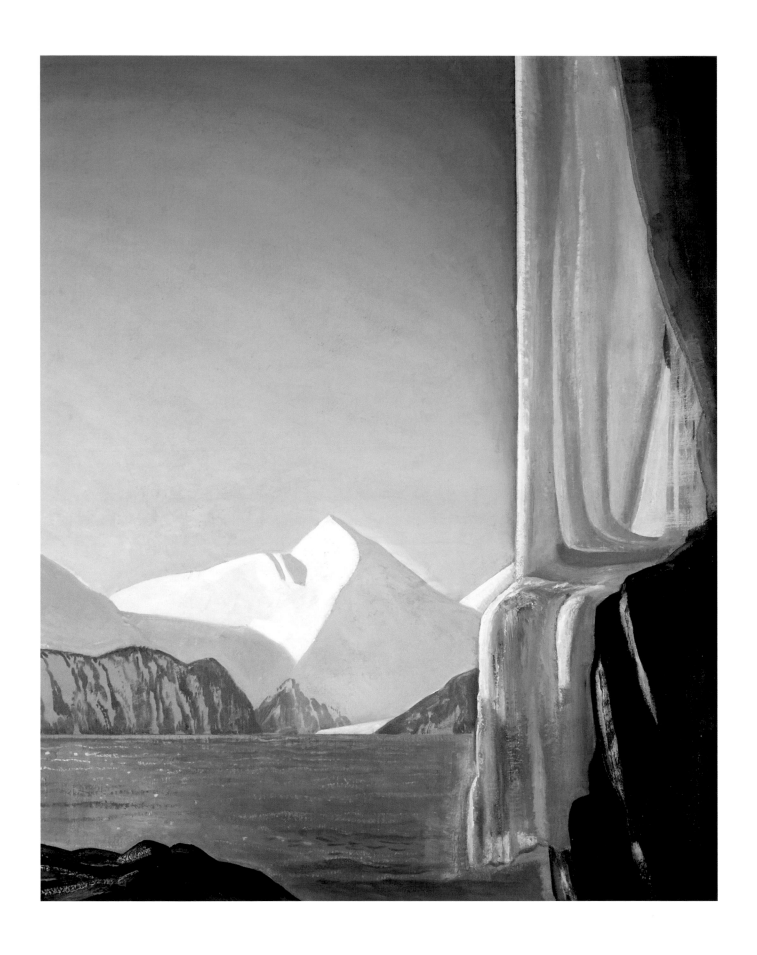

Rockwell Kent American, 1882–1971

Frozen Waterfall, Alaska, 1919

Oil on canvas 86.5 x 71.2 cm

Art Gallery of Hamilton, Hamilton
Gift of the Women's Committee, 1971; 71.75.1

AFTER STUDYING architecture at Columbia University in New York, Rockwell Kent shifted to fine art, enrolling in private art schools in the city run by William Merritt Chase as well as Robert Henri. Kent practiced architecture for ten years after graduating from Columbia, but he also continued with his art-making, focusing on painting and printmaking. By the 1930s he had become one of the leading illustrators in the United States, producing prints for several books, journals, and magazines, including a number of political publications.

The remote and isolated landscape remained a steady source of inspiration for his art, and Kent travelled extensively to find places and subjects that appealed to him. Sketching trips took him to the coasts of the United States and Canada including Maine, Washington, Alaska, British Columbia, and Newfoundland. He also visited Tierra del Fuego, Ireland, and Greenland. It was the northern landscape, however, that remained a constant force and point of discovery in his work. Recalling his passion for the north, Kent wrote: "I came to Alaska because I love the North. I crave snow-topped mountains, dreary wastes, and the cruel Northern sea with its hard horizons at the edge of the world where infinite space begins. Here skies are clearer and deeper and, for the greater wonders they reveal, a thousand times more eloquent of the eternal mystery than those of softer lands" (Rockwell Kent, *Wilderness: A Journal of Quiet Adventure in Alaska*, Los Angeles: Wilderness Press, 1970, xxxi).

In the fall of 1918, Kent and his nine-year-old son, Rockwell Kent III, travelled to Alaska to explore the northern frontier of the United States and to see for the first time the spectacular glacial formations. The next winter, he and his son stayed on Fox Island in Puget Sound off the coast of Washington State. At the time, there were very few people living on the island, and Kent's only contact was with a local trapper who acted as their guide. During his winter sojourn on Fox Island, Kent augmented his studies of the north by reading two key books on the early explorations of the north: *A Voyage Round the World in the Years 1740–1744* by the British admiral George Anson, and *In Northern Mists* by the Norwegian explorer Fridtjof Nansen.

Recalling his time in Alaska from the previous summer, Kent returned to the theme of icebergs during his stay on Fox Island. The scene depicted in the Art Gallery of Hamilton painting is Resurrection Bay on the Kenai Peninsula of Alaska. Kent reserves his most brilliant colours and lighting to highlight the masses of ice and stone. The moment is literally frozen as the artist has managed to convey both the light and cold that defines the scene. The Chugach Mountain range can be seen in the distance, and to the immediate right is Bear Glacier, which is part of the Kenai Mountains. Bear Glacier is a 25-kilometre long outlet glacier of the Harding Icefield. Since 1909, when the glacier was first mapped, it has retreated (melted) more than four kilometres from its terminus position, yielding smaller icebergs into the new lake that was formed in the basin.

Not surprisingly, Kent became friends with another artist inspired by the far north, the Canadian painter Lawren S. Harris. Harris collected all of Kent's illustrated books and several prints of his paintings.

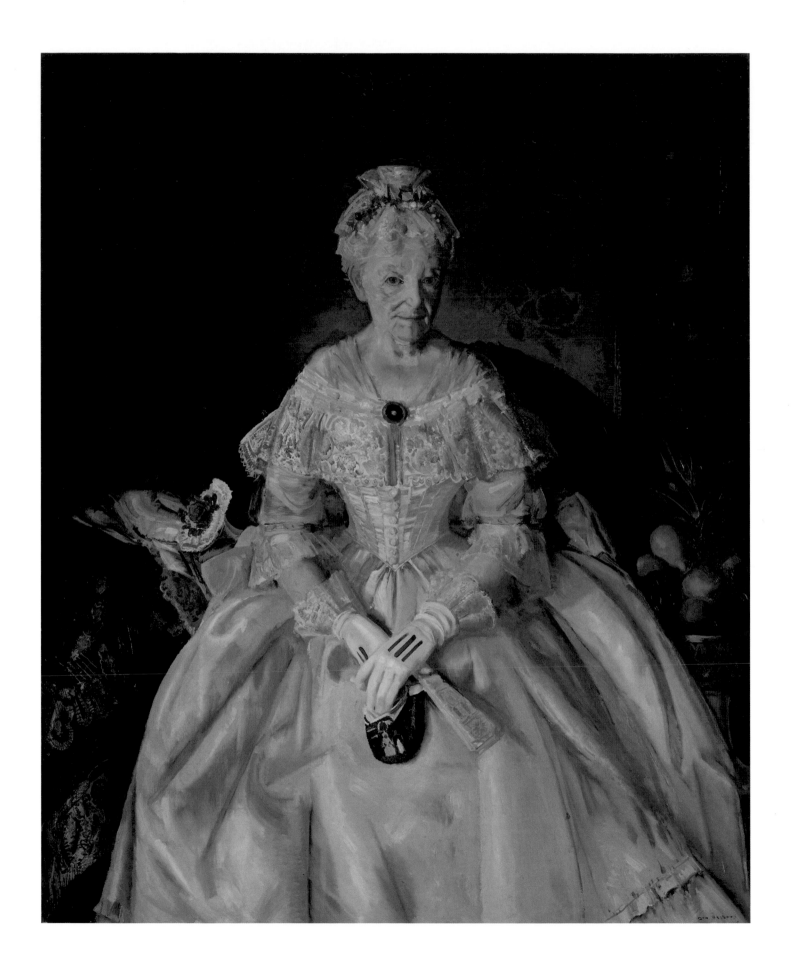

George Bellows American, 1882–1925

Mrs. T. in Cream Silk, No. 2, 1920

Oil on canvas 134.6 x 109.2 cm

Minneapolis Institute of Arts, Minneapolis
The Ethel Morrison Van Derlip Fund; 60.33

CONSIDERED TO BE ONE of George Bellows's most brilliantly executed portraits, with the spirit and directness of a portrait by Francisco Goya, *Mrs. T. in Cream Silk, No. 2* was commissioned at the height of the artist's career. Five years later in 1925, at the age of forty-two, Bellows died suddenly of peritonitis from a burst appendix.

Mrs. Mary Brown Tyler was a Chicago dowager whose family had deep roots in the city. She was married in 1863 at the family mansion directly across the street from the Art Institute of Chicago. Fifty-seven years later she sat for her portrait by Bellows and chose her original cream silk wedding dress as the costume for the sitting. The choice of dress was perhaps not surprising as Mrs. T. (as she was known) had an extensive collection of beautiful costumes that she had preserved since her youth.

Although she is sitting rather awkwardly in a large upholstered Victorian armchair with the bulk of her floor-length skirt and the train of her gown carefully arranged behind her on the chair, Mrs. T. appears at ease with the viewer and the artist. Clearly, this was not the first portrait Mrs. Tyler, in her seventies when this was painted, had sat for in her day. With her head turned gracefully—almost with a youthful coyness—to one side, her hands are clad in white silk gloves and hold a fan and small oriental purse as they rest in her lap. She is presented in an elegantly furnished room decorated with gold-coloured wallpaper, a bookcase with leather-bound volumes, red and gold silk brocade table covering, and large white porcelain fruit basket and stand. A nosegay with pink roses rests on the table at her side, and similar blooms are reserved for the

silk and lace covering she wears on her head. Bellows has intended to sum up the life and character of Mrs. T. in one sitting. With a loaded brush and a full complement of colours, Bellows adds dramatic shifts from light to shadow to give us a portrait in the grand tradition and one befitting a society matron who was known for her charming and witty personality.

At the time of the portrait commission, Bellows was teaching at the Art Institute of Chicago. He painted two other portraits of Mrs. T. (including another version from this sitting); however, the Minneapolis Institute of Arts picture is the most famous, capturing the personality of the sitter in a refreshingly frank and direct manner.

The son of an architect of the same name, George Bellows was born and raised in Columbus, Ohio, and attended Ohio State University where he excelled in baseball and basketball. Before his graduation, when he was considering going semi-professional in baseball, he decided to move to New York to pursue an art career. He studied with Robert Henri at the New York School of Art, which was run by William Merritt Chase. Perhaps not surprisingly, some of Bellows's most famous paintings feature the sport of boxing and prizefighting. Although he was never officially a member of The Eight, he was associated with the Ashcan School in New York, the larger group that absorbed the original eight artists. He exhibited with members of both groups, including in the Armory Show of 1913.

David Milne Canadian, 1882–1953

Blue Church, c. 1920

Oil on canvas adhered to hardboard 46 x 56.2 cm

McMichael Canadian Art Collection, Kleinburg
Gift of the Founders, Robert and Signe McMichael
1966.16.22

LARGELY UNKNOWN IN his native Canada until several decades after his career had already begun, David Milne stands today as one of this country's earliest and most innovative modern painters. He was a contemporary of the artists of the Group of Seven, but his work shares little in common with theirs. Using an exceedingly minimal palette and adhering to a basic set of mark-making tools, Milne created contemplative images of stark complexity. "To claim that Milne was arguably Canada's 'greatest painter' is not extravagant," the American critic Clement Greenberg famously remarked after the artist's death, adding that "he can hold his own anywhere" (David P. Silcox, *Painting Place: The Life and Work of David B. Milne*, Toronto: University of Toronto, 1996, 402).

Milne was born and grew up in rural southwestern Ontario. His first art lessons were through correspondence courses that he took while working as a public school teacher. In 1903 he moved to New York where he studied under Robert Henri and William Merritt Chase at the Art Students League and sought work as a commercial illustrator. He frequented American artist Alfred Stieglitz's 291 art gallery where he was inspired by the work he saw by such artists as Paul Cézanne, Vincent van Gogh, and Pablo Picasso. Milne was attracted to the lack of sentiment and technical preciousness he discerned in the work of these European Modernists. By the early 1910s, he had made the decision to leave the commercial art world and become a full-time artist. He developed a blocky Post-Impressionist style reminiscent of Édouard Vuillard, and contributed frequently to exhibitions including the famous 1913 Armory Show, at which he received favourable reviews from the New York press. Milne moved

to the upstate hamlet of Boston Corners, south of Buffalo, in 1916. However, before the change in locale could have any lasting impact on his artistic practice, he joined the war effort. Shortly after he completed his military training and had landed in Britain, armistice was declared and World War I ended. By chance, he was given the opportunity by the Canadian War Memorials Fund to document the after-effects of war in England, France, and Belgium. In Milne's war paintings his practice takes a new direction. He returned to Boston Corners where he honed his new approach; he then moved to Canada in 1929 and began exhibiting his work regularly. He earned the respect of three influential figures: art patron Vincent Massey, National Gallery of Canada director Alan Jarvis, and gallery owner Douglas Duncan. Milne lived in mostly rural locations throughout Ontario for the last two decades of his life, finally settling near Bancroft.

Blue Church, completed on February 16, 1920, two months after he returned to Boston Corners, represents one of the earliest realizations of the new painting approach Milne had initiated overseas. Of particular novelty is the artist's dry-brush articulation of sky and distant hills. An astute observer and reflective writer, Milne composed the following the same day: "The vertical lines . . . are drawn with a fine brush, then filled between in places with a very small amount of colour, exactly the same as in the trees. Had thought before of doing it this way but never tried it" (David Milne Fonds, Library and Archives Canada). Milne's account underscores his commitment to Modernism; formal design takes precedence over the church and landscape subject matter, an inconsequential afterthought.

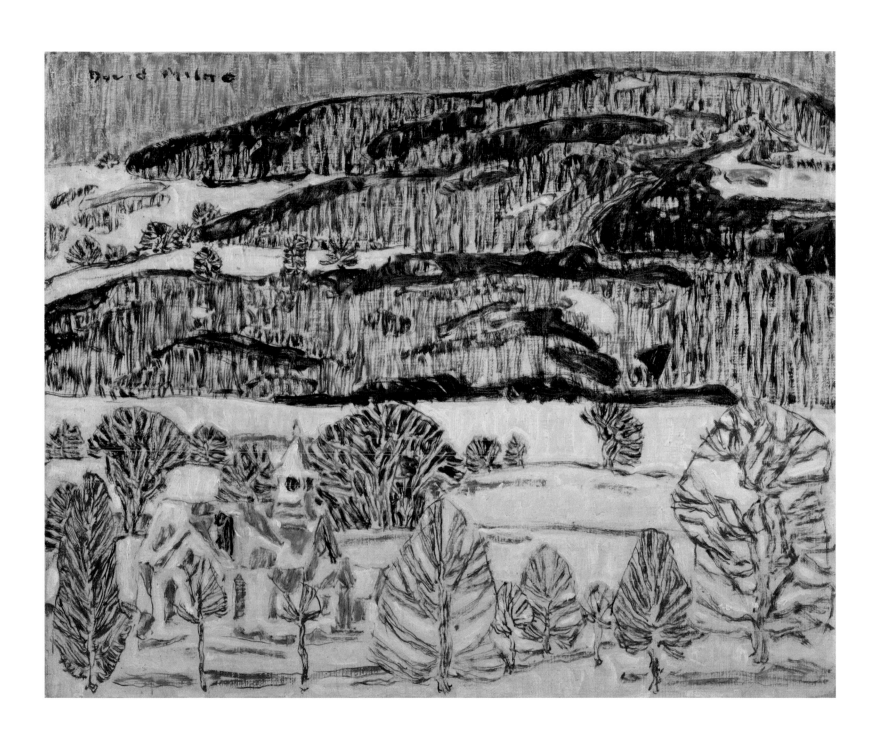

Walter Gramatté German, 1897–1929

Confession, 1920

Oil on canvas 218 x 157.5 cm

Winnipeg Art Gallery, Winnipeg
Gift of The Eckhardt-Gramatté Foundation; 2009-621

WALTER GRAMATTÉ WAS PART OF the second generation of German Expressionists working in the 1920s and 1930s. One of the movement's guiding philosophies was the desire to illustrate or embody elements of the human condition in art, a theme that characterized much of Gramatté's art. Born in Berlin, he served in the German army between 1914 and 1918. He suffered serious injuries in the war, and during an extended convalescence he enrolled at the Königliche Kunstschule in Berlin. After the war he resumed art studies and worked in several studios in Berlin, becoming friends with Erich Heckel and Karl Schmidt-Rottluff, who were associated with the Die Brücke group. By 1920 he had had several solo exhibitions and saw his work acquired by several important private collectors. That same year he married the Russian composer Sophie-Carmen Fridman, daughter of Katharina de Fridman-Kochevskaia, a friend of Leo Tolstoy. The couple lived a nomadic life, moving to Spain in 1924 where they stayed for two years. Gramatté worked equally in oils and watercolour, and excelled in printmaking including woodcut, dry point, lithography, and etching, the *Wozzeck* series (1925) being his most famous graphic work. While he achieved early acclaim, his international success came only after his untimely death in 1929 in Hamburg. A major touring show organized in 1933 was cut short when Gramatté's art was declared degenerate by the National Socialist regime. In 1934 his widow Sophie (later called Sonia) married the Viennese art historian Ferdinand Eckhardt, who was researching Grammaté's graphic work, and together they moved to Canada in 1953 when Eckhardt was appointed director of the Winnipeg Art Gallery.

Confession is one of Gramatté's most ambitious works, measuring over two metres in height, and was painted shortly after he had seen Matthias Grünewald's Isenheim altarpiece (the central panel depicting the Crucifixion) exhibited in Munich. Gramatté's composition is set in a church interior, the space loosely defined by a group of figures in dramatic and contorted poses set between flanking barred windows and terminating with a cleric standing before a large crucifix. Two figures in the foreground shown in the act of prayer appear illuminated against the intense blue ground, which is made up of a juxtaposition of dark colours that results in unusual harmonies. On July 15, 1920, Gramatté wrote about the work to his friend, art critic Wilhelm Niemeyer: "I am now working on a large picture that I have had in mind for years . . . I am painting the *Confession*. Rarely have I felt so much willpower standing in front of my easel. I am so much in the grip of the picture that I work from 8 a.m. to 4 a.m. and only sleep because reason tells me to do so . . . Rays of light emanating from this landscape fall on two life-size figures who are the most important characters in the picture. The woman on the left side is kneeling, the man on the right side is standing with his hands folded over his breast. Both have obviously been exposed to the hardships of human fate, but have reached an understanding of the essence of all things. They kneel and confess with a longing that comes from the bottom of their souls. They do not participate in the frenzy of the place around them, but rather kneel outside, in God" (Claude Pese, ed., *Walter Gramatté 1897–1929, Catalogue raisonné of the Oil Paintings*, Cologne and Winnipeg: Wienand Verlag and the Eckhardt-Gramatté Foundation, 1994, 120).

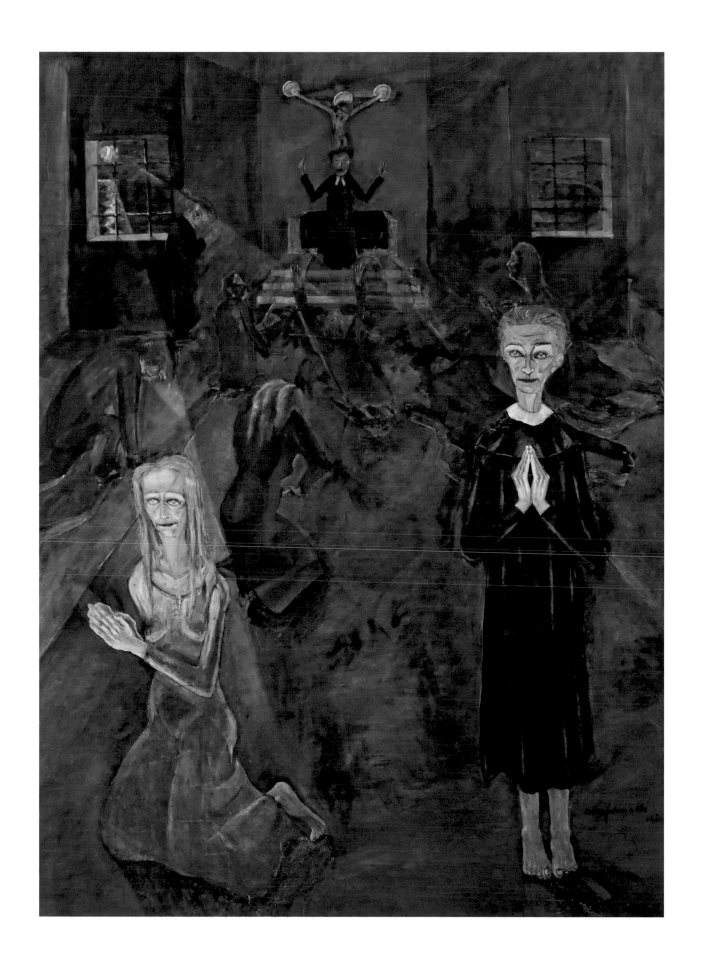

Félix Vallotton French (born in Switzerland), 1865–1925

Fleurs, 1921

Oil on canvas 55.2 x 46.3 cm

Art Gallery of Hamilton, Hamilton
Gift of the Women's Committee, 1961; 61.112.H

BORN IN LAUSANNE, Switzerland, Félix Vallotton moved to Paris in 1882 to study at the Académie Julian (the private art school founded by Rodolphe Julian), where he trained under Jules Joseph Lefebvre. He augmented his art education with regular visits to the Musée du Louvre where he became fascinated with the paintings of Hans Holbein and Jean-Dominique Ingres, two artists whose work would remain pivotal in Vallotton's own mastery of the figure and portraiture. Some of his first paintings to garner attention were his portraits, including an early self-portrait whose austere compositional quality and arresting gaze would anticipate the genre that continued to develop throughout his career. However, it was his printmaking—primarily the avant-garde black and white woodcuts of the 1890s—that brought him critical acclaim as well as commercial success. In 1898 the prestigious French arts and literary journal *La Revue Blanche* published Vallotton's *Intimités* (*Intimacies*), a suite of ten woodcuts depicting interior scenes featuring a man and a woman in a love affair that is coming to an end.

For a period in the 1890s, Vallotton was associated with the Nabis (a Hebrew word meaning prophets), a group of Post-Impressionist artists who banded together to paint and write, and whose membership included Pierre Bonnard, Édouard Vuillard, Paul Sérusier, and Maurice Denis. The Nabis were interested in a variety of media including painting and prints, book illustration, and textile and furniture design, the latter due to the influence of the English Arts and Crafts movement. Hoping to revitalize and redirect painting as "prophets" of modern art, the group focused on representational work using cutting-edge approaches to colour, composition, design, and materials. It was their unofficial leader, Maurice Denis, who defined the painting as "a flat surface covered with colours assembled in a certain order," which anticipated the work of the Fauves and Cubists in the first decades of the twentieth century. By 1900, twenty years before Vallotton painted the still life now in the Art Gallery of Hamilton, the Nabis had largely disbanded; however, the impact of their art-making left a clear mark on the Parisian avant-garde.

Landscapes and still lifes followed in Vallotton's later years, but these genres kept the restraint and directness associated with his portraiture. The Art Gallery of Hamilton painting features orange-red nasturtiums and a pink and white hydrangea (or geranium) bloom in a dark glazed ceramic vase set against a neutral backdrop, with a patterned rose-coloured tablecloth. The light reflects off the side of the pot, but then it is diffused evenly throughout the scene, enabling each part of the composition to be presented with a non-idealized realism. It is a simple, unadorned documentation of the flower piece, much in the same way Vallotton approached his sitter, which allows for a striking clarity through form and colour. Vallotton gives us a stark world in his painting. The theme or focus of the work is established by the object, in this instance, the vase of flowers. Here we see the uncompromising craftsmanship of a purist where the idea of truth is conveyed through the subject and its placement.

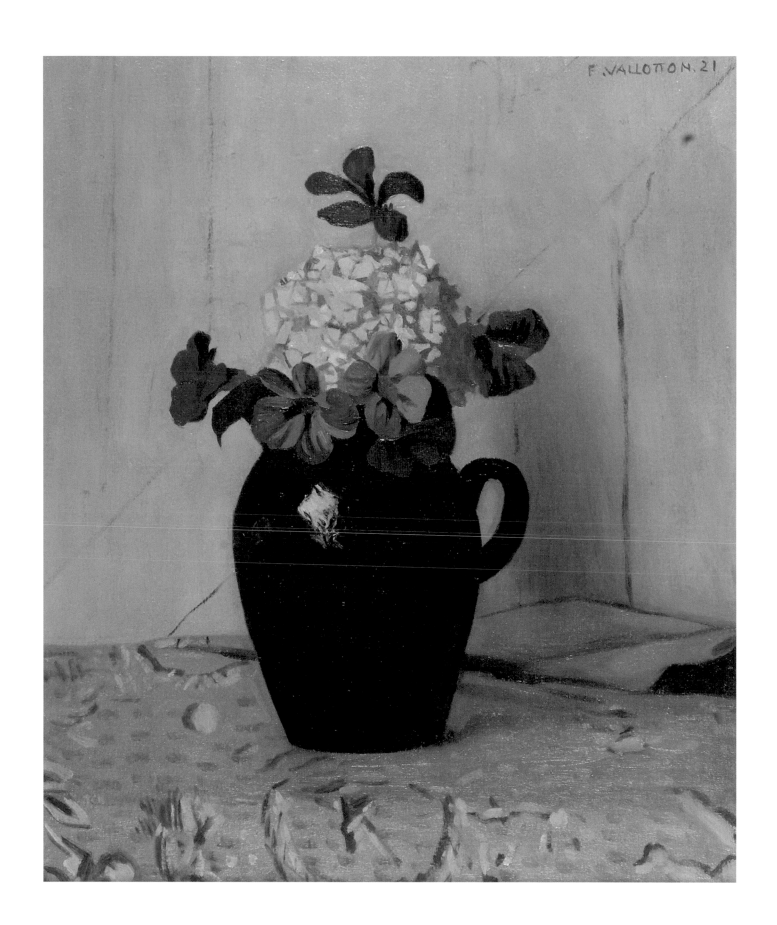

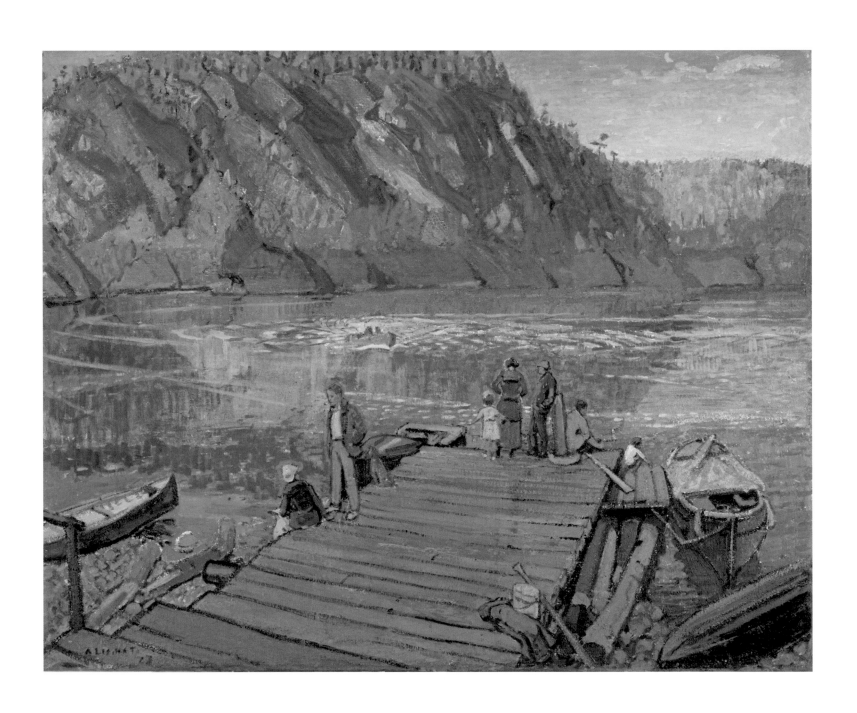

Arthur Lismer Canadian (born in England), 1885–1969

Autumn, Bon Echo, 1923

Oil on canvas 106 x 132.9 cm

Mendel Art Gallery, Saskatoon
Gift of the Mendel Family, 1965; 1965.4.3

In August of 1921, Arthur Lismer, a founding member of the then newly formed Group of Seven, travelled to Bon Echo in southern Ontario for a vacation. This was his first of many visits to this region, a popular tourist destination known for its deep lakes and large granite outcroppings. Lismer and his family had been invited to stay at the Bon Echo Inn, owned and operated at that time by the former architect and playwright Merrill Denison. They had met earlier in the year at Toronto's Hart House Theatre where Denison had replaced Lismer as the new artistic director. Both men shared interests in the Canadian wilderness as an artistic subject as well as the nature poetry of Walt Whitman. The two no doubt bonded over Bon Echo's dramatic landscape. Lismer's friendship with Denison grew in 1922, chiefly as a result of their shared appearance in the cast of Denison's play *From Their Own Place*, performed at Toronto's Arts and Letters Club. Lismer returned to Bon Echo and the inn later that year to work on preliminary studies for the Mendel Art Gallery picture which he completed in 1923.

This work was painted at a pivotal moment in Canadian art history, just one year before the successful 1924 British Empire Exhibition at Wembley, England, would significantly help launch the Group of Seven to national prominence. The painting bears the broad telltale signs of the Group. The idea of nature as a somewhat threatening and alien wilderness is emphasized by the far shore. A looming ridge of orange rock cut through by bolts of green and purple shadow carries into the water, creating what looks almost like a toxic slick, before being infiltrated by swatches of turquoise. The jagged forms and optical intensity of the painting's middle ground and background stand in dramatic contrast to the scene of serene leisure—the dock and clusters of people, pets, and watercraft—that constitutes the bottom third. Lismer, like several other members of the Group (Lawren S. Harris and Frederick H. Varley, in particular), did not expunge the human figure from his work entirely. However, very rarely do we find a finished canvas like the Mendel work by a Group member that pays such close attention to people at ease in the natural environment.

Autumn, Bon Echo was displayed in the Mendel Art Gallery's inaugural exhibition of 1964. This exhibition featured European and Canadian works of art from the private collection of Frederick S. Mendel, the gallery's chief benefactor. One year later, to mark twenty-five years of residence in Saskatoon, the German-born businessman donated the painting along with a dozen other works, which remain the nucleus of the gallery's expanding permanent collection.

A.Y. Jackson Canadian, 1882–1974

Lake Superior Country, 1924

Oil on canvas 117 x 148 cm

McMichael Canadian Art Collection, Kleinburg
Gift of Mr. S. Walter Stewart
1968.8.26

IN 1921, HAVING ALREADY explored more southerly regions of the Quebec Laurentians as well as Ontario's Algonquin Park and Algoma district, A. Y. Jackson and his Group of Seven colleagues moved on to the rougher and less aesthetically ostentatious region of Lake Superior's north shore. Lake Superior was the latest within a series of increasingly remote Group painting sites, which would eventually include the Canadian Rockies and the Arctic.

Jackson left school as a teenager to work as a delivery boy in a local commercial art firm in Montreal. From there he developed an interest and aptitude for drawing, and was soon promoted to the art department. He furthered his informal education by reading voraciously, particularly the writings of the English Victorian critic John Ruskin, and sketching outside around his home turf of Montreal. He eventually pursued formal instruction with Edmond Dyonnet and then William Brymner before moving to Chicago, where he took night classes at the Art Institute of Chicago. In 1907 he was in Paris, enrolled at the Académie Julian. Jackson began exhibiting his work after returning to Montreal in 1910 and quickly caught the attention of Toronto-based painters J. E. H. MacDonald, Lawren S. Harris, Arthur Lismer and, in 1914, Tom Thomson. Jackson famously called Thomson the great "interpreter" of the country north of Toronto, but there is no doubt that the former also imparted much of his training to the latter before Jackson enlisted in the war effort in 1915. Wounded in battle in 1916, he returned to the front in 1917 as an official war artist. After the war, Jackson became a founding member of two organizations that continue

to loom large within Canadian art history: the Beaver Hall Group in Montreal and the Toronto-based Group of Seven. Jackson's subsequent career was defined by his wry humour and tireless promotion of a certain nationalistic understanding of Canadian art. Jackson would remain in Toronto until the mid-1950s, when he moved to the Ottawa area. After suffering a stroke in 1968, the "grand old man of Canadian art" assumed residency at the newly established McMichael Canadian Art Collection, in Kleinburg, Ontario. Jackson died there in 1974, and his remains, along with five other former Group members, are interred at a small cemetery on the gallery's grounds.

Jackson, a perennial bachelor with no direct family, made travelling a constant component to his art practice. Despite his lifelong treks into the country's farthest reaches, the Lake Superior paintings best encapsulate what it was that kept drawing him back to landscape as his artistic subject. Jackson's encounter with the ravaged landscape of northern Europe during World War I also had a profound effect on how he would render the terrain north of Lake Superior in the 1920s. This region regularly displayed the effects of fire, both the devastation and the hints of new life. It is rugged and undulating—even beautiful, in an unforgiving way. While Jackson's associate Lawren S. Harris famously focused on the region's sky and the Great Lake itself, Jackson turned inland to the palisades of dark conifers surging over terra firma. With *Lake Superior Country*, painted in the fall of 1924 from sketches made at Jackfish, Ontario, Jackson shows that he had reached stylistic maturity.

Ernst Ludwig Kirchner German, 1880–1938

View of Dresden: Schlossplatz, 1926

Oil on canvas 120 x 149.9 cm

Minneapolis Institute of Arts, Minneapolis
Gift of Mr. and Mrs. John Cowles; 64.23

BEFORE TURNING TO PAINTING, Kirchner studied architecture at the Königliche Technische Hochschule in Dresden, completing his degree in 1905. He never actually practiced architecture, and in the same year of his graduation he founded the avant-garde group Die Brücke with fellow artists Fritz Bleyl, Erich Heckel, and Karl Schmidt-Rottluff, who worked and exhibited together for the next eight years in Dresden and Berlin. Ignoring the academic practices of the day, the group believed they could establish a link between the past and present, and as such they were influenced by the art of Albrecht Dürer and Lucas Cranach the Elder as well as the most current trends including Expressionism and Fauvism. Kirchner worked comfortably in painting, printmaking, and sculpture. He also was interested in a variety of genres including the urban and rural landscape, often depicted on a grand scale such as the *View of Dresden* from the Minneapolis Institute of Arts, which is one of his most important city views.

Outside of Europe, Kirchner's work was included in the 1913 Armory Show in New York, and was collected by American museums during the following decade. The Minneapolis painting was first exhibited in the United States at an exhibition of Kirchner's work at the Detroit Institute of Arts in 1933. That same year, in Germany, Kirchner had been labelled a degenerate artist by the National Socialist regime and was forced to resign from the Berlin Academy of Arts. By 1937 over six hundred of his artworks were seized from public museums in Germany and either sold or destroyed. In the following year, Kirchner committed suicide in Switzerland where he had been living since 1917.

Most of Kirchner's city views were painted from memory including *View of Dresden*, which enabled him to alter the formal elements of the scene to suit his painterly composition. In this particular work, he also rethought the colour harmonies and how they played against the architectonic nature of the scene. The painting features several key buildings in the historic centre of the city by the Schlossplatz near the river Elbe, documented here with a palette of rich purples, blues, and greens. All of the buildings depicted in this painting were extensively damaged or destroyed during the 1945 Allied bombing, which took place in the final months of the war. At the far left is the Semperoper, which houses the state opera house and concert hall. Built in 1841, the building was completely destroyed in 1945 and rebuilt forty years later to an almost identical design. To the right is the massive equestrian monument of König Johann I von Sachsen (King John of Saxony), which stands in the centre of the Theaterplatz. To the right of the monument is the Katholische Hofkirche (Catholic Church of the Royal Court of Saxony), today called the Kathedrale Sanctissimae Trinitatis (Cathedral of the Holy Trinity). The church was severely damaged during the bombing and was only restored in the 1980s. At the right is the Dresdner Residenzschloss (Dresden Castle), the royal residence of the electors and kings of Saxony from 1547 to 1918. During the Allied bombing, the castle was reduced to a roofless shell and remained that way (with the exception of a temporary roof added after the war) until the 1960s when a fifty-year restoration project was undertaken.

Henri Matisse French, 1869–1954

Nude on a Yellow Sofa, 1926

Oil on canvas 55.1 x 80.8 cm

National Gallery of Canada, Ottawa
Purchased 1958; 6971

FOLLOWING STUDIES IN LAW in Paris in the 1880s and subsequent work as a court officer, Matisse turned to painting during a period of extended convalescence. Abandoning his legal career, he enrolled in the Académie Julian in 1891 where he worked under William Bouguereau and Gustave Moreau and made frequent trips to the Musée du Louvre to study the Old Masters. Matisse had his first solo exhibition at Ambroise Vollard's gallery in 1904, which came at the height of the Fauvist movement. Matisse and André Derain, the two leaders of the Neo-Impressionist movement, exhibited together with the other Fauves in the following year at the Salon d'Automne. Matisse met Pablo Picasso for the first time in 1906, the beginning of a lifelong friendship and rivalry.

Matisse began spending the winters in Nice in 1917, eventually securing an apartment there in 1921, which became his home in the city until he moved to an apartment in the former Hotel Regina. He would only return to Paris for the summer months to escape the heat of the Côte d'Azur. Matisse turned to the female form in the 1920s and focused his paintings, drawings, printmaking, and sculptures on this subject. During this period he exchanged ideas and techniques on the subject with Claude Monet, Pierre-Auguste Renoir, and Albert Marquet. Matisse travelled to southern Italy and Sicily in 1925, returning to Nice with a renewed interest in sculpture.

The National Gallery of Canada painting is an excellent example of the artist's extended interest in the depiction of the female nude, and was painted at the height of his exploration of the sculptural form. The bold palette of yellow, white, pink, and green contrasts with the flesh tones of the figure, which fills the centre of the composition and extends across the yellow sofa. Instead of using fluid lines to define the nude form as he often did during this period, Matisse has approached his model like a sculpture. The contours of the model's body, yellow sofa, white sheet, and the floral screen define the interior space. Here the focus is on substance and volume rather than movement or line, and it is sustained by the brushwork of a brilliant colourist and the leader of the Fauves. The subtle patterns of floral and arabesque animate the surfaces and textures, but they also function within the sculptural character of the painting. This balancing of form and colour allows the viewer to understand the architectural dimensions of the entire interior space.

The female model in *Nude on a Yellow Sofa* has been identified as Henriette Darricarrère, a musician who was trained in classical ballet and who worked as a model for Matisse in the 1920s. She also is the subject of a bronze head by Matisse in the National Gallery of Canada's collection. The NGC first attempted to acquire this painting directly from Matisse in 1950 when it was included in the artist's solo exhibition at the Venice Biennale. However, after first considering the sale, Matisse decided to keep the painting for his personal collection. It was not until after the artist's death that the work was acquired from the artist's son, Pierre Matisse, giving the NGC the finest Matisse nude in the country.

Bertram Brooker Canadian (born in England), 1888–1955

Sounds Assembling, 1928

Oil on canvas 112.3 x 91.7 cm

Winnipeg Art Gallery, Winnipeg

L-80

IN THE JULY 1930 ISSUE OF *Canadian Forum*, Bertram Brooker—artist, man of letters, and advertising executive—described the poetry of E. E. Cummings as "metaphysical" because, in his words, it "inevitably tends toward the mathematical and the musical." Such an assessment might equally apply to Brooker's canvas *Sounds Assembling*. This composition, abounding in a vibratory geometry that appears at once mystical, musical, and technological, confirms Brooker as one of the earliest and most theoretically informed abstract painters in Canada.

Brooker emigrated from Surrey, England, in 1905. He and his family settled in Portage la Prairie, Manitoba, where Brooker began earning a living with the Grand Trunk Pacific Railway. A man of boundless energy, by 1914 Brooker had experience as a journalist, worked in advertising, operated a cinema in Neepawa, composed and sold film scripts, and published film criticism. In 1921 he relocated to Toronto where he started publishing the advertising trade magazine *Marketing*. He wrote and contributed poetry and criticism to periodicals such as *Canadian Forum* and wrote a syndicated column entitled "The Seven Arts" that appeared in the Southam newspaper chain. His skills as an art writer and editor were well represented by his *Yearbook of the Arts in Canada 1928–29*, the first of an intended annual series devoted to surveying the development of modern art in Canada that, with the outbreak of the Depression in 1929, proved economically unsustainable. His literary endeavours bore equally impressive results. Brooker's novel *Think of the Earth* was honoured with the first Governor General's Award for Fiction in 1936. Over and above these accomplishments, he is also

recognized as one of the country's most innovative early modern painters. In January 1927, "without any knowledge of drawing or of pigments," as he later maintained, Brooker exhibited his first "abstractions" at Toronto's Arts and Letters Club, paintings that sought to visually replicate his emotional response to music (Bertram Brooker, "Painting Verbs," in *Sounds Assembling: The Poetry of Bertram Brooker*, ed. Birk Sproxton, Winnipeg: Turnstone Press, 1980, 35). The link between abstraction and music reflects Brooker's exposure to the Russian artist Wassily Kandinsky's influential treatise *Concerning the Spiritual in Art* (1912). Two months after the Arts and Letters Club exhibition, Brooker saw Kandinsky's painting first-hand at the Art Gallery of Toronto (today the Art Gallery of Ontario) as part of the *International Exhibition of Modern Art*, which introduced Canadian audiences to the global manifestation of abstract art.

The Winnipeg Art Gallery picture was first exhibited in Toronto in February 1928. Subsequently, Brooker largely abandoned abstraction for an exacting realism. His representational turn reflected his burgeoning appreciation for the work of the Winnipeg-based Lionel LeMoine FitzGerald, whom he met in the summer of 1929 (the two men had not known each other while Brooker was living in Manitoba). What Brooker discerned in FitzGerald's art was not slavish replication, but an attentiveness to form as the vehicle for emotional expression. For his part, FitzGerald, who was then principal of the Winnipeg School of Art (at the time affiliated with the Winnipeg Art Gallery), recognized *Sounds Assembling* as an important moment in Canadian Modernism and acquired it from Brooker for the Gallery.

Charles Comfort Canadian (born in Scotland), 1900–1994

The Dreamer, 1929

Oil on canvas 101.7 x 122.1 cm

Art Gallery of Hamilton, Hamilton
Gift of The Hamilton Spectactor, 1957; 57.56T

CHARLES COMFORT IMMIGRATED to Canada from Scotland with his family in 1912, traversing the Atlantic Ocean at the same time the Titanic took its fateful voyage. They settled in Winnipeg the year that the Winnipeg Museum of Fine Arts (now the Winnipeg Art Gallery) opened. Comfort was a regular visitor to the modest but free exhibitions the museum offered, and this experience helped spur his nascent aptitude and interest in art. One year later, Comfort's own creative talents were recognized by Frederick Brigden after the Toronto artist awarded first prize to a painting Comfort had submitted to a YMCA exhibition. Brigden, in Winnipeg to oversee the establishment of a branch of his family's commercial art firm, hired the young teenager as a studio apprentice, and later as a layout artist, at Brigdens Limited. Comfort not only emerged as one artist among a significant coterie who would help redefine modern Canadian painting in the 1930s, he would also serve as director of the National Gallery of Canada from 1959 to 1965.

Having acquired a solid technical foundation in printmaking, drawing, and watercolour in Winnipeg, Comfort used his relocation to Toronto in 1925 to begin serious explorations in oil. Two years later, the *International Exhibition of Modern Art* opened at the Art Gallery of Toronto (now the Art Gallery of Ontario). For many Canadians, it provided their first exposure to Modernism. For Comfort, who had already discovered the formalist criticism of Clive Bell and had studied for roughly six months in New York under senior American Modernists like Robert Henri, the exhibition of more than one hundred fifty works confirmed his outlook. The Futurist reimagining of the Brooklyn Bridge by the Italian-American painter Joseph Stella proved particularly memorable for Comfort, and may have

inspired the stark design, spatial ambiguity, and brashly coloured background in *The Dreamer*. Within Comfort's oeuvre, this portrait constitutes a milestone. The face's garish underlighting, the figure's rigid unnatural pose, and the painting's overall Modernist sensibility mark a vivid originality that Comfort would not return to for another two decades with his first tentative forays into abstraction. The Art Gallery of Hamilton work appeared in several exhibitions during the early 1930s and garnered significant public attention, with one critic complaining that the subject resembled a dazed, freshly pummelled boxer. It was acquired by the AGH from the artist in the 1950s, more than twenty years after it had last been on public display.

The Dreamer is, even by today's standards, an unconventional and unsettling portrait. It depicts Norman Robertson, an architect and friend of the artist. According to Comfort, Robertson was an avid reader who took interest in the social and ethical problems facing a civilization still reeling from the effects of World War I. Through a half-dozen sittings, Robertson and Comfort discussed artistic, literary, and social ideas that had been recently expounded by such polarizing figures as André Breton, André Gide, Norman Douglas, and Aldous Huxley. Letters pertaining to the surnames of the latter three float and fade in the background, transforming the portrait into a denuded dreamscape of unattached signifiers, a world stripped of empirical quality. Centrally placed, the enrobed Robinson stares out with delirious intensity, avoiding the viewer's gaze. He appears to be reclining, although his bathrobe's flattened, overexposed contours and the backdrop's recessional confusion only add to his distorted physical appearance. The wide eyes, the splayed fingers, the elevated ridge of his shoulders suggest someone less than at ease.

Lionel LeMoine FitzGerald Canadian, 1890–1956

Poplar Woods, 1929

Oil on canvas 71.8 x 91.5 cm

Winnipeg Art Gallery, Winnipeg
Acquired in memory of Mr. and Mrs. Arnold O. Brigden; G-75-66

ALTHOUGH HE IS OFTEN remembered as the last artist to join the Group of Seven, Lionel LeMoine FitzGerald is more accurately characterized by his rooted and solitary independence. He was a great correspondent, and befriended artists across the country. He was collegial and an active contributor to the artistic and cultural life of his community. Nonetheless, as critic Robert Ayre noted philosophically, "freedom for FitzGerald," the "Painter of the Prairies," meant "staying home" (Robert Ayre, "Painter of the Prairies," *Weekend Magazine* vol. 5, no. 2, 1958, 31).

FitzGerald was born in Winnipeg, although his family's connections in Manitoba were originally to the farming community of Snowflake. As a youth he was enamoured of that region's intense light and spaciousness, and returned frequently as an adult to sketch the landscape. His public school education ended when he turned fourteen and began a spate of odd jobs, eventually working at a local commercial art firm just before World War I. In a city that lacked a professional art school until 1913, FitzGerald struggled to nurture an artistic ability and confidence, studying privately with the local artist Alexander Keszthelyi sometime between 1905 and 1910. By the end of the war, FitzGerald had developed to such a degree that the National Gallery of Canada purchased a painting from him. In 1921 he was given a solo exhibition at the Winnipeg Museum of Fine Arts (today the Winnipeg Art Gallery). FitzGerald used the funds he earned from the sale of work toward financing six months of study at the Art Students League in New York. His work from the 1920s shows the distinct influence of Paul Cézanne as well as two of FitzGerald's instructors at the League, Kenneth Miller and Boardman Robinson.

Back in Winnipeg, by 1924 FitzGerald was working as an instructor at the Winnipeg School of Art under principal Frank Johnston, a founding member of the Group of Seven. In 1928 he caught the attention of other Group members with an exhibition of drawings at Toronto's Arts and Letters Club, and in 1932 was invited by Arthur Lismer to join the association. Membership would be short-lived as the Group disbanded later that year; however, in 1933 they re-formed along with FitzGerald as the much larger Canadian Group of Painters. An enthusiastic instructor, FitzGerald nonetheless felt that the demands of his teaching career encroached on his capacity to develop as an artist. In 1947 he left the school on a sabbatical and never returned. His later work is typified by a gradual shift into an elegant, classically inspired form of abstraction. In 1958, two years after his death, a memorial exhibition toured to Ottawa, Toronto, and Montreal, as well as Winnipeg, testifying to FitzGerald's impact on the national art stage.

The Winnipeg Art Gallery work is an early example of FitzGerald's mature style. It contains the fundamental elements—the precise articulation of form, the earthy hues, the biomorphic contours —that are found even in his later canvases exploring abstraction. The canvas was painted the same year that the artist became principal of the Winnipeg School of Art and, most significantly, the year he first met an important pioneer of non-objective painting in Canada, Bertram Brooker. He and Brooker developed a lasting friendship. Moreover, Brooker expressed great enthusiasm for FitzGerald's particular naturalism, and demonstrated this appreciation by reforming his own painting style to reflect the qualities of paintings like *Poplar Woods*.

Lawren S. Harris Canadian, 1885–1970

Icebergs, Davis Strait, 1930

Oil on canvas 121.9 x 152.4 cm

McMichael Canadian Art Collection, Kleinburg
Gift of Mr. and Mrs. H. Spencer Clark
1971.17

ICEBERGS, DAVIS STRAIT, by one of the Group of Seven's most vocal and captivating figures, dates from a period when Lawren S. Harris sought a greater understanding of the Canadian landscape than what was proximal to his home in southern Ontario. Harris was the Brantford-born son of entrepreneurial farmers who had invented a harvesting machine that cut and bundled grain. The artist's grandfather started a successful company that manufactured farming equipment. The family amassed a great fortune when it merged its business in 1891 with its main competitor, Massey Manufacturing, to form the Massey-Harris Company, the largest of its kind in the British Empire.

Harris, who was independently wealthy throughout his life, studied art in Berlin between 1904 and 1908. He settled in Toronto where he soon developed close friendships at the Arts and Letters Club with a network of like-minded British and Canadian artists who were unsatisfied with the current state of art in the country. In 1913 he travelled to Buffalo, New York, with J. E. H. MacDonald to see an exhibition of contemporary Scandinavian painting. The exhibition helped convince Harris of the need for an analogous national school of painting in Canada, one based around a dramatic and decorative approach to depicting the nation's landscape. The Group of Seven formed in 1920 with Harris as its public profile and unofficial leader. Initially devoting his time to exploring and painting the slums and working-class suburbs of Toronto, Harris soon began traversing what he and his colleagues called the North Country including Georgian Bay, the Laurentians, and Algonquin Park. Gradually, conscious that a crucial aim of the Group was to paint the natural diversity of the country, he struck out further afield, to the Algoma region north of Lake Huron, then to the north shore of Lake Superior, and finally to the Rocky Mountains.

The McMichael work (originally titled *Icebergs, Smith Sound*) was painted from studies Harris executed while aboard the *Beothic*, a northern supply ship operated by the Canadian government. The vessel completed an extensive tour that included navigating the coastal waters off Greenland, Baffin and Ellesmere Islands, and up into the Kane Basin via the Davis Strait, within a few hundred kilometres of the North Pole. Earlier, in 1927, A. Y. Jackson and Frederick Banting (the Nobel Prize–winning co-discoverer of insulin and also an accomplished amateur painter) had embarked on a similar journey. Harris reports having had to develop his sketches rapidly inside the crowded ship and under insufficient light. He also took photographs, many of which include Inuit, and yet human presence is so thoroughly absent from his Arctic work in general, and the McMichael picture in particular. This painting suggests a magisterial isolation that, for Harris, did not denote a negative physical condition, but a positive state of consciousness that freed the mind from empirical detail and visual noise. The arctic canvases were some of the last works the artist painted before the Group disbanded in 1933, and before he would move into a distinctly abstract idiom.

Icebergs, Davis Strait was acquired from H. Spencer Clark and Rose Hewetson Clark in 1971 by the McMichael Canadian Art Collection, which holds one of the largest Group of Seven collection in the world. The Clarks were Toronto art patrons best known for establishing the Guild of All Arts co-operative during the Depression years, which Harris and other members of the Group often visited.

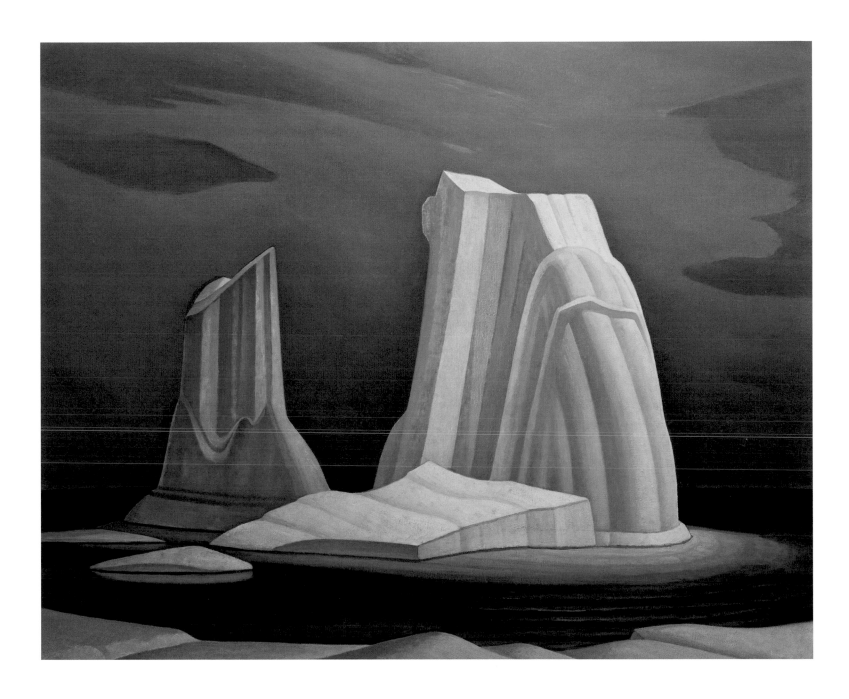

Prudence Heward Canadian, 1896–1947

Sisters of Rural Quebec, 1930

Oil on canvas 157.4 x 106.6 cm

Art Gallery of Windsor, Windsor
Gift of the Willstead Art Gallery of Windsor
Women's Committee, 1962; 1962.016

WHILE THEY DISPLAY A stark respect for verisimilitude, Prudence Heward's portraits are concerned with more than just the quest for resemblance. The simplified, broadly painted forms and her linear treatment of shapes are quintessentially modern, and serve to heighten the psychological dimensions and social status of her subjects. Heward was born into a wealthy Montreal family. Her early life was marked by the death of her father and two sisters. With her remaining family, she relocated to England in 1912 where she was directly exposed to the modern aesthetic theories of Roger Fry and the Bloomsbury Group. After World War I, she returned to Canada and enrolled in studies at the Art Association of Montreal (today the Montreal Museum of Fine Arts). She became active in a network of painters at art school, notably women such as Sarah Robertson, Anne Savage, and Kathleen Morris. These artists would form, in 1920, the short-lived and informal—but important—Beaver Hall Group. Awarded the Women's Art Society prize for painting in 1924, Heward continued her fine art education in Paris. She studied at the Académie Colarossi with the Post-Impressionist painter Charles Guérin as well as at the École des beaux-arts. Two of her paintings were displayed at Wembley, England, in the pivotal British Empire Exhibition in 1925. In 1928, along with fellow Canadian artist Isabel McLaughlin, Heward developed an interest in the work of André Lhote and Tamara de Lempicka while studying at the Scandinavian Academy in Paris.

Heward's skill as a portraitist and figure painter was first recognized in the late 1920s when her work was exhibited on several occasions alongside that of the Group of Seven. After the Group's dissolution in the early 1930s, she became a founding member of the larger and more inclusive Canadian Group of Painters. Although collegial with the Group, Heward's focus on the figure set her apart from their anchored place in landscape painting. When she did paint the Canadian landscape, it served as the stage for figures, which were usually poised female nudes. The recurring portraits of girls and young women that appear in her work, and how she depicted them—alternately world-weary and displaced, confident, and even confrontational—stands in dramatic contrast to the peasants, nymphs, wives, and mothers-in-waiting that characterized earlier representations of women by Canadian figure painters.

Child subjects famously presented a unique challenge and opportunity to the modern portrait painter. Proximate, but never fully accessible to the adult viewer, the child's image came to be analogized as the perceived inaccessible interiority of the adult self. The two sitters in *Sisters of Rural Quebec* are rendered in a manner that is identical to their environment: jagged angles, hard edges, and intersecting forms appear in equal measure, articulating figure, foliage, and the minimal architectural setting. The viewer's eye is made to run a zigzag, before settling on the three-quarter portrait of the sister who returns our inquiring gaze with a confrontational stare. Her dark reclining body frames her sibling who, in marked contrast, stares off absently to the lower right, away from the viewer. Alone in her thoughts, the second sister is a vision of the modern self, an inwardness into which the subject must retreat, over and against the world.

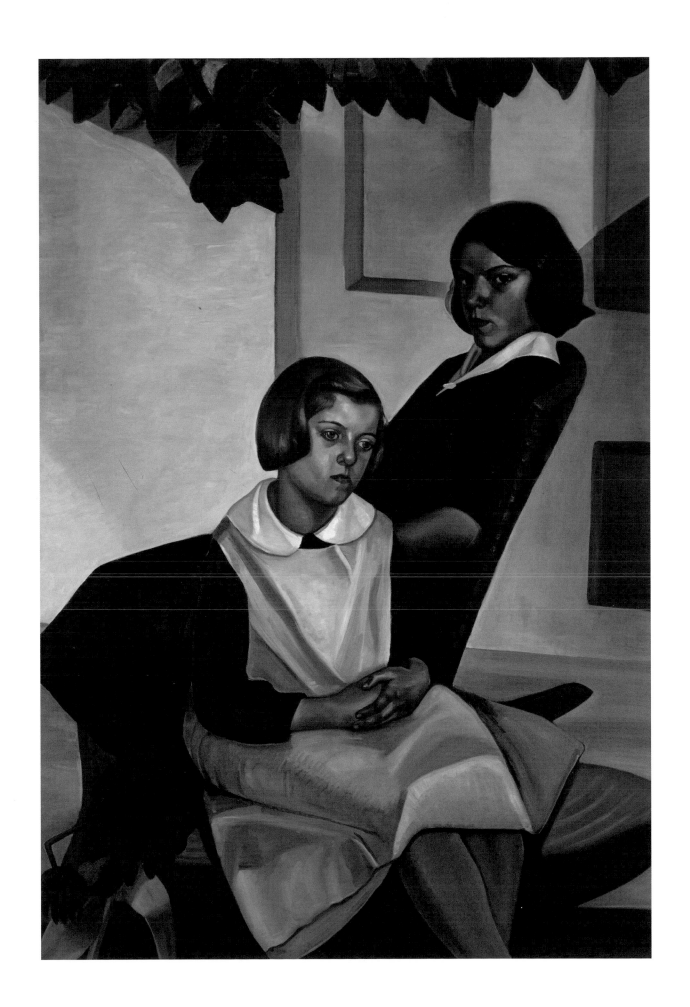

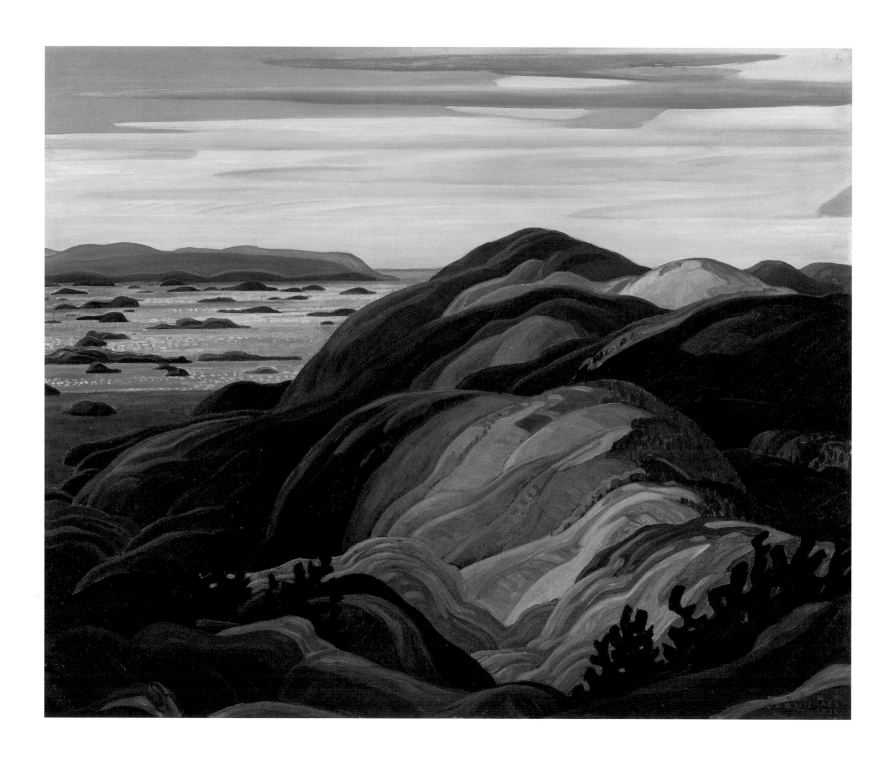

Franklin Carmichael Canadian, 1890–1945

Bay of Islands from Mt. Burke, 1931

Oil on canvas 101.6 x 122 cm

McMichael Canadian Art Collection, Kleinburg
Gift of Mr. and Mrs. R. G. Mastin
1975.62

FRANKLIN CARMICHAEL was the youngest founding member of the Group of Seven. Lacking independent wealth and beholden to important family responsibilities throughout much of the Group's existence, Carmichael developed slowly but surely, as time and money would allow. His soaring vistas from the mid-1920s and 1930s of Ontario's La Cloche region, north of Lake Huron, stand as his most remarkable and consistent achievement.

Carmichael was born in Orillia, Ontario. His art education began as a decorative painter for his father's carriage business. In 1911 he moved to Toronto, studied with George Reid at the Ontario College of Art, and apprenticed at the commercial art firm Grip Limited. At Grip, Carmichael worked under J. E. H. MacDonald and alongside Arthur Lismer, Frederick Varley, and Frank Johnston, all future members of the Group of Seven, as well as Tom Thomson. He travelled overseas to study briefly at the Royal Academy of Fine Arts in Antwerp. He returned to Toronto just as World War I broke out and resumed working as a graphic designer. After the formation of the Group of Seven in 1920, only Carmichael continued employment as a commercial artist at Grip, and then later for the firms Rous and Mann and Sampson-Matthews, before gaining a teaching position at the Ontario College of Art in 1932. Carmichael's earliest work shows the strong influence of Lawren S. Harris, with whom he shared a certain level of interest in Theosophy's understanding of the hidden spiritual dimension of the natural world. However, by the mid-1920s his work began displaying a unique sensitivity and refinement. Carmichael especially distinguished himself within the Group as a watercolourist, and in 1925 was a founding member (and later president) of the Canadian Society of Painters in Water Colour.

At his best, Carmichael is able to transpose the translucent, dappled light found in his watercolours to his oil paintings. The McMichael work is exceptional in this regard. Through the 1920s, working full time to support a wife and young daughter, holidays and family excursions often doubled as sketching trips. Carmichael first visited the La Cloche region in 1924 while visiting family in Sudbury. He was enamoured of the dynamic landscape, high vantage points, and especially the quality of light, the laws of which, he said, "didn't always apply" (Megan Bice, *Light and Shadow: The Work of Franklin Carmichael*, Kleinburg, ON: McMichael Canadian Art Collection, 1990, 43). While other Group members gradually began to strike out farther afield, Carmichael remained rooted in Ontario and especially to La Cloche where he returned to paint almost annually for the rest of his life. He eventually purchased land and built a cabin near Cranberry Lake.

Bay of Islands from Mt. Burke displays the artist's proclivity for the region's scenery in early fall. Near the bottom, strands of yellow and gold fold together like fingers, forming a valley that is inversely reflected by the brooding peak of green and grey that obscures the horizon. Between valley and peak, the terrain undulates like a strange fabric, dipping and cresting in languid choreography. A distant archipelago forms a flotilla in the shimmering water, lit by a cold sky.

Emily Carr Canadian, 1871–1945

Big Raven, 1931

Oil on canvas 87 x 114 cm

Vancouver Art Gallery, Vancouver
Emily Carr Trust; VAG 42.3.11

EMILY CARR, A PAINTER AND writer who lived a relatively isolated life in Victoria, British Columbia, stands today as one of Canada's most popular and important artists. She was born in Victoria the year British Columbia became Canada's sixth province. She attended the California School of Design in San Francisco in the early 1890s, before receiving further formal instruction in Britain from 1899 to 1905. In London she discovered a love for the English *plein-air* painting tradition. With her return to British Columbia, Carr's interest in Northwest Coast First Nations people and material culture blossomed. A vacation to Alaska in 1907 was, in the words of art historian Gerta Moray, "a decisive event" that not only convinced the artist to paint "a pictorial record of totem poles," but also that she lacked the skills to do so (Gerta Moray, *Unsettling Encounters: First Nations Imagery in the Art of Emily Carr*, Vancouver: University of British Columbia, 2006, 81). Carr addressed this perceived shortcoming by travelling to France in 1910 where she was exposed to Post-Impressionism (particularly Fauvism) and to European Modernism's general infatuation with the cultural objects of non-Western societies. Carr's appreciation of and approach to representing the Indigenous art of her Northwest Coast were reinvigorated. The first body of mature work she executed upon returning to British Columbia in late 1911 consisted of landscapes and paintings of First Nations villages. Observational and ethnographic, this body of work also displayed distinctly modern passages that convey a vivacious and contemporary view of the life of First Nations people. Carr garnered little public interest from an exhibition of her 1912 works held a year later in Vancouver. Although she met and received encouragement from the important and innovative American artist Mark Tobey, Carr produced very little

of her own work until 1927. That year, over two dozen of her pieces from 1912 were paired with artifacts from Northwest Coast First Nations in an exhibition at the National Gallery of Canada entitled *Canadian West Coast Art, Native and Modern*. The exhibition also included work by the Group of Seven, for whom Carr felt great kinship. She was particularly drawn to Lawren S. Harris for his manner of representing the Canadian landscape and the spiritual significance he ascribed to it.

Through the late 1920s and early 1930s, Carr resumed painting First Nations material culture and the British Columbia landscape. However, the earlier documentary quality is transcended by a decidedly subjective and monumentalizing vision. The Vancouver Art Gallery work, which is based on a watercolour the artist made in 1912, is one of Carr's most popular works from a series of totem paintings completed at this time. The canvas shows a carved raven perched amidst the elements of a swirling West Coast landscape. All aspects of the work—the totem, the trees, the distant shafts of penetrating light—are articulated by the same smooth modelling, bear the same dimensional girth, and together convey great formal unity. Yet, as Carr wrote in her journal, the image is one of "great loneliness," "great broodiness," and expresses a sense of nature's profound impartiality (Emily Carr, *Hundreds and Thousands: The Journals of Emily Carr*, Toronto: Clark, Irwin, 1966, 26). *Big Raven* typifies Carr's best-known and briefest period. In the early 1930s, landscape forms became her dominant subject, and her paint application became thinner, her technique looser, almost calligraphic. In 1937, after suffering a heart attack, Carr abandoned her painting practice for writing.

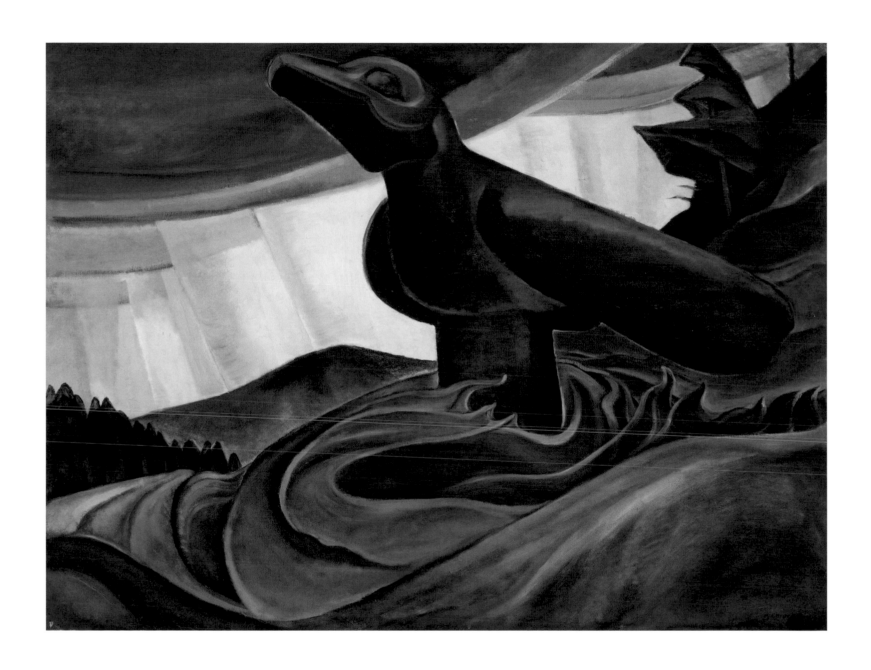

Edwin Holgate Canadian, 1892–1977

The Bathers, 1937

Oil on canvas 81.3 x 81.3 cm

Montreal Museum of Fine Arts, Montreal
Purchase, Robert Lindsay Fund; 1937.664

EDWIN HOLGATE'S CONTRIBUTION to Canadian art extends well beyond his association with the Toronto-based Group of Seven, just as his oeuvre encompasses more than paintings of wilderness landscapes. A careful and exquisite draughtsman, Holgate directed his skill at a wide range of subjects. His figures and sensitive portraits, rendered in oil or as dramatic wood engravings, convey a remarkable sense of solid composure and weight. When he attends to the figure within the landscape, as he does in *The Bathers*, Holgate's talents are fully revealed.

Edwin Holgate was a founding member of the Beaver Hall Group, a short-lived, loosely associated, but highly influential, coterie of Montreal artists. The artists of this group shared a certain degree of stylistic affinity with the Group of Seven—indeed, A. Y. Jackson was also a founding member of Beaver Hall—but maintained an interest in the human figure that was less prevalent in the work of most Group of Seven members. Holgate was, however, also an avid painter of place. Taught by William Brymner and Maurice Cullen at the Art Association of Montreal (today the Montreal Museum of Fine Arts), Holgate's coursework included outdoor sketching. He continued his art education in Paris, studying initially at the Académie de la Grande Chaumière, then resumed his studies in Paris after World War I at the Académie Colarossi. René Ménard, who instructed Holgate before the start of the war, introduced his student to painting the female nude within a natural surround, a theme Holgate would rediscover back in Montreal in paintings by Marc-Aurèle de Foy Suzor-Coté and Randolph Hewton. Holgate remained close friends with A. Y. Jackson, and through the 1920s the two

often painted together in various locations in Quebec and on the West Coast. In 1929 Holgate was invited to join the Group of Seven; his membership represented a rejoinder to critics who charged that the Group was too Toronto-centric to be truly representative of a national school. When the Group disbanded in 1933, Holgate became a founding member of its more inclusive successor, the Canadian Group of Painters. Throughout the 1930s, he also taught art classes alongside Lilias Torrance Newton at the Art Association of Montreal.

In 1930 the artist Bertram Brooker observed that Holgate's work was distinguished from that of other Group of Seven members for "placing emphasis on 'form' . . . instead of 'rhythm'," and as such bore "a closer relation to the modern movement in other countries" (Bertram Brooker, "The Seven Arts," *Ottawa Citizen*, 19 April 1930). At Académie Colarossi, Holgate had received instruction from the Russian painter Adolf Milman, whose volumetric rendering of figures are echoed in the Montreal Museum of Fine Arts work. In this painting, figure and land receive similar and equal treatment, even though each element was painted on separate occasions (the nudes were sketched in the artist's studio). Flesh, rock, water, and verdant shoreline are all rendered in broad and well-defined zones of bold colour. Interestingly, the structured composition of the painting—its emphasis on decorative design— may also be seen as working to lessen its otherwise erotic implications. The painting was exhibited at W. Scott & Sons gallery in Montreal the same year it was completed, and was promptly purchased by what is today the Montreal Museum of Fine Arts.

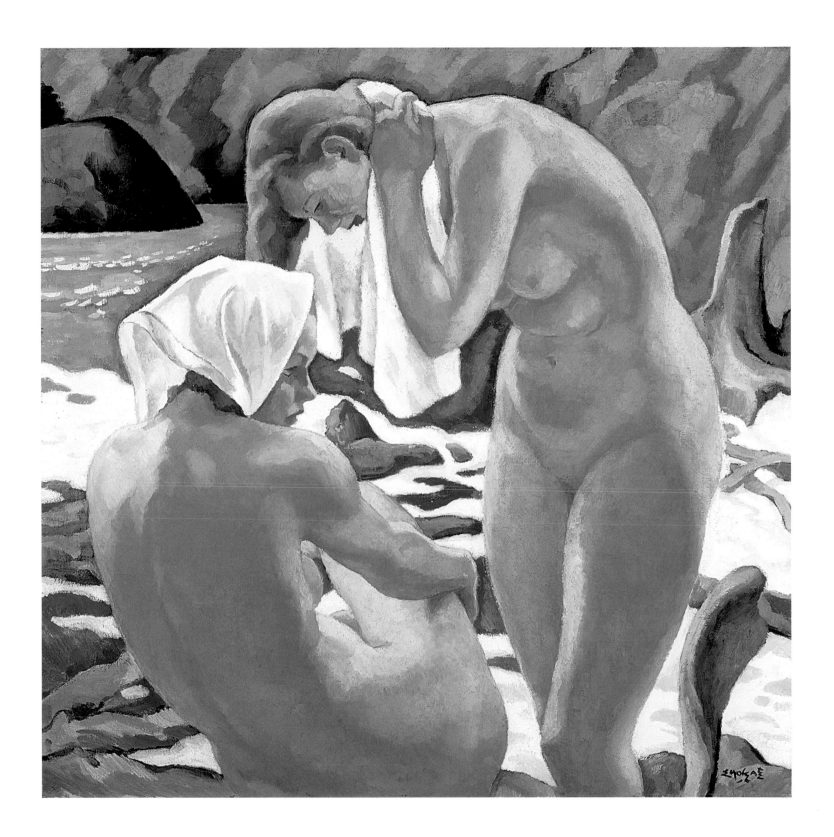

Frederick H. Varley Canadian (born in England), 1881–1969

Mirror of Thought, 1937

Oil on canvas 48.8 x 59.2 cm

Art Gallery of Greater Victoria, Victoria
Gift of Harold Mortimer-Lamb; 1978.104.001

ALTHOUGH A COMMITTED landscape painter like his fellow founding members of the Canadian Group of Seven, Frederick Horseman Varley was an equally talented portraitist. Based in Toronto from 1912 (when he emigrated from Sheffield, England) to 1926, his output—with the exception of canvases he painted as a war artist in Europe between 1918 and 1920—consisted largely of commissioned society portraits and scenes depicting the landscapes of southern Ontario's northern region. Varley was, by most accounts, a complex personality. Contemporaries found him unconventional, and as early as the 1910s, when he produced a number of romantic portrait studies and scenes depicting Gypsies and their nomadic way of life, the artist projected an attitude and outlook that, if not exactly in outright opposition to polite society, was certainly intrigued by its margins.

In the autumn of 1926, along with his wife, Maud, and their young family, Varley relocated to Vancouver. He had been hired to teach at the newly formed Vancouver School of Decorative and Applied Arts, and he yearned for a new setting that would inspire greater experimentation. If anything, the majestic and monumental environment of the Northwest Coast increased Varley's already keen interest in landscape painting. Vancouver also introduced new muses to the artist. One of his students, Vera Weatherbie, became both his lover (although he was married and twenty-nine years her senior) and a recurring model. To this day, Varley's portraits of Weatherbie project "an intensity unrivalled in Canadian art" (Katerina Atanassova, *F. H. Varley: Portraits into the Light*, Toronto: Dundurn, 2007, 84).

Resigned from the VSDAA since 1933, and unable to sustain his upstart British Columbia College of Art, by 1935 Varley found himself without a secure income and a need to leave the West Coast. In 1936 he moved to Ottawa, but he returned to Vancouver for a brief stay during the summer of 1937, which was when he started painting *Mirror of Thought*. This canvas signals not only the end of Varley's time in British Columbia, but the end of his affair with Weatherbie (although they would remain correspondents) as well as the end of his marriage. As if for the last time, the artist, his expressionless face reflected in a mirror that hangs like a corpus upon a window pane cross, stares out from his Lynn Valley studio to Rice Lake Bridge where two figures—presumably lovers—stand idly together. A portrait and a landscape painting, the hardened reflection and the unsettled terrain serve as metaphorical externalizations of the artist's state of mind. The image reads as a personal lament to the revelation that a very significant and enriching part of the artist's life had come to an end. Interestingly, before this painting was acquired by the Art Gallery of Greater Victoria, it was owned by Harold Mortimer-Lamb, a photographer, progressive art critic, and colleague of Varley's, who married Vera Weatherbie in 1942.

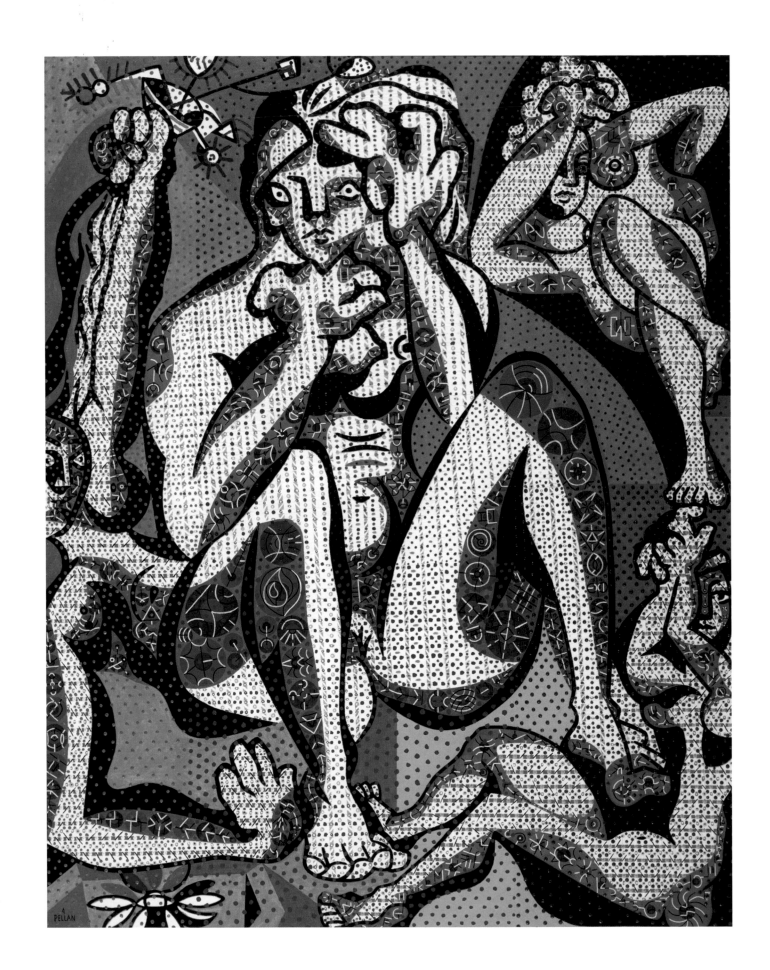

Alfred Pellan Canadian, 1906–1988

Quatre femmes (Four Women), 1944–1947

Oil on canvas 208.4 x 167.8 cm

Musée d'art contemporain de Montréal, Montreal
A 71 27 P 1

ALFRED PELLAN'S ARTISTIC STAR rose quickly. Enrolling at Quebec City's École des beaux-arts in 1920, he sold his first work to the National Gallery of Canada two years later at the age of seventeen. Upon graduation he was awarded a provincial scholarship that allowed him to maintain his studies in Paris at the École supérieure nationale des beaux-arts. The accolades continued overseas, for in 1928 Pellan won the school's annual painting prize. Although his scholarship funds expired in 1930, he continued to live in France, receiving financial support from his father and working as a graphic and fabric designer. The investment and dedication paid off. By 1940, the year he returned to Canada amidst the outbreak of World War II, Pellan had contributed to major European and American exhibitions. His work appeared alongside that of Pablo Picasso, André Derain, Raoul Dufy, Fernand Léger, and Salvador Dalí. Pellan was, himself, on collegial terms with many of these same artists. Moreover, before he left, Pellan's work had been acquired by major French institutions such as the Musée national d'art moderne.

Not yet forty years of age, Pellan brought his abiding appreciation for and knowledge of European Modernism—particularly for Cubism, Fauvism, and Surrealism—back to Canada. He settled in Montreal and was soon hired to teach painting at the École des beaux-arts. Exhibitions of his Paris work received positive reviews from influential figures such as the critic Robert Ayre and art historian Maurice Gagnon, and the artist quickly developed friendships with the peers who shared his enthusiasm for Modernism including John Lyman, Jacques de Tonnancour, Jori Smith, Philip Surrey, and Goodridge Roberts.

Quatre femmes combines eroticism with a contorted sense of figuration. Following a Cubist formal device, especially as it was deployed by Léger, Pellan incorporates decorative designs that appear mechanically rendered toward the construction of spatial ambiguity. The tactile patterns of the massive painting, which the artist laboured on for three years, resemble fabric designs, and thus illustrate the way in which the artist was able to draw on his past experience with many aspects of visual culture. A sense of eroticism and violence—competing aspects of the same Cubist coin at least since Picasso's 1907 *Les demoiselles d'Avignon*—are suggested by the presence of languorous nudes on the one hand and their contorted competition for space within the picture plane on the other. The large, seated central figure stares back at the viewer, expressionless and yet clutching her neck and head while the ball of her left foot presses into the yielding midsection of another of the nudes.

Pellan's interest in plastic form and decorative eclecticism placed him in relief to the graphic impulsiveness of his Automatiste contemporaries, led by Paul-Émile Borduas. After completing *Quatre femmes*, Pellan formed Prisme d'Yeux, a group of artists that was drawn to modern modes of artistic production, but resisted what they saw as the overly narrow understanding of Modernism being advanced by Borduas and the Automatistes. Prisme d'Yeux only lasted until 1950, at which point a new generation of Quebec Modernist painters began following a more resolutely abstract and geometric approach to their work.

Alex Colville Canadian, 1920–

Infantry, near Nijmegen, Holland, 1946

Oil on canvas 101.6 x 121.9 cm

Canadian War Museum, Ottawa
Beaverbrook Collection of War Art; CWM 19710261-2079

IN 1916 CANADA BECAME the first country to oversee an official war art program with the establishment of the Canadian War Memorials Fund by the New Brunswick-raised businessman, and British politician and peer Max Aitken (Lord Beaverbrook). Inserted into barracks, training camps, munitions plants, and the front line of combat, these artists succeeded in creating a rich visual record of wartime activities and conditions overseas and on the home front. The program was reintroduced during World War II. In 1942 a youthful Alex Colville, nearing the end of his fourth year as a fine art student at Mount Allison University in New Brunswick, enlisted to fight with the Canadian military. Initially a member of the infantry, he was promoted to the rank of second lieutenant. In 1944 he became one of the military's thirty-one official war artist-officers.

Colville's wartime fieldwork was largely undertaken in ink and watercolour. His first subjects were scenes done around Yorkshire, England, and depicted the maintenance and transport of wartime equipment. He later completed sketches aboard the HMCS *Prince David*, which conducted raids along the coast of France and into the Mediterranean Sea. His final tour saw him marching through the Low Countries with the 3rd Canadian Infantry Division, initially recording events of everyday life and the scarred landscape. Colville began to develop a greater interest in expressing the toll the war was having on its human soldiers, rather than simply rendering what he described as "local atmosphere." He continued to make field sketches, however, in February 1945 he envisioned painting a larger canvas that would communicate a broad feeling about the experience

of war. The Canadian War Museum work (originally titled simply *Infantry*) was completed by the artist in Ottawa, several months after he had made his first sketches. Although it denotes a specific place and depicts a particular group of infantrymen—the Royal Winnipeg Rifles—Colville's image is aimed at the broader theme of war itself, and it bears little in common with his earlier, documentary approach.

With *Infantry, near Nijmegen, Holland*, Colville adopts an approach to a wartime subject that becomes familiar later in his post-war scenes of domestic life, repose, and leisure. The line of soldiers trudging along a flat, barren landscape of snow, mud, and ice conveys more than a particular event or moment in time. In the painting, a corporal—whose face, Colville has acknowledged, resembles his father's—leads the column of men who trail behind. The figures do not appear to move through time and space so much as they endure it with Sisyphean resolve, and point to Colville's intention for his art to provide a means of existential reflection. The geometrical scheme—the use of a vanishing point to suggest both disappearance and infinity—lends weight to the image, and helps establish the mood of preternatural stillness. In an age that increasingly understood the modern artist as spontaneous and expressive, the Ottawa painting stands out for its pictorial engineering. Of course, the apparent rationalism of Colville's artistic process stands in deep contrast to its content—the irrational devastation of war, its physical and psychological wreckage.

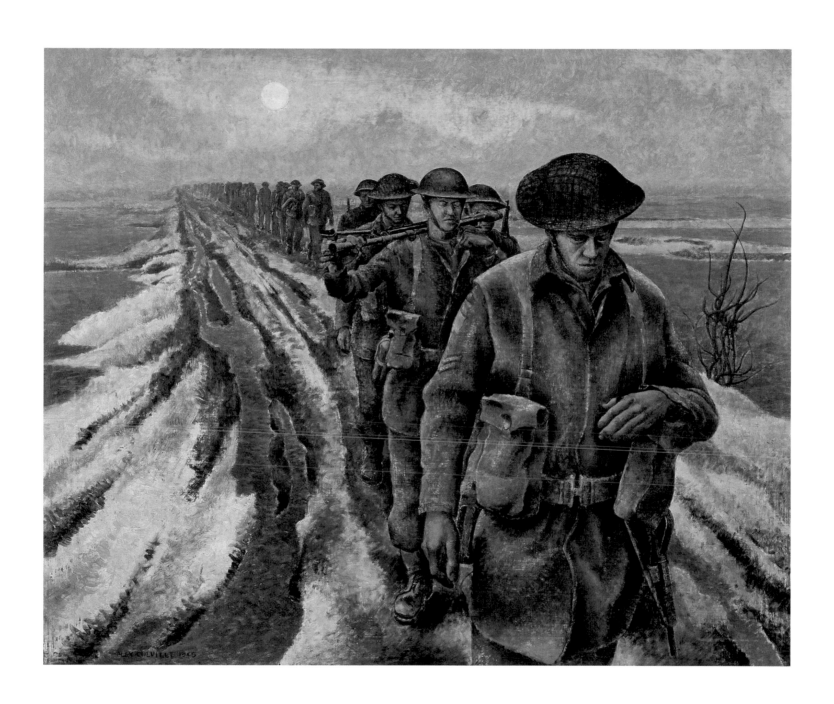

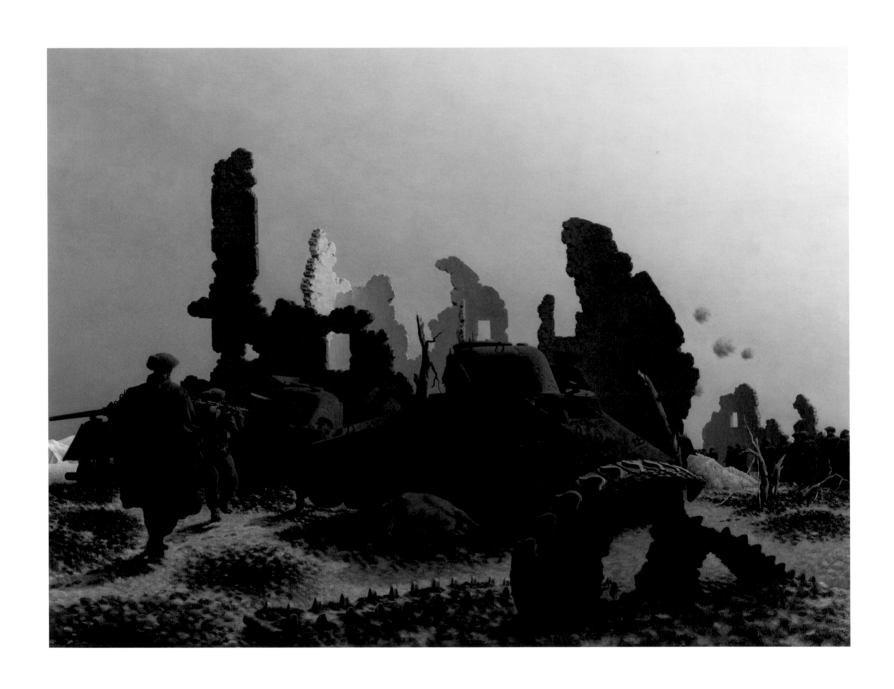

Lawren P. Harris Canadian, 1910–1994

Reinforcements Moving up in the Ortona Salient, 1946

Oil on canvas 76.3 x 102.1 cm

Canadian War Museum, Ottawa
Beaverbrook Collection of War Art; CWM 19710261-3100

ON SEPTEMBER 3, 1943, Allied forces landed along three southern shores on the Italian mainland, initiating what would be a very slow and treacherous liberation campaign. Lawren P. Harris, one of the first to be hired as an official war artist for Canada in World War II, accompanied Canadian troops through Italy. The son of a founding member of the Group of Seven, he received his art training from his father Lawren S. Harris, and also at Toronto's Central Technical School and at the School of the Museum of Fine Arts, Boston where his instructors included the British landscape and figure painters Rodney J. Burn and Robin Guthrie. After the war, Harris would make his mark as an educator at Mount Allison University in New Brunswick, working alongside Alex Colville to establish that university's School of Fine and Applied Arts as the centre of Atlantic Realism. Harris's realism, like Colville's, was not fundamentally illustrative or naturalistic. Before the war he was, in fact, approaching abstraction, a tendency that built momentum in his post-war work after he witnessed the innovations of Wassily Kandinsky, Piet Mondrian, and Rudolf Bauer in New York in 1946. Nonetheless, whether figurative or abstract in his subject matter, Harris's technique remained invariably precise.

Harris arrived in Italy in 1944 as part of the 5th Armoured Division. His painting depicts Canadian soldiers marching through ruins and over charred debris in the ancient town of Ortona. The view is of the aftermath of the Battle of Ortona, which took place in late 1943 and represented the Italian campaign's first major challenge for the Canadian contingent. Much of the fighting involved navigating narrow streets and "mouse-holing" (smashing through walls). To create his war canvases, completed back in Canada in 1946, Harris worked from watercolours he had undertaken in the field as well as from photographs. The overall effect in the Canadian War Museum picture, which Harris admitted was one of his personal favourites, is unsettling and nightmarish rather than documentary. The colours are limited, but evoke a sense of contrast between cool greys and warm browns and greens. The buildings, or what remains of them, appear torn, as if constructed of paper or cardboard. The central feature, a burned-out British Sherman V tank, looms over a twisted animal carcass. This tank, T-146480, belonged to the 11th Canadian Tank Regiment before it was destroyed on or about the second day of the Battle of Ortona. A tank track rises out of the snow-dusted earth like monstrous tentacles from a mist-covered lagoon. There is also a disturbing neatness and formal order to the scene, which perversely emphasizes the destruction and chaos.

Laurence Stephen Lowry British, 1887–1976

Beach Scene, Lancashire, 1947

Oil on canvas 71.4 x 91.4 cm

Beaverbrook Art Gallery, Fredericton
Gift of the Beaverbrook Foundation; 1959.321

BORN IN STRETFORD, LANCASHIRE, Laurence Stephen Lowry spent much of his life close to his birthplace, and the bulk of his paintings and drawings depict scenes from this region in northwest England. He considered himself to be self-taught, though he studied fine art at a number of schools including the Municipal College of Art in Manchester and the Salford School of Art. As a child he lived in a comfortable suburb of Manchester; however, financial difficulties forced his family to move to Pendlebury, an industrial suburban area in the city of Salford, near Manchester. The main industry of Pendlebury was mining and textile manufacturing, and these activities and structures provided the subject matter for many of Lowry's paintings. Recalling his trips to communities in the north of England, Lowry told the art critic Edwin B. Mullins: "For a great many years, when I was very active, I used to visit all the industrial towns and stop a couple of nights in each . . . And I always gravitated to the poorer areas. It wasn't that I felt sorry for those people; they were just as happy as anyone else, and certainly as happy as I was" (Edwin B. Mullins, *L. S. Lowry, RA: Retrospective Exhibition,* London: Tate Gallery, 1966). Today, his paintings have come to symbolize the working-class communities of the north in the same way John Constable and J. M. W. Turner are associated with specific places and characteristics of the English landscape.

The Lancashire beach scene depicted in the Beaverbrook painting is teeming with people and boats set against a pale sky coated by a film of grey that envelops the entire composition. The paint is carefully applied in even brushstrokes with areas of impasto marking a change in ground or to emphasize a subject or gesture. The rhythm of lateral brushwork is interrupted by neatly arranged parcels of colour spread out across the beach, making up Lowry's subjects. These naive-like characters have come to define his urban landscapes, and he is often referred to as England's Brueghel.

While he painted throughout his life, Lowry kept a day job as a clerk, and later as chief cashier with the Pall Mall Property Company in Manchester from 1910 until he retired in 1952. His employer was supportive of his painting, and as his artistic career developed, Lowry was granted time off work to travel to his exhibitions. By the 1920s, he was exhibiting regularly at the New English Art Club, and he also participated in the Royal Academy of Arts in London and at the Salon d'Automne in Paris. Assessing Lowry's work for a solo exhibition in 1975, the celebrated British art historian Herbert Read wrote that there was no other artist who was so "sensitively aware of the poetry of the English industrial landscape," which "usually condemned as ugly . . . can nevertheless be transformed if seen objectively" (Herbert Read, *L. S. Lowry, a selection of 36 paintings,* London: Crane Kalman Gallery, 1975). Lowry's rich body of work numbers close to one thousand paintings and over eight thousand drawings. This work and two other canvases in the Beaverbrook's collection represent the only major paintings by Lowry in a Canadian public collection.

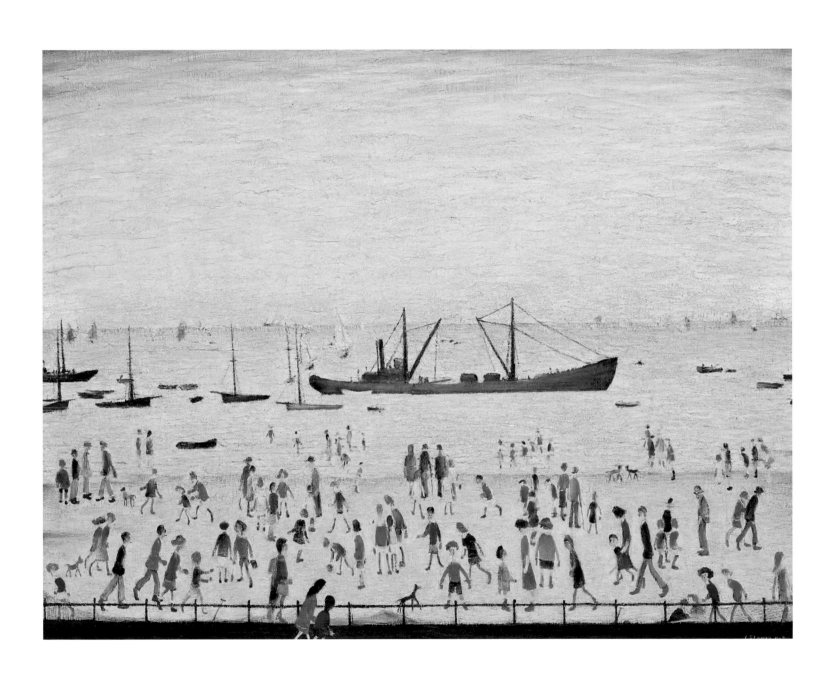

Henry George Glyde Canadian (born in England), 1906–1998

She Sat Upon a Hill Above the City, 1949

Casein on hardboard 60.4 x 76.2 cm

Glenbow Museum, Calgary
Gift of Helen Collinson, 1981; 81.50.2

THE ALBERTA ARTIST Henry Glyde was a committed painter of the Prairies. The interaction of land and people are fundamental elements of his artistic vision. Yet, in the British Romantic tradition of William Blake, Glyde evokes the archetypal and spiritual quality of everyday life. His work combines an interest in regional specificity with figurative and compositional elements drawn from the late Gothic and early Italian Renaissance periods. Glyde's masterful compositional skill in *She Sat Upon a Hill Above the City*, combined with the work's enigmatic message, makes it his most captivating canvas.

Glyde was born in southern England and studied at the Royal College of Art through the latter half of the 1920s. He taught in England for a number of years before accepting a post at Calgary's Provincial Institute of Technology and Art in 1935. For over three decades, Glyde was an inexhaustible art educator in Alberta. One year after his arrival in Canada, he was appointed head of the institute's fine arts department, and was also hired to lead the painting division of the fledgling Banff School of Fine Arts. In 1937 Glyde began delivering art instruction in rural areas through the University of Alberta's extensions program. A decade later, he established and headed the fine arts program at the University of Alberta, a position he would maintain until 1966.

Despite time-consuming instructional duties, Glyde remained a practising artist throughout his long life. In fact, as an educator he received constant motivation through the intellectual and practical exchanges he had with numerous visiting artists from across the country including Walter J. Phillips, Charles Comfort, and A. Y. Jackson. His training at the Royal College of Art ensured that he was always an attentive draughtsman. This is apparent in the Glenbow Museum work, which combines three distinct vignettes into a single, tightly woven tableau. Glyde paints a regionalist scene combining figures and rural landscape, although it is one that depicts parallel narratives, and is thus, at its root, intended to be read in a didactic way. Glyde, who said that "art is a silent affair" is not explicit about the painting's underlying narrative or message. Judging by the title, the work may allude to the biblical Sermon on the Mount in which Christ describes his followers metaphorically as being the "light of the world. A city that is set on a hill cannot be hidden." (Matthew 5:14) A dark underworld populated by groping, eyeless souls takes up the painting's bottom third. The top third shows a pair of travellers, one blindly leading the other up a rolling rural road toward a town, whose skyline is dominated by a church steeple and grain elevator. The central and dominating component of the work, a female nude reclining upon an undulating area of grassy earth, occupies a third space. Who is "she" that sits on the hill overlooking the city? Based on Glyde's Romantic sympathies, it is tempting to see this nude figure as Nature, delivering mankind when the modern city or town has ceased to be the beacon it was once thought to be.

Jean-Paul Riopelle Canadian, 1923–2002

Vallée, 1949–1950

Oil on canvas 200.7 x 150.5 cm

Winnipeg Art Gallery, Winnipeg
Acquired with funds from the Volunteer Committee
to the Winnipeg Art Gallery; G-78-74

AMONG THE QUEBEC Automatistes, Jean-Paul Riopelle received the most international attention and acclaim. "Le trappeur supérieur," as the Surrealist writer André Breton affectionately called him, was especially renowned in France where he maintained a residence for more than thirty years. Throughout his career, Riopelle observed a committed faith in unconscious instinct as a driving creative force.

During World War II, Quebec hosted its share of displaced European intellectuals such as the French priest Father Marie-Alain Couturier and, for a brief period, Breton himself. Such individuals introduced ideas that were new to Quebecers and very often threatening to the province's conservative social status quo upheld by the omnipresent Roman Catholic Church and draconian Union Nationale government. Riopelle, who was born in Montreal, was exposed to anti-establishment ideas while studying at the École des beaux-arts and the École du meuble, where he met Paul-Émile Borduas. Outside of class, Borduas gathered with like-minded students and colleagues at his home to read and discuss the merits of various writers, poets, and philosophers. This group, which included ambitious young artists like Riopelle, Marcel Barbeau, Roger Fauteux, Fernand Leduc, and Jean-Paul Mousseau, shared the tenet that the liberation of the creative mind—an idea linked to the psychoanalytic theory of the unconscious—could be understood as a political tool in the modernization of Quebec. Riopelle visited Paris in 1946 on a Government of Canada Fellowship and followed that trip up a year later by visiting New York. He returned to Paris in 1947 and began moving away from Surrealism, finding more aesthetic affinity with the lyrical approach to abstraction typified by painters like Georges Mathieu, Hans Hartung, and Antoni Tàpies. Additional members of Riopelle's circle included artists like his companion and artist Joan Mitchell, art historian Georges Duthuit, and playwright Samuel Beckett. Returning to Montreal in 1948, just in time to add his signature to the controversial Automatiste manifesto *Refus global*, Riopelle was back in Paris late that same year to begin one of the most enormously productive periods of his career. While he returned to Canada to visit, was its representative at the Venice Biennale in 1954, and took part in his first retrospective at the National Gallery of Canada in 1963, Riopelle would not return permanently to his country of birth until 1989.

The Winnipeg Art Gallery painting is one of the artist's undisputed masterpieces, painted after he returned to France having just signed *Refus global*. It is, in many ways, a work that bridges two significant periods in his mature career, retaining a degree of frenetic automatism while at the same time hinting at the more disciplined pallet-knife applications that he would bring to his best-known mosaic-like canvases from the 1950s. As the title suggests, Riopelle did not regard abstract painting and the natural world as mutually exclusive; in fact, he relied on the latter as a potent source of creative inspiration and the vehicle through which to convey emotions. When *Vallée* was acquired by the Winnipeg Art Gallery in 1978 its purchase price represented the highest amount the gallery had paid for a single work in its collection to date.

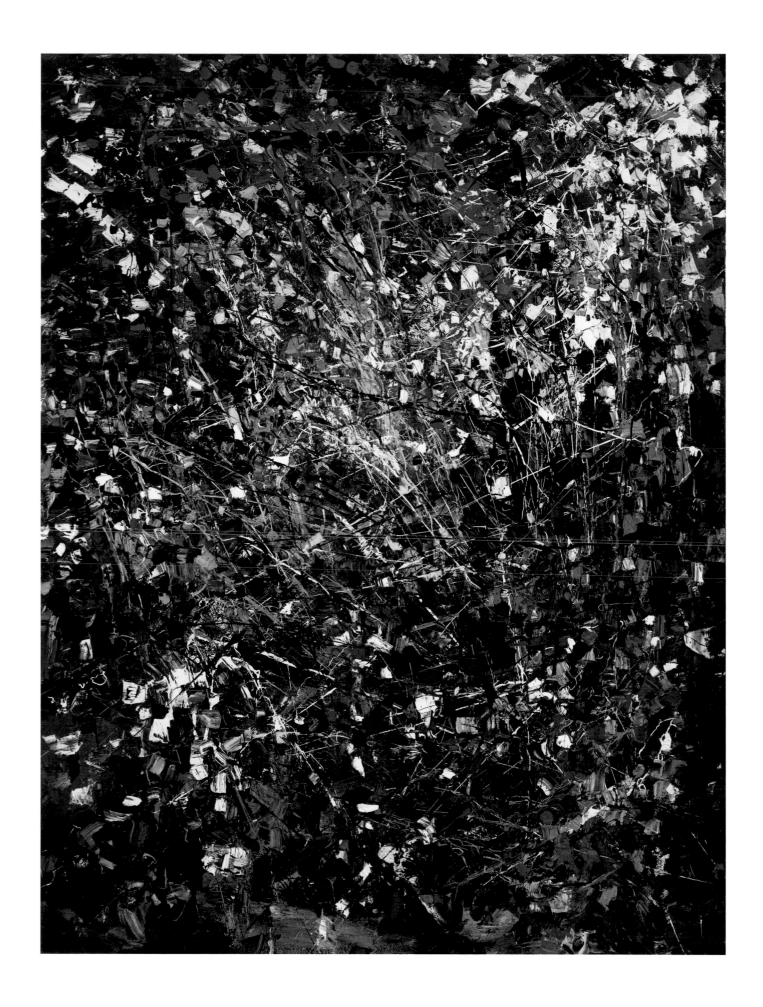

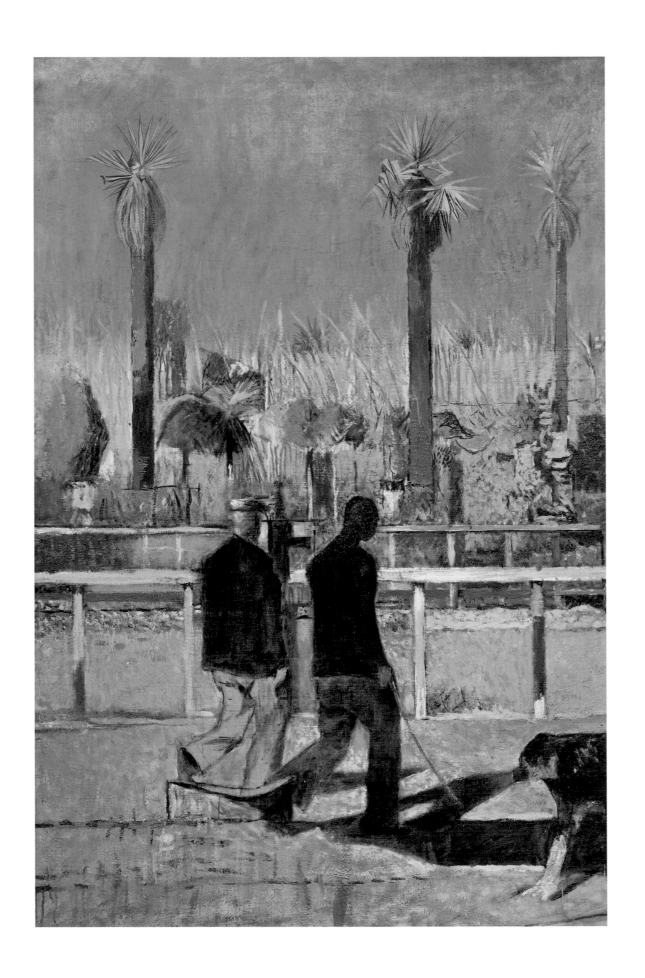

Graham Vivian Sutherland British, 1903–1980

Men Walking, 1950

Oil on canvas 145.4 x 98.4 cm

Beaverbrook Art Gallery, Fredericton
Gift of the Beaverbrook Foundation; 1959.248

AT THE HEIGHT OF HIS CAREER in the 1950s, Graham Vivian Sutherland was considered the most original British painter of his day, and the best representative of the post-war Neo-Romantic landscape movement. Only Francis Bacon, his Irish-born contemporary, would come to rival Sutherland's position in British art at the mid-century mark. Sutherland began his formal art training in 1921 at the Goldsmith's College of Art in London where he concentrated on printmaking after being inspired by the etchings of the nineteenth-century landscape painter Samuel Palmer. During World War II he served as an official war artist and produced a large body of drawings documenting the war effort and devastation in England, Wales, and France.

Sutherland's first trip to the south of France took place in the spring of 1947 when he visited Villefranche-sur-Mer, located just east of the city of Nice on the Côte d'Azur. He returned in the fall of that same year and visited Henri Matisse and Pablo Picasso, who also had residences in the area. After a series of annual visits, Sutherland bought a house in Menton in 1955, which became his primary residence until his death in 1980. Situated on the Côte d'Azur, Menton was called the "pearl of France" and was a popular destination for British tourists, who built many of the luxury hotels and villas in the area.

The setting for *Men Walking* is taken from one of the gardens for which Menton is famous, possibly the Jardin Serre de la Madone or the Jardin botanique exotique du Val Rahmeh, which was established by the British army officer Sir Percy Radcliffe in 1905. The two men and a dog (truncated in a manner similar to

Francis Bacon's animals), all in stride, are framed by three towering palm trees within a massing of tropical plants and foliage and set against a bold backdrop of yellow ground and turquoise sky. The Mediterranean landscape with its palette of bright colours and radiant light is captured in this lush garden scene.

Recalling his daily garden strolls, which served as inspiration for many of his landscapes from the 1950s, Sutherland wrote in 1951: "The first reaction, of course, is through the eye. Perhaps one goes for a walk. There is everything around one; but one reacts to certain things only, as if in response to some internal need of the nerves. The things one reacts to vary. I have myself noticed a juxtaposition of forms at the side of a road, and on passing the same place next week they are gone. It was only at the original moment of seeing that they had significance for me" (Graham Sutherland, "Thoughts on Painting," *The Listener*, XLVI, 1951, 376).

The Beaverbrook Art Gallery work relates to a painting series called *Standing Forms*, which Sutherland embarked on around 1950. In this series he created organic forms, referencing trees and plants, and placed them in realistic settings. Calling them monuments and presences, the large forms appeared two or three in a row, often set against a hedge or grove of trees—not unlike the way the two figures in this landscape are presented. The Beaverbrook holds the largest collection of Sutherland's work in Canada including many examples of his portraiture.

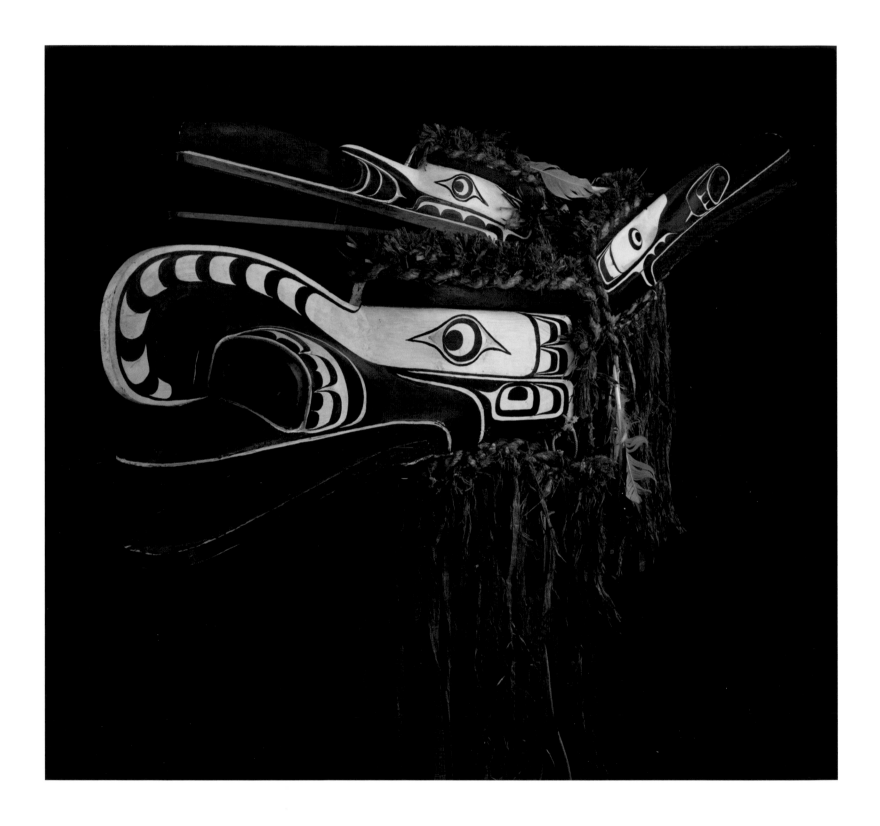

Chief N̲akap̓ank̲am, Mungo Martin

Kwakw̲aka'wakw (Kwagu'ł)/Canadian, c. 1881–1962

Cannibal Birds mask, 1953

Paint, cedar bark, feathers on wood 138 x 57.1 x 33 cm

Royal BC Museum, Victoria
RBCM 9201

Chief N̲akap̓ank̲am, Mungo Martin, was born at Tsax̲is (Fort Rupert) on Vancouver Island to a high-ranking Kwakwaka'wakw family. He received early instruction from his stepfather, Charlie James, a recognized carver in the community. Until 1947, before the University of British Columbia asked Martin to oversee their totem pole restoration program, he made his living primarily as a commercial fisherman. In learning to carve, Martin also became an authority on the traditions and narratives underpinning many Northwest Coast First Nations. Working with ethnographers such as Wilson Duff, curator at the BC Provincial Museum (now the Royal BC Museum), in the early 1950s, Martin recorded songs and oral histories. In 1952, at the age of 72, Martin was hired as Chief Carver of the Totem Preservation Program at Thunderbird Park in Victoria.

Mungo Martin made this *mugums* (four-headed Cannibal Birds mask) in 1953 for the opening of *Wawaditła*, the Mungo Martin House in Thunderbird Park. It replaced an earlier version he had previously owned, now in the Denver Art Museum, which was carved in 1938 by George Walkus of Blunden Harbour and sold in 1948. The mask is the hereditary cultural property of Mungo Martin's grandson, Chief Oasťakalagalis ´Walas ´N̲amugwis, Peter Knox, of Fort Rupert. His son, 'Maxw̲a'yalisdzi, David Knox, has carved a third version of this mask for use in his family's potlatches today.

The narrative that underpins the mask's ceremonial significance involves the three supernatural attendants of Baxwbakwalanuxwsiwe', the Cannibal-at-the-North-End-of-the-World. The main Cannibal Bird on this piece held by the Royal BC Museum is a Crooked-Beak of Heaven. According to Mungo Martin, this Crooked-Beak is *galu'kwəmł*, the form taken by the wife of Baxwbakwalanuxwsiwe' when she hunted food. Raven (there are two Ravens on the mask, both facing backward) and Huxwhukw (facing forward) are forms worn by Baxwbakwalanuxwsiwe' when he flies to get food. Each of the four birds on the mask has a hinged beak that can be moved separately. Although a Cannibal Birds mask, this particular piece is also a *ługwe* (treasure) that the chief has a prerogative to show. This honour was inherited by Chief Peter Knox from his grandfather, Chief N̲akap̓ank̲am, Mungo Martin.

Francis Bacon British, 1909–1992

Study for Portrait No. 1, 1956

Oil on canvas 197.7 x 142.3 cm

National Gallery of Canada, Ottawa
Purchased 1957; 6746

OVER A PERIOD OF FOURTEEN years, from 1950 to 1964, Francis Bacon produced forty-five works based on Diego Velázquez's *Portrait of Pope Innocent X*, painted in 1649 and located in the Galleria Doria Pamphilj in Rome. His fascination with this one painting by the Spanish master and the resulting body of work is unmatched in the history of modern art. Bacon never actually saw the original canvas in person, but relied instead on photographs and reproductions of the painting in books for his own work purposes. Even during a three-month stay in Rome in 1954, when he was working on the *Pope* series, Bacon chose not to visit the gallery where the painting was on display, fuelling questions as to whether he deliberately avoided an encounter with the original or simply wanted to keep his own exploration of the work at a distance. Recalling his study of the Velázquez painting, Bacon stated: "I've always thought this was one of the greatest paintings in the world. I've had a crush on it and I've tried very, very unsuccessfully to do certain records of it. Distorted records. Of course I regret them because I think that they're very silly . . . because I think that this thing is an absolute thing that was done and nothing more can be done about it" (David Sylvester, *Francis Bacon Recent Paintings*, London: Marlborough Fine Art Ltd., 1967).

Born in Dublin, Ireland, to English parents, and raised in London, Bacon had no formal training in art. In his early twenties, his career aspiration was to become an interior decorator, and he organized two exhibitions featuring furniture and rugs he had designed and fabricated. He had been experimenting with painting and drawing at the same time, but destroyed most of these early works. When Bacon was declared unfit to serve in the military because of his health, he finally turned to painting full time. In this period, he also revisited a theme that he had explored ten years before, the Crucifixion of Christ, and produced a triptych in a Surrealist style that brought critical attention to his work once again.

Bacon's reliance on photographs and reproductions of historical and popular images continued throughout his career. The National Gallery of Canada work is based on three distinct images that informed his painting series: Velázquez's *Portrait of Pope Innocent X*; a photograph of the twentieth-century pope, Pius XII, being carried through the Vatican on his *sedia gestatoria*; and the screaming nurse wearing pince-nez in the Odessa steps sequence (where the tsar's white-clad soldiers march down the steps firing on the crowd) in the 1925 silent film *Battleship Potemkin* by the Russian director Sergei Eisenstein. Bacon takes Velázquez's seated pope, then adds the distorted face of the screaming nurse, framing the pope within the architecture of the canopied sedan chair. Four long horizontal brushstrokes below the chair reference the steps of the papal throne. A bold palette made up mainly of purple, grey, and black defines the composition, with black filling the entire background to create the impression of the pope both encased and floating in the space.

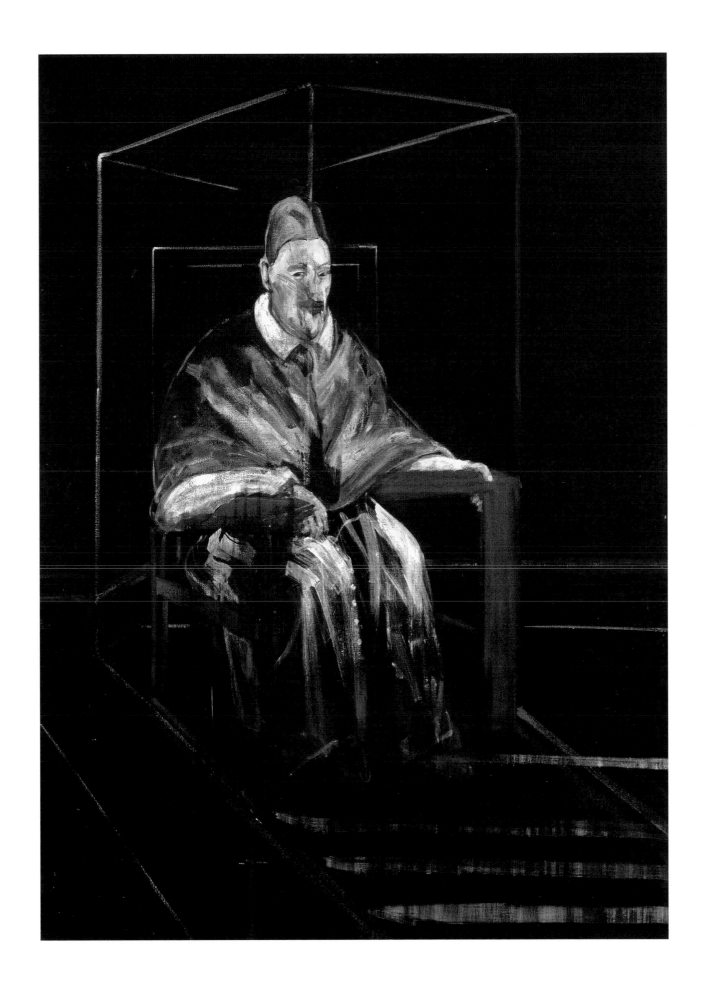

Paul-Émile Borduas Canadian, 1905–1960

Épanouissement (Blossoming), 1956

Oil on canvas 129.9 x 195 cm

Musée d'art contemporain de Montréal, Montreal
A 71 49 P 1

PAUL-ÉMILE BORDUAS was an influential teacher, theorist, and artist best known as the main spokesman for the Montreal-based Automatistes. His art and writing—particularly his contribution to the Automatistes' 1948 manifesto *Refus global*—not only had a profound influence on internationally acclaimed younger artists, like Jean-Paul Riopelle, but also shook Quebec's conservative political and religious establishments two decades before the Quiet Revolution.

Borduas's early artistic career provided little indication of the radicalism that would define his approach later in life. He was born and raised in Saint-Hilaire, near Montreal, and in 1921 began an apprenticeship with Ozias Leduc, a uniquely independent figure within Canadian art. Under Leduc, Borduas learned the techniques required to be a church decorator. They worked on major commissions in Sherbrooke, Montreal, and Halifax, during which time the young artist also attended Montreal's École des beaux-arts where he studied with academic painter Edmond Dyonnet, among others. On Leduc's suggestion, Borduas travelled to Paris in 1928 to enrich his knowledge of church decoration under the tutelage of Post-Impressionist painter Maurice Denis. Borduas returned to Quebec at the outset of the Depression, but eventually found work teaching at the École du meuble where he had access to one of the most comprehensive collections of international publications on contemporary art in the province. He discovered the writings of André Breton and the Surrealist periodical *Minotaur*, theoretical founts that would transform Borduas's practice, which to this point had been figurative and

largely indebted to Post-Impressionism. In 1939 he co-founded the Contemporary Arts Society with John Lyman, and swiftly distinguished himself as its most radically innovative member. In 1941 he began painting in a Surrealist-inspired style approaching complete abstraction, and engaged in lively theoretical discussion with a band of younger francophone artists including Jean-Paul Riopelle, Marcel Barbeau, and Françoise Sullivan. Officially named the Automatistes in 1947, the group was spurred on by the idea of applying Surrealist principles that stressed the need to liberate unconscious thought through chance operations that embrace social and political issues. They published the *Refus global* manifesto, which advocated, in Borduas's main text, a "break with the conventions of society," "resplendent anarchy," as well as the demise of the Roman Catholic Church and the province's repressive Duplessis government. The manifesto cost Borduas his position at the École du meuble and in 1953 he moved to New York.

Borduas completed *Épanouissement*—a word that means both to bloom and to glow—almost a decade after the release of *Refus global*. By this time he had moved away from Surrealism and developed an all-over painterly idiom that reveals the influence of Abstract Expressionism, particularly the work of Jackson Pollock and Franz Klein. However, *Épanouissement* was in fact finished in Paris where Borduas relocated after spending only two years in the United States. It combines the gestural and smeared application that derives from his New York period, with an increasingly selective use of colour that would come to typify, along with a more structural and broadly conceived layout, the last chapter of the artist's oeuvre.

Alexander Calder American, 1898–1976

Red Mobile, 1956

Painted sheet metal and metal rods 274.3 cm (diameter)

Montreal Museum of Fine Arts, Montreal
Purchase, Horsley and Annie Townsend Bequest; 1960.1235

STANDING AMIDST A collection of Alexander Calder mobiles on the occasion of a tribute exhibition to Calder at the Museum of Modern Art, New York, in 1970, curator Bernice Rose wrote: "There have been few statements from Calder on aesthetics or the formal aims in his work; the work itself makes its statement. A room filled with moving and standing Calders is a new experience in space, a world of shifting transitory forms in which steel and aluminum flutter like the lightest leaf on a tree" (Bernice Rose, *A Salute to Alexander Calder*, New York: Museum of Modern Art, 1970, 12). The *Red Mobile* in the collection of the Montreal Museum of Fine Arts provides an excellent illustration of the kinetic power and beauty of Calder's mobiles, and their ability to fully occupy and animate a space. The mobile also communicates the idea of spontaneous and random motion where the movement of the piece is controlled largely by air currents, which are often created by the viewer in the space. Different from his mechanized mobiles where he had control over the movement of the piece, the mobile design, like the Montreal piece with its multiple lightweight metal parts, is open to countless variations in movement and choreography.

Using Calder's work as the pre-eminent example, the British art historian Patrick Heron described the mobile, a term first used by Marcel Duchamp, as "an abstract configuration of articulated parts in which each part, or segment, is free to describe a movement of its own; but it is a motion, conditioned by, yet distinct from, the movements of all the other articulated segments of which the total construction is made up" (Patrick Heron, *The Changing Forms of Art*, London: Routledge & Kegan Paul, 1955, 222). When installed,

the disks and the connecting rods of *Red Mobile* respond to the air currents that surround them. As well, the painted surfaces of the moving disks respond to the natural or artificial light in the space.

There was rarely a moment in Calder's life when he was not confronted by art, particularly in three-dimensional format. He was born into a family of artists: his father was a prominent sculptor in Philadelphia; his French-born mother was a portrait painter who studied at the Académie Julian in Paris; and his grandfather, the Scottish-born Alexander Milne Calder, was responsible for the famous statue of William Penn that crowns the tower of the Philadelphia City Hall. The young "Sandy" Calder's engagement with art—and specifically the three-dimensional object—was lifelong. He produced his first sculpture, a clay elephant, at the age of four. At eleven, he presented his parents at Christmas with a three-dimensional sheet-brass sculpture of a dog and duck that rocked when tapped.

Despite a penchant for art-making, instead of first pursuing a formal art education, Calder enrolled at the Stevens Institute of Technology in Hoboken, New Jersey, in the mechanical engineering program, graduating in 1919. He worked in the engineering field until 1922 when he finally succumbed to the pull of his artistic side, moving to New York where he began studies at the Art Students League where his fellow students included Thomas Hart Benton and Joan Sloan. Calder left New York for Paris in 1926 where he lived for the next seven years. There he met his future wife, Louisa James, the grandniece of Henry James, and became good friends with a number of artists including Marcel Duchamp, Jean Arp, and Joan Miró.

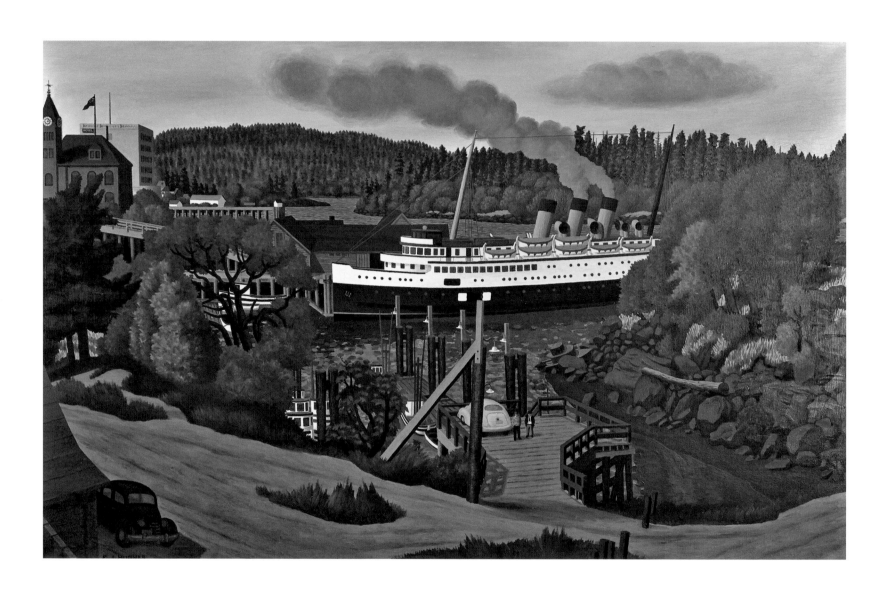

Edward John Hughes Canadian, 1913–2007

Steamer at the Old Wharf, Nanaimo, 1958

Oil on canvas 61 x 94 cm

Art Gallery of Greater Victoria, Victoria
Gift of Mary Alice Segal, Miles Keenleyside, Anne Katherine McCullum, and Sara Lynn Jackson; 1992.056.001

E. J. HUGHES, WHOSE ARTISTIC career spanned more than seventy years, is famous for his iconic paintings of the Canadian West Coast and its natural and man-made landmarks and symbols. Tightly packed fishing villages, ferries traversing the Georgia Strait, and the expansive coniferous forests of Vancouver Island are his recurring subjects. Stylistically, Hughes's works intimate a strange and entrancing amalgam of sources, combining a tactile mark-making commonly associated with folk art, a surveying sensibility reminiscent of eighteenth-century topographic painting, and the haunting clarity of Magic Realism. Hughes is also well known for the arresting scenes of trudging soldiers and armaments that he produced as a government-commissioned war artist from 1939 to 1946. A popular regionalist in the best sense of the term, Hughes provides a focused and sustained look at a certain locale, in all its particularity. His art affects how people have come to understand the region it represents, providing for southwest British Columbia what William Kurelek does for the Prairies, or David Blackwood for Newfoundland.

Hughes was instructed by a founding member of the Group of Seven, Frederick Varley, at the Vancouver School of Decorative and Applied Arts in the 1930s. By the 1940s, the Vancouver-born artist had earned praise from former Group members A. Y. Jackson and Lawren S. Harris. At this time, however, Hughes began developing his mature style and exploring iconography that, while indebted to the natural world, revealed very little in common with the Group. The world he constructs in his paintings is strangely compressed, off-kilter, dramatically lit, and rarely devoid of human presence. Additionally, by the 1950s, when Hughes painted *Steamer at the Old Wharf, Nanaimo*, his representational and clearly delineated compositions had come to stand in marked contrast to the increasingly prevalent lyrical abstraction of his British Columbian peers like Jack Shadbolt and Gordon Smith.

Despite passages of intense compression, where bundled shapes appear to slope or churn together, in the Art Gallery of Greater Victoria work Hughes also manages to convey an expansive sense of distance. Overlooking the harbour and eastern edge of downtown Nanaimo, we take in the telltale signs of Hughes's undulating landscape, guided throughout the picture plane by a series of connecting cues—the jagged wharf meeting the snaking inlet of water, the ferry and its plume of coal smoke—that conclude at the distant ridge of green. In the upper-left corner of the canvas, the artist has inserted the anecdotal landmarks that add particularity to the scene. The since demolished post office, its clock tower visible, and the Malaspina Hotel (for which the artist was commissioned to paint a mural in the late 1930s) rise above Front Street. Underlining the Victoria picture, and summarized perfectly by a single cloud and the steamer's sooty emission, is a subject that Hughes returned to throughout his entire career: human industry ensconced within and in comfortable balance with nature.

Morris Louis American, 1912–1962

Beth Vav, 1958

Acrylic on canvas 253 x 360.8 cm

Glenbow Museum, Calgary
Anonymous gift, 1995; 995.032.001

MORRIS LOUIS STUDIED AT the Maryland Institute College of Art in Baltimore from 1929 to 1933, and later worked in the Works Progress Administration Federal Art Project (WPA) in the late 1930s. Louis worked in a mainly Cubist style, and it was not until 1952, when he met the painter Kenneth Noland, who in turn introduced him to the art critic Clement Greenberg, that Louis began exploring Abstract Expressionism and the works of Jackson Pollock. Along with Noland and Jules Olitski, Louis was linked to the Spatio-Luminism painters, as Greenberg called them. More importantly, Louis's work formed a link between Abstract Expressionism and Post-painterly Abstraction, which became known as the Colour Field school.

At the invitation of Greenberg, Louis and Noland visited Helen Frankenthaler in her New York studio in 1953. There, they saw Frankenthaler's 1952 painting *Mountains and Sea,* which she had made using transparent oils thinned with turpentine poured directly onto the unprimed canvas, largely without the aid of a brush. The visit was a revelation to Louis (and Noland), and he immediately adopted parts of Frankenthaler's technique and began experimenting with the act of staining the unprepared canvas. As evident in the Glenbow Museum painting, the resulting work exposed an interpenetration of the colours on the absorbent support where the pigment became an integral part of the canvas. Using an acrylic paint called Magna, made by his friend Leonard Bocour, Louis would tilt and manipulate the canvas, which was partly stapled to a wood support, so that the liquid paint ran smoothly to create a wash-like effect. Louis remained very secretive about his painting method, rarely talking about his technique and working in complete privacy.

The first series of works resulting from this stylistic and technical shift came in 1954. The series was given the title *Veils* by William Rubin, a curator of painting at the Museum of Modern Art. This was followed by a second series of the same name produced between 1957 and 1959. While working on the first series, Louis wrote to Greenberg in June 1954: "The more I paint the more I'm aware of a difference in my approach and others. Am distrustful of over-simplification but nonetheless think that there is nothing very new in any period of art: what is true is that it is only something new for the painter and that this thin edge is what matters" (Diane Upright, *Morris Louis: The Complete Paintings*, New York: Harry N. Abrams, 1985, 15).

The Glenbow painting was made in 1958 at the height of the second *Veils* series. The title of the work, *Beth Vav*, represents the second and sixth letters of the Hebrew alphabet, and it is likely that Louis's widow, Marcella Siegel, assigned the title after the artist's death as he titled very few works. The next two series of works, called *Unfurleds* and *Stripes*, followed in 1959 and 1961. Louis continued using the pour and stain technique until his untimely death from lung cancer in 1962, which was attributed to his extensive exposure to paint vapours. Major exhibitions of his work were organized almost immediately: in 1963 at the Guggenheim Museum, New York; in 1967 at the Museum of Fine Arts, Boston; in 1976 at the National Gallery of Art, Washington; and in 1986 at the Museum of Modern Art, New York.

Jack Bush Canadian, 1909–1977

Spot on Red, 1960

Oil on canvas 203.2 x 177.8 cm

Agnes Etherington Art Centre, Queen's University, Kingston
Gift of Ayala and Samuel Zacks, 1962; 05-025

THE TORONTO-BORN PAINTER Jack Bush earned international acclaim late in his career. In the 1960s and 1970s his paintings became known for their bold colour sensibility, unique designs, and large-scale format. He had studied art first in Montreal, under teachers like Adam Sherriff Scott and Edmond Dyonnet, before returning to Toronto in 1928 to attend evening classes at the Ontario College of Art. In both cities, and until 1968, Bush made his living as a commercial artist, including at the Rapid Grip company, which his father managed and which had employed several members of the Group of Seven. His earliest mature work shows the influence of the Group, along with the rustic regionalism of Toronto artists Charles Comfort and Carl Schaefer. In the post-war years, Bush began developing an understanding of and interest in non-objective painting through regular trips to Montreal and New York where he was exposed to the groundbreaking work of the Automatistes and to Abstract Expressionism. In 1953 he joined the nascent Painters Eleven, a group of Toronto-based artists united by a common practical directive to introduce, promote, and nurture an appreciation for modern painting in Canada, particularly in Toronto. Over the remaining decade, as part of Painters Eleven, Bush developed a densely packed, all-over style. His work from this period, mostly done on Masonite panel, is characterized by well-defined, chunky, and angular shapes painted in high-contrast earthy colours.

An important turning point in Bush's career came in 1957 when a number of Painters Eleven members sponsored Clement Greenberg to visit Toronto and conduct studio critiques for the artists. The influential New York-based art critic saw great promise in recent watercolours Bush had been working on, which indicated a move away from the gestural expressionism that defined his larger-scale work. Greenberg encouraged him to apply and adapt his watercolour technique to oil painting. Following the demise of Painters Eleven that same year, and over the ensuing decade, Bush honed a new painting approach that is evident in *Spot on Red*. While its central motif retains a certain expressionist energy, the painting contains elements that would come to typify and distinguish the artist's output over the next two decades. The grid of four unevenly applied colours, separated by a white intersection, points toward Bush's later Colour Field work, characterized by large canvases containing broad bands of stained colour. Compositionally, the Kingston work is economical and draws attention to the flatness of the picture plane; it eschews illusory depth. Bush's approach appears intuitive, his defining of shape and the boundary between forms almost whimsical; however, as would become clearer in the 1970s, he often drew his ideas for colour and graphic motifs from the world of commercial advertising. Greenberg included Bush in his important 1964 exhibition, *Post-painterly Abstraction*, which toured to three venues across North America and included work by thirty other international painters. His success culminated in representing Canada at the 1967 San Paulo Biennale, receiving a Guggenheim Fellowship in 1968, and having a major retrospective at the Art Gallery of Ontario in 1976, a year before his death.

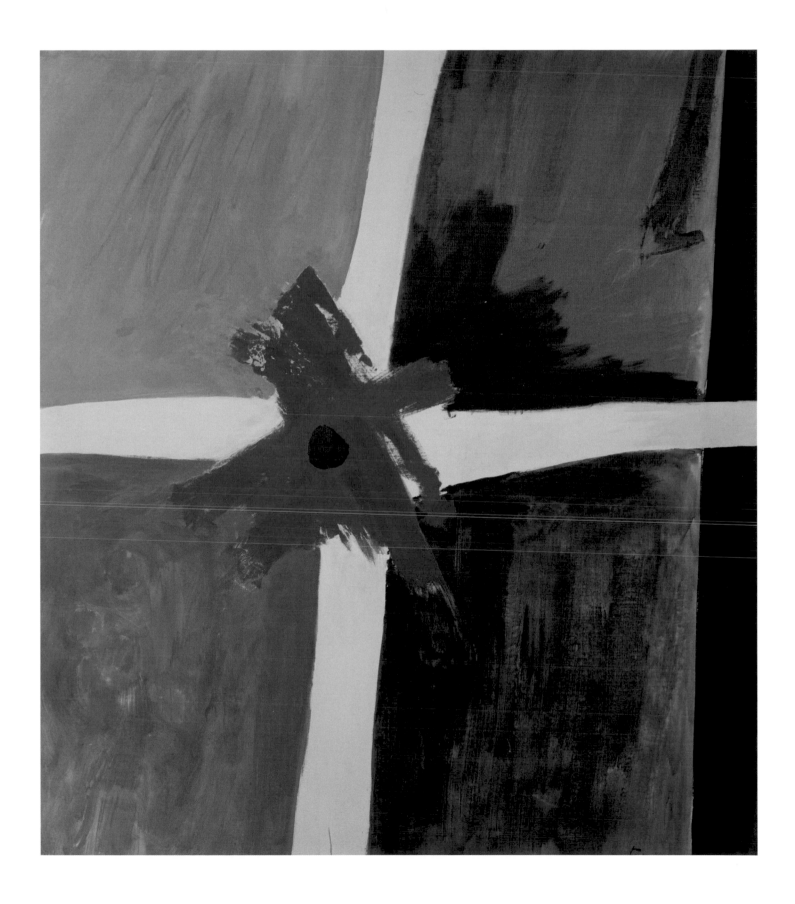

Alex Colville Canadian, 1920–

Ocean Limited, 1962

Oil and synthetic resin on board 68.5 x 119.3 cm

Art Gallery of Nova Scotia, Halifax
Purchased with funds provided by Christopher Ondaatje,
Toronto, Ontario; the Art Sales and Rental Society, Halifax,
Nova Scotia; and a private donor, 1994; 1994.18

ALEX COLVILLE'S PAINTINGS explore and analyze the world through the interwoven and juxtaposed perspectives of suspended action, labour and leisure, solitude and togetherness, care and indifference. Born in Toronto, Colville grew up in Amherst, Nova Scotia, along the border with New Brunswick. Today, he lives and works in Wolfville, Nova Scotia; he is the only artist represented by two works in *100 Masters: Only in Canada*. He attended and then taught painting at New Brunswick's Mount Allison University, the first post-secondary institution in Canada to grant a bachelor's degree in fine art. Upon graduation in 1942, he enlisted in the army, was sent to Europe, and became an official war artist in 1944. After the war, Colville's artistic success grew, and he took up the mantle of a realist painter in direct response to the growing attention abstract painting, particularly Abstract Expressionism, enjoyed in the 1940s and 1950s.

As much as his work strives to conform with perceptual and mathematical truth, it is undeniable that the particular mode of realism Colville adopted by the early 1950s—variously termed High and Magic—does not provide a mere register or record of the world. He has rejected the privileging of subjectivity and improvisation in Modernism and declared "the value and significance of the objective world" (Tom Smart, *Alex Colville: Return*, Halifax and Vancouver: Art Gallery of Nova Scotia and Douglas and McIntyre, 2003, 38). Facing the devastation in the aftermath of World War II, Colville has also understood naive realism, grounded in an unreflective rationalism or an anachronistic naturalism, to be insincere. His realism is stark, almost mechanical, as well as paradoxical, conveying a sense of both enchantment and banality.

Ocean Limited perfectly exemplifies the sense of alienation that underscores Colville's realism. The title refers to a passenger train owned in the early 1960s by the Canadian National Railway that ran between Montreal and Halifax. In this work, an elevated track cuts through the flat, prairie-like region of New Brunswick's Tantramar Marsh. The painting's aspect ratio is significant; the support is a $\sqrt{3}$ rectangle, which holds aesthetic significance within a proportional system that Colville employs in many of his works to help create the tense telltale stillness. While the man in the painting is clearly out of harm's way, there remains a preoccupying sense of impending chaos and violence. The theme of an approaching and irreconcilable, if latent or inexplicable, threat reiterates throughout the artist's oeuvre as, for instance, a robed figure lurking behind a bathing woman; a large dog's close proximity to a naked toddler; and a black horse and a distant locomotive racing headlong toward one another. Various strata of earth form the horizontal bands that provide the lines of contact that bind the figure, in mid-step, and the blunt-nosed machine. We can conceive that, in less than a second, the train will pass the man and the silent tension will end; but the painting keeps this tension eternally suspended.

Bill Reid Haida/Canadian, 1920–1998

Wasgo (Sea Wolf), 1962

Red cedar and paint 145 x 170 x 250 cm

Museum of Anthropology at The University of British Columbia, Vancouver
Purchased from the artist, 1963; A50029

BILL REID, THE SON of a Haida mother and an American father of Scottish and German ancestry, was born in Victoria, British Columbia. He went on to play an instrumental role in reviving interest in Haida art, particularly carving and sculpture. Reid's practice helped to bridge the gap between traditional Haida mythology and contemporary realities facing the Haida people.

Reid worked as a radio broadcaster for the Canadian Broadcasting Corporation in Toronto until the mid-1950s. During that time he developed a facility as a silver- and goldsmith. He studied jewellery and engraving at what is today Ryerson University as well as at what is now the Central Saint Martins College of Art and Design in London, England. Reid's career change from broadcaster to artist was inspired by his maternal Haida grandfather, Charles Gladstone, who had trained under his uncle, the master carver and jeweller Charles Edenshaw. Reid developed a reputation for his craftsmanship and for the way he combined Indigenous design with European techniques while working with a range of materials including precious metals, argillite, bronze, and cedar. He created over fifteen hundred objects of various scale over his lifetime. He also rediscovered his Aboriginal roots, an activity that had been discouraged by Reid's Haida mother, and he gradually emerged as a leading authority on Haida art history and design. His major pieces include the cedar sculpture *Raven and the First Humans* at the Museum of Anthropology at The University of British Columbia (1980) and, perhaps most famously, *Spirit of Haida Gwaii* (1985–1991), three versions of which appear at the Canadian Museum of Civilization, the Canadian

Embassy in Washington, D.C., and the Vancouver International Airport. Despite his consummate knowledge of materials, techniques, and design, Reid developed an understanding of Haida art that is irreducible to an analytic formula or set of aesthetic qualities. The Haida artist must have an understanding of the politics of the land and the people who occupy the land. Reid put this principle into practice when, in 1987, he refused to continue working on the monumental *Spirit of Haida Gwaii* for the Canadian government unless the latter halted clear-cutting on the islands of Haida Gwaii, the Haida's traditional land. In the summer of 1988, logging ceased and a national park was established.

Wasgo (Sea Wolf) is carved from a single block of cedar. Reid commenced the sculpture after having already worked with the Royal BC Museum to salvage and restore Haida mortuaries and frontal poles from abandoned villages. He had also apprenticed briefly with the Kwakwaka'wakw master carver Mungo Martin. The carving was completed as part of a four-year commission Reid undertook to produce Haida poles, houses, and other sculptures for the Museum of Anthropology at The Univeristy of British Columbia. This early mature work is significant not only because direct carving was held in high esteem in Haida culture, but also due to the fact that Reid largely abandoned the practice after being diagnosed with Parkinson's disease in 1973. The sculpture depicts a supernatural being within Haida culture, one that has the power to occupy both land and ocean. The creature clutches three killer whales in its forepaws, mouth, and tail.

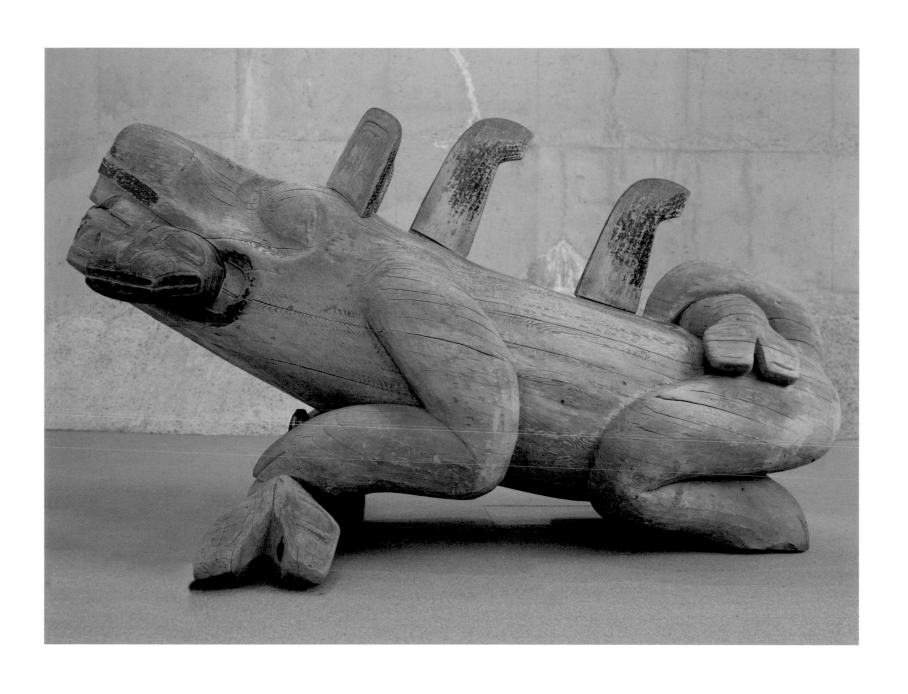

Frank Stella American, 1936–

Sketch Les Indes Galantes, 1962

Oil on canvas 181.9 x 181.9 cm

Walker Art Center, Minneapolis
Gift of the T. B. Walker Foundation, 1964; 1964.26

FRANK STELLA STANDS AS the leading figure of Post-painterly Abstraction, which was rooted in the premise that a painting is a physical object rather than a symbol or reference to something else. The movement, which emerged from Abstract Expressionism, also prepared the way for Minimalism. Stella's own studies began at the Phillips Academy in Andover, Maine, and continued at Princeton University where he enrolled in studio and art history classes. Upon graduation from Princeton in 1958, he settled in New York. One of the first exhibitions he saw there was the Museum of Modern Art's *16 Americans* show, which included the *Flag* and *Target* paintings by Jasper Johns.

The Walker Art Center painting is from the artist's *Mitered Mazes* series, begun in 1962, and which is among the most complex works Stella had produced at that point in his career. The paintings were square in format, comprising a "maze" made up of diagonal lines drawn from around the corners of the canvas leading in a step-like succession to the centre band. He used a monochrome or single value for the paint, except for the unpainted interstitial strips. As he continued to explore the relationships of colour, form, and pattern in these paintings, for the first time there was an acknowledgement of recessional space, which anticipated Stella's interest in sculpture.

The title, *Sketch Les Indes Galantes*, is taken from the opera-ballet *Les Indes galantes* by the seventeenth-century French composer Jean-Philippe Rameau, which was inspired by contemporary travel accounts and literature. Stella described Rameau's opera-ballet as "a Frenchman's idea of the new world" (*Walker Art Centre Collections*, Minneapolis: Walker Art Center, 2005, 532), although he also made it clear that the titles for his paintings represented personal associations with the pictures rather than any content or theme.

In a 1966 interview with Alan Solomon for a national television series called *U.S.A. Artists*, Stella talked about some of the basic ideas surrounding his art including how he dealt with the issue of the "background" in the painting and what he hoped people could see and understand in his paintings. The artist's intellectual and physical approach to the canvas and to the act of painting is well articulated in this extended conversation with Alan Solomon: "One of the real problems that has always been present in Western art . . . has been atmosphere, background, even in abstract painting. The only one who really dealt with it was Mondrian. He ran it out to the edge and he still stayed relational. This was a recurring thing in my paintings too. It seemed to me that the bands and the blocks had some kind of landscape relationship or atmospheric space in them, and I wanted to get away from that as much as I could. I wanted to solve the problem of what happened to the painting as it faded out around the edges . . . One of the basic ideas behind the painting, one of the reasons why I started painting this way . . . was that I wanted people to be able to see the paintings directly and unequivocally. The emphasis on the surface, on the symmetrical quality of things, was to keep people from moving around in the painting. It's non-atmospheric, non-resilient, there's no room to run around in so there's almost only one way you can see the painting. The real point of the paintings is that they're supposed to be self-evident and supposed to be easy to see and easy to understand" (Alan Solomon, *U.S.A. Artists: Frank Stella*, National Educational Television Network and Radio Center, 1966).

Michael Snow Canadian, 1929–

Olympia, 1963

Oil on canvas 175.3 x 307.1 cm

MacKenzie Art Gallery, Regina
University of Regina Collection; 1972-011

MICHAEL SNOW SET THE standard for
interdisciplinary experimentation in Canadian
art. A painter, filmmaker, sculptor, photographer,
performance artist, and improvisational musician,
Snow disturbed the dominant Modernist value of
medium specificity, the presumed unbridgeable
division between art and life, and in turn became
an internationally respected avatar of cutting-edge
Canadian art.

Snow was born, raised, and spent the first ten
years of his career in Toronto. He attended the
Ontario College of Art, earned a living as a musician,
animator, and filmmaker, and developed as a painter.
By the late 1950s he was working in a mode of Colour
Field abstraction that drew inspiration from American
painters like Mark Rothko and Barnett Newman. He
acquired a deep interest in a new breed of
communication theory being developed at the
University of Toronto by Harold Innis and Marshall
McLuhan, one that focused on the role media plays in
not only the delivery but the formation of information
and knowledge. Snow was also drawn to the Dada
artist Marcel Duchamp, whose iconoclastic efforts to
undermine traditional conceptions of art in the early
twentieth century saw a resurgence in the late 1950s.
Shortly before leaving Toronto for New York in 1962,
he began working in collage, creating the now iconic
female silhouette that inaugurated the *Walking
Woman* series, his best-known body of work. In this
series, which he continued until 1967, the artist
replicated, manipulated, and recontextualized the
original cut-out in a variety of media, from painting,
sculpture, and film to clothing and graffiti. Snow was
fascinated by the way in which the same unremarkable

figure could convey a different message, connote
different kinds of information, depending on where
and in what form it appeared. His overall output at
this time, which included *Wavelength*—Snow's
seminal contribution to structural filmmaking—
continued to be eclectic and interdisciplinary.
He returned to Canada in 1972, the same year he
received a Guggenheim Fellowship. He was awarded
the Governor General's Award in Visual and Media
Arts in 2000.

Olympia is an important early example of Snow's
Walking Woman series. The five figures provide
a consolidated look at the artist's manipulation
and reformulation of the original stencil. This
instantiation is also significant for the way in which
the title refocuses the viewer's attention on its subject
matter: the female body. Snow has earned criticism
for the way in which *Walking Woman* objectifies
women, reducing women to a silhouette, a serial
cut-out that is endlessly repeatable. *Olympia*, as
the title suggests, references another painting that
also stirred controversy, Édouard Manet's depiction
of a naked courtesan who stares confidently out
to meet the viewer's gaze. In drawing a parallel to
Manet's masterpiece from exactly one hundred years
earlier, Snow is taking up the mantle for the modern
twentieth century artist. For him, the artist is one who
does not regard his or her practice as separable from
the world of commercial exchange and mechanical
reproduction, but who actively engages with this
reality by working in dialogue with it.

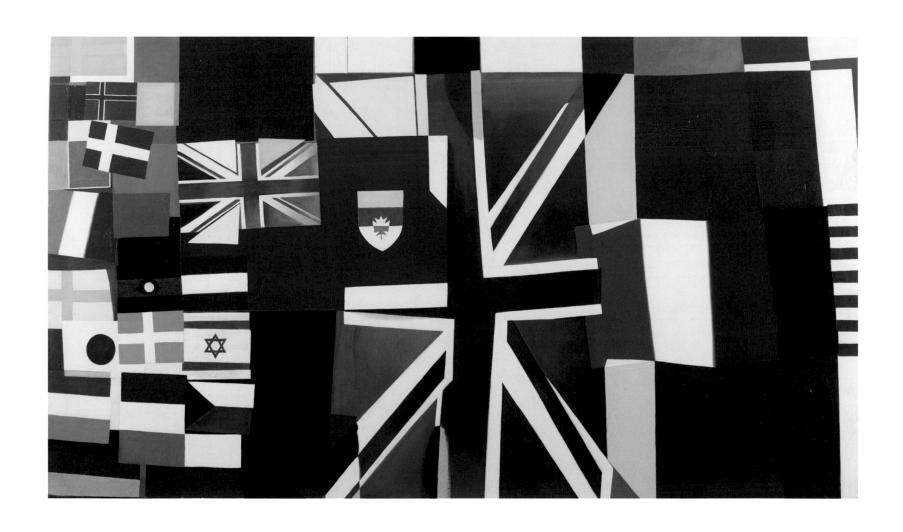

Jack Shadbolt Canadian (born in England), 1909–1998

Flag Mural, 1964

Enamel on canvas board 213.5 x 376 cm

Confederation Centre of the Arts, Charlottetown
Commissioned with funds donated by the Molson Family,
Montreal, 1964; CAG 66.29

FLAG MURAL, BY THE British-born artist Jack Shadbolt, was created and installed for the newly constructed Confederation Memorial Centre in Charlottetown, Prince Edward Island. By the early 1960s, when the mural was made, Shadbolt had only recently established himself as an artist of national significance. His family had immigrated to British Columbia in 1912. As a teenager, Shadbolt encountered several significant individuals who encouraged his interest in pursuing modern forms of artistic expression. Two major influences were the scholar, musician, and editor Ira Dilworth as well as the painter Emily Carr, who was just beginning to garner the national recognition she has today. *A Canadian Art Movement,* Frederick Housser's celebratory 1926 account of the Group of Seven, inspired Shadbolt to begin sketching and painting the landscape around Victoria, British Columbia. He worked as a teacher for several years before taking night classes at the Vancouver School of Decorative and Applied Arts under Frederick Varley, a founding member of the Group. Visits to major American cities in the early 1930s exposed him to works by an eclectic array of modern artists including Paul Cézanne, Georgia O'Keefe, Salvador Dalí, Diego Rivera, and Edward Hopper. Later that decade, before settling into a teaching position at the Vancouver School of Art, Shadbolt continued his studies in London and Paris where he studied with and was particularly drawn to the work of Cubist painter André Lhote.

Throughout his life, Shadbolt made a point of not only considering but incorporating a wide range of artistic styles and media into his practice. By the late 1940s the artist had explored Group-inspired landscapes, urban Social Realism, and Surrealist imagery that drew from Northwest Coast First Nations material culture. During World War II, Shadbolt was employed by the Canadian Army War Artists Administration, cataloguing photographs of concentration camps; this experience had a profound impact on a later body of figurative work that reflected on existential themes. In the late 1940s he was also exposed to Abstract Expressionism in New York while studying at the Art Students League as well as with Hans Hoffman. Shadbolt's encounter with Hoffman propelled him to explore gestural abstraction. In Canada his reputation as an artist and innovator continued to rise. Not only did Shadbolt lead the first artist workshop at Emma Lake, Saskatchewan, an important and unexpected hub of North American Modernism, he also represented Canada at the Venice Biennale in 1956 and was a founding member of Vancouver's Intermedia, a collective that served as the model for today's artist-run centres.

Although Shadbolt had executed murals as early as the mid-1930s, his reputation in the field was not established until 1963 with the completion of *Bush Pilot in the Northern Sky* for the Edmonton International Airport. *Flag Mural,* painted in 1964, marked the one-hundredth anniversary of the Charlottetown Conference, a touchstone event that brought together delegates from the colonies of British North America to discuss the idea of political union three years before Confederation in 1867. A century later, when Shadbolt executed the commission, there was a heated national debate over plans to create a new flag that would replace the Canadian Red Ensign. While emphasizing the British Union Flag, Shadbolt's painted collage pays tribute to the ideas of multilateralism that emerged as topics of significant international debate following the establishment of the United Nations after World War II. It also exposes the way in which multiculturalism was, by the 1960s, gradually replacing biculturalism as a defining feature of Canadian identity.

Christopher Pratt Canadian, 1935–

Young Girl with Seashells, 1965

Oil on Masonite board 73.3 x 46.3 cm

The Rooms Provincial Art Gallery, St. John's
Memorial University of Newfoundland Collection; 65.6

THE IMMEDIATE FAMILY of Newfoundland artist Christopher Pratt, whose ancestry in the region stretches back several hundred years, did not support the former British colony's union with Canada in 1949. Like his famous great-uncle, poet E. J. Pratt, Christopher Pratt maintains through his art a distinct awareness of his Newfoundland roots. His early post-secondary pursuit of an engineering degree at Memorial University was interrupted in 1953 when he transferred to Mount Allison University in New Brunswick. There he took classes in several different programs before Alex Colville and Lawren P. Harris —instructors associated with the development of Atlantic Realism in the 1950s and 1960s—convinced him to pursue fine art. Later that decade, Pratt married fellow student Mary West, and the two moved to Glasgow Scotland, where Christopher studied at the Glasgow, School of Art. He returned to Mount Allison University after two years in Scotland and completed his bachelor of fine arts degree. The Pratts returned to Newfoundland where Christopher became curator at Memorial University Art Gallery (predecessor of The Rooms Provincial Art Gallery) for two and a half years, before settling into the life of a full-time artist in St. Mary's Bay on the southern shore of the Avalon Peninsula. Today, Pratt maintains his studio at Bay Roberts on the southwest side of Newfoundland's Conception Bay.

Initially, Pratt worked in watercolour, painting landscapes of vacant infrastructure and vernacular architecture. He turned to the human figure and began using oil paint in 1964. *Young Girl with Seashells* is his second major work in oil, completed in 1965, the same year as the artist's first solo exhibition organized by Memorial University. The Rooms Provincial Art Gallery, which owns the work, also holds the preparatory studies. These works show the composition's evolution from an Edenic image of a young boy placing apples in the upturned skirt of a young girl in an orchard setting—a particular childhood memory of Pratt's—to a young woman (an amateur model named Bernadette) carrying seashells through the threshold of a house by the ocean. As such, the painting is a composite of the past and present, memory and perception. In a letter to curator Caroline Stone from 2012, Pratt noted that at the time *Young Girl with Seashells* was painted, he "never drew from a professional 'artist's model'" (Letter from Christopher Pratt to Caroline Stone, 12 November 2012). Regular people remained the focal point of Pratt's practice until 1967, after which he returned his attention almost exclusively to architectural subjects that were devoid of human presence. The writer and curator Jeffrey Spalding has described Pratt as an "image painter" rather than as a representational one. Pratt paints scenes of the world around him, but these images hold our attention as much for their distilled formal precision as for their narrative content.

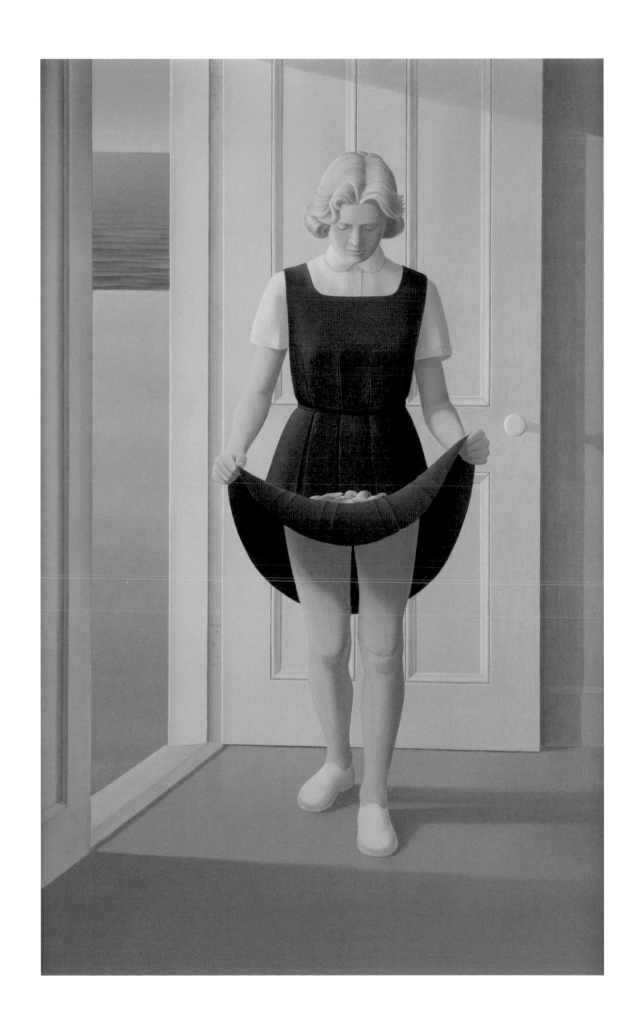

Kenneth Noland American, 1924–2010

Must, 1966

Acrylic on canvas 120.7 x 243.6 cm

Art Gallery of Alberta, Edmonton
Purchased in 1976 with funds donated by
Westburne International Industries; 76.19

AFTER SERVING IN THE United States Air Force from 1942 to 1946, Kenneth Noland took advantage of the Servicemen's Readjustment Act (known as the G.I. Bill), which provided cash payments for tuition and living expenses so war veterans could attend college. He enrolled at Black Mountain College in North Carolina, studying under Ilya Bolotowsky and Josef Albers, and then travelled to Paris where he studied with the sculptor Ossip Zadkine. Following his first solo show in Paris in 1949, Noland returned to the United States and became an instructor at the Institute of Contemporary Arts, and then at the Catholic University of America, both in Washington, D.C. His acquaintance with Clement Greenberg and Helen Frankenthaler led to a meeting with Morris Louis, and the two became lifelong friends and colleagues. Together they visited Frankenthaler's studio in 1953 and were introduced to her large stained canvases, which resulted in significant stylistic shifts in their own painting. By staining the canvas with colour—literally pouring the paint onto the canvas, allowing it to soak into the support—Noland eliminated his reliance on the brush and stroke, focusing instead on the spatial relationship between the canvas and colour, superseding the presence of the artist and the status of the design.

Stressing that the primary function of the design and shape of the painting is to act as a vehicle for colour, Noland wrote: "In all the different kinds of pictures that I make I look for that possible range of size, scale, color . . . When you play back and forth between the arbitrariness and the strictness of the conditions of making pictures it's a very delicate threshold back and forth . . . But you can plan the conditions for color ahead . . . you can get together all the frames of reference that will get you into the condition of using color in relation to shape, to size, to focus, to depth, to tactility" (Diane Waldman, *Kenneth Noland: A Retrospective*, New York: The Solomon R. Guggeheim Museum and Harry N. Abrams, 1977, 33).

Beginning in the mid-1950s, Noland began working on a group of paintings based on circles or centred images (also called targets), followed by three more series featuring chevrons, stripes, and finally shaped canvas. The Art Gallery of Alberta work is one of his diamond paintings, which is part of the artist's shaped canvas series. Noland led the way with the shaped canvas in the 1960s, starting with his symmetrical and asymmetrical chevrons. In 1966 he moved from the chevron to the diamond, and in the case of *Must*, he squeezed the square into an elongated diamond shape to create one of his most brilliant compositions, or platforms, for colour. Here, the sections or bands of fully saturated colours are stacked and aligned with the parallel sides of the diamond-shaped canvas. Noland used different proportions for the diamond paintings, but many were in the proportion of 60 x 240 centimetres and called "needle diamonds." Greenberg included several of Noland's new paintings in his 1964 travelling exhibition *Post-painterly Abstraction* (a term coined by Greenberg), which introduced audiences to Colour Field Painting, to which Noland and Louis were significant contributors.

Claude Tousignant Canadian, 1932–

Gong 80, 1966

Acrylic on canvas 204.1 x 204.1 cm

Art Gallery of Alberta, Edmonton
Purchased in 1969; 69.11

AMONG CANADIAN ARTISTS working in the post–World War II era, Claude Tousignant undertook some of the most distinctive and rigorous investigations of sensory experience. In 1952, after initial studies in Montreal under Jacques de Tonnancour, Tousignant spent an unfruitful year in Paris where he attended the Académie Ranson. He returned to Montreal and quickly began developing a bold and unique artistic vocabulary. By the mid-1950s, the young Québécois artist had begun producing reductive and Hard-edge enamel paintings: large monochromes as well as canvases divided into two and sometimes three bands of saturated and unmodulated colour. In a way that shocked even his close colleague Guido Molinari, Tousignant's work expunged not only the illusory space of both naturalistic and Cubist representation, but also the indexicality of New York Abstract Expressionism as well as the psychic imaging of Montreal Automatism. Seeing Barnett Newman's monumental and simplified canvases in New York in 1962 strengthened the younger artist's resolve: "It is exactly what I was trying to do in 1956," Tousignant observed, "to say as much as possible with as few elements as possible" (Danielle Corbeil, *Claude Tousignant*, Ottawa: National Gallery of Canada, 1973, 14).

Gong 80, completed a decade after Tousignant's first reductive experimentations, is a testament to the maturation and refinement of his vision. The circle had captivated him for some time. For Tousignant, the circle represented geometrical purity in the sense that the shape inherently eliminated any contest between horizontality and verticality. The *Transformateurs chromatiques* works, structured by thin concentric bands of serial colour and equal width that are themselves subdivided into narrower bands, were the first that he painted using an exclusively circular format. This series contributed to Tousignant's association with Op Art and, specifically, his inclusion in the 1965 exhibition *The Responsive Eye* at the Museum of Modern Art in New York. Later in the 1960s, reflecting a desire to emphasize colour relation over optical vibration (and thereby distancing himself from Op Art), Tousignant introduced his famous *Accélérateurs chromatiques* series. Between the two *Chromatiques* series, in 1966, he initiated his second series of circular paintings, *Gongs*. Among the three, *Gongs* (which, for Tousignant, referred to the composer Edgar Varèse's excitement for the way in which the sound of a gong persists within a musical performance) is the most visually distinct, with wider bands and fewer colours than either the *Transformateurs chromatiques* or the *Accélérateurs chromatiques* series. While every band reads as a single dominant colour from a distance, they each comprise two different colours that, in visual juxtaposition, combine to read as the perceived third. Optically, the works in the *Gongs* suite display centripetal and centrifugal movement, and appear veiled by a strange luminous haze.

The sensory dialectics of Tousignant's *Gongs* make them highly refined expressions of the artist's chromatic explorations. The paintings heave and undulate; their colours activate the surfaces of these canvases in a way that makes them appear as though the work is breathing. This somatic reference, and indeed the central role that holistic sensory experience occupies in his work in general, distinguishes Tousignant's oeuvre from Op Art. More than visual effect, the paintings envelop and situate the viewer's entire being. They do not aim to deceive the viewer, but to create pure perceptual events. Far from alienating us, Tousignant, as the curator and critic James D. Campbell has noted, "invites us to see" (James D. Campbell, *After Geometry: The Abstract Art of Claude Tousignant*, Toronto: ECW, 1995, 10).

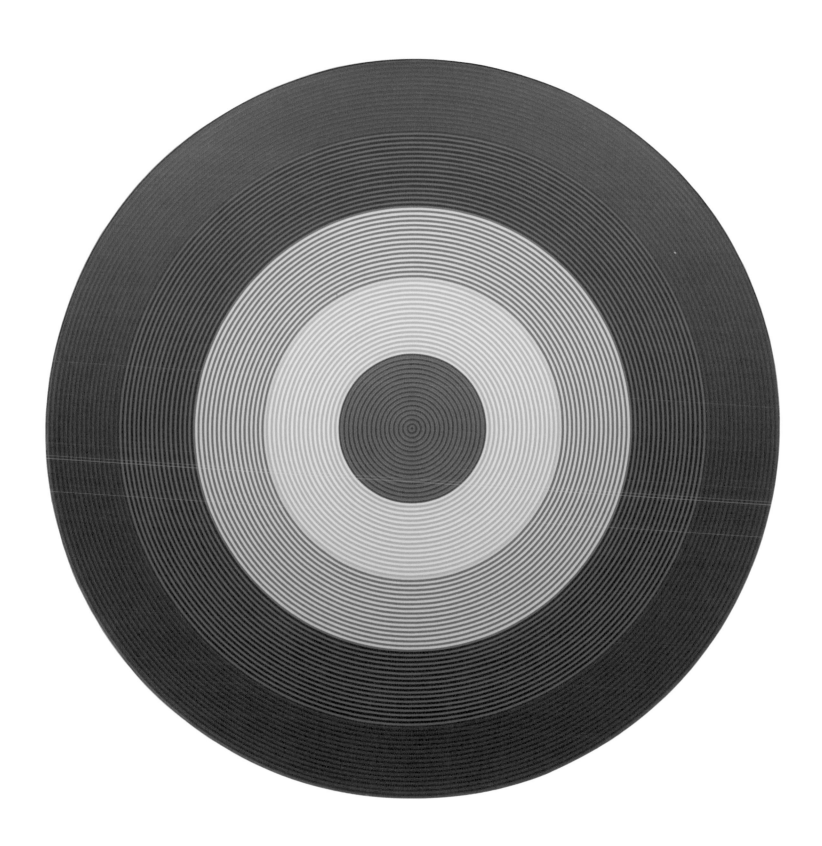

Greg Curnoe Canadian, 1936–1992

The True North Strong and Free, 1968

Polyurethane and ink on wood 60 x 63.5 cm (each of five panels)

Museum London, London
Art Fund, 1970; 70.A.44.1-5

GREG CURNOE TOOK A LEADING role in transforming his hometown and creative base, London, Ontario, into an unlikely centre of artistic activity. He was a paradoxical figure, an artistic gadfly and family man who made, in his words, "no distinction between art and life" (Lisa Balfour Bowen, "Greg Curnoe unleashes a life's work, *Toronto Star*, 27 March 1982). His work is unabashedly particular and personal in its consistent reference to local figures, regional landmarks, and grassroots politics. Curnoe was an avowed defender of Canadian cultural independence, yet he was also an internationalist with a comprehensive knowledge of art history and a keen awareness of contemporary art around the world.

Curnoe's interest in art bloomed and focused after he entered the specialized art program at H. B. Beal Technical and Commercial High School. The program was highly innovative at the time. It encouraged interdisciplinary study and minimized the traditional hierarchy between student and teacher by reinforcing creative possibilities that result from collaboration and discussion. At Beal, Curnoe developed an appreciation for the Dada artists, particularly for their sense of irreverence and the lack of preciousness they brought to making art. He later attended the Doon School of Fine Arts as well as the Ontario College of Art in Toronto, which he disliked intensely, failing his final year. His time in Toronto was not entirely disappointing. Before returning to London, Curnoe developed a friendship with the internationally respected Dada scholar Michel Sanouillet, who was then teaching at the University of Toronto. In London, he immersed himself in the

task of developing an art scene. Curnoe organized the first performance art in Canada (*The Celebration*), self-produced an art magazine and opened a gallery, waged a puckish anarchist poster campaign against the Conservative government during the 1963 Ontario provincial election, and formed the sonically experimental Nihilist Spasm Band. He also created art objects—paintings, collages, and sculptures—that drew stylistically on American Pop Art, but ruminated on themes related to his daily life that linked him more deeply to British representatives like David Hockney and Peter Blake.

Curnoe began to gain national attention in the late 1960s. In 1967, a commissioned mural he had completed for the new Montreal International Airport was summarily removed for containing elements that criticized American military involvement in Vietnam. A year later he produced *The True North Strong and Free*. For this series of five panels—alternating red and blue—he stamped in inconsistently inked black capital letters terse, slogan-like phrases expressing Canada's self-image and relationship with the United States: "Canada Feeds the Brain," "Close the 49th Parallel," "Can. Costs Less Than Drugs," "Canada Always Loses," and "Did Chartier Die in Vain?" This work, a crystallization of Curnoe's contrarian humour, innovative irreverence, and political commitments, was one of the artist's contributions to the 1969 Sao Paulo Biennale. Curnoe was selected by the National Gallery of Canada, along with sculptor Robert Murray and the collaborative conceptual artists Iain and Ingrid Baxter, to represent the country.

Robert Motherwell American, 1915–1991

Untitled (Ochre and Black Open); previously titled *Window in Sienna*, 1968

Acrylic on canvas 137.2 x 175.3 cm

Walker Art Center, Minneapolis
Gift of Margaret and Angus Wurtele
and the Dedalus Foundation, 1995; 1995.56

As a boy, Robert Motherwell moved with his family from Washington State to San Francisco when his father became president of the Wells Fargo Bank. He later studied painting at the California School of Fine Arts before enrolling at Stanford University, where he majored in philosophy. At the bidding of his father, Motherwell went to Harvard, but in 1940 he switched to Columbia University in New York, which led to his decision to pursue a career in painting, due in part to the encouragement of his advisor, the distinguished art historian Meyer Shapiro. Through Shapiro, he was introduced to a group of Surrealist artists who were living in New York including Marcel Duchamp and Max Ernst. The following year, Motherwell joined the Chilean-born artist Roberto Matta on a trip to Mexico, which proved to be a pivotal experience for the aspiring young artist. During this trip with Matta, he was exposed to the Surrealist principle of automatic drawing where the hand moves freely and randomly across the paper as a way to allow the subconscious to lead in a form of mark-making.

Working in New York in the 1940s, Motherwell became friends with Jackson Pollock and Willem de Kooning, and he played a major role in the development of Abstract Expressionism. He had his first one-man show at Peggy Guggenheim's gallery in New York in 1944, the same year the Museum of Modern Art purchased its first work by the artist. Aside from this studio work, Motherwell wrote and lectured extensively on painting and art theory, and became the primary spokesperson for the avant-garde in the United States.

The Walker Art Center painting comes from a suite of works known as the *Open* series, which Motherwell began in 1967 and continued to work on until his death. In his studio one day, he noticed two canvases leaning against each other, which caused him to draw the outline of the shape of the smaller canvas onto the larger canvas. The result was a rectangular design set against a backdrop of a solid colour, as we see with the black space surrounded by the burnt orange ground in the Walker painting. The compositional effect also reminded Motherwell of the façade of a Spanish house as well as the concept of the window in painting, which dates back to the Renaissance.

Motherwell recalls an experience when he was standing in front of one of his paintings in an art gallery, and the visitor next to him, unaware he was talking to the artist, asked him what the picture was all about and what it really meant. Looking directly at his painting, which happened to be one of his large black and white paintings, Motherwell remembered the very actions that resulted in this work: "In the end I realize that whatever 'meaning' that picture has is just the accumulated 'meaning' of ten thousand brush strokes, each one being decided as it was painted. In that sense, to ask 'what does this painting mean?' is essentially unanswerable, except as the accumulation of hundreds of decisions with the brush . . . when you steadily work at something over a period of time, your whole being must emerge" (Dore Ashton and Jack D. Flam, *Robert Motherwell*, exhib. cat., New York: Abbeville Press, 1983, 12).

Jack Chambers Canadian, 1931–1978

Mums, 1968–1971

Oil on wood 244 x 121.9 cm

Museum London, London
Purchased with funds provided by the Volunteer Committee
and other generous donors, 1993; 93.A.106

JACK CHAMBERS REMAINS ONE of Canada's most visionary artists, universally respected as both an experimental filmmaker and a painter. Deemed "Canada's highest-earning artist" in 1970, Chambers was born to a working-class family in London, Ontario, and studied at H. B. Beal Technical and Commercial High School. During the latter half of the 1950s he travelled and studied in Mexico, France, and England, meeting both Pablo Picasso and Henry Moore. However, it was at Madrid's Escuela Central de Bellas Artes de San Fernando in 1959 that Chambers developed an appreciation for the still lifes of Spanish Baroque artist Francisco de Zurbarán and gained the technical prowess required to paint works like *Mums*. In Spain he met his wife, converted to Roman Catholicism, and won several major awards, including the state prize for painting, before returning to London in 1961. Chambers immediately involved himself in what had become a dynamic cultural scene that included artists like Greg Curnoe and, later, Paterson Ewen. In 1963 he began exhibiting regularly at the Isaacs Gallery, an important early hub for contemporary art in Toronto. His representational paintings from this period, those completed before he turned almost exclusively to film in 1966, convey an unreal, dreamlike quality. The artist was also something of an activist. In 1967 Chambers was instrumental in founding Canadian Artists' Representation, an organization that lobbies for the payment of reproduction rights and rental fees for artists.

Chambers returned to painting in 1968, focusing his attention on objects and scenarios drawn from everyday life with luminous warmth and precision. *Mums*, painted that year, stands as the only still life Chambers would execute until he returned to the genre in 1975. The painting depicts a domestic interior dominated by a central bureau on which, among scattered notebooks, a plate, and a change purse, stands a glass vase of yellow flowers and rose branches. The glimpse of a hallway and cropped rug at once frame the still life and free the eyes' movement across the picture plane. The painting is significant for being one of the first and finest examples of what the artist termed "perceptual realism." Chambers drew his understanding of perception, and by extension artistic representation, from the French philosopher Maurice Merleau-Ponty. Sense experience, according to Merleau-Ponty, is not the result of external stimuli. It is not caused by something distinct or isolatable from the perceiving subject, but is an expression of that subject's embodied interactive place within the world. Merleau-Ponty's phenomenology was important for Chambers because, as he wrote in October 1969, it implied that "perception of the natural world is the source of truth about oneself because not only what we project but also what we receive is ourselves" (Jack Chambers, "Perceptual Realism," *artscanada*, October 1969, 7). Given Chambers's contention that "perception redeems reality (José L. Barrio-Garay, *Jack Chambers: The Last Decade*, London, ON: London Regional Art Gallery, 1980, 9) and the way this idea informed and resonated in his artistic practice, the Museum London work defies the common idea that still lifes in the Western tradition invariably offer symbolic reflection on the advent of death. Viewed through the lens of perceptual realism, *Mums* becomes a celebration of the artist's engagement with life.

Mary Pratt Canadian, 1935–

Caplin, 1969

Oil on Masonite board 76.5 x 101.5 cm

The Rooms Provincial Art Gallery, St. John's
Memorial University of Newfoundland Collection; 70.31

MARY PRATT, NÉE WEST, was born in Fredericton, New Brunswick, and has gone on to become one of Canada's best-known realist painters. In 1957 she married Christopher Pratt, a fellow fine art student at Mount Allison University in Sackville, New Brunswick, where both studied under Alex Colville. She lived in St. John's, Newfoundland, and then Scotland (where her husband studied at the Glasgow School of Art), before returning to Sackville to complete her degree in 1961. The Pratts had four children by 1964 and had relocated to the Salmonier River region south of St. John's on the Avalon Peninsula. While Christopher's career blossomed, Mary's initially suffered from competing domestic demands. Finally, in 1967, she had her first exhibition at the Memorial University Art Gallery (predecessor of The Rooms Provincial Art Gallery). She achieved wide attention beginning in 1975 as part of the group exhibition *Some Canadian Women Artists* mounted by the National Gallery of Canada, which toured the country and parts of the United States.

Her artistic practice underwent a significant development in 1969 when she began projecting Kodachrome colour slides her husband had taken onto her canvases as painting aids. "The camera was my instrument of liberation" because it ensured that "[I] no longer had to paint on the run" (Sandra Gwyn, "Introduction," *Mary Pratt*, Toronto and Montreal: McGraw-Hill Ryerson, 1989, 13). *Caplin* was one of the first works Pratt completed using this technique. It had a neutralizing effect, freeing the image of any stylistic signature. In her later paintings of set tables and scenes depicting various stages of food preparation, Pratt achieved the combined appearance of both commercial advertising photography and seventeenth-century Dutch still-life painting. The artist's great analytical skill does not, however, drain her canvases of emotional intensity. There is luminous sensuousness, even at times a visceral sexuality, in Pratt's work that distinguishes it from the alienating coolness of other Atlantic Realists such as Christopher Pratt and Alex Colville. Light is transmitted and refracted within a shallow space between surfaces that appear pliable and proximal. In Pratt's work we find none of Colville's geometric solemnity and none of her husband's panoramic expansiveness. One feels the slipperiness of the dead fish in their glistening closeness. The Rooms painting is a celebration of bounty obtained by the annual inshore migration of Atlantic caplin. It also offers insight into the way the human world links itself to such natural regularities. Caplin migration, harvest, and preparation as food draw attention to the separate broader realms within which men and women traditionally operate in Western societies. Pratt's focus on food is a focus on domesticity, the social sphere that both competed with her early professional ambitions and granted those ambitions a unique and rich subject matter.

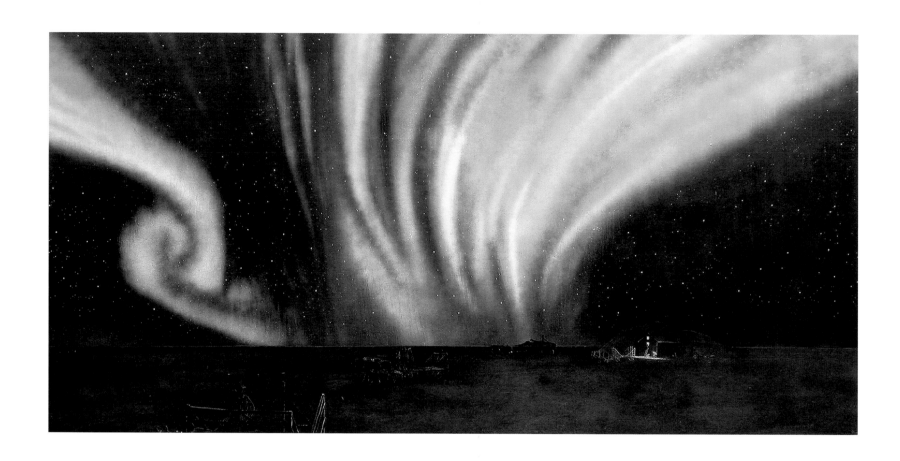

William Kurelek Canadian, 1927–1977

Glimmering Tapers 'round the Day's Dead Sanctities, 1970

Mixed media on hardboard 120.5 x 243.3 cm

Art Gallery of Alberta, Edmonton
Purchased with funds from the Art Associates
of The Edmonton Art Gallery; 90.15

IN HIS LIFETIME, William Kurelek often appeared to be out of step with his contemporaries. A deeply religious man, he painted scenes of farming, immigrant experience, and family life, often using them as the basis for moral and socio-religious commentary. This was at a time when his peers Michael Snow, Dennis Burton, and John Meredith at Toronto's Isaacs Gallery defined the urban and secular outlook of that city's post-war contemporary art scene. Yet the Alberta-born and Manitoba-raised son of Ukrainian immigrants garnered an immense amount of attention during his short career from both critics and the general public, a rare accomplishment among visual artists in Canada. In 1961 Alfred H. Barr, director of the Museum of Modern Art, shockingly selected Kurelek's *Hailstorm in Alberta* as an addition to its permanent collection over decisively modern works by other Toronto artists.

Glimmering Tapers 'round the Day's Dead Sanctities, an undeniable masterpiece, is one of the artist's most monumental landscape paintings. Kurelek expresses the vastness of the Canadian Prairie where his Ukrainian parents first farmed and where he was born. Although a committed Roman Catholic, his landscapes routinely betray an almost pantheistic sense of awe toward nature. They depict vast open spaces, stages that purposefully dwarf their inhabitants. Kurelek usually installs the viewer at an elevated point, with the ground appearing to tilt slightly up toward them. His romantic interest in the natural world did not originate from fine art studies—his time at the Ontario College of Art and the Institudo Allende in Mexico were

relatively brief. Rather, it reflects his appreciation for Victorian literature and poetry, which he studied as a humanities undergraduate at the University of Manitoba in the 1940s. Kurelek was particularly drawn to the poetry of nineteenth-century Romantic luminaries such as William Wordsworth, Samuel Coleridge, and Robert Browning.

Francis Thompson, and particularly the Victorian poet's 1893 work *The Hound of Heaven*, proved a particularly enduring influence on Kurelek. It served as the basis for an entire series of paintings and an Isaacs Gallery exhibition in 1970 entitled *Nature, Poor Stepdame*. At one point, the poem describes the protagonist's revelatory encounter with nature, and the title of this painting is derived from a phrase that appears at the poem's midpoint: "I was heavy with the even, / When she lit her glimmering tapers / Round the day's dead sanctities." The poem expresses the majesty and power of nature, as well as its blind unconsciousness, its obliviousness to human purpose. Nature is at once holy and hostile. This painting appeared in Kurelek's major solo exhibition at the Edmonton Art Gallery (today the Art Gallery of Alberta) the year that it was painted, and was acquired by the same institution in 1990.

Norval Morrisseau Anishinaabe/Canadian, 1932–2007

Bearman, c. 1970

Acrylic on canvas 181.1 x 141 cm

Glenbow Museum, Calgary
Gift of Nicholas J. Pustina, 1986; 986.226.23

BORN IN SAND POINT FIRST NATIONS, near Thunder Bay, Ontario, Norval Morrisseau was raised, as was customary, by his maternal grandparents near Beardmore, Ontario. He received early instruction in the Anishinaabe beliefs and legends from his sixth-generation shaman grandfather. It was on early canoe trips with his grandfather that Morrisseau was exposed to ancient Anishinaabe rock drawings—petroglyphs—on northern Ontario's lakeside cliffs. His grandfather also allowed him to view sacred Midewiwin birchbark scrolls, which were passed from one generation to the next and held encrypted pictographic drawings that, properly deciphered, illuminate ancient knowledge. Morrisseau's formal education was limited to several years at a Roman Catholic residential school and a community school.

Although he had drawn for most of his life, Morrisseau only became aware of his artistic proclivities in the late 1950s while working in the mining industry at Red Lake, Ontario. A local art collector took an interest in the young artist's talent and purchased his work. In the 1960s, Morrisseau began developing his characteristic Woodland school "X-ray" style, which derived from pictographic drawings of petroglyphs and shamanic scrolls as well as from nineteenth-century Anishinaabe beadwork. The rich colour associated with the artist's best-known images was incorporated gradually, becoming enclosed within the sinuous and unifying power lines. Many within the Anishinaabe community initially reacted negatively toward Morrisseau's work, which conveyed esoteric narratives and spiritual knowledge, especially after it was first exposed to a mainstream audience in 1962 at Toronto's Pollock Gallery. However, the artist maintained an idiosyncratic approach; his canvases were personal statements that soon transcended, in form and content, their origin in pictographic sources. In 1967 he contributed a mural to the Indians of Canada Pavilion at Expo 67. The pavilion is a crucial marker in Canadian history, as it was the first formal exhibition of Aboriginal art organized and mounted by Aboriginal artists. In 1973 Morrisseau was one of seven First Nations artists, including Daphne Odjig and Alex Janvier, who formed the Professional Native Indian Artists Incorporation. This collective, based in Winnipeg, played an instrumental role in bringing public exposure to the work of an emerging generation of contemporary First Nations artists.

Morrisseau described his artistic purpose as "to reassemble the pieces of a once-proud culture, and to [win] the dignity and bravery of [his] people" (Donald C. Robinson, "Tales of Copper Thunderbird," *Norval Morrisseau: Return to the House of Invention*, Toronto: Key Porter, 2005, 146). However, his imagery often syncretically incorporates elements from Indigenous and Western spiritual and artistic sources, reflecting the self-taught artist's own Anishinaabe/Roman Catholic duality. *Bearman* relates to a legend of Maudjee-kawiss, a figure within Anishinaabe oral history who stole wampum sashes that recorded the deeds, dreams, and prayers of the Bear people for the Anishinaabe, and subsequently became the chief warrior of the Bear people. The bear is also of personal significance to Morrisseau, who encountered one during a vision quest as a young man. Retreating into the forest to fast in isolation, a practice that is believed to help clarify a man's future course in life, a black bear approached the artist, sniffed his face, and moved on. The experience made the bear a significant animal for the artist.

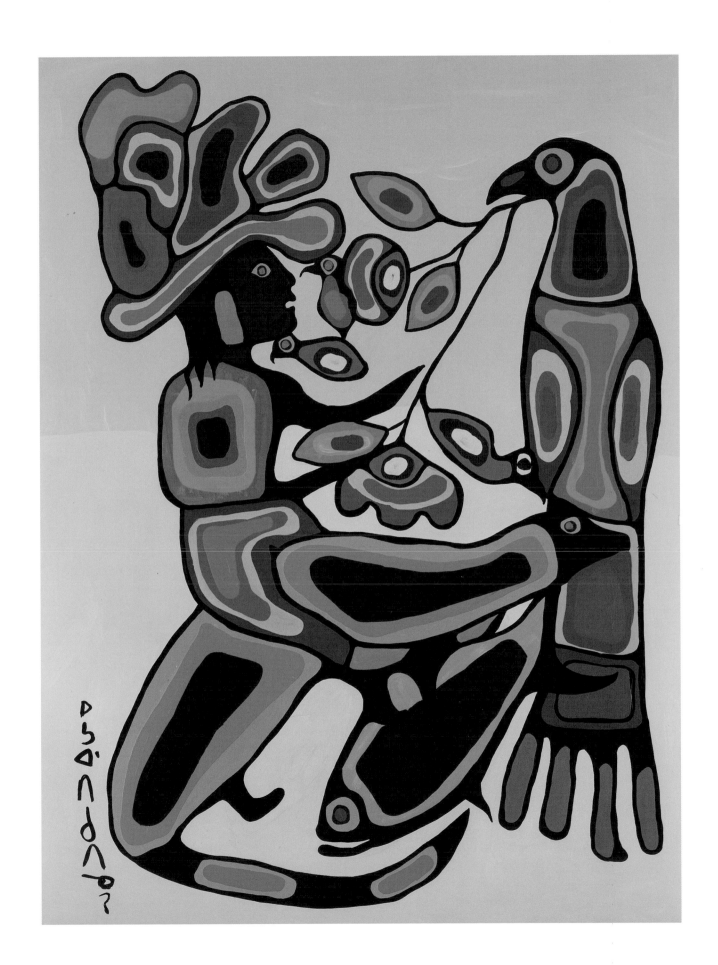

Andy Warhol American, 1928–1987

Mao, 1973

Acrylic and ink on canvas 30.5 x 25.4 cm

University of Lethbridge Art Gallery, Lethbridge
Purchased in 1984 with funds provided by the Alberta 1980's
Endowment Fund and as a result of an anonymous donation; 1984 22

MAO ZEDONG (1893–1976) was the Chinese Marxist theorist and statesman who rose through the ranks of the Chinese Communist Party to become Chairman in 1949 when the People's Republic of China was established. Warhol's documentation of Chairman Mao in the early 1970s came at the height of the Cultural Revolution, which began in 1968 when Mao, with the support of his Red Guards, attempted to reassert his power over the Communist Party and the people. In his efforts to create a cult for himself through social, economic, and cultural initiatives, Mao also brought unrest and devastation to his country. He had strong views on culture, believing that art and literature should serve the people and the Communist Party, and that it should celebrate the Chinese workers, peasants, and military rather than support the idea of art for art's sake.

Warhol first considered doing a print series on Mao in 1972 when he saw the image of the chairman in the frontispiece of *Quotations from Chairman Mao Tse-tung*, which was published in 1964. The book was widely distributed during the Cultural Revolution and became known as "The Little Red Book" due to its bright red cover. The following year, Warhol produced a line drawing of Mao and carried out a "process of mutation" in a sequence of photocopy prints of the original image. Next, he produced the image on canvas through a silkscreening technique, then added acrylic paint and ink. While working on the series, Warhol wrote: "I've been reading so much about China. They're so nutty. They don't believe in creativity. The only picture they ever have is of Mao Zedong. It's great. It looks like a silkscreen" (David Bourdon, *Warhol*, New York: Harry N. Abrams,

1989, 317). The portrait of Mao in the University of Lethbridge Art Gallery collection is one of the few painted works from the series in Canada.

Like many of his portrait or object series, Warhol began with appropriating a ready-made image, often taking a very familiar image such as the Campbell's soup can, Marilyn Monroe, and Jackie Kennedy. Introducing new media to the silkscreened image with painted and printed areas used to define and animate the composition, Warhol plays with the idea of what is real and what has been added.

After studying at the Carnegie Institute of Technology in Pittsburgh in the late 1940s, Warhol moved to New York where he embarked on a commercial art career. His design and illustration work for a variety of popular and fashion magazines exposed him to the work of other artists working in the same media. By 1960 Warhol was presenting his commercial-based work as legitimate art to be taken seriously as the art of the day. This new work was based almost entirely on screen-printing photographic images onto canvas and paper, and then incorporating painting and drawing. The work embodied the ideas of the avant-garde Pop Art movement, which was gaining popularity in the United States through the work of Robert Rauschenberg and Jasper Johns. Coined by an English critic in the 1950s and further defined by the British writer and curator Lawrence Alloway, Pop Art elevated and incorporated the images of popular culture, such as advertising, television, and film, into contemporary art-making practices and aesthetics.

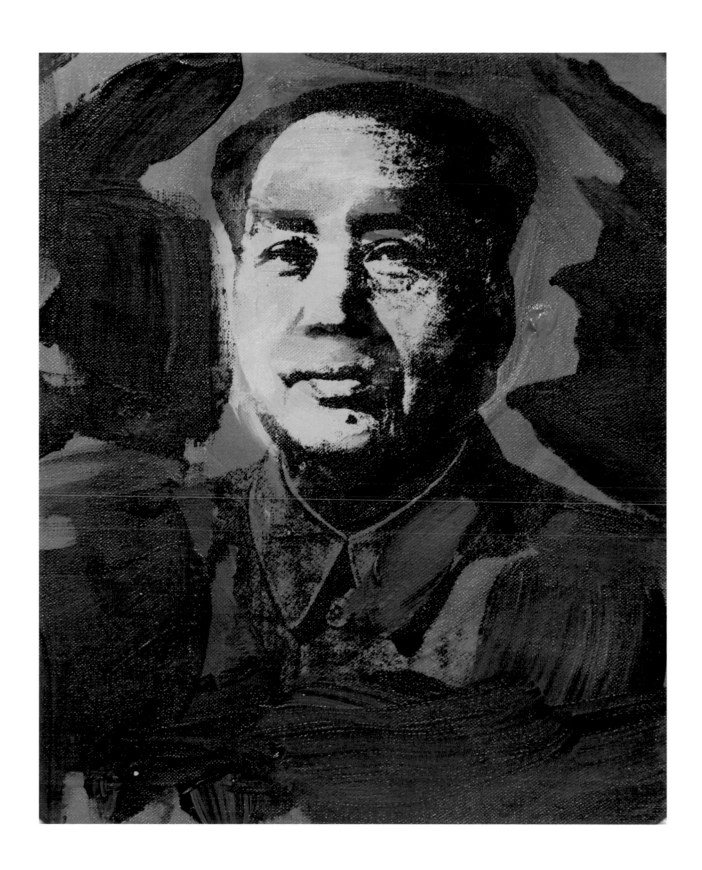

Charles Gagnon Canadian, 1934–2003

Splitscreenspace/of April/d'avril, 1974

Oil on canvas 228.7 x 203 cm

Musée d'art contemporain de Montréal, Montreal
Collection Lavalin; A 92 448 P 1

CHARLES GAGNON—PAINTER, photographer, filmmaker, and sound artist—is renowned as one of Canada's first multidisciplinary artists. The Montrealer distinguished himself early by choosing to study and work in New York from 1955 to 1960. With the exception of Paul-Émile Borduas (who briefly resided in New York before leaving for Paris the year Gagnon arrived), most of Quebec's aspiring mid-twentieth-century francophone Modernists looked to Europe, and particularly France, for guidance. While studying at a number of institutions, including the Parsons School of Design and New York University, Gagnon was exposed to Abstract Expressionism and the work emerging from Neo-Dada artists like Robert Rauschenberg and Jasper Johns. In his later practice, Gagnon would draw from both streams of contemporary American art. From Abstract Expressionism he derived his sustained interest in the signifying potential of the calligraphic mark, especially the drip. From Neo-Dadaism he discovered the power borne by the integration of disjunctive points of contrast between traditional media and unconventional materials such as chains, plummets, aluminum sheeting, and wooden boxes. Gagnon was also inspired by the Metropolitan Museum of Art's collection of Egyptian art and artifacts. What intrigued the artist were, in his words, the objects' "signs of wear with all their implied mysteries" (Martine Perreault, "Biographical Notes," *Charles Gagnon*, Montreal: Musée d'art contemporain de Montréal, 2001, 194). The balance between coherence and indecipherability that runs through Gagnon's entire body of work developed during his time in New York.

The artist returned to Montreal in 1960. He befriended slightly more senior artists like Jean McEwen and Paterson Ewen, who were reformulating a gestural and painterly approach in their work without reverting to the accomplishments of the earlier Automatiste generation. As the decade progressed, Gagnon earned significant national and international exposure including as a Canadian representative at the 1961 Paris Biennale, and he continued to parallel his painting practice with photography and film. In 1978 the Montreal Museum of Fine Arts organized a career retrospective, and this exhibit toured to Ottawa, Vancouver, Toronto, and Winnipeg. In 2002, one year before his death, Charles Gagnon received a Governor General's Award in Visual and Media Arts.

Splitscreenspace/of April/d'avril is an early and emblematic example of Gagnon's *Screenspace* series. These paintings illuminate Gagnon's engagement with Minimalism, offering at once a poetic and succinct revelation of the structural elements of painting itself. The picture plane is divided horizontally at three locations: through the centre and along the top and bottom edges. This effectively creates four discrete zones. These zones, all of which are painted in the same loose consistency in creamy white and opaque blue, are differentiated from one another by virtue of having been masked with tape along their edges. Discontinuity from one zone to the next is announced through the disruption of gesture caused by the masking. The Montreal work invokes ideas of contrast—gestural freedom versus gridded regimentation, indexical uniqueness versus seriality, material literalism versus spatial illusion—creating, as curator Gilles Godmer remarks, "vast pictorial expanses" that are also "tormented and clouded" (Gilles Godmer, "Charles Gagnon: Art and Attitude," *Charles Gagnon*, Montreal: Musée d'art contemporain de Montréal, 2001, 158).

Jean Paul Lemieux Canadian, 1904–1990

Autoportrait (Self-Portrait), 1974

Oil on canvas 167 x 79 cm

Musée national des beaux-arts du Québec, Quebec
Purchased through a donation from the
Fondation du Musée national des beaux-arts du Québec; 2001.01

THE QUEBEC PAINTER Jean Paul Lemieux was seventy years old when he painted this, the only work within his oeuvre he admitted to being a self-portrait. He began his artistic career with Marc-Aurèle de Foy Suzor-Coté, training with the senior artist for several months before entering the École des beaux-arts in Montreal in 1925. His classmates included a veritable who's who of Canadian Modernism including Paul-Émile Borduas, Louis Muhlstock, and Jori Smith. The École offered a strict academic regimen. An exception to this was Edwin Holgate, a future member of the Group of Seven who exposed Lemieux to a comparatively modern approach in landscape painting. Touring parts of Europe with his mother in 1929, Lemieux seized the opportunity to continue his studies by attending classes at both the Académie de la Grande Chaumière and Académie Colarossi in Paris. His return to Canada via Chicago, New York, and Boston exposed Lemieux to American Social Realism and the work of Mexican muralists like Diego Rivera. Back in Montreal, Lemieux exhibited his work for the first time, quickly earning critical praise in the press. Between 1937 and his retirement in 1965, he taught at the École des beaux-arts in Quebec City.

Lemieux was enamoured of the vistas, terrain, and cultural traditions of people in Charlevoix County. Not one to shy away from controversy, he began publishing writings on the social purpose of art, lashing out at the social conservatism of Quebec under Premier Duplessis and the Roman Catholic Church, and urging awareness of international developments in modern art. In the early 1950s, Lemieux's approach changed in a way that would have a sustained effect on his future output. From early Group of Seven–inspired landscapes and hovering panoramic views inspired by Quebec folk art, Mexican mural art, and narrative painting from the late Middle Ages, he turned to depicting stolid figures in vast imagined landscapes. Lemieux, according to the artist's daughter, was "melancholy by nature" (Anne-Sophie Lemieux, "Memories of my Father," *Homage to Jean-Paul Lemieux*, Ottawa: National Gallery of Canada, 2004, 20). After 1955, when he returned from a sabbatical in France, his work became a meditation on existential themes, anxiety in the face of passing time, and the solitary, ultimately incommunicable, nature of felt experience. Desolate skies and frozen fields cleaved by sharp horizons that are themselves punctured by seemingly immoveable figures—as in *The Evening Visitor* (1956) and *Horseman in the Snow* (1967), both of which appear in this self-portrait — came to populate his oeuvre. This painting is, in fact, a triple self-portrait. Lemieux appears in the foreground as a confident, if world-weary, old man; as a tentative ten-year-old boy in the left middle ground; and as an art student, lurking in a darkened passageway. Lemieux's paintings often deal with the way in which the incomplete memories we have of ourselves and our lives inspire our understanding of the passage of time.

Some years after painting this self-portrait, Lemieux presented it as a gift to his only daughter. The painting was acquired from Anne-Sophie Lemieux in 2001 by the Musée national des beaux-arts du Québec, which holds the largest public collection of the artist's work. Despite the often understated and brooding character of Lemieux's work, he remains one of Canada's most popular artists. In 2004, to honour the centennial anniversary of his birth, Canada Post issued a stamp featuring an image of this painting.

Marion Tuu'luq Inuit (Baker Lake)/Canadian, 1910–2002

Thirty Faces, 1974

Wool felt, embroidery floss, thread on wool stroud 141 x 124 cm

Winnipeg Art Gallery, Winnipeg
G-76-956

INUIT ARTIST MARION TUU'LUQ is renowned for her works in appliqué and embroidery. Beginning in 1966, she became one of the first women to produce cloth wall hangings, or what in Inuktitut are called *neevingatah*. These works on cloth are remarkable for their scale, vibrant colour, skillful construction, and formal dynamism; the artist's repeated and loosely gridded motifs—human, spirit, and animal figures and faces; tools; abstracted natural forms—are immediately recognizable.

Until the 1960s, Tuu'luq and her family led a traditional nomadic life. Born at her family's camp at Innituuq near Chantrey Inlet, inventiveness and enterprise were qualities Tuu'luq needed to develop at a young age for the sake of survival. Orphaned by the age of ten at a formative point when Inuit children begin acquiring essential skills through their parents, she lived with various families northwest of Baker Lake, teaching herself how to cut and sew traditional clothing. Between the 1920s and 1950s, she married her first husband with whom she had as many as fourteen children (only four survived); and when her husband died in 1954, Tuu'luq remarried Luke Anguhadluq, a respected hunter who would become a significant artist in his own right. In the early 1960s the family moved to Baker Lake, the geographical centre of Canada and an emerging permanent settlement, taking advantage of recently introduced government medical and educational services and infrastructure. Later in the decade, a short-lived sewing project was established in which Tuu'luq received formal training in sewing clothing out of wool duffle; at this time she also began drawing and producing small embroidered pictures from sewing scraps. The sewing project was revived between 1969 and 1972, with artists Jack and Sheila Butler operating as the program's artistic advisors. The Butlers provided the practical guidance from which the Sanavik Co-operative emerged in 1971 to coordinate the settlement's economic development through artistic and craft-based production. Moreover, the Butlers encouraged Baker Lake artists to explore subjects—from shamanism to ancient myths—largely forbidden by the established Anglican Church. Tuu'luq developed her distinctive imagery, colour sensibility, and bold design of her cloth works over the ensuing three decades. Unintentionally, her application of a skill that is largely understood as feminine and utilitarian paralleled many of the same issues that had begun to preoccupy feminist artists and scholars in the 1970s. Moreover, her work has proven enormously popular, and earned her a solo exhibition organized by the National Gallery of Canada that toured to institutions such as the Winnipeg Art Gallery and the Art Gallery of Ontario.

By 1974, Tuu'luq's works in cloth, which initially incorporated earthy colours that were close in tonal value, had become much brighter. Her approach to embroidery remained, however, straightforward and simple and, as *Thirty Faces* reveals, she increasingly sought to integrate foreground and background through the repetition of deceptively simple motifs. The highly structured design belies an unconscious working process whereby Tuu'luq sews without, in her words, "thoughts filling my mind."

Carl Andre American, 1935–

Neubrückwerk Düsseldorf gewidmet
(*Construction of a new bridge dedicated to Düsseldorf*), 1976

Red cedar 121.9 x 30.5 x 823 cm

Musée d'art contemporain de Montréal, Montreal
A 80 108 S 19

THE SON OF A MARINE architect of Swedish descent, Andre was born in Quincy, Massachusetts, very close to the United States Navy shipyards, which employed about thirty-two thousand workers during World War II. Recalling his childhood years, Andre remembers a vivid image of "rusting acres of steel plates" laid out and exposed to the natural elements. The image of these massive sheets of steel remained one of his strongest memories from Quincy, and one that would have an impact on his art-making years later. It was during his studies at the Philips Academy in Andover, Massachusetts, that Andre received his only formal art training in the studio of Maud and Patrick Morgan. In 1954, the year following his graduation from the elite boarding school, Andre travelled to England, which included a visit to Stonehenge that left a powerful impression on the twenty-one year old and which he would draw upon throughout his career as an artist. He returned to the United States to serve in the military for a year before settling in New York where he ended up sharing a studio with Frank Stella and began constructing large-scale sculptures with natural and common building materials. Andre continued to hold jobs outside his studio including working as a railway freight brakeman and then a conductor.

In the mid-1960s, as Andre turned to his art career full time, he began to look at new materials for his sculptures. He continued to favour building products including steel, bricks, timber, and aluminum and lead plates, and used only one material for each new piece. These sculptures were installed directly on the floor so the work could be physically experienced. Wood became one of his favourite media. Considering the placement and presence of his sculptures, Andre noted in a written interview: "Every work of art is located somewhere. A work of mine disappears when placed in storage exactly the way your lap disappears when you stand up. My sculpture is completed only when it is experienced by someone other than myself. Art, like justice, must be seen to be done" (Carl Andre, *Cuts: Texts 1959–2004*, Cambridge, Massachusetts: The MIT Press, 2005, 263). His sculptures exist only in their physical installation and in their interaction with the viewer, which distanced Andre from any association with conceptual art.

This sculpture from the Musée d'art contemporain de Montréal comprises nineteen aligned pieces of red cedar, each unit measuring ninety-two centimetres in height. Ten vertically placed sections support nine horizontal sections to make up the finished work. The uniformity of size and weight is in keeping with Andre's principle of aesthetic consistency of never allowing any single component to exceed one metre in length. The mass of the building materials remains integral to the overall composition and his artistic intent, as Andre explained: "The mass of an object on the earth and on the moon is the same, its weight is different. My sculpture has a great deal to do with the relations between mass, volume, and area" (Carl Andre cited by Ace Gallery Los Angeles, 2002). This work is meant to be easily assembled and disassembled, and if necessary individual timbers can be replaced, as Andre was concerned only with the overall effect of the piece and that the individual components not detract from this outcome.

Richard Long British, 1945–

Niagara Sandstone Circle, 1981

362 sandstones 488 cm (diameter)

Musée d'art contemporain de Montréal, Montreal
A 85 34 S 362

RICHARD LONG RECALLS A winter walk he took in his native Bristol in 1964 when he was eighteen years old. With the ground covered in freshly fallen snow, he set out to make a snowball and began rolling it down a path until it had become too large to move by hand. He documented the work by photographing the trail left bare by the path of the snowball, and entitled it *Snowball Track*. The snowball was not part of the work. Three years later, Long produced his famous *A Line Made by Walking*, which was the photographic documentation of a trail left in the grass made by the artist walking back and forth in a straight line.

Long studied at the West of England College of Art in Bristol, and then at St. Martin's School of Art in London. Within a year of finishing art school, Long had begun to explore a new art form called Land Art. Also known as Earth Art and Earthworks—the later name used by the American artist Robert Smithson— this movement links the landscape and the artwork at all fronts, starting with the landscape as the means of the artistic production. Some land works are meant to be ephemeral in nature with photographic or video documentation being the only extant part of the piece, while other works remain physically part of the landscape as the land itself changes and erodes over time. Long, however, distanced himself from the massive Land Art projects in the United States involving significant earth movement or removal, such as Smithson's famous works like *Spiral Jetty*. Long is interested primarily in the relationship between people and the natural environment, and his own creative intervention or footprint remains less invasive or exploitive. His epic walks that highlight the art of walking have resulted in major land works created around the world including interventions in Canada.

The title of the Musée d'art contemporain de Montréal work, *Niagara Sandstone Circle*, references the geographic origin of the materials used: various sized and shaped stones from the Niagara region in Ontario. While the circular shape of the piece (measuring almost five metres in diameter) is determined by the artist, how the three hundred and sixty-two stones fill and animate the circular space is left to chance with each installation. Distancing himself from any set iconography or symbolism within his work, Long focuses on more universal references. In the case of the circle shape, it is a form that the artist sees as long connected to humankind and our diverse histories. For him, the same work is remade with each presentation: "I like the fact that every stone is different, one from another, in the same way all fingerprints or snowflakes (or places) are unique, so no two circles can be alike. In the landscape works, the stones are of the place and remain there. With an indoor sculpture there is a different working rationale. The work is usually first made to fit its first venue in terms of scale, but it is not site-specific; the work is autonomous in that it can be re-made in another space and place. When this happens, there is a specific written procedure to follow. The selection of the stones is usually random; also individual stones will be in different places within the work each time. Nevertheless, it is the 'same' work whenever it is re-made" (*Tate Collection: Richard Long*, London: Tate Gallery).

Paterson Ewen Canadian, 1925–2002

Shipwreck, 1987

Acrylic on gouged plywood 228.6 x 243.6 cm

Museum London, London
Purchased with the support of the Volunteer Committee and the Government
of Ontario through the Ministry of Culture and Communications, 1988; 88.A.01

PATERSON EWEN WAS BORN into a Protestant family in Montreal's west end. After a brief military service at the end of World War II, he began studying earth sciences at McGill University. Ewen would remain on this academic course for only a year, as he turned his attention to fine art in the fall of 1947; however, aspects of geology, meteorology, and astronomy would reappear in his later art practice. He was instructed by John Lyman at McGill, and Arthur Lismer at the Montreal Museum of Fine Arts. In 1949 Ewen was introduced to the city's young francophone Automatiste group, meeting Paul-Émile Borduas and Jean-Paul Riopelle, among others. Through the next two decades, he exhibited in Montreal and New York, his work developing in a manner consistent with his Montreal peers. His gestural non-figurative motifs and impasto surfaces of the 1950s gradually gave way to a more formally reduced visual language in the mid-1960s. Series like *Lifestream*, although contextualized at the time in relation to the Hard-edge approaches of contemporaries like Guido Molinari, also hint at the unique trajectory his later practice would take.

The late 1960s were traumatic years for Ewen. He was fired from his personnel job at RCA Victor, and his family fell apart when his marriage to artist Françoise Sullivan ended. Hospitalized for depression in 1968, Ewen was effectively forced to regroup his life. He left Montreal and settled in London, Ontario, where he began teaching art at H. B. Beal Secondary School. London was, by that time, an enclave of vibrant artistic activity, whose signature participants—Greg Curnoe and Jack Chambers—made work that revelled in countering the Modernist orthodoxy that had dominated the contemporary art

worlds of Montreal and Toronto. Ewen's breakthrough exhibition came in 1971 at an abandoned auto showroom in Toronto. The figurative canvases he displayed, painted in a purposefully awkward and diagrammatic manner, were of cloud formations and air masses. He started experimenting with gouged plywood, from which he initially intended to pull large woodblock prints, but which he soon concluded "was the work." He began incorporating a broader range of non-traditional materials such as sheet metal, chains, and screws. This body of work, and the new direction his practice was taking, brought Ewen immediate attention. He went on to represent Canada at the Venice Biennale in 1982, received the Banff Centre's National Award in 1987, and had major exhibitions at the Art Gallery of Ontario in 1988 and 1996.

The stormy seascapes of J. M. W. Turner and Albert Pinkham Ryder were important touchstones for Ewen throughout his career. *Shipwreck*, among what Ewen called his *phenomascapes*—images that seek to communicate meteorological and cosmic events—provides the clearest indication of Ewen's debt to the nineteenth-century British and American Romantics. Indeed, the Museum London painting stands out within Ewen's plywood seascapes for its particular ferocity and sublime force, and the narrative symbolism that the ship's presence, between the glaring moon and jagged waves, implies. The work has also been singled out as a potent indicator of the artist's own trials with mental illness and alcohol dependence, for which he sought treatment in late 1986.

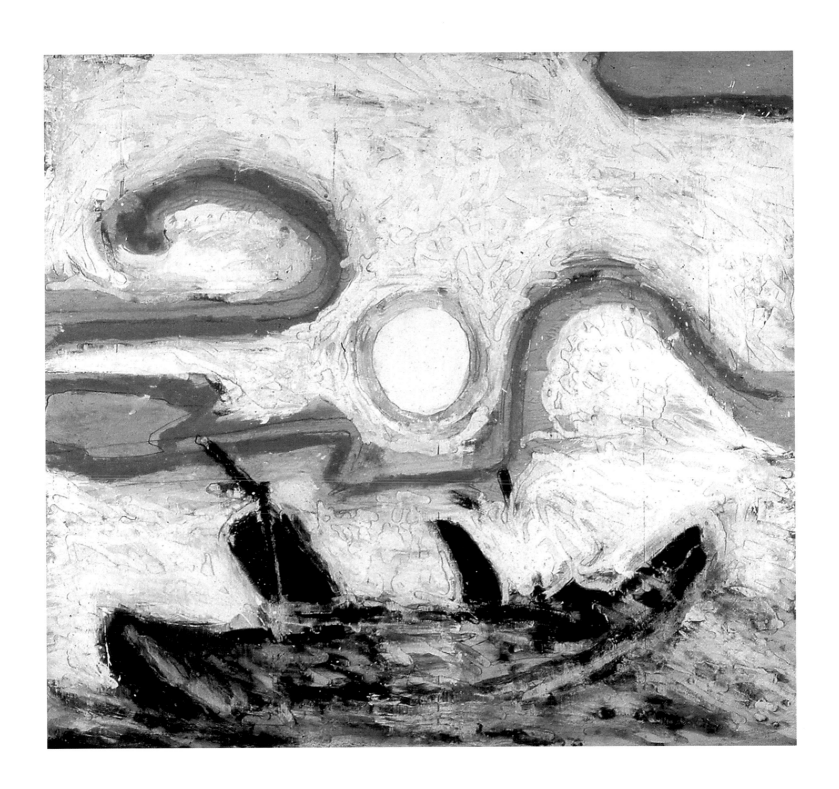

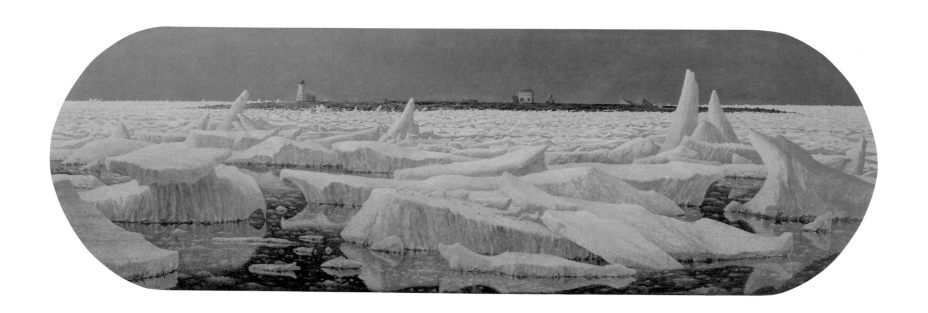

Tom Forrestall Canadian, 1936–

Island in the Ice, 1987

Egg tempera on Masonite 72.5 x 214.5 cm

Art Gallery of Nova Scotia, Halifax
Acquisition made possible with funds provided
by Christopher Ondaatje, Toronto, Ontario, 1994; 1994.19

TOM FORRESTALL'S CAREER GREW out of the realist painting tradition that flourished in the Maritimes, particularly at Mount Allison University in New Brunswick, following World War II. Training under Alex Colville and Lawren P. Harris (the son of the famed Group of Seven member Lawren S. Harris) during the latter half of the 1950s, Forrestall developed the technical and compositional skills that underpin his tightly rendered paintings. In the 1960s, after touring European art centres and working briefly at the Beaverbrook Art Gallery, he turned his attention exclusively to his painting practice. Forrestall began experimenting with unconventionally shaped supports—circles, T-forms, triangles, lozenges—and used only egg tempera, a medium he preferred for its naturalistic luminosity. He also developed his now familiar repertoire of subjects including seascapes, views of empty rooms, and framed scenes of orchards, fields, and alleys from windows and doorways. His works invariably pay tribute to the Maritime locales in which he grew up and has lived: Fredericton, New Brunswick, and Dartmouth and the Annapolis Valley in Nova Scotia.

As is true of much Atlantic Realism—rooted as it is in the *Pittura metafisica* (Metaphysical art) of Giorgio de Chirico, the German *Neue Sachlichkeit* (New Objectivity) movement, and North American Precisionism—Forrestall's scenes are only prima facie straightforward presentations of visual reality. His reliance on photography within his studio practice is minimal. Field sketching renews the artist's connection with his original perceptual experience and constitutes a vital link between himself, the final work, and the audience. As a way of reminding his audience that nature, in his words, "never comes in a squared rectangle" (Virgil Hammock, "The Notebooks of Tom Forrestall," *Artfocus*, Summer 1994, 94), Forrestall draws attention to his original perceptual experience by approximating the field of binocular vision.

A pregnant, suspended, almost premonitory sense of mystery haunts his images, and *Island in the Ice* irresistibly references the great nineteenth-century Arctic seascapes of Caspar David Friedrich and Frederic Edwin Church. However, unlike Alex Colville and Christopher Pratt, Forrestall's Atlantic Realism is neither alienating nor emotionally remote. Rather, akin to artists like Jack Chambers and William Kurelek, his commitment to a variant of high realism is informed by his Roman Catholic faith. In title and image, the Art Gallery of Nova Scotia work seems, on one hand, to be a scene from nowhere, a picture of a timeless non-place of invented possibility. On the other hand, the painting in fact refers to a particular (and rare) event when an ice floe drifted into Halifax's normally ice-free harbour in the early spring of 1987. Dwarfed and seemingly held hostage by the massive flotilla of surrounding ice, Devil's Island, near Dartmouth, balances on the distant horizon. This competing sense of universality and particularity, ideality and actuality, testifies to the theological dimension of Forrestall's work. It expresses human finitude and imperfection, as well as the idea of the incarnation of the divine within the earthbound and everyday.

Gerhard Richter German, 1932–

Landscape near Koblenz, 1987

Oil on canvas 140 x 200 cm

Montreal Museum of Fine Arts, Montreal
Purchase; Caroline Durand Fund; Deirdre M. Stevenson Fund;
Murray Vaughan Foundation; Royal Trust; Michael McKenzie;
Horsley and Annie Townsend Bequest; and Pierre Thomas; 1988.6

THE LANDSCAPE HELD BY the Montreal Museum of Fine Arts represents an important body of work in which Gerhard Richter explored the idea and the representation of the landscape. In many instances, these paintings from the 1980s depict the countryside around Cologne and Düsseldorf where the artist had lived. The landscape was an almost constant motif or point of departure in Richter's work for over two decades, beginning in the 1970s when he used the camera to document the landscape as a theme for his painting.

Born in Dresden, Richter studied painting at that city's Kunstakademie from 1951 to 1956, and continued his studies at the Kunstakademie in Düsseldorf in 1961 when he escaped to West Germany. He would not return to Dresden for twenty-five years. At the academy in Düsseldorf he became good friends with Sigmar Polke and Konrad Lueg, and the three artists, under their teacher Karl Otto Götz, were introduced to the latest developments in Pop Art from England and the United States. The students adopted an anti-style agenda called Kapitalistischer Realismus (Capitalistic Realism), which approached popular advertising much in the same way as Pop Art. Richter still regarded himself as a painter, although he had begun to include both conceptual art and performance art in his artistic production, and shifted easily between media.

In 1969 Richter turned away from using found photographs from magazines and newspapers, which had been part of his experimentation with Pop Art and Art Informel in Düsseldorf (of which his teacher Götz was a leading representative). In the 1970s, he began using his own photographs, mainly of rural fields and meadows, for his new painting. In 1945, when he was thirteen years old, Richter received a single plate camera as a Christmas gift from his mother, and he immediately set about learning the art of photography including doing his own developing and printing. The photographic medium or image has stayed with Richter throughout his career, much in the same way the landscape has been a mainstay in his choice of subject.

In *Landscape near Koblenz*, Richter has used an out-of-focus technique to underline his pretense as he explores the idea of representation and realism, alluding to the complicated relationship between photography and painting. For this landscape, he has shifted the low, flat horizon line (used in earlier works) upward, allowing for greater contrasts between the foreground and background. The act of painting is paramount here, superseding the recording of a particular place. Working on the canvas with the photographic images projected, he painted the same site from different perspectives with each paint layer adding another lens or angle to the scene. Critics have linked these landscapes to the German Romantic tradition of Caspar David Friedrich as well as to the Danish Golden Age of painters; and while Richter does not deny the lineage, the suggestion of dreamscapes seems more fitting for these breathtaking works. When asked in an interview in 1991 if he was still interested in painting landscapes, Richter stated: "Not any more. I don't like any of my photographs. I'm still taking them, though not so many of them. Perhaps it's because I can imagine how it would all turn out, and I don't like it" (Gerhard Richter, *Text. Writings, Interviews and Letters 1961–2007*, London; Thames & Hudson, 2009).

Alex Janvier Dene/Saulteaux/Canadian, 1935–

Lubicon, 1988

Acrylic on canvas 165.2 x 267 cm

Art Gallery of Alberta, Edmonton
Purchased with funds from the Estate of
Jean Victoria Sinclair; 98.13

BORN ON ALBERTA'S LEGOFF RESERVE of Cold Lake First Nations to the region's last hereditary Dene chief, Alex Janvier's artistic talent was recognized when he attended Blue Quills Indian Residential School. He went on to study art at the Alberta College of Art in 1956. Janvier's work draws on the modern Western tradition, imparted by instructors such as Marion Nicoll, as well as by the works of exemplars of European Abstraction such as Wassily Kandinsky and Paul Klee. He creates, in his words, "a language within the perimeters of abstraction" (Mark Walton, "Alex Janvier: Enduring Spirit," *Artfocus*, Fall 1995, 12), combining this modern awareness with motifs and a chromatic symbolism that draws from his Dene and Saulteaux lineage, particularly patterns derived from these cultures' bead- and quillwork. Janvier is a politically engaged painter. He contributed, along with Daphne Odjig and Jackson Beardy, to the landmark *Treaty Numbers 23, 287, 1171* exhibition at the Winnipeg Art Gallery in 1972. He was a founding member of the Professional Native Indian Artists Incorporation in 1973, which advocated for and brought attention to contemporary First Nations art and artists. Through the 1970s, as an ironic gesture of anti-assimilation and post-colonial reclamation, he signed his work with his treaty number, 287. In 2008 he received a Governor General's Award in Visual and Media Arts.

Lubicon is a crowning example of Janvier using an apparently abstract idiom to speak to a particular political and economic issue affecting a First Nations people. It was painted the same year that the exhibition *The Spirit Sings* opened at the Glenbow Museum, which helped mark the 1988 Winter Olympics in Calgary. The exhibition provided an extensive historical survey of Canadian First Nations visual culture, and it also became a highly charged and controversial event. It featured historical objects made exclusively by Aboriginal peoples that are now owned and loaned by North American and European institutions, which for many First Nations artists continue to represent colonial interests. *The Spirit Sings* was also sponsored by Shell Canada, which at the time was engaged in exploiting natural resources on land in northern Alberta occupied by the Lubicon Cree, a group that had been struggling for half a century to settle a land claim with the Canadian federal government. The exhibition was controversial, in the words of curator Lee-Ann Martin, for "romanticiz[ing] aboriginal history while denying contemporary realities" (Lee-Ann Martin, *Alex Janvier: Negotiating the Land*, Saskatoon, SK: Mendel Art Gallery, 1994, 10).

The Art Gallery of Alberta work features a red ground torn open to expose a dizzying, undulating zigzag of calligraphic colour, and Janvier painted it with rage as a response to the plight facing the Lubicon Cree. It expresses a painful paradox that many Aboriginal people face: desiring sovereignty and to live free of the legalistic strictures of government treaties, while at the same time understanding the ever-present need for diligence and consciousness in safeguarding the integrity of their land and culture for the future.

Jeff Wall Canadian, 1946–

Outburst, 1989

Transparency in light box 235 x 320 x 22 cm

Vancouver Art Gallery, Vancouver
Vancouver Art Gallery Acquisition Fund; VAG 90.1 a–f

CANADIAN ARTIST JEFF WALL is recognized internationally for his luminous, monumental, immaculate, and rigorously staged colour photographs. His scenes, mostly shot in the vicinity of his native Vancouver, often appear to be suspended moments that document everyday life. They are, in fact, the result of detailed planning, lengthy rehearsals, and careful shooting.

After completing his fine art degree at the University of British Columbia, Wall turned to art history, continuing post-graduate studies at the Courtauld Institute of Art in London, England. This period of academic transition gave the artist a new perspective on his own practice. Previously interested in Conceptualism and the deconstruction of aesthetic criteria traditionally employed in understanding and defining art, Wall gradually developed the idea of reconnecting with art history through the medium of photography. The particular approach he took and the attendant theoretical and art historical issues that his work explores has had a foundational influence on the development of post-conceptual photography in Vancouver and worldwide since the late 1970s.

Wall began orchestrating and taking photographs of indoor and outdoor scenes in and around Vancouver in the 1980s. With captivating precision, his images suspend people and elements within a particular environment, freezing them at a halting, pregnant moment: a carton of milk explodes in a man's hand; paper scatters in an unseen wind; a racist gesture is made. He chooses to print his images using the same processes and materials used in the reproduction of film transparency on paper, and he displays them mounted within, and backlit by,

fluorescent light boxes to create images that literally glow. Their luminosity, scale, and subject matter draw references from a range of diverse phenomena, from the desire of nineteenth-century modern painters and commentators like Édouard Manet and Charles Baudelaire to define and capture modern life, to the visual tropes of cinematic narrative and the abiding quest for documentary realism. Modern advertising is also an important influential touchstone. Wall claims he arrived at the idea of using light boxes from seeing similarly lit advertisements in bus shelters in Europe.

In his work Wall stimulates the viewer's interest in a photographic image's irretrievable backstory. *Outburst*, from the late 1980s, shows a moment of workplace confrontation between a threatening manager and an employee at what appears to be a garment factory or a sweatshop. In this case, one point of visual contrast between the two main protagonists is not without irony: we distinguish one from the other, note the hierarchy at play, not in the last analysis through body language, race, or even gender, but by what they are each wearing. Where does this apoplectic boss buy his clothes? Where do the workers get theirs? Wall's power resides in his ability to create a scene that is at once banal, passing, and generic—like the sartorial products being manufactured—and absolutely exceptional, archetypal. The scene is also unsettling; it implicitly raises ethical questions concerning the substandard working conditions associated with sweatshop labour. However, the work of art itself, as a glowing, large-scale photograph, does not allow it to offer a coherent rejoinder.

Edward Poitras Plains Cree/Saulteaux/Metis/Canadian, 1953–

Traces: A Car, A Camera, A Tool, A Container, 1995

Bronze, paint, patina
Variable dimensions A Car: 23.5 x 129 x 57.5 cm; A Camera: 23.5 x 107.5 x 72 cm;
A Tool: 47 x 79.5 x 50 cm; A Container: 19.5 x 116 x 73.5 cm

MacKenzie Art Gallery, Regina
1995-026-001-004

BORN AND RAISED IN REGINA as well as on the Gordon First Nation, Edward Poitras became the first Aboriginal artist and Saskatchewanian to represent Canada at the Venice Biennale. His performances, mixed-media sculptures, and often site-specific installations typically incorporate non-traditional artistic materials with those common to his First Nations material culture, from circuit boards to animal bones. Poitras works to poetically explore the clash of cultural histories.

Poitras's paternal roots lie in Manitoba. His Metis great-great-grandfather served as a member of Louis Riel's provisional government. He was arrested by Lieutenant Colonel Garnet Wolseley's expeditionary force in 1869, after which he fled to the Qu'Appelle region of present-day Saskatchewan. On his mother's side, Poitras is Plains Cree/Saulteaux. The artist's mixed European-Aboriginal ancestry was often cause for prejudicial misunderstanding and provoked Poitras to use art as a means to explore cultural hybridity. He began making art in the 1970s while studying at the Saskatchewan Indian Cultural College under Sarain Stump, and at Quebec's Manitou College under Domingo Cisneros. Like Poitras, both instructors were of mixed ancestry, and both viewed this as a creative source that could be expressed through art. Dada artist Marcel Duchamp's combinatory, associative, conceptually driven approach to art-making was another important early influence. The young Poitras adopted a principle of alterity, and began creating work that united different kinds of objects and technologies, not only as an honest expression of self-acceptance, but also as a way of nomadically criss-crossing established artistic boundaries. After his

first major exhibition at the MacKenzie Art Gallery in 1984, he also turned to the issue of Aboriginal treaty rights and history. Members of his family had borne witness to the signing of Treaty Four, and Poitras became interested in the historically fraught legacy of contractual interpretation. Throughout the ensuing decades, the artist's success continued with solo exhibitions such as *Indian Territory* (Mendel Art Gallery, 1988) and inclusion in several landmark surveys of contemporary Aboriginal art, from *Indigena: Contemporary Native Perspectives* (Canadian Museum of Civilization, 1992) to *Close Encounters: The Next 500 Years* (Plug In ICA; Urban Shaman: Contemporary Aboriginal Art; Winnipeg Art Gallery, 2011). In 2002 he received the Governor General's Award in Visual and Media Arts.

The artist's participation in the Venice 46th Biennale in 1995 stands as his greatest professional achievement to date. *Traces* appeared in the exhibition; indeed, it was the first piece visitors encountered upon entering the Canadian pavilion. The work consists of four bronze sculptures, all of which lie directly on the floor. Each is an enlarged version of an object drawn from the artist's personal medicine bundle. Each represents a natural or archeological remnant, and bears a seemingly disconnected contemporary designation: a coyote jaw is a car, a bear claw a camera, a shard from a clay vessel is a container, and a flint scraper is a tool. Poitras monumentalizes objects of personal significance, collapses past and present, and thereby continues his role as trickster, pushing established boundaries as a way of discovering new knowledge.

Wanda Koop Canadian, 1951–

Native Fires, 1996

Acrylic on canvas 300 x 401 cm

Winnipeg Art Gallery, Winnipeg
Gift of the artist; 2010-113

WANDA KOOP'S CAREER HAS spanned three decades and included painting, installation, video, and performance work. In a 1998 interview she described her interdisciplinary approach as speaking to her interest in creating art objects that reflect "a continuum of ideas and thoughts." As with *Native Fires*, which represents twin campfires reflected in the Assiniboine River at night, the artist often explores ideas that relate both poetically and politically to subjects pertinent to her Winnipeg home.

As a child, Koop moved with her family from Vancouver, her city of birth, to Winnipeg. She took children's art classes through the Winnipeg Art Gallery before attending the University of Manitoba, graduating in 1973. Koop was one of a handful of important female painters working in a medium and style, and at a heroic scale conventionally associated with male painters. She came to the fore in the 1980s, along with artists like Joanne Tod, Carol Wainio, and Eleanor Bond, at a time when figurative painting was experiencing a revival internationally under designations such as New Image painting and Neo-Expressionism. Her artistic production over the decade was characterized by discrete series of large-scale paintings, often on plywood, that routinely featured prominent, singular, loosely painted motifs. For Koop, monumentality operates as a device that transfigures paintings from being merely images on walls to becoming architectural interventions. Key bodies of work from this period, such as *The Plywood Series* (1981), *Reactor Suite* (1984), and *Northern Suite* (1986), consist of iconic images that speak at once boldly and cryptically to the intersection of humanity and landscape, banal technology and sublime nature,

sign systems and systems of magic. In the 1990s, canvas became Koop's primary painting support. Additionally, video became increasingly central to her practice, appearing as both stand-alone works and replacing photography as the primary means by which she gathered reference material for her paintings. The technology of surveillance—the ubiquitous computer and television screens as metonyms for the spectacle of all-encompassing social visibility—also emerged as a potent subject for Koop in the 1990s and 2000s. Indeed, the line separating video and painting is blurred. In series such as *In Your Eyes* (1997), *Green Zone* (2004), and most recently *Hybrid Human* (2009), Koop reveals her marked interest in the role technology plays in mediating and transfiguring everyday visual experience.

Motifs have often recurred in Wanda Koop's work throughout her career. *Native Fires* represents one such image. The urban riverbank at night first emerged as a subject in her painting in 1989. She drew her inspiration from Winnipeg's First Nations community, which, for thousands of year before the completion of the Assiniboine Riverwalk in 1990, had gathered around campfires at night along the shore of the city's Assiniboine River. In the painting, a dark and moody forest wall divides a gleaming shoreline from three looming buildings. An office tower, a church steeple, and the cupola of the provincial legislature, each expressing a different mode of colonial imposition, stand in ethereal contrast to the glowing tear-shaped fires and their reflections. Koop has stated in an interview from 2012 that the work is "probably the most compact painting that I've ever done in terms of how I think and view the world."

Lawrence Paul Yuxweluptun Coast Salish/Canadian, 1957–

The Impending Nisga'a Deal. Last Stand. Chump Change., 1996

Acrylic on canvas 201 x 245.1 cm

Vancouver Art Gallery, Vancouver
Vancouver Art Gallery Acquisition Fund; VAG 96.27

LAWRENCE PAUL YUXWELUPTUN works at the intersection of Modernism, Coast Salish-Okanagan cosmology, and post-colonial politics. His symbolically charged paintings combine oneiric Surrealism and traditional Northwest Coast design. In so doing, they implicitly interrogate categories that Western anthropology and art history have historically imposed on First Nations material culture. Yuxweluptun's work also addresses issues affecting Northwest Coast First Nations' communities today, lending the figures and narratives that calibrate the artist's cultural worldview a subversive form.

Yuxweluptun, whose father, Benjamin Paul, served as president of what is today the Assembly of First Nations and as an official of the Union of British Columbia Indian Chiefs, was born in Kamloops. He was raised largely in urban areas of British Columbia, not on rural reserves. His father's example and his own experiences as an "urban Indian" impacted both the formation of his artistic identity and his political consciousness. Between 1978 and 1983, Yuxweluptun attended what is now the Emily Carr University of Art and Design, where he was exposed to the history and development of Western painting and developed an interest in the historical adaptation of so-called primitive cultural expression by modern artists. Reversing this arrangement, he adopts the materials and motifs of modern painting in order to represent issues and events of central importance within contemporary Northwest Coast Aboriginal culture. In *The Impending Nisga'a Deal. Last Stand. Chump Change.*, he deploys Indigenous design elements to construct a hallucinatory British Columbia landscape. Such paintings within Yuxweluptun's oeuvre "ripple and ooze and erupt with a terrible and terrifying

brilliance" (Allan J. Ryan, *The Trickster Shift: Humour and Irony in Contemporary Native Art*, Vancouver: University of British Columbia, 1999, 110). The artist's work has been shown in several landmark exhibitions of contemporary Aboriginal art including *Indigena: Contemporary First Nations Perspectives* (Museum of Civilization, 1992); *Land, Spirit, Power: First Nations at the National Gallery of Canada* (1992); and *Close Encounters: The Next 500 Years* (Plug In ICA; Urban Shaman: Contemporary Aboriginal Art; Winnipeg Art Gallery, 2011).

The Impending Nisga'a Deal. Last Stand. Chump Change. displays Yuxweluptun's ability to politically mobilize the hybrid aesthetic sensibilities of the Northwest Coast First Nations and Modernism. Its subject is the century-long history of treaty negotiations between the government and the Nisga'a people. In 1955 the Nisga'a gained the legal right to establish a tribal council to represent their people at treaty talks. However, the terms of the eventual land claim, which did not achieve legal effect until 2000, was not universally embraced by the Nisga'a. In this work, the first major canvas by Yuxweluptun to enter the Vancouver Art Gallery, a government bureaucrat steps across the newly imposed treaty boundary, and away from an obliterated and toxic environment. "Chump change" can be seen falling from the hand of the Nisga'a negotiator. As critical of destructive compromise on the part of some Nisga'a representatives as he is of government policy, Yuxweluptun offers a no-holds-barred assessment of issues that remain central within Canadian public discourse.

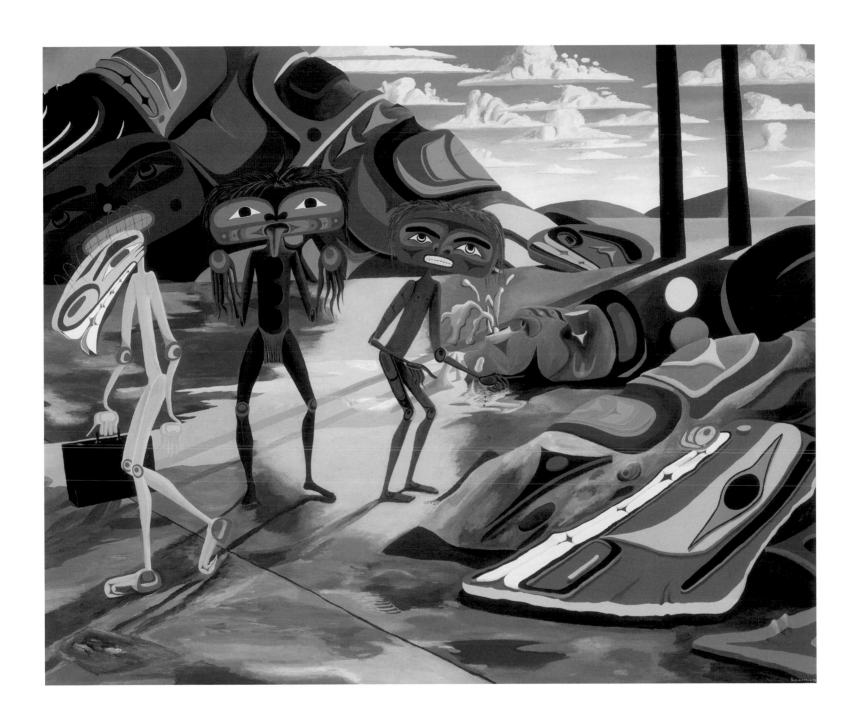

Jane Ash Poitras Cree/Canadian, 1951–

From Riel to Peltier, 1999

Mixed media on canvas 162.7 x 315.2 cm

Art Gallery of Alberta, Edmonton
Purchased with funds from the Estate of Jean Victoria Sinclair,
and with the financial support of the Canada Council for the
Arts Acquisitions Assistance Program; 99.3

THE ALBERTA-BORN PAINTER, printmaker, and writer Jane Ash Poitras completed an undergraduate degree in microbiology before studying art at the University of Alberta. At Columbia University (where she received her master's degree in fine arts, specializing in printmaking), Poitras discovered collage and the work of artists like Robert Rauschenberg, Kurt Schwitters, and Cy Twombly who experimented with the interplay between text and image. She was also exposed to and influenced by the non-Western aesthetic sensibility of her Japanese printmaking instructors. A member of Mikisew Cree First Nation, Poitras grew up living between two worlds. Born to a Chipewyan mother who perished from tuberculosis while Poitras was still young, the orphaned artist was subsequently raised in Edmonton by a German foster mother. Poitras attended public school and services at a Roman Catholic Church, experiences that simultaneously enriched and complicated her rediscovery of her Aboriginal community and spirituality as an adult.

Poitras emphasizes the role her hybrid personal history has had on her art practice. Her mature works combine image and text, and involve observation and reading with an aim to both syncretically connect and disruptively collapse the histories of otherwise disparate peoples and belief systems. Her tableaus are at once painterly and graphic, expressive and documentary, and within them she routinely aligns symbols of recognized and acknowledged events— for example, a map outlining the imperialist expansion of Nazi Germany leading up to World War II—with those that have been forgotten or downplayed—a map of a Navajo reservation as a testament to colonialism's systematic cultural genocide in North America—to create scenes of schism and analogy.

This work's title, *From Riel to Peltier*, refers to two representatives of militant North American activism in the mid-west, separated by a century. Louis Riel was the charismatic Metis leader who was hanged as a traitor for his role in the Red River (1869–1870) and North-West (1885) Resistances. Leonard Peltier, a member of the American Indian Movement, participated in an armed standoff with U.S. authorities at the Pine Ridge Indian Reservation in South Dakota in 1975, which resulted in him receiving a controversial judgment of two lifetime sentences for the murder of two FBI agents. The Art Gallery of Alberta work is a *bricolage* tour-de-force. A patchwork of photographic images unfolds like a timeline across a central third of the canvas: Riel appears twice—in a 1876 portrait and at his trial in Regina—along with portraits and the names of the North-West Resistance protagonists including Prime Minister John A. Macdonald, Gabriel Dumont, Big Bear, Poundmaker, and Crowfoot. Poitras encloses this historical testament, which also includes the artist's characteristic handwritten reflections, between two bands that contain the bold geometric designs and colours of the Plains First Nations. *From Riel to Peltier* reads as both an homage to the past and a stirring call to future activism.

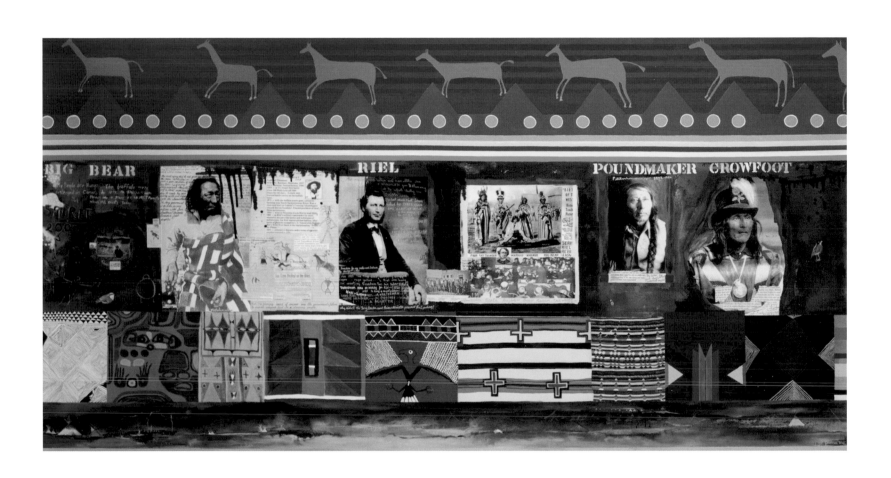

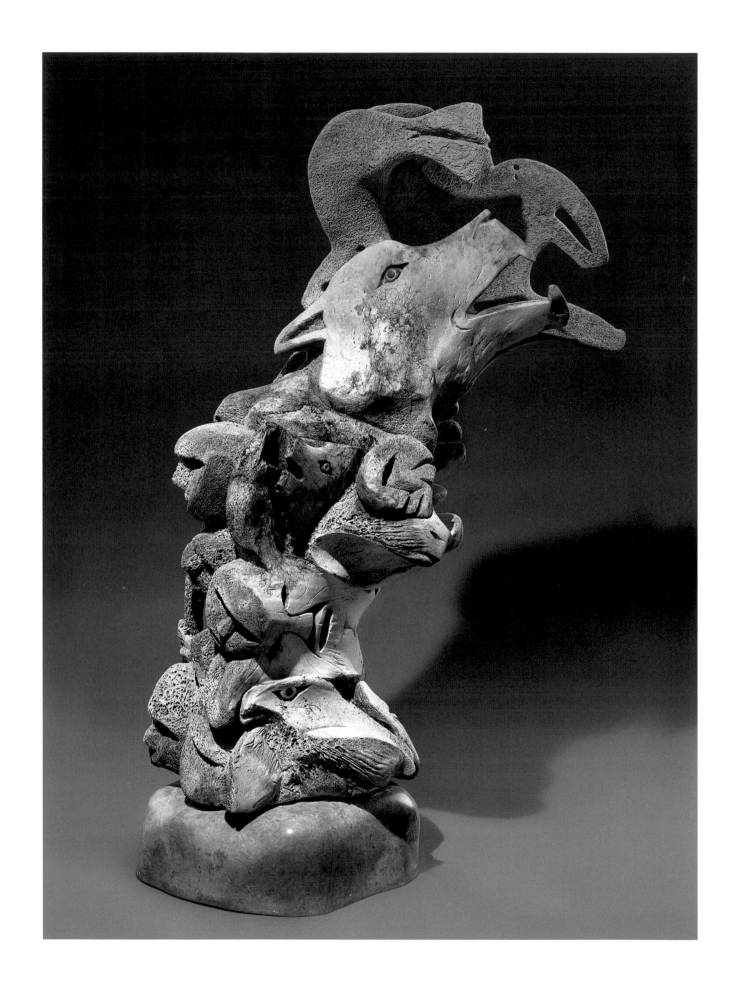

Abraham Anghik Ruben Inuit (Paulatuk)/Canadian, 1951–

Kittigazuit, 1999–2000

Whale bone, Brazilian soapstone, African wonderstone 129.5 x 42.5 x 73 cm

The Winnipeg Art Gallery, Winnipeg
Commissioned from the artist; acquired with funds from
The Winnipeg Art Gallery Foundation Inc. and with the support of the
Canada Council for the Arts Acquisition Assistance program; 1999-616

ABRAHAM ANGHIK RUBEN'S recollections of early childhood, spent several hundred miles north of the Arctic Circle, are filled with memories of the land when, as he describes it, the "old magic"— the vivid dreams of other worlds populated with creatures that are part of the artist's shamanic heritage—"was still there." These memories faded after he entered residential school and lost his ability to speak Inuktitut. As an artist, much of Anghik Ruben's work centres on themes of spiritual recovery and cultural rediscovery.

Anghik Ruben's early years were spent near Paulatuk where his family engaged in the seasonal cycle of hunting and fishing along the western Arctic coast. However, from the age of eight until his expulsion at eighteen, he attended residential school where his life hung in a cultural limbo between his Inuit heritage and the school's colonial values. He reached a turning point in his life in the early 1970s when he met and began apprenticing with Ronald Senungetuk, who taught at the Native Art Center at the University of Alaska. Senungetuk encouraged the young artist to combine the study of his traditional stories and imagery with an exploration of contemporary forms and techniques. Anghik Ruben decided to pursue carving as a full-time artist in 1975, establishing a studio in Yellowknife. A visit by Toronto gallery owner Jack Pollock resulted in the artist receiving four solo exhibitions in that city from 1977 to 1980. His work was well received, and he moved his studio to Vancouver and then Salt Spring Island. On the West Coast, Anghik Ruben discovered Brazilian soapstone, which became his main carving medium. In 1989 and 2001 he received major exhibitions at the Winnipeg Art Gallery.

After his 1989 exhibition, Anghik Ruben's practice took a new direction. He became interested in the settlement history of the western Arctic, and began working in bronze and bone as well as stone. *Kittigazuit* was carved from a section of a bowhead whale's skull that was originally two and a half metres long and had been a landmark outside the DEW Line station north of Paulatuk. He received permission to relocate the giant skull to his Salt Spring Island studio in 1994. It bears the same title as an ancient fishing and hunting town in the western Arctic, once peopled by whalers, traders, Inuvialuit, Dene, and Alaskans. A series of epidemics between 1865 and 1902 decimated the population including relatives of Anghik Ruben; survivors dispersed along the coastline. Today, in curator Darlene Coward Wight's words, "it is little more than a landmark on the tundra" (Darlene Coward Wight, *Abraham Anghik Ruben*, Winnipeg: Winnipeg Art Gallery, 2001, 14). The bottom stratum of the porous bone carving features eyeless effigies of those who perished in the epidemic. To move up the sculpture is to travel forward in time, from the circular void and the woman's face framed by an *amautik* (parka) that is empty of children—both symbols of generational loss and cultural desolation— to the multitude of animals—loons, seals, ravens, and bears—that encircle the sculpture's perimeter. Today, the animals are Kittigazuit's only inhabitants.

David Blackwood Canadian, 1941–

Home from Bragg's Island, 2009

Oil tempera on canvas 183 x 272 cm

The Rooms Provincial Art Gallery, St. John's
Gift of BMO Financial Group; 2009.07.01

DAVID BLACKWOOD IS A Newfoundland painter and printmaker whose work mines the stories and history of a region, collapsing and re-enacting these tales in imagery that is at once dramatic and concise, documentary and poetic. Blackwood was born and raised on the north side of Bonavista Bay. For four hundred years, the area was well known for sealing and its fishing grounds, and his father and grandfather both pursued careers on the sea. His family attended a Methodist church, and Blackwell credits the sermons—and particularly those focused on stories and themes from the Old Testament—as having a significant impact on his artistic imagery and narrative sensibility. He attended the Ontario College of Art on a scholarship in the late 1950s and early 1960s, and went on to teach at Trinity College School (Port Hope, Ontario). In 1969 he was appointed the first artist-in-residence at the University of Toronto, and held this position until 1975.

Blackwood's work is fundamentally about survival, or, in his words, "living intimately, every day, with life and death" (Gary Michael Dault, "Ice and Fire: An Interview with David Blackwood," *Black Ice: David Blackwood Prints of Newfoundland*, Toronto and Vancouver: Art Gallery of Ontario and Douglas and McIntyre, 2011, 32). While his maritime roots, interest in existential themes, and non-naturalistic realism have encouraged many to relate his work to that of artists like Christopher Pratt and Alex Colville, Blackwood regards his pursuits as being different from theirs. His compositions highlight the immensity of the natural world, which he often sublimely articulates by making visible the hidden depths of the ocean in relation to fading modes of human life and enterprise.

Blackwood's art deals in a recurring iconography of place—dories, lighthouses, fishing gear, icebergs, as well as community customs—that communicate a sense of otherworldliness through the commonplace. The brightly coloured doors of fishing sheds, such as the one that appears in *Home from Bragg's Island*, frequently appear in his work. Indeed, this large 2009 painting (which the artist began in the early 1990s before abandoning it for many years) derives its three main elements—the door, the cod-splitting table, and the sea vessel—from a number of paintings and etchings dating back to the early 1980s. The scene is a visual reminiscence of the Blackwood family's return from Bragg's Island, where the artist's maternal grandparents lived and ran a general store, to their home in Wesleyville; the distant landform is Bennett's High Island, the entrance to the village harbour. The family, backlit by competing lights from the moon and lighthouse, cast an ethereal shadow over the tools and fixtures that defined their livelihood.

The myths and histories that Blackwood's work visually represent are unapologetically regional; they reflect formative narratives that provided the artist with the first means of understanding and orienting himself within the world. Yet the artist's regional tropes and motifs are communicated in a grand way, unfolding universal themes in a manner reminiscent of Melville, Coleridge, or indeed the Bible's Book of Jonah.

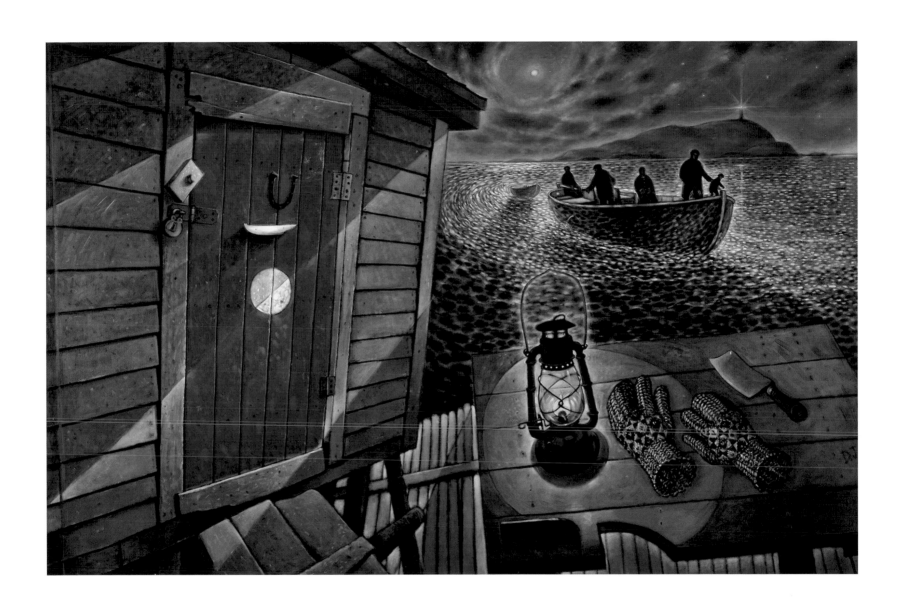

Robert Davidson Haida/Canadian (born in the United States), 1946–

Killer Whale Transforming into a Thunderbird, 2009

Wood, paint, electric motor, and remote control 95 x 310 x 73 cm

Vancouver Art Gallery, Vancouver
Commissioned with funds from Arts Partners
in Creative Development, the Jean MacMillan Southam
Major Art Purchase Fund, and Gary Bell; VAG 2009.30.1

THE HAIDA-TLINGIT ARTIST Robert Davidson maintains the craftsmanship of his Haida predecessors in his work. However, like his senior contemporary Bill Reid, Davidson strives to manipulate long-established designs and technical knowledge toward creating objects that shine new perspectives on the stories and figures that populate traditional Haida culture.

Davidson was born to a long line of artists. His great-grandfather Charles Edenshaw and his grandfather Robert Davidson Sr. were both artists. His father Claude Davidson taught him fine carving so that he could carry on the family tradition at a time when there was a perception that Haida art was beginning to disappear. Born in Alaska and raised in Masset on the northern tip of Haida Gwaii, Davidson moved to Vancouver in 1965 to complete his high-school education. Access to the Museum of Vancouver's collection of material culture from Haida Gwaii provided Davidson with greater opportunity to learn about Haida art and its history. One year after his arrival in the city, Davidson met and apprenticed for half a year under the Haida carver, sculptor, and jeweller Bill Reid. The young artist also benefited from meeting anthropologist Wilson Duff as well as the artist and art historian Bill Holm, who had just published *Northwest Coast Indian Art: An Analysis of Form*, a landmark structuralist analysis of the general principles and design elements common within Northwest Coast First Nations art. Seeking formal instruction, Davidson enrolled in the Vancouver School of Art in 1967 where he discovered drawing, followed by printmaking. In 1969 he carved a totem pole that was subsequently installed in Masset, the first to be raised in the village in over forty years.

In his mature practice, Davidson has followed two parallel paths. With the first, he continues in the time-honoured tradition of Haida carving to produce mostly ceremonial objects. With the second, Davidson, like Reid, has actively and innovatively sought to incorporate materials that are not indigenously Haida such as bronze, aluminum, and epoxy. He was also the first Haida artist to use canvas as a primary support for his painting, and he provided drawings that served as the basis for a line of clothing designed by Dorothy Grant. Moreover, Davidson has often diverged from the "formline" strictures of traditional Northwest Coast design, bending the rules in order to develop new vocabularies of visual expression. He received a Governor General's Award in Visual and Media Arts in 2012.

Killer Whale Transforming into a Thunderbird relays, in form and content, the idea of two intersecting and commingling paths or traditions. The work is a kinetic transformational sculpture constructed from both natural and industrial materials. The central component is a bifurcated killer whale head that encloses, and which can be opened to reveal, the face of a Thunderbird. According to Haida narrative, Killer Whale is the indomitable force below the oceans, but is itself quarry for the mythical Thunderbird, whose realm is the sky or upper world. In Davidson's sculpture, the mortal enemies are conjoined so that prey transforms into predator.

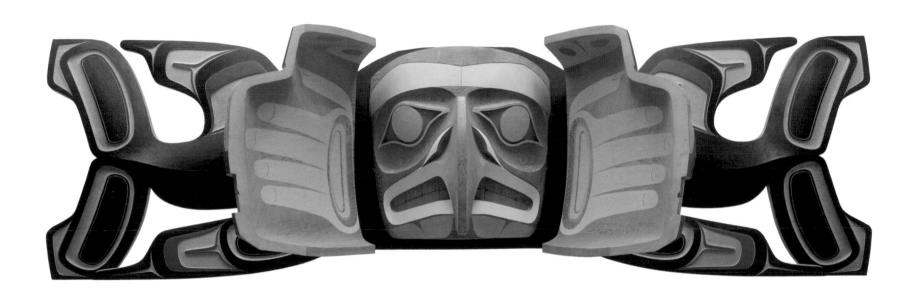

Index

Photo Credits

Lucas Cranach the Elder
Adam and Eve
Photo: University of Toronto
Art Centre

Italian
"The Aldobrandini Tazza"
With permission of the Royal
Ontario Museum © ROM

Aelbrecht Bouts
The Man of Sorrows and
The Mater Dolorosa
Photo: John Tamblyn

Bartholomaeus Bruyn
the Younger
Portrait of a Man
Photo: Ernest Mayer,
Winnipeg Art Gallery

Matthias Walbaum
Diana and the Stag
With permission of the Royal
Ontario Museum © ROM

Rembrandt van Rijn
A Woman at her Toilet
Photo © NGC

Jan Lievens
Portrait of Jacob Junius
Photo: Agnes Etherington
Art Centre

Michiel Sweerts
Self-Portrait with Skull
Photo: Agnes Etherington
Art Centre

Philips Koninck
*Panoramic River Landscape
with Hunters*
Photo: Agnes Etherington
Art Centre

Claude Gellée,
called Claude Lorrain
*Coast View with the
Embarkation of Carlo and
Ubaldo*
© 2012 AGO

Giovanni Paolo Panini
*A Capriccio of Roman Ruins
with the Arch of Constantine*
*A Capriccio of Roman Ruins
with the Pantheon*
© 2012 AGO

Thomas Gainsborough
*An Extensive Wooded River
Landscape, with Cattle and a
Drover and Sailing Boats in the
Distance*
Photo: Beaverbrook Art
Gallery

Jean-Honoré Fragonard
*The Grand Staircase of the
Villa d'Este at Tivoli*
Photo: Minneapolis Institute
of Arts

Dominic Serres
*Governor's House and St.
Mather's Meeting House on
Hollis Street*; *Part of the Town
and Harbour*; *Town and
Harbour of Halifax*; *Town
and Harbour of Halifax*
Photo: Art Gallery of
Nova Scotia

Chelsea Porcelain Manufactory
Potpourri or perfume vase
With permission of the Royal
Ontario Museum © ROM

François Boucher
Les sabots
© 2012 AGO

William Pars
Portrait of Three Friends
Photo: University of Toronto
Art Centre

George Romney
*Robert, 9th Baron Petre,
Demonstrating the Use of an
Écorché Figure to His Son,
Robert Edward*
Photo: John Tamblyn

Sir Henry Raeburn
*Portrait of William MacDowall
of Garthland and Castle
Semple, M.P. and Lord
Lieutenant of Renfrewshire
(1793–1810)*
Photo: Montreal Museum of
Fine Arts

Paul Storr
Monumental candelabrum
With permission of the Royal
Ontario Museum © ROM

James Duncan
Montreal from the Mountain
Photo: McCord Museum

Antoine Plamondon
*Joseph Guillet, dit
Tourangeau fils* and *Madame
Joseph Guillet dit Tourangeau,
née Caroline Paradis*
Photo: Musée national des
beaux-arts du Québec

Joseph Légaré
*Paysage au monument à
Wolfe* (*Landscape with Wolfe
Monument*)

Photo: Musée national des
beaux-arts du Québec
Cornelius Krieghoff
An Officer's Room in Montreal
With permission of the Royal
Ontario Museum © ROM

Paul Kane
Fort Garry and St. Boniface
Photo © NGC

Unidentified artist
'Tlaolacha' [dhuẃláx̌'a] mask
Photo: Royal BC Museum

Théophile Hamel
Jeunes Indiennes à Lorette
(*Young Indian Girls in Lorette*)
Photo: Musée national des
beaux-arts du Québec

Henri Fantin-Latour
Le jeune Fitz-James
Photo: Art Gallery of Hamilton

Lucius O'Brien
*Sunrise on the Saguenay,
Cape Trinity*
Photo © NGC

Gustave Caillebotte
*Voiliers au mouillage sur
la Seine, à Argenteuil*
Photo: John Tamblyn

Sir Edward Burne-Jones
Portrait of Caroline Fitzgerald
Photo: University of Toronto
Art Centre

Vincent van Gogh
*Vase with Zinnias and
Geraniums*
Photo © NGC

Robert Harris
The Local Stars
Photo: Confederation Centre
of the Arts

Sir John Everett Millais
Afternoon Tea (*The Gossips*)
Photo: Ernest Mayer,
Winnipeg Art Gallery

Paul Peel
The Modest Model
Photo: John Tamblyn

George Agnew Reid
The Story
Photo: Ernest Mayer,
Winnipeg Art Gallery

Auguste Rodin
The Kiss
Photo: MacKenzie Art Gallery

James Wilson Morrice
La communiante (*The
Communicant*)
Photo: Musée national des
beaux-arts du Québec

Pablo Picasso
La Miséreuse accroupie
© Picasso Estate /
SODRAC (2012)
Photo: Art Gallery of Ontario

Claude Monet
Waterloo Bridge, effet de soleil
Photo: John Tamblyn

Albert Marquet
*Le pont Marie vu du
quai Bourbon*
Photo: Art Gallery of Hamilton

Maxfield Parrish
Dream Castle in the Sky
© Maxfield Parrish /
SODRAC, Montreal / VAGA,
New York (2012)
Photo: Minneapolis Institute
of Arts

Tom Thomson
In Algonquin Park
Photo: McMichael Canadian
Art Collection

Lyonel Feininger
Yellow Street II
Photo: Montreal Museum
of Fine Arts, Richard-Max
Tremblay

Sir William Nicholson
Canadian Headquarters Staff
© Canadian War Museum

John Byam Liston Shaw
The Flag
© Canadian War Museum

Pierre-Auguste Renoir
Le concert
© 2012 AGO

Rockwell Kent
Frozen Waterfall, Alaska
Photo: Art Gallery of Hamilton

George Bellows
Mrs. T. in Cream Silk, No. 2
Photo: Minneapolis Institute
of Arts

David Milne
Blue Church
Photo: McMichael Canadian
Art Collection

Walter Gramatté
Confession
Photo: Ernest Mayer,
Winnipeg Art Gallery

Félix Vallotton
Fleurs
Photo: Art Gallery of Hamilton

Arthur Lismer
Autumn, Bon Echo
Photo: Mendel Art Gallery

A. Y. Jackson
Lake Superior Country
Photo: McMichael Canadian
Art Collection

Ernst Ludwig Kirchner
View of Dresden: Schlossplatz
Photo: Minneapolis Institute
of Arts

Henri Matisse
Nude on a Yellow Sofa
Photo © NGC

Bertram Brooker
Sounds Assembling
Photo: Ernest Mayer,
Winnipeg Art Gallery

Charles Comfort
The Dreamer
Photo: Art Gallery of Hamilton

Lionel LeMoine FitzGerald
Poplar Woods
Photo: Ernest Mayer,
Winnipeg Art Gallery

Lawren S. Harris
Icebergs, Davis Strait
Photo: McMichael Canadian
Art Collection

Prudence Heward
Sisters of Rural Quebec
Photo: Art Gallery of Windsor

Franklin Carmichael
Bay of Islands from Mt. Burke
Photo: McMichael Canadian
Art Collection

Emily Carr
Big Raven
Photo: Trevor Mills,
Vancouver Art Gallery

Edwin Holgate
The Bathers
Photo: Montreal Museum of
Fine Arts, Brian Merrett

Frederick H. Varley
Mirror of Thought
© Varley Art Gallery,
City of Markham
Photo: Art Gallery of
Greater Victoria

Alfred Pellan
Quatre Femmes
© Estate of Alfred Pellan /
SODRAC (2012)
Photo: Patrick Altman,
Musée national des beaux-arts
du Québec

Alex Colville
*Infantry, near
Nijmegen, Holland*
© Canadian War Museum

Lawren P. Harris
*Reinforcements Moving up in
the Ortona Salient*
© Canadian War Museum

Laurence Stephen Lowry
Beach Scene, Lancashire
Photo: Beaverbrook Art
Gallery

Henry George Glyde
*She Sat Upon a Hill
Above the City*
Photo: Glenbow Museum

Jean-Paul Riopelle
Vallée
© Estate of Jean Paul Riopelle /
SODRAC (2012)
Photo: Ernest Mayer,
Winnipeg Art Gallery

Graham Vivian Sutherland
Men Walking
Photo: Beaverbrook
Art Gallery

Chief Nakaṕankam,
Mungo Martin
Cannibal Birds mask
Photo: Royal BC Museum

Francis Bacon
Study for Portrait No. 1
© Francis Bacon Estate /
SODRAC (2012)
Photo © NGC

Paul-Émile Borduas
Épanouissement
Photo: Richard-Max Tremblay

Alexander Calder
Red Mobile
© Calder Foundation,
New-York / Artists Rights
Society (ARS) New-York /
SODRAC, Montreal (2012)

Photo: Montreal Museum of
Fine Arts, Christine Guest

Edward John Hughes
*Steamer at the Old
Wharf, Nanaimo*
Photo: Art Gallery of
Greater Victoria

Morris Louis
Beth Vav
Photo: Glenbow Museum

Jack Bush
Spot on Red
© Estate of Jack Bush /
SODRAC (2012)
Photo: Agnes Etherington
Art Centre

Alex Colville
Ocean Limited
Photo: Steve Farmer
Photography

Bill Reid
Wasgo (Sea Wolf)
Photo: Museum of
Anthropology at The
University of British Columbia

Frank Stella
Sketch Les Indes Galantes
© Frank Stella /
SODRAC (2012)
Photo: Walker Art Center

Michael Snow
Olympia
Photo: MacKenzie Art Gallery

Jack Shadbolt
Flag Mural
Photo: Confederation
Centre of the Arts

Christopher Pratt
Young Girl with Seashells
Photo: The Rooms
Provincial Art Gallery

Kenneth Noland
Must
© Kenneth Noland /
SODRAC, Montreal / VAGA,
New York (2012)
Photo: Art Gallery of Alberta

Claude Tousignant
Gong 80
Photo: Art Gallery of Alberta

Greg Curnoe
*The True North Strong
and Free*
© The Estate of Greg Curnoe /
SODRAC (2012)
Photo: John Tamblyn

Robert Motherwell
*Untitled (Ochre and
Black Open)*
© Dedalus Foundation /
SODRAC, Montreal / VAGA,
New York (2012)
Photo: Walker Art Center

Jack Chambers
Mums
Photo: Linda
Louwagie-Neyens

Mary Pratt
Caplin
Photo: The Rooms
Provincial Art Gallery

William Kurelek
*Glimmering Tapers 'round
the Day's Dead Sanctities*
© Estate of William Kurelek,
courtesy of the Wynick/Tuck
Gallery, Toronto
Photo: Art Gallery of Alberta

Norval Morrisseau
Bearman
Photo: Glenbow Museum

Andy Warhol
Mao
© The Andy Warhol
Foundation for the Visual Arts,
Inc. / SODRAC (2012)
Photo: University of
Lethbridge Art Gallery

Charles Gagnon
*Splitscreenspace/
of April/d'avril*
Photo: Richard-Max Tremblay

Jean Paul Lemieux
Autoportrait (Self-Portrait)
Photo: Musée national des
beaux-arts du Québec

Marion Tuu'luq
Thirty Faces
© Public Trustee for Nunavut,
Estate of Marion Tuu'luq
Photo: Ernest Mayer,
Winnipeg Art Gallery

Carl Andre
*Neubrückwerk
Düsseldorf gewidmet*
© Carl Andre / SODRAC,
Montreal / VAGA, New-York
(2012)
Photo: Denis Farley

Richard Long
Niagara Sandstone Circle
© Richard Long /
SODRAC (2012)
Photo: Richard-Max Tremblay

Paterson Ewen
Shipwreck
Photo: John Tamblyn

Tom Forrestall
Island in the Ice
Photo: Steve Farmer
Photography

Gerhard Richter
Landscape near Koblenz
© 2011 Gerhard Richter –
All rights reserved /
Alle Rechte vorbehalten

Alex Janvier
Lubicon
Photo: Art Gallery of Alberta

Jeff Wall
Outburst
Courtesy of the artist

Edward Poitras
*Traces: A Car, A Camera,
A Tool, A Container*
Photo: MacKenzie Art Gallery

Wanda Koop
Native Fires
© CARCC 2012
Photo: Ernest Mayer,
Winnipeg Art Gallery

Lawrence Paul Yuxweluptun
*The Impending Nisga'a Deal.
Last Stand. Chump Change.*
Photo: Trevor Mills,
Vancouver Art Gallery

Jane Ash Poitras
From Riel to Peltier
Photo: Art Gallery of Alberta

Abraham Anghik Ruben
Kittigazuit
Photo: Ernest Mayer,
Winnipeg Art Gallery

David Blackwood
Home From Bragg's Island
Photo: The Rooms Provincial
Art Gallery

Robert Davidson
*Killer Whale Transforming
into a Thunderbird*
Photo: Trevor Mills,
Vancouver Art Gallery